D1117225

LIBRARY

Gift of

The Bush Foundation

WITHDRAWN

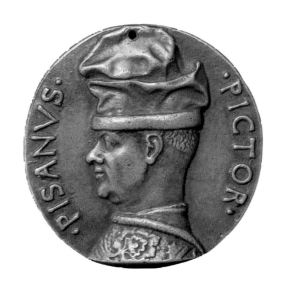

PISANELLO

PAINTER TO THE RENAISSANCE COURT

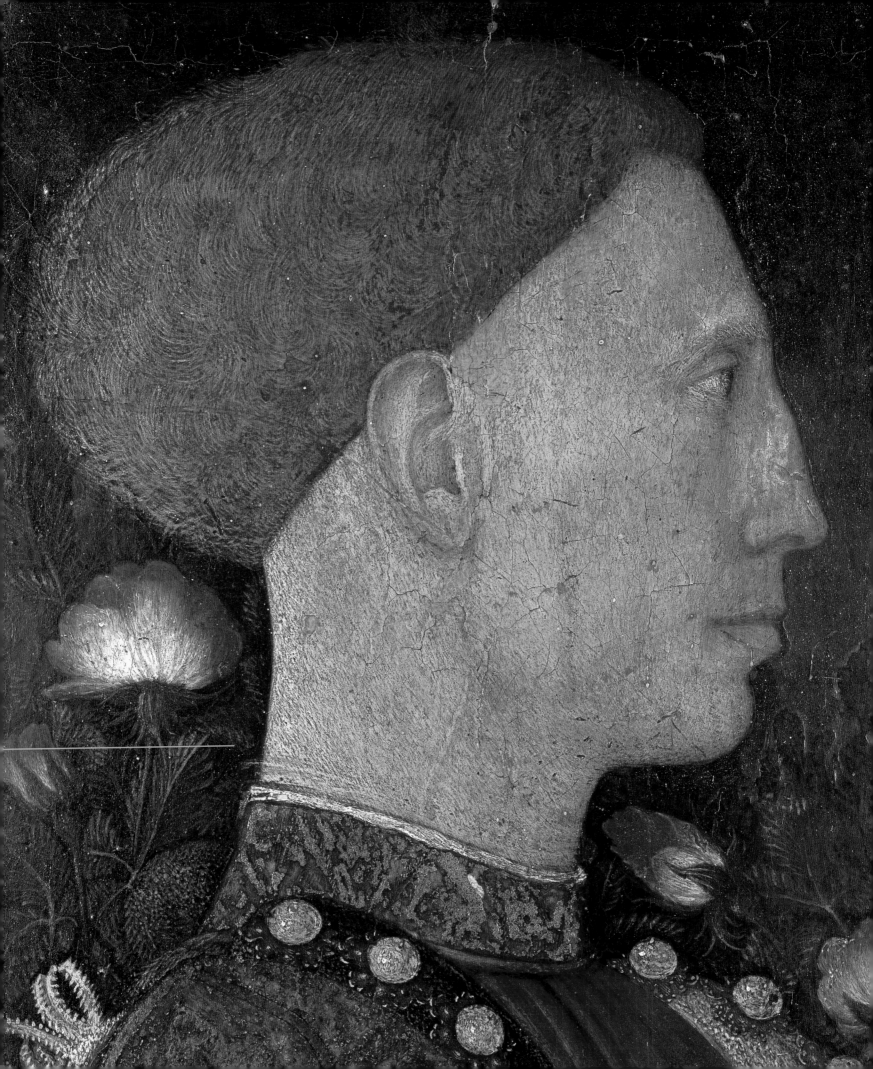

PISANELLO

PAINTER TO THE RENAISSANCE COURT

Luke Syson and Dillian Gordon

With contributions by Susanna Avery-Quash

NATIONAL GALLERY COMPANY, LONDON
DISTRIBUTED BY YALE UNIVERSITY PRESS

This book was published to accompany an exhibition
at the National Gallery, London
24 October 2001–13 January 2002

Exhibition curated in association with The British Museum

Exhibition sponsored by ExxonMobil

© 2001 National Gallery Company Limited

All rights reserved. No part of this publication may be
transmitted in any form or by any means, electronic or
mechanical, including photocopy, recording, or any
storage and retrieval system, without the prior
permission in writing from the publisher.

First published in Great Britain in 2001 by
National Gallery Company Limited
St Vincent House, 30 Orange Street,
London WC2H 7HH
www.nationalgallery.co.uk

ISBN 1 85709 946 x Paperback 525081
ISBN 1 85709 932 x Hardback 525082

British Library Cataloguing-in-Publication Data
A catalogue record is available from the British Library
Library of Congress Catalog Card Number 2001095569

MANAGING EDITOR Kate Bell
EDITOR Paul Holberton
DESIGNER Philip Lewis
PICTURE RESEARCHER Xenia Geroulanos

Printed and bound in Great Britain by
Butler and Tanner, Frome and London

FRONT COVER Pisanello, *Margherita Gonzaga*, c.1438–40
(detail of fig. 3.19)
BACK COVER Pisanello, Portrait medal of Niccolò Piccinino,
reverse, c.1439–42 (detail of fig. 3.37b)
HALF TITLE Pisanello and/or workshop, Self-portrait medal,
obverse, c.1445–52 (fig. 1.2a)
FRONTISPIECE Pisanello, *Leonello d'Este, marquis of Ferrara*, c.1441
(detail of fig. 3.2)
PAGE VI Pisanello, Portrait medal of Pier Candido Decembrio,
reverse, 1448 (fig. 3.33b)
PAGES X, XI Pisanello, Sala del Pisanello (Arthurian frescoes), south-east wall,
The Tournament at the Castle of King Brangoire (detail of fig. 2.10)

CONTENTS

folio
ND
623
.P68
A4
2001

013102—3500A8

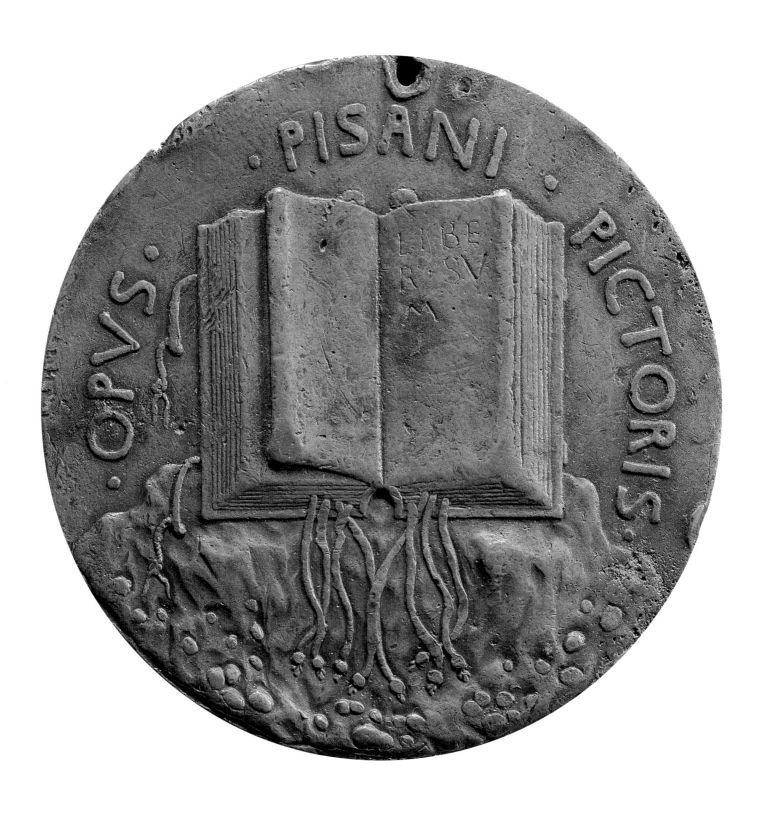

AUTHORS' ACKNOWLEDGEMENTS

This book was written to accompany the exhibition of the same title at the National Gallery. No monographic study of Pisanello has been published in English since the appearance of G. F. Hill's book in 1905, and we therefore decided that, rather than write a traditional catalogue, we should seize the opportunity to put Pisanello's art in context for an English-reading audience. This seemed desirable not least because in the last six years a group of ground-breaking works in other languages has appeared, in which many of the works included in this book and exhibition have been exhaustively catalogued and discussed. Certainly the most significant of these are the catalogues that accompanied the 1996 exhibitions in Paris and Verona, and the three associated publications written or edited by Dominique Cordellier. These have shed new light on Pisanello's biography, his paintings, drawings and medals, and his workshop, introducing arguments we have here attempted to synthesise, summarise and sometimes choose between. The writing of this book, and the planning of the exhibition it accompanies, would not have been possible without the extraordinary achievements of Dominique Cordellier, and it is appropriate that we should thank him first, not just for his scholarly work, but also for his support and assistance at every level in planning the exhibition. We are very aware that this exhibition could not have taken place without the generous cooperation of the Musée du Louvre and we would also like therefore to express our gratitude to Françoise Viatte, François Cuzin and Dominique Thiébaut. We are also very grateful to the curators of all the other lending institutions.

Other scholars have assisted greatly. Annegrit Schmitt-Degenhart kindly allowed us to use some of the illustrations published in the exceptionally beautiful and lucid book she published on Pisanello with her husband in 1995. We have benefited from conversations with her and with Joanna Woods-Marden. Indeed, this has been a collaborative effort from the outset and many other scholars have given assistance. We are especially grateful to Georgia Clarke, who shared her knowledge of Italian humanism and chivalry with us and who made available her remarkable bibliography, thus transforming chapters II and III (of which latter she also read a draft). Lorne Campbell and Erika Langmuir both read the entire text and offered many valuable suggestions and corrections. Different parts of the text have benefited greatly from the informed readings of Kurt Barstow, Hugo Chapman, John Cherry, Fabrizio Lollini, Scot McKendrick, Susie Nash, Peter Stacey and last, but not by any means least, Karen Watts, all of whom also contributed invaluably to the exhibition in various ways. We would also like to thank the following for their advice and assistance in a wide range of areas: Philip Attwood, François Avril, Dirk Breiding, Jane Bridgeman, Andrew Burnett, Tom Campbell, Pat Collins, Elena Corradini, David Ellis-Jones, Antony Griffiths, John Henderson, Martin Kauffmann, Lauren Jacobi, Thomas Kren, Andrew Meadows, Mark O'Neill, Xavier Salomon, Wolfgang Steguweit, Kay Sutton, Dora Thornton, René van Beek, William Voelkle, Susan Walker, Roger Wieck, Dyfri Williams, Jonathan Williams and Alison Wright. Needless to say, errors of fact or interpretation are our own.

We were fortunate to work with the designer Philip Lewis and with Paul Holberton, who acted throughout as the kind of academic editor who so rarely exists these days.

Lastly we would like to thank our families and friends for their unfailing support over many months.

LUKE SYSON AND DILLIAN GORDON

Following the highly successful Making and Meaning series of exhibitions, with which we were privileged to be associated from 1993 to 1997, we are pleased to be able to return to the theme of putting artists' work into context through sponsorship of the exhibition *Pisanello: Painter to the Renaissance Court.*

Pisanello is one of the outstanding artists of the Italian Renaissance and this is the first exhibition in this country devoted to his work. Two of the four panel paintings by him that survive are in the National Gallery. We focus on them, examine their subject matter, see how they were made and place them in the courtly culture of fifteenth-century Italy.

Esso UK, now part of the ExxonMobil group of companies, has enjoyed a long-standing association with the National Gallery since 1988. In sponsoring this inspirational and scholarly exhibition we are proud once again to be able to assist the Gallery in its aim to offer the fullest access to the pictures held in its Collection for the education and enjoyment of the widest possible public.

We benefit as well from this partnership. Not only does it afford us the honour of being associated with remarkable and beautiful works of art, but it helps us in our objective to support and enrich the lives of the communities in which we work. This is important to us in our endeavour to be a good corporate citizen.

Aside from the benefits for ExxonMobil and the National Gallery, it is the visitors to the exhibition who stand to gain the most. The wonderful range of works on display provides a rare opportunity to grasp the essence of Italian court life in the fifteenth century. This transposition into another world can only make lives today that much richer.

ANSEL CONDRAY
Chairman
ExxonMobil International Limited

Sponsored by **ExxonMobil**

Among the Renaissance masterpieces in the National Gallery are two of only four surviving panel paintings by Antonio di Puccio, better known as Pisanello. Although his nickname identifies the artist with his father's birthplace in Pisa, he mainly served the rulers of petty, warring principalities in northern Italy. We have been taught to view Italian Renaissance art through Florentine-tinted glasses, as monumental, 'realistic', reviving classical forms and focused on the human figure. Pisanello introduces us to an alternative, imaginative, more inclusive, Renaissance.

Unlike the commercial entrepreneurs of Florence, Pisanello's patrons acquired power and wealth through the practice of arms. Their favoured recreation was hunting. But these were no simple action men. They tempered the brutalities of *Realpolitik* and the chase with the chivalric culture of Arthurian romance, emulated the refined opulence of Franco-Burgundian courts and, while professing Christian values, sought the *virtù* of pagan Greeks and Romans.

All these currents are expressed in Pisanello's art, which admits no contradiction between them. He was the first to confer on modern princelings the grandeur of ancient emperors, but in miniature, casting portrait medals in imitation of antique coins. Inspired equally by classical treatises and northern manuscript illuminations, he made drawings based on accurate observation, especially of hounds, horses and their trappings, wild animals and birds, costume and armour. In his paintings he transmuted the intense naturalism of his drawings into poetry. Huntsmen find God in forests teeming with game, austere hermits converse with stylish warrior saints, knights joust and rescue fairy-tale princesses from dragons (though commoners hang on gibbets in the background). Pisanello's true subjects are not the heroic dramas of human or divine history, but the glamour of aristocratic ideals, the heady beauty and variety of nature, and above all the enchantment of dreams.

Pisanello was the earliest modern artist to be celebrated by literati; his descriptive and evocative powers were said to rival those of the greatest poets – even Homer. Yet today his fame barely outstrips that of the princes who employed and praised him. Much of his work is lost. Most of what survives is small in scale, hidden away in specialised collections; his few remaining murals are off the main tourist trails, and none is in good condition. Fortunately, thanks to the continuing generosity of ExxonMobil – patrons as dedicated to scholarship and the arts as Pisanello's – with the collaboration of colleagues at the British Museum, and very generous loans, above all from the Louvre, we are able for the first time in Britain to show the artist's medals and drawings together with his panel paintings. We can thus regain the measure of both his achievement and its milieu, Pisanello's 'alternative' courtly Renaissance. No-one who visits the exhibition, or reads this book, can fail to see in the magic mirror of Pisanello's works the reflection of all that his employers knew and loved, and all they longed to become: as great as Alexander, as eloquent as Cicero, as chivalrous as the Christian knights of the Round Table.

NEIL MacGREGOR
Director of the National Gallery

1 Life and Work

*. . . we had heard of the multitude of the outstanding and virtually divine
qualities of Pisano's matchless art . . . this age of ours has been made glorious
by one who, as it were, fashions nature herself There is nothing more
becoming to a prince than to pursue, with honour, dignity and rewards,
men of virtue, endowed with elegant and outstanding talent . . .*

Pisanello's contract of employment with
ALFONSO OF ARAGON, king of Naples, 1449

Pisanello was probably the most celebrated and among the most sought-after painters of
his generation in Italy. However, our picture of him today is less than complete. Although
the course of his career is relatively well documented, and his paintings and other works
often received detailed and adulatory descriptions, it is almost impossible to tie any
of his extant works to any set of documents naming him as the artist. Tragically little
survives of his painted works today: only four universally accepted panel paintings and
three frescoes, two in churches in Verona and the third an unfinished chivalric cycle
re-discovered in the Ducal Palace in Mantua in 1969. These are pictures of meticulous,
intense beauty, combining moments of great invention and extraordinary naturalistic
observation; these qualities are confirmed by his portrait medals and by the plethora of
his drawings, sometimes delicately coloured, that have come down to us.

Paradoxically, the names by which Antonio di Puccio was most commonly known
in his lifetime, Pisano (the Pisan), or Pisanello (the little Pisan), are problematic, since
he never worked in Pisa, and it is not even certain that he was born there.[1] His image –
plump and, to judge from the rich brocade of his costume, prosperous – is recorded in a
portrait medal (fig. 1.2) of the later 1440s or early 1450s. Probably executed by a member
of his workshop after a design or existing work by Pisanello himself, the medal depicts

OPPOSITE
1.1 (detail of 1.21) **Pisanello**
Saint George and the Princess of Silena, Verona,
Sant'Anastasia: Saint George and the Princess

RIGHT
1.2a, b **Pisanello and/or workshop**
Self-portrait medal, c.1445–52
Cast bronze, 5.8 cm
New York, Alan Stone and Lesley Hill

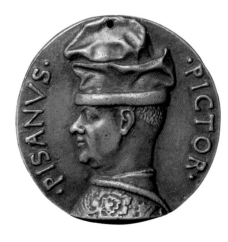
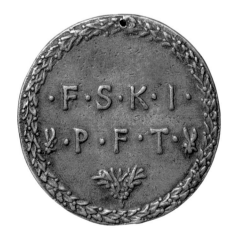

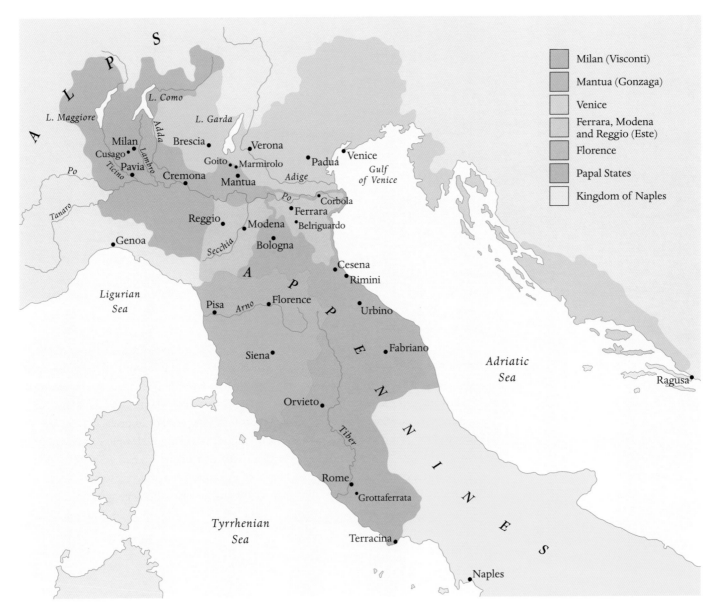

Milan (Visconti)

Mantua (Gonzaga)

Venice

Ferrara, Modena
and Reggio (Este)

Florence

Papal States

Kingdom of Naples

the artist at the climax of his hugely successful career.[2] Although the medal labels his portrait in Latin *Pisanus Pictor* (the painter Pisano), its reverse omits any allusion to his artistic skills or profession; it does not even bear an image. Instead this medal, and another, smaller variation, have the initials of the three theological virtues, Faith, Hope and Charity, and the four cardinal virtues, Justice, Prudence, Fortitude and Temperance. It is thus suggested that his high social status was as dependent on his possession of religious and civic virtues as on his artistic prowess.[3]

Nevertheless there can be no doubt that the basis of his success was the quality of his art. And not only the quality but particular qualities of his surviving works explain his popularity among the ruling élite of the Italian peninsula (fig. 1.3). Pisanello was the favourite artist at some of the most sophisticated and self-conscious courts in Italy. He is chiefly documented in the service of the Gonzaga in Mantua and the Este in Ferrara. He also worked for Filippo Maria Visconti, duke of Milan, for two popes, and at the end of his life as a salaried court artist for Alfonso V of Aragon, king of Naples.

1.3 **Map of northern and central Italy** showing the approximate extent of the Papal States and of the territories under the control of the Visconti (centred on Milan), the Gonzaga (centred on Mantua), the Este (centred on Ferrara) and of the Republic of Venice in the middle of the fifteenth century; Alfonso V of Aragon, king of Naples, controlled almost all southern Italy

Pisanello was active during a period dominated by two sets of political events: in the Italian peninsula, the battle for territory and the resultant series of shifting alliances between city states and their rulers; and in the eastern Mediterranean the decline of the Byzantine empire, which had protected Italian trade routes to the east and formed a bastion against encroaching Islam. It is against these backgrounds that Pisanello's art should be read. After a long campaign, Alfonso of Aragon finally won the kingdom of Naples from the Angevins of France in 1442.[4] In the north, Venice and Milan fought constantly over the cities and fertile plains lying between them in the Veneto; Verona, which was a particular point of contention, had become a subject city of Venice in 1405, but this did not prevent attempts by the duchy of Milan to renew its claims to the city. During the first half of the fifteenth century, these major powers were assisted by *condottieri* – mercenary commanders of freelance armies – who often controlled smaller territories of their own. These *condottieri* – Niccolò Piccinino of Perugia, for example, or the overweeningly ambitious Francesco Sforza, who was to become duke of Milan in 1450 – were prone to switch sides at the drop of a hat, depending on financial and territorial reward and external diplomatic pressures.[5] The Gonzaga of Mantua and the Malatesta in Rimini and Cesena were rulers of their territories by papal or imperial decree, but they, too, might enter into *condotte* with larger powers, selling their military services to provide additional income for their regimes. Only Ferrara, which had long been ruled by the Este dynasty, theoretically on behalf of the pope, seems successfully to have maintained a neutral position.[6] For an artist, or anyone else who depended on court patronage, maintaining a political balancing act between these frequently antagonistic potential employers was a continual challenge.

This was also a particularly unsettled period for the Church. The first pope to return from Avignon (where the papacy had transferred in 1309) to Rome was Gregory XI in 1377. However, there followed a period of contested, rival papacies – Roman and Avignonese – until the election in 1417 of Martin V by the Council of Constance, which removed no fewer than three rival popes. Martin returned the papacy to Rome in 1420. Threats to papal authority nevertheless continued to come from General Councils of the Church. Martin was succeeded in 1431 by Eugenius IV, whose rule was constantly challenged by foreign rulers, the reformist Council of Basle and the Roman nobility. His pontificate was not made any easier by the aggression of the Ottomans in the eastern Mediterranean. From the beginning of the century moves had been afoot to reconcile the divided Roman and Greek Churches in order to organise a united front against the heathen. In Italy, there may have been less enthusiasm for the organisation of a religious crusade than elsewhere in Europe; Italian rulers were sometimes ready to parley privately with the enemy to protect trade or to gain the upper hand over a local rival, and members of the two Churches continued to dispute many doctrinal points. However, that is not to gainsay a public rhetoric, promoted by Eugenius, which deplored the encroachments of the Ottomans in the East.[7]

Pisanello is first documented in 1394 in the will of his father, Puccio di Giovanni de Cereto, who was Pisan; the precise date of his birth, however, is unknown.[8] The next thirty years are deeply obscure. His mother came from Verona, where he almost certainly grew up, and where he bought a house in 1422. He was by then, however, resident in Mantua,[9] where he remained (or to which he returned) in 1424–5, when he received two small payments for unspecified activity from the Gonzaga.[10]

He may, however, have been termed *magister* (master) as early as June 1416, if he was the Antonio Pisano involved in a scholarly exchange of manuscripts in that year: the humanist Guarino da Verona wrote from Padua to ask one of his pupils to return a copy of Cicero, which '*magister* Antonio Pisano' had taken for him on his way through Padua perhaps to Venice.[11] By 1424 he was called '*pictor egregius* (distinguished painter)',[12] and he is termed '*Magister Antonius Pisanellus pictor*' in the Gonzaga account books in 1425.[13]

SAN FERMO, VERONA

The earliest of Pisanello's works that survives today is a fresco in the Franciscan church of San Fermo in Verona, forming part of the Brenzoni funerary monument situated on the left side of the nave (fig. 1.4).[14] Thus our first encounter with Pisanello is as a fully formed artist. His work is signed, using a form of classical epigraphy, PISANUS PINSIT. The commission was conducted, according to the inscription of 1426, by Francesco Brenzoni, executor for the will of his father Niccolò, described in his epitaph as a noble man, model citizen and devoted father;[15] Niccolò had died by 6 July 1422.[16] The ensemble is typical of Veronese funerary monuments in its combination of painting and sculpture.[17] The sculptural element, representing the Resurrection of Christ, is signed by the Florentine Nanni di Bartolo, called Il Rosso, a pupil of Donatello.[18] It was originally coloured and decorated with gold leaf, much of which has disappeared. This painting and gilding would have integrated it to a greater degree with Pisanello's fresco, which surrounds it, than is now apparent, in a constant play between the three-dimensional and two-dimensional surfaces. Painter and sculptor evidently worked in unison to create not only a visual but an iconographic coherence. Rising above the crown of the curtain is a statue, probably representing a Prophet, either Ezekiel or Isaiah, thought to have foretold the Annunciation, which is painted below. The full-length sculpted figure is flanked by the similarly full-length painted figures of two archangels, Raphael (fig. 1.5) and Michael (fig. 1.6), standing against fictive windows within niches formed by a pergola of rose bushes, which surrounds the whole scene on either side of the marble frame; somewhat curiously it is set against a background of red drapery. Raphael and Michael stand guard above their fellow archangel, Gabriel, who is announcing her impending motherhood – the conception of Christ – to the Virgin (figs. 1.7, 1.8).

The Annunciation, which traditionally occupied the spandrels of devotional panel paintings or of arches, as in Giotto's fresco in the Arena Chapel in Padua of about 1305, has here become a full narrative, albeit spread across the arch, uniting the figures of

OPPOSITE
1.4 **Pisanello**
The Brenzoni funerary monument, 1426
Fresco, 850 × 550 cm
Verona, San Fermo Maggiore

5

1.5 (detail of 1.4) **Pisanello**
The Brenzoni monument, San Fermo:
the Archangel Raphael

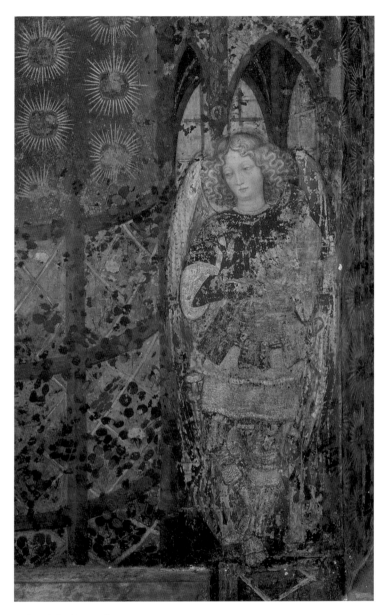

1.6 (detail of 1.4) **Pisanello**
The Brenzoni monument, San Fermo:
the Archangel Michael

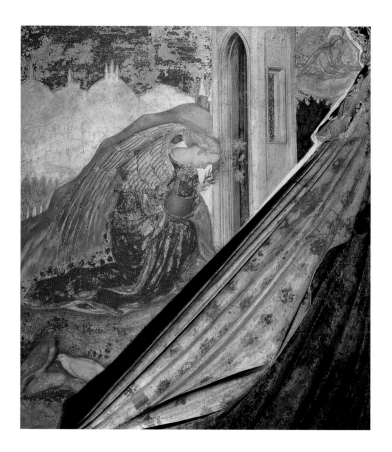

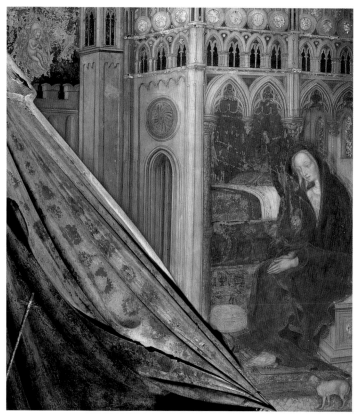

Gabriel and the Virgin.[19] The fresco is now damaged, but the breathtaking quality of its conception and execution still sings from the walls. The youthful archangel Gabriel bows his head in humility before the Virgin, his cheeks flushed, his mouth half-open, his long bird-like neck extended below his hair, which streams upwards, still windswept from the flight he has just made, while his powerful swan-like wings close in a graceful arc over his back, their tips almost touching the ground. He holds a stem of white lilies, symbol of the Virgin's purity, and below him is a pair of doves: doves are a recurring theme from the 'Song of Songs', which was often related to the Virgin. Gabriel kneels before a half-open door, before which God the Father is despatching the Child, being borne down to his mother by a *mandorla* of cherubim. The Holy Spirit, in the form of a white dove, flies down in a stream of gilded rays of light, composed of small golden dots, which pierces the tracery of the rose window and floods the elaborate Gothic architectural niche enclosing the Virgin. The Virgin sits modestly with her hands clasped in prayer, the book she was reading on the lectern beside her. In the furnishing of her chamber the experience that Pisanello would have gained during his early period in Mantua of the visual traditions of the courts is made evident.[20] It has oriental carpets and a cushion woven or embroidered with golden thread. On her lectern is a tapestry (fig. 1.9) woven with a scene of courtly love – an amorous couple in a garden, the richly dressed young man playing a lute (on the right, dressed in red) serenading his beloved (on the left, dressed in blue). Her bed has a cover and pillows of golden brocade, embroidered sheets and a canopy tapestried with the figure of a woman playing a portable organ. At her feet is a small lapdog with a collar of bells.

ABOVE LEFT
1.7 (detail of 1.4) **Pisanello**
The Brenzoni monument, San Fermo:
the Archangel Gabriel

ABOVE RIGHT
1.8 (detail of 1.4) **Pisanello**
The Brenzoni monument, San Fermo:
the Virgin Mary

1.9 (detail of 1.8) **Pisanello**
The Brenzoni monument, San Fermo: tapestry
on the Virgin Mary's lectern

1.10 (detail of 1.11) **Gentile da Fabriano**
The Valleromita Altarpiece: the Virgin

The fresco was executed in two stages: a true fresco painted on the wet plaster was elaborated *a secco*, after the plaster had dried – a more vulnerable technique, which partly explains why the painting is now in such a damaged state. As we will see, this technique perfectly accords with Pisanello's detailed and painstaking drawing and panel-painting style. Instead of covering large patches of plaster with broad washes of paint, as true fresco demands, the artist built up paint in individual layers, stroke by stroke, in a method very similar to that of his tempera painting. Pisanello painted in meticulous detail, introducing minutiae which he must have known could not possibly be seen from the floor of the nave: eyebrows and eyelashes, soft hairs exposed on the nape of Gabriel's neck, the spiralling locks of Raphael's hair, the scales on the claws of the doves, the nipples on the pink underbelly of the lapdog. The mail of the archangels' armour has been textured with incisions which bite deep into the plaster, and the gold of the haloes and the rays that decorates the roundels of the architecture is not paint, but gold leaf applied to the plaster, echoing the gold leaf on the sculpture. The massive architecture behind the Virgin reflects the monumental buildings to be found in the work of Altichiero (active *c*.1364–93), also working in Verona, whose use of dominating Gothic architecture is first noticeable in his Paduan works.[21] Nevertheless, if Pisanello had looked to paintings by other artists to shape the appearance of the fresco, his primary model was the work of Gentile da Fabriano (active 1408–27).[22] From Fabriano in the Marches, Gentile had an extraordinary impact on the painting style of north-east Italy and was, like Pisanello slightly later, notably in demand. Pisanello's debt to Gentile is especially evident in the close comparisons that can be made between the figure of the Virgin in the central panel of Gentile's polyptych from Valleromita of about 1405 (figs. 1.10, 1.11) and the Annunciate in the San Fermo fresco. Their faces are extraordinarily similar; both have the same small, slightly pouting mouth, long nose, half-closed eyes and arching brows. Their costumes, too, have much in common, and Pisanello has imitated Gentile's meandering draperies. Pisanello's method of painting the tonality of the Virgin's skin, emphasising the lovely bloom in her cheeks, depends on Gentile's example. The luxuriance and variety of naturalistic detail – the inclusion of closely observed birds and animals to delight the eye, the movement of the figures – can be found in what is perhaps Gentile's most celebrated work, the *Adoration of the Magi* altarpiece painted in 1423 for Palla Strozzi in Florence (see fig. 1.17). Pisanello has seemingly also absorbed Gentile's technical approach to tempera painting, fully exploiting the potential tempera offers for hatching to describe volume, structure and texture.

TRAINING AND FORMATION AS A PAINTER

The very evident impact of Gentile's style on Pisanello's 1426 fresco raises the thorny question of Pisanello's training and formation as painter.[23] There was almost certainly contact between the two artists, if not before, then in the second decade of the fifteenth century, when Gentile and Pisanello were both in Venice, the former a mature and established artist, the latter probably in his early twenties. The humanist Bartolomeo Facio, in his separate biographies of Gentile and Pisanello in his book *Of Famous Men* of

1.11 **Gentile da Fabriano**
The Valleromita Altarpiece: *The Coronation of the Virgin with Saints Jerome, Francis, Dominic and Mary Magdalene*, c.1405
Tempera on panel, 160 × 240 cm
Milan, Pinacoteca di Brera

1456, states that both painters executed works in the Ducal Palace there.[24] They were contributing to the twenty-two narratives frescoed on the south, west and north walls of the Hall of the Great Council in the palace.[25] A series, supposedly painted in *terraverde*, had been begun in about 1365, but had fallen into disrepair, and in 1409, under Doge Michele Steno, it was decided to repaint them in full colour, work which was still in train in 1411.[26] Gentile is documented in Venice from 1408 to 1414, when he left to enter the service of Pandolfo Malatesta in Brescia.[27] The 1416 letter from Guarino suggests that Pisanello was in Venice before that date; by 1422 he was in Mantua.[28] In 1415, a new staircase was built to give grander access to the room, and the Council met there in 1419. It is likely therefore that Pisanello had finished painting by that date.[29] Among other scenes of Venetian glory, the series celebrated Venice's rôle in brokering peace in 1177 between emperor Frederick I Barbarossa and pope Alexander III. According to Facio, Pisanello's painting showed Frederick Barbarossa's son Otto, liberated by the Venetians, pleading with his father to make peace with pope Alexander III and the

Lombards.[30] Facio reported that Pisanello's composition included courtiers, in German costume, and a priest pulling faces to make a group of boys laugh, inducing hilarity in anyone looking at the painting. Francesco Sansovino, writing in 1581, stated that it contained a portrait of Andrea Vendramin, 'the most beautiful young man' in Venice.[31] The fresco was replaced by a canvas by Alvise Vivarini in 1488 (also now lost).[32] It has been proposed that Pisanello also painted the preceding scene of Otto released to treat for peace with Barbarossa, since a sketch (Louvre 2432v) that is certainly attributable to Pisanello seems to be of that subject.[33] It is not known whether Gentile and Pisanello worked side by side or successively, although the former is more likely to be the case. The cumulative evidence of a common style and technique and the available documentation strongly suggest that Pisanello was Gentile's pupil.

Although the elder painter's influence was profound, he was not the only artist whose work was important for Pisanello. The long-held theory that Pisanello was taught in the workshop of the painter Stefano da Verona is ill-founded, not least because Stefano does not seem to have settled in Verona until 1425.[34] Nevertheless there are stylistic connections between Pisanello and Stefano. He was actually known as Stefano da Francia, being christened 'da Verona' only in the sixteenth century by Giorgio Vasari. He was the son of a French painter, Jean d'Arbois, who worked for Philip the Bold of Burgundy before settling in Pavia.[35] His formation is even more problematic than Pisanello's own, since his earliest securely autograph work is the signed *Adoration of the Magi* in the Brera in Milan, dated 1435(?) (see fig. 1.16).[36] Although his father is likely to have been his first teacher, it has been suggested that Stefano trained subsequently with the Lombard painter Michelino da Besozzo, who was active in Pavia in 1388 and 1394, and resident there in 1404. In 1410, when Michelino was in Venice, he was described as 'the most excellent of all the painters in the world'.[37] His only surviving signed work is a *Mystic Marriage of Saint Catherine* (fig. 1.13) in Siena – undated, but painted perhaps around 1400.[38]

Michelino was particularly famous, as Pisanello would be, for his depiction of animals; several surviving coloured studies have been attributed to him, though without much evidence.[39] Pisanello could certainly have drawn inspiration from the aesthetic culture of Michelino, and of his fellow Lombard painter and illuminator Giovannino de' Grassi (fl. 1389, died 1398; also a noted painter of animals; see fig. 4.56), when he encountered their works – murals and manuscripts – in Pavia and Milan.[40] Thus the perceived similarities between the works of Stefano and Pisanello may be explained partly by their common prior contact with the œuvre of Michelino and partly by a process of mutual exchange once they were both in Verona.[41]

The difficulty of all these overlapping styles comes to a head in the web of attributions which links these three painters with three paintings: *The Madonna of the Quail* (fig. 1.15), in Verona, *The Virgin and Child in a rose-garden with Saint Catherine*, known as the *Madonna del Roseto*, also in Verona (fig. 1.14), and *The Virgin and Child Enthroned* in Rome (fig. 1.12). The *Madonna of the Quail* lies at the very heart of the problem. It has traditionally been considered Pisanello's earliest work, datable to about 1420.[42] The loveliness of the image is beyond question; its attribution to Pisanello, however, is by no means so straightforward. There are, in fact, irreconcilable differences from the San Fermo fresco – variances which

1.12 **Attributed to Stefano da Verona**
The Virgin and Child Enthroned, c.1420–5
Tempera on panel, 97.8 × 49.4 cm
Rome, Museo Nazionale di Palazzo Venezia

1.13 **Michelino da Besozzo**
The Mystic Marriage of Saint Catherine, c.1400?
Tempera on panel, 75 × 58 cm
Siena, Pinacoteca Nazionale

1.16 Stefano da Verona
The Adoration of the Magi, 1435?
Tempera on panel, 73 × 47 cm
Milan, Pinacoteca di Brera

and motifs familiar from other works, rather than introducing stridently individualistic flourishes or motifs. The San Fermo fresco belongs to just such a conservative genre, and Pisanello restricted his artistic fingerprinting to the treatment of subsidiary details.

The San Fermo fresco was probably begun around 1424 and, according to the inscription, was completed in 1426. By 1431 Pisanello was in Rome, where he completed a cycle of frescoes left unfinished by Gentile. What had happened in the interim? The documents, once again, fall silent. It may, however, be possible to fill the gap with a lost fresco cycle in Pavia, paintings by Pisanello in the *castello* of the Visconti mentioned in the sixteenth century by Cesare Cesariano,[49] although, given that this source is so late, the putative date of these frescoes is difficult to ascertain. The intriguing statement of Marcantonio Michiel, also writing in the sixteenth century, that one could see one's own reflection in them is likely to be a conflation of two pieces of information from Cesariano, who also described a room of mirrors.[50] Alternatively, though less plausibly, the description may refer to Pisanello's minute *a secco* technique: such a surface, treated with varnishes, might well have resulted in a reflective, enamel-like appearance.[51] Even if this explanation does not entirely satisfy, it reminds us that such a technique demanded time and that Pisanello may have taken a considerable time to complete fresco projects, especially if he was working on his own. In order to execute frescoes of any size, Pisanello may have required a period of years in Pavia between his work at San Fermo and his arrival in Rome.

PISANELLO IN ROME

It is conceivable therefore that Pisanello journeyed to Rome from Lombardy. When pope Martin V returned to Rome in September 1420, he set about the renewal of the capital of Christendom and called a number of painters to the Holy City. For example, the Marchigian painter Arcangelo da Camerino was given a safe-conduct by Martin V in 1422.[52] Masaccio came from Florence and began a double-sided altarpiece for Santa Maria Maggiore probably in late 1427 or early 1428, dying, before its completion, in June 1428. His erstwhile partner in Florence, Masolino, either began the altarpiece together with him or (less likely) was summoned to complete it after his death. Whichever the case, Masolino stayed in Rome to paint frescoes for the chapel of Saint Catherine for cardinal Branda da Castiglione in his titular church of San Clemente (before 1431), also a cycle for cardinal Giordano Orsini; he had left Rome by 1432.[53]

From our point of view, the most important of the painters who came to Rome in those years was Gentile da Fabriano. According to Gentile himself, he had personally promised Martin V during a papal visit to Brescia that he would come to Rome as soon as he had finished the chapel he was painting there.[54] In 1419 Gentile set out for Rome with eight members of his household and eight horses, stopping on the way to paint *The Adoration of the Magi* (fig. 1.17) in Florence in 1423, and working in Siena and Orvieto during 1425.[55] In Rome he began a fresco cycle in the papal basilica of San Giovanni in Laterano, consisting of scenes from the life of John the Baptist (titular saint of the church) and monochrome images of Prophets above, set in fictive niches, to resemble

OPPOSITE
1.17 **Gentile da Fabriano**
The Adoration of the Magi, 1423
Tempera on panel, 173 × 220 cm
Florence, Galleria degli Uffizi

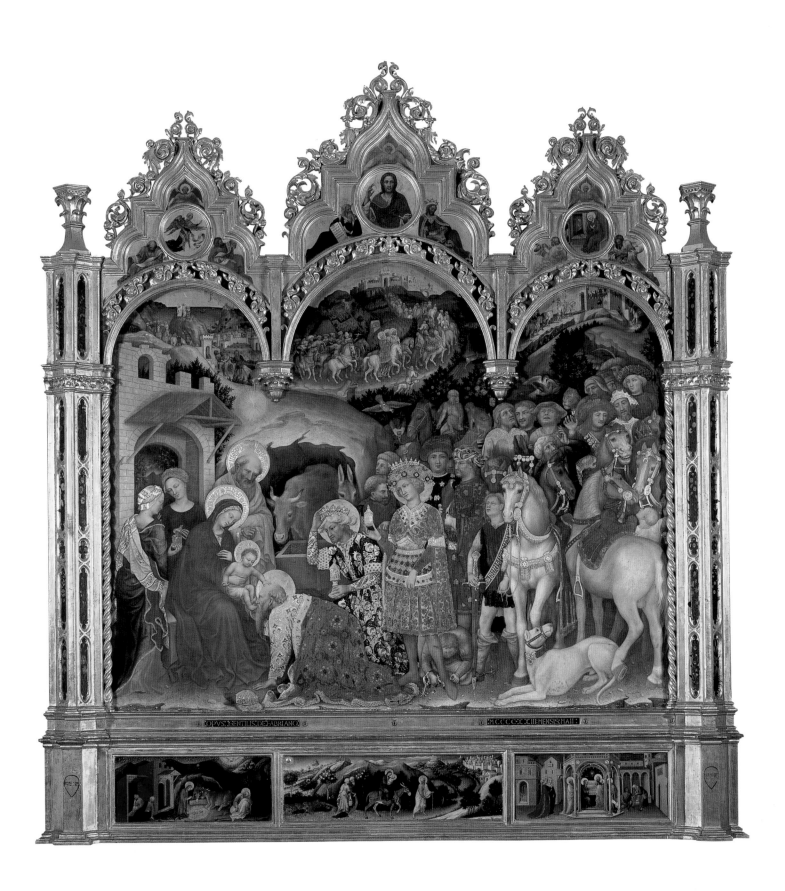

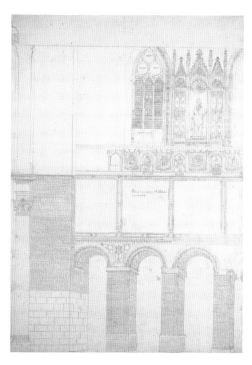

1.18 Workshop of Francesco Borromini
*Part of the north wall of the nave of San Giovanni in
Laterano*, 1646
Pen and ink over black chalk, 66.4 × 48.3 cm
Berlin, Staatliche Museen zu Berlin, Kunstbibliothek,
inv. HdZ 4467

sculpture.[56] Gentile was paid a salary of 25 florins a month from 28 January to August
1427. He died that year, leaving the work unfinished. The frescoes were destroyed when
the church was remodelled in 1646 by Francesco Borromini. Only a decorative frieze of
acanthus leaves painted in monochrome to simulate sculpture remains in place, probably
from Gentile's workshop, and it has been suggested that a frescoed head, thought to be
of David, attributable to the workshop of Gentile, may have come from the cycle.[57]

According to Facio, on the testimony of the artist himself, the frescoes were already
suffering from damp in Pisanello's lifetime.[58] A member of Borromini's workshop drew
a sketch of part of it (fig. 1.18), but left the part of the wall which would have contained
the narrative scenes blank. An inscription on only one of the fields indicates that it
contained a *Visitation*. A sheet with drawings of *The Visitation* and *The Circumcision* by
a member of Pisanello's workshop may therefore reflect the contents of the cycle.[59]
Drawings of two scenes from the life of John the Baptist, his *Capture* (British Museum
1947-10-11-20) and the *Baptism of Christ* (fig. 1.19), have also been linked with the project.
Like the *Visitation* sheet, they are not by Gentile, but are attributable to the workshop of
Pisanello,[60] and may be somehow connected with Pisanello's preparations to complete
the project. However, it should be stressed that these drawings cannot themselves have
been produced for the Lateran cycle, given that the paintings, to judge from Borromini's
drawing, were square,[61] while these scenes are oblong. In any case they look more like
studies for small predella panels, of the kind to be found under the main panel or panels
of an altarpiece.

Pisanello continued, and presumably completed, the fresco cycle.[62] It was logical to
ask the pupil or previous collaborator of a painter to complete unfinished work, since
they would be able to match their predecessor's style. Pisanello took over some of
Gentile's effects (apparently household equipment rather than any sort of artistic
inheritance); in April 1433, when he had surely left Rome, these were sold by the chapter
of San Giovanni in Laterano for ten gold ducats.[63] If Pisanello was called to Rome
immediately after Gentile's death by Martin V, anxious to see the project completed,
the date of the Pavia frescoes would have to be reconsidered; however, Martin may
have summoned him only rather later, for he received his first recorded payment for the
frescoes, 40 florins, for work already done, on 18 March 1431, under Eugenius IV, who
had become pope fifteen days earlier.[64]

Pisanello received a further 50 florins on 27 November 1431, and 75 florins on
29 February 1432.[65] If Gentile's payments described above represent the total amount he
received, he was paid 175 florins. Pisanello's payments add up to 165 florins – so Gentile
may have been just over half-way through the cycle when he died. The fragment of a
head of a woman in courtly costume (fig. 1.20), which looks to have been executed by
Pisanello or, more likely, by a member of his workshop, possibly came from a scene in
the Lateran of *The Feast of Herod*.[66] It is clear from a later document that Pisanello was
at this point a member of the papal household, and Eugenius calls him 'beloved son'.[67]
The new pope bought or commissioned a painting of *The Virgin with Saint Jerome*, 'a most
noble little panel', as a special gift for the Holy Roman Emperor Sigismund IV, whose
visit was imminent.[68] On 28 June 1431 or 1432 Pisanello wrote to the duke of Milan,

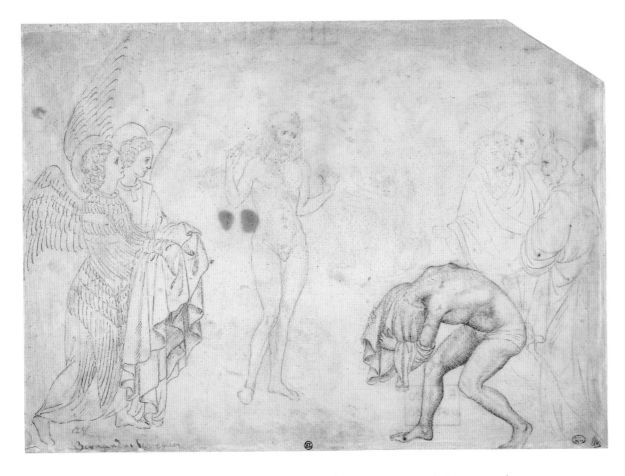

ABOVE

1.20 **Pisanello or workshop**
Head of a woman in courtly costume,
c.1431–2
Fragment of fresco, 24 × 17 cm
Rome, Museo Nazionale di Palazzo
Venezia

LEFT

1.19 **Workshop of Pisanello**
perhaps after Gentile da Fabriano
The Baptism of Christ, c.1431–40
Pen and ink over metalpoint
on parchment, 18.3 × 25.9 cm
Paris, Musée du Louvre,
inv. RF 420 recto

Filippo Maria Visconti, asking him to wait for a work he was executing in bronze, and reporting that he would not be permitted to leave Rome until he had finished the works in 'a church' – San Giovanni in Laterano – which, he anticipated, would not be before the end of the summer.[69] On 26 July 1432, the work presumably complete, Eugenius IV gave the artist leave to depart and a safe-conduct for himself, his assistants and household, with up to six horses.[70]

VERONA: THE SANT'ANASTASIA FRESCOES

Pisanello returned home to Verona, where he is documented in 1433, living with his seventy-year-old widowed mother, four-year-old daughter Camilla and two servants.[71] Before his arrival he seems to have broken his journey in Ferrara – his first documented contact with the Este family: Leonello d'Este wrote to his brother Meliaduse in Rome, recording Pisanello's visit ('when he came from Rome to Ferrara') and asking his brother to send him a painting of the Virgin which Pisanello had promised him, but had left behind.[72] In February 1435 Pisanello sent an 'image of the divine Julius Caesar' to Leonello d'Este and was rewarded with two gold ducats, carried back to the artist by a servant.[73]

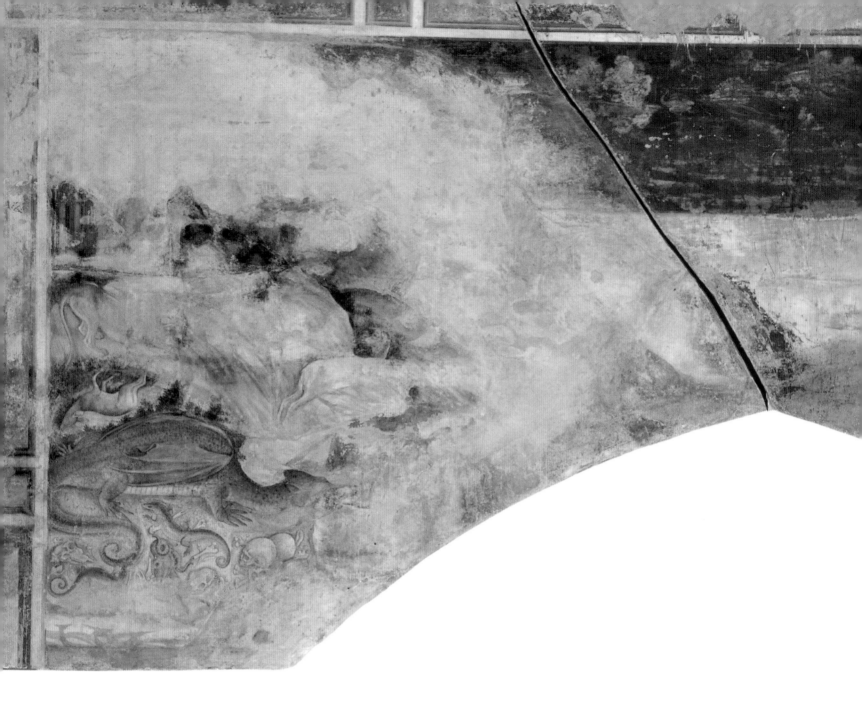

1.21 **Pisanello**
*Saint George and the Princess of Silena; the coat of arms
of the Pellegrini family with the image of a pilgrim,*
c.1434–8
Fresco, 223 × 620 cm
Verona, Sant'Anastasia

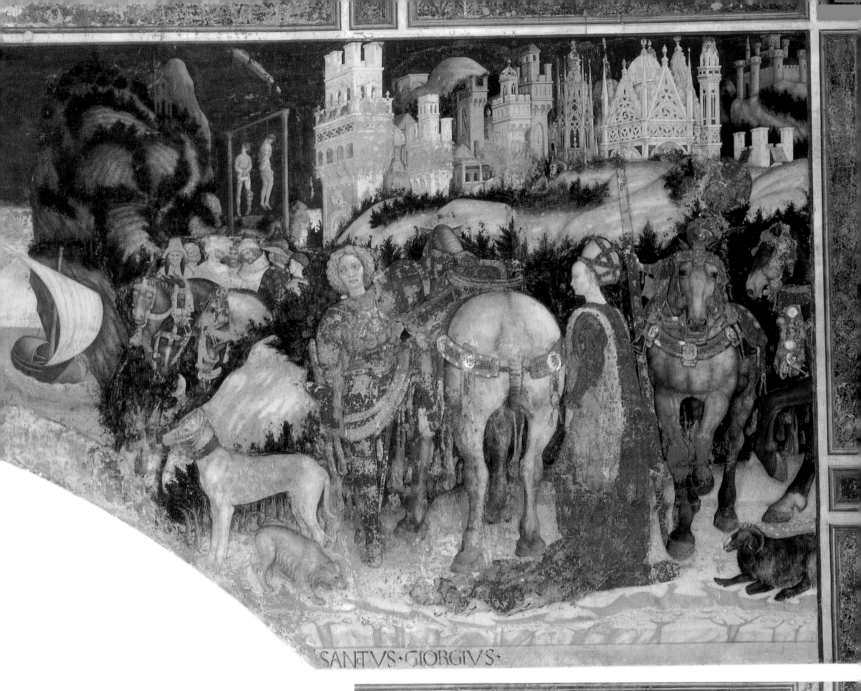

SANCTVS · GIORGIVS ·

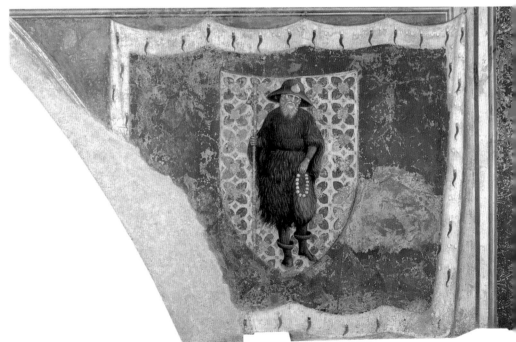

Pisanello was still to be found in Verona in 1434 and 1435, remaining there probably until 1438–9.[74] It was during this period that he executed a group of frescoes in the Pellegrini chapel in the Dominican church of Sant'Anastasia, frescoes which included his *Saint George and the Princess of Silena* and a shield with the image of a pilgrim (*pellegrino* in Italian – a pun on the family name) painted as on a hanging (fig. 1.21).[75] Once again the style of the surviving part of the work proclaims his debt to Gentile, and especially to the *Adoration of the Magi* (see fig. 1.17). It is not known exactly when he started or how long it took Pisanello to paint these frescoes; his detailed hatching technique would, however, have been extremely time-consuming, as would the application of silvering, gilding or *pastiglia* in details like the horses' harnesses. Nor is it known how many assistants he had at that time.[76] The church was then dedicated to Saint Peter Martyr, patron saint of Verona, and was consequently a prestigious burial site. Members of the Pellegrini family, one of the wealthiest in Verona, were buried from 1387 in the family chapel there, which was situated in the right transept, immediately next to the choir. Pisanello's frescoes have been linked to the will of Andrea di Nicola of 17 October 1428; he died on 6 April 1429.[77] He left the enormous sum of 900 florins towards the project. The decoration of the chapel included a terracotta altarpiece and terracotta panels showing scenes from the life of Christ by Michele da Firenze; these were being made in 1436.[78] Because the frescoes by Pisanello were on the external façade, above the entrance to the chapel, his freedom to paint would not have been constricted by Michele's manufacture of his reliefs. Since the sixteenth century, the condition of the chapel has been severely compromised, and the surviving fresco has been restored several times. Its left side was detached in 1891 and the right in 1900. For a while they were shown in the Giusti chapel in the same church, but they have recently been returned to their original setting.

Giorgio Vasari gave a description of the frescoes in his *Lives of the Artists* of 1568. He had not seen them himself, but Fra Marco de' Medici, who was a friar in Sant'Anastasia, provided the information.[79] Vasari stated that the work was signed by Pisanello underneath a fresco of Saint Eustace: 'And because he liked to depict animals … Saint Eustace [is] stroking a brown and white dappled dog. The dog is standing with his [front] paws on the saint's leg, and is turning its head behind, almost as if it had heard a sound …. Below this figure is painted the name of Pisano, the name he used as an alternative to Pisanello …. After this Saint Eustace … he painted all the outer façade of the chapel. On the other side Saint George in white armour, made of silver, as, in that age, all the painters, not just Pisanello, were wont to do …. This Saint George, after having killed the dragon, [and] wanting to put back his sword in its sheath, raises his right hand, holding the sword, which already has its tip in the sheath, while he lowers his left ….' These two figures are now lost, but evidently the figure of Saint Eustace was on the left pier, with the signature below, from which the eye moved upwards to the surviving narrative of Saint George's meeting with the Princess, painted above the arch, and then down again on the other side where Saint George, having killed the dragon, sheathed his sword.[80]

Once it was recognised that a drawing of architectural decoration on a sheet of studies by Pisanello (fig. 1.23) could be connected with the decorative borders around the family emblem of the pilgrim, it was logical to suggest that the study for two legs on the

1.22 **Masolino**
The Execution of Saint Catherine: the executioner sheathing his sword, *c.*1431
Fresco
Rome, San Clemente

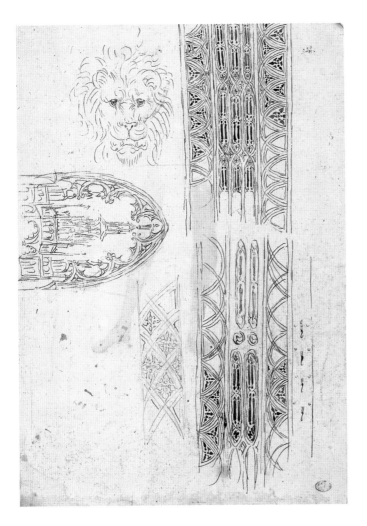

verso (fig. 1.24) might be a study for the lost Saint George.[81] It is possible, moreover, that a sketch of sabatons, or foot armour (see fig. 2.29) may be related to this study, particularly since the verso has a sketch for the head of a man richly dressed in ermine who appears in the background of the main composition (see fig. 1.29).[82] The suggestion, on the basis of Vasari's description, that the lost figure of Saint George may have resembled a fresco of a figure sheathing a sword by Masolino (fig. 1.22) is likely enough; Masolino had been painting in San Clemente around the same time that Pisanello was painting in the Lateran, and the Louvre study of two legs is very close indeed to those of Masolino's sword-sheathing figure.[83]

The tale of Saint George and the Dragon is told in the *Golden Legend*, a popular compilation of the lives of the saints made by Jacopo de Voragine in the thirteenth century. The story finds George, a native of Cappadocia, on the road to the city of Silena, in the province of Lybia, which was being terrorised by a plague-bearing dragon. It lived in a lake, and would come up to the city walls and poison all who came within reach of its breath. The citizens of Silena appeased the dragon by feeding it two sheep a day and then, when these became scarce, by feeding it a single sheep and a single human, chosen by lot. Eventually the lot fell upon the king's only daughter and, with much sorrow, he resigned himself to her sacrifice. He sent her down to the lake dressed

ABOVE LEFT
1.23 **Pisanello**
Architectural motif, lion's head, designs for a border,
c.1434–8
Pen and ink over metalpoint, 29.4 × 20.5 cm
Paris, Musée du Louvre, inv. 2290 recto

ABOVE RIGHT
1.24 **Pisanello**
Legs of a standing figure, c.1434–8
Ink and watercolour over black chalk or metalpoint,
29.4 × 20.5 cm
Paris, Musée du Louvre, inv. 2290

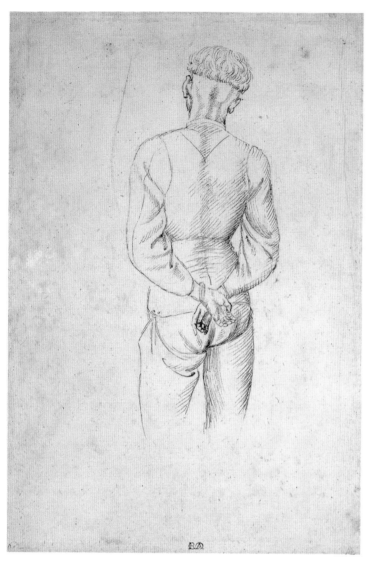

1.25 **Pisanello**
A young man with his hands behind his back, c.1434–8
Pen and ink over metalpoint, 26.8 × 18.6 cm
Edinburgh, National Gallery of Scotland, inv. D722

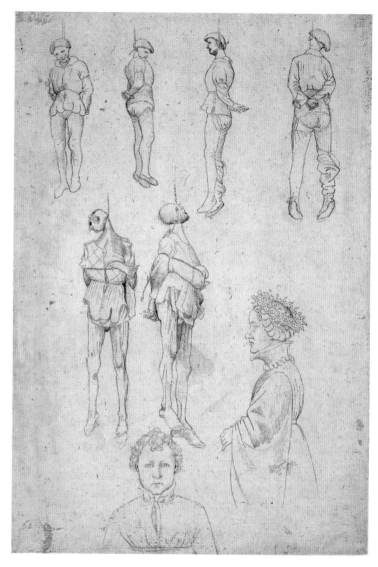

1.26 **Pisanello**
Studies of a female dwarf, hanged men,
a child's head, c.1434–8
Pen and ink over metalpoint, 28.3 × 19.3 cm
London, The British Museum, inv. 1895-9-15-441

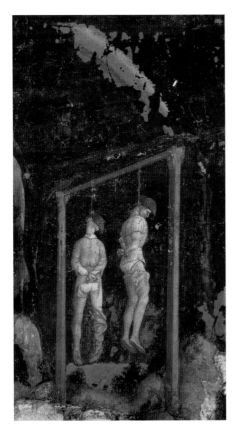

1.27 (detail of 1.21) **Pisanello**
Saint George and the Princess of Silena, Sant'Anastasia:
hanged men and rainbow
Fresco, 63 × 51.5 cm
Verona, Sant'Anastasia

in regal garments, and there she happened upon Saint George. The princess told George to flee, but instead the saint mounted his horse, armed himself with the sign of the cross, and pierced the dragon with his lance. The princess put her girdle around the dragon's neck and led it to the city where, after the citizens had agreed to be baptised, Saint George slew it with his sword.[84]

The painting follows the *Golden Legend* faithfully.[85] The princess, dressed in especially luxurious garments, is accompanied by a single ram; the saint has stopped to water his horse at the edge of a lake, and has his foot in his left stirrup, dismounting or about to ride off in pursuit of the dragon which lurks on the shores of the lake – on the other side of the arch. Around it is a grisly assortment of bones, lizards and a slain doe, while a lion prepares to spring on to a frightened stag. One of the few elements included which appears extraneous to the story is the gibbet in the background from which dangle two hanged men (figs. 1.25, 1.26, 1.27; see fig. 4.48). This may be a touch of realism, since it was customary for hangings to take place outside the city walls.[86] However, they have also been said to be reminder of man's mortality, appropriate in a scene which is concerned with Christian conversion: a sinister black crow is sitting on the gibbet waiting hungrily. Moreover, above them is a rainbow, now isolated in a sky from which almost all of the blue pigment has fallen. Since the rainbow seems have been a recognised symbol of Christ (at least in northern Europe), its presence may signal the possibility of redemption, once again an appropriate message within such a scene.[87]

If Pisanello's literary source is uncomplicated, the reasons for its choice (rather than a more usual *Annunciation*, for example), and particularly of this moment of the saint's encounter with the princess rather than the more dramatic battle with the dragon, and also for the inclusion of Saint Eustace, are less easy to determine. It has been proposed, on the basis of a close reading of the *Golden Legend*, that the etymology given there for George's name, which is said to derive from '*gero*' meaning '*peregrinus*' (pilgrim), suggested a play on the surname Pellegrini, and therefore the choice of this scene from George's legend – Saint George about to set out on a hazardous journey – would be appropriate.[88] But the figure of Saint George also had a more universal meaning: as a soldier saint, he epitomised a contemporary ideal of Christian chivalry. He may have had particular appeal for the Pellegrini family in this rôle: a posthumous inventory of the possessions of Tommaso Pellegrini shows that he owned numerous items of armour, both for battle and for the tournament – helmets, helm crests, banners and so on.[89] Moreover, devotion to Saint George was endemic in north Italy; he was, for example, a patron saint of both Mantua and Ferrara, and one of the districts or *contrade* of Verona was named after him. In both Veronese and Paduan devotional paintings executed around the turn of the fourteenth century, it had become fashionable for the male members of a family to be depicted dressed in armour, presented to the Virgin and Child by Saint George, sometimes accompanied by other saints.[90]

If this type of Saint George was common, so, too, was the episode of the saint piercing the dragon with his lance – as, for instance, on the walls of San Zeno, Verona, and of other churches in the region.[91] However, in Pisanello's frescoes, the viewer is presented not with the event itself, but with imminent action and (formerly) mission

accomplished. Despite the damage the surviving fresco has sustained, the deliberate splendour of its style and content is still very apparent. The image turns around the dynamic diagonals of the saint, on one side, balanced by the still stoicism of the princess on the other, with the great upright of the lance behind her. The figures of richly, indeed exotically, garbed horsemen (the king and his court?) standing under the gibbet, their horses turned to look over the lake towards the dragon, may be significant. So, too, may be the crenellations and tracery in the Gothic architecture of the city behind and the horses and animals which form part of the saint's retinue. However, they remain subsidiary, there to provide a context, setting and atmosphere for the narrative rather than to contribute to it as such. Saint George and the princess, unusually, are presented as equal protagonists; the focus thus falls on the capacity of the princess to inspire Saint George to action. Given the geographical setting for the action, it is not surprising that scholars have suggested that the person of the princess stands for the danger in which Christian Greece and Asia Minor then stood.[92] It may not be coincidental that her traditional title – the Princess of Trebizond – recalls that of the consort of the Byzantine emperor, John VIII Palaeologus; Maria, the daughter of Alexis IV of Trebizond, was married to John in 1427. She therefore becomes the Christian princess in peril (even if the chronology of the narrative is not exact), whose rescue was to inspire the mass conversion of a heathen community. Saint George thus stands for both pilgrim and crusader.

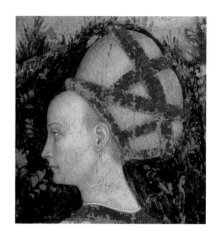

1.28 (detail of 1.21) **Pisanello**
Saint George and the Princess of Silena, Sant'Anastasia: head of the Princess

The pairing of Saint George with Saint Eustace, a saint who, unlike George, is not commonly encountered in Italian art, reinforces the message of Christian militarism in the Pellegrini chapel. He, too, was a military commander converted to Christianity, and was also evidently considered to embody the ideal of the Christian knight. His story is also told in the *Golden Legend*.[93] It is possible that Pisanello had encountered images of the saint in Rome, one of the chief centres of his cult.[94] He may even have suggested the pairing to his patron. He was certainly later to paint a small painting of *The Vision of Saint Eustace*, now in the National Gallery (see p. 156). However, at a period when the creation of a unified front against the Turk was seen, by some, as paramount, it may be significant that one of these Christian knights was Roman, while the other was 'Greek'. The Pellegrini have no documented connection with any negotiations for union, but, as members of a family manifestly keen to establish their chivalric credentials, they would surely have kept the military protection of Constantinople not far from their minds.

PISANELLO'S DRAWINGS

Although the survival rate of Pisanello's paintings is sadly sparse, the large number of extant drawings by his hand and by members of his workshop (which need to be distinguished from one another) are enormously helpful in illuminating Pisanello's working practice and the artistic values it enshrined. The group of drawings relating to the Sant'Anastasia frescoes seems to epitomise Pisanello's approach as a draftsman. No compositional drawing survives, but we can follow the way he employed drawings of individual motifs both ready-made and specially prepared. He would employ his own 'pattern' drawings from stock, often very finished and beautiful – drawings above all of

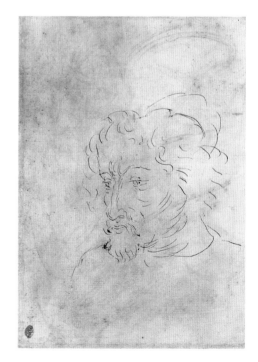

1.29 **Pisanello**
Head of a bearded man, c.1434–8
Pen and ink on red prepared paper, 27.4 × 19.5 cm
Paris, Musée du Louvre, inv. 2281 verso

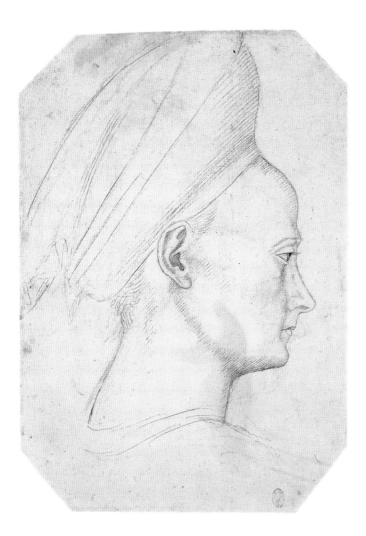

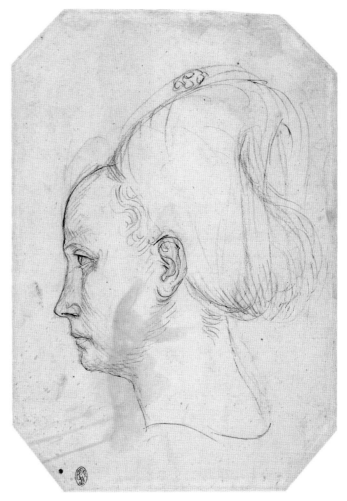

birds and animals – and also make new sketches for specific elements in the project in hand. For the latter he used a range of techniques. He might start with a rapid sketch of an established type: his head of a bearded man (fig. 1.29) is not from life and instead depends on models invented by Gentile.[95] It did not undergo any significant change before its inclusion in the fresco. However, more typical are the studies that survive for the head of the Princess (fig. 1.28) – first a loose sketch from a live model (fig. 1.31), which was then more precisely defined in an orangey-brown ink, often with further reference to a live model (fig. 1.30).[96] So as to develop the precise forms of the heads and hands of the cadavers hanging from the gibbet, for example, he made rapid sketches of the dead bodies seen from different angles, characteristically combining them on a single sheet with other motifs which seem totally unrelated (see fig. 1.26): in this case studies of a female dwarf, of the kind frequently employed as permanent side-shows at the Italian courts, and of the face of a child.[97] Having chosen a particular view and pose, he worked up the anatomy and the details of head and hands by drawing a young man, probably a member of his workshop, in the selected pose (see fig. 1.25).[98] These drawings were clearly made specifically for the fresco, even if some, like the rapid sketch of flying egrets (see fig. 4.52), which is used both in the Sant'Anastasia frescoes and in the National Gallery *Vision of Saint Eustace* (see fig. 4.53), might be re-employed in later works. Pisanello would also execute a series of finished studies on a particular

ABOVE LEFT
1.30 **Pisanello**
Profile of a young woman with a balzo, c.1434–8
Pen and ink over black chalk, 24.6 × 17.2 cm
Paris, Musée du Louvre, inv. 2342 recto

ABOVE RIGHT
1.31 **Pisanello**
Profile of a young woman with a balzo, c.1434–8
Metalpoint with some pen and ink, 24.6 × 17.2 cm
Paris, Musée du Louvre, inv. 2342 verso

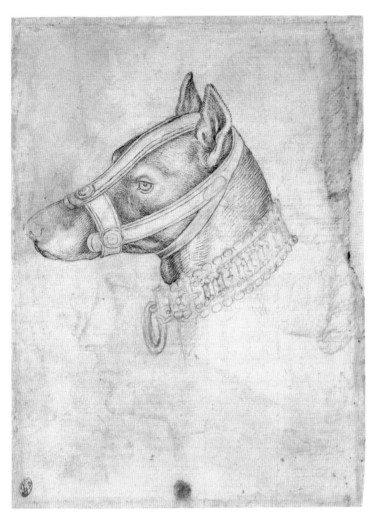

1.32 **Pisanello**
Head of a hound, c.1434–8
Pen and ink over black chalk on red prepared paper,
24.5 × 18.2 cm
Paris, Musée du Louvre, inv. 2343 verso

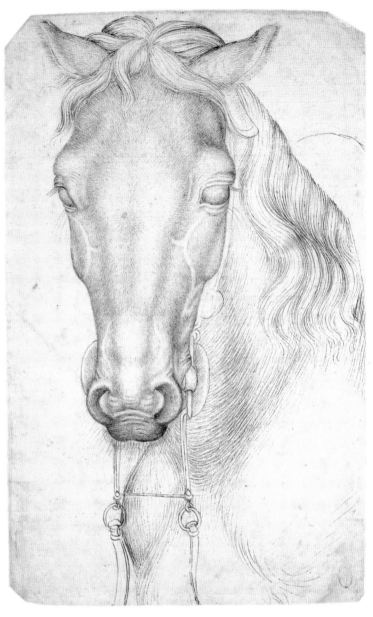

1.33 **Pisanello**
Head of a horse, c.1434–8
Pen and ink over metal- or leadpoint,
26.8 × 16.8 cm
Paris, Musée du Louvre, inv. 2360

theme. These would provide him with a corpus from which he could select one or more drawings to be used in the final painting, and which he could use again as workshop patterns in the future. Such drawings usually represent animals, drawn from life – for example hounds (see fig. 1.32) and, above all, horses (fig. 1.33; see figs. 4.20, 4.22, 4.23, 4.63, 4.64, 4.67). The pen-and-ink study of a hound is typical of Pisanello's technique, combining a wash with hatched strokes which convey the texture and direction of the dog's hair.

THE MALASPINA CHAPEL

At about the time when Pisanello is presumed to have been working for the Pellegrini in Sant'Anastasia, he seems to have been consulted by the Veronese canon Antonio Malaspina, a member of another of the city's leading families. In his will of May 1440, Malaspina detailed the projected programme for his funerary chapel, dedicated to Saint Jerome. It was to contain an altarpiece costing 120 ducats with the main tier showing the Virgin and Child, flanked on their right by the cleric's patron saints, Jerome and Anthony Abbot, presenting the kneeling donor, and on their left by Saint Catherine of Alexandria and the omnipresent Saint George. Above them he asked for images of the Crucifixion and the twelve Apostles, and the whole was to be executed by the sculptor Giacomello da Venezia. The chapel was to be painted by 'a good master'. Its walls and vaults were to bear the images of the four Evangelists, the four Doctors of the Church and the Annunciation, either painted or sculpted. The only connection with Pisanello is in the intriguing stipulation that near his tomb should be images of angels modelled in all respects on their counterparts in the Brenzoni chapel.[99]

Most of these subjects appear, however, in a working drawing by Pisanello's own hand (fig. 1.34) – a series of very quick, rather scratchy pen-and-ink sketches which include the projected altarpiece with the Crucifixion below, the angel Gabriel and, smaller, the Virgin, the symbols of the Evangelists and figures who are identifiable with the Doctors of the Church (Saint Gregory with his papal tiara, the visionary Saint Augustine looking up to a radiant sun, with his bishop's mitre and crozier, and Saint Jerome in the desert with the lion at his feet).[100] There can be little doubt that at one stage or another Pisanello assisted Malaspina in envisaging the decoration of his chapel. The busy combination of somewhat scratchy lines used to describe figures and draperies with consistently diagonal parallel hatching suggests a date towards the end of the 1430s.

THE COUNCIL OF FERRARA

The place of the Malaspina drawing in Pisanello's chronology is suggested by its similarities to two sheets, in Paris and Chicago (figs. 1.36, 1.37, 1.38, 1.39), which link the artist with what was potentially one of the most significant events of the first half of the fifteenth century – the union (as it turned out, very temporary) between the Latin and Greek churches.[101] Union was decreed in Florence in July 1439 – to be almost immediately repudiated by elders of the Greek Church in Constantinople. Its negotiation

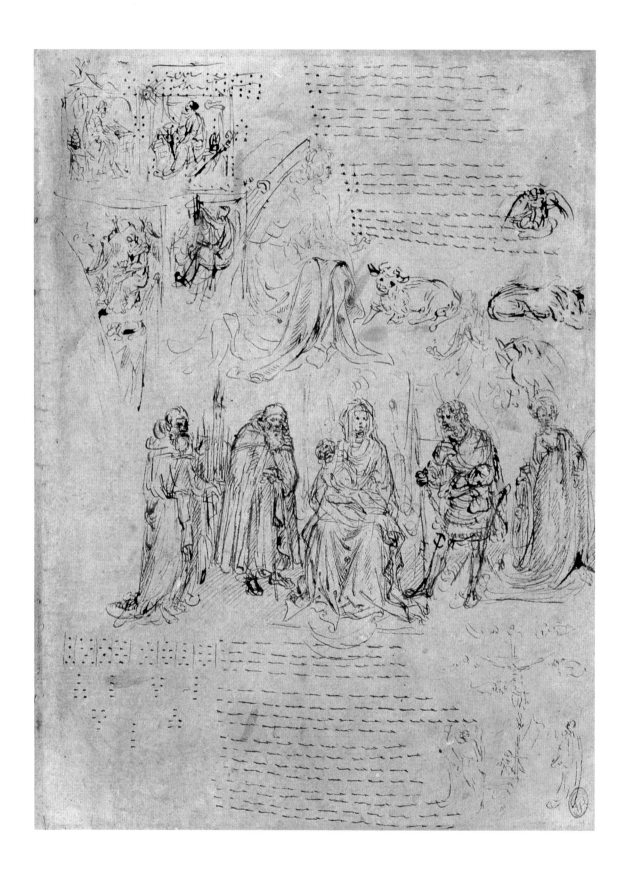

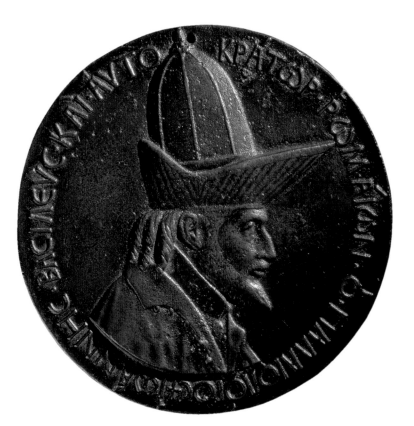

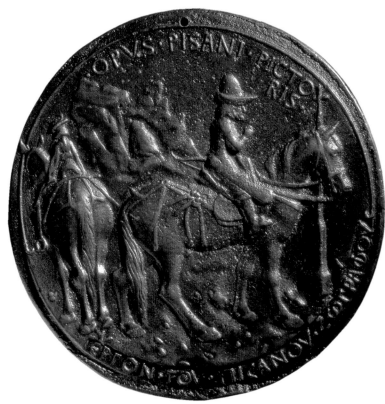

1.35a, b **Pisanello**
Portrait medal of emperor John VIII Palaeologus,
c.1438–43
Cast bronze, diam. 10.3 cm
London, The British Museum, inv. GIII, Naples 9

OPPOSITE
1.34 (detail of 5.11) **Pisanello**
Sketches for the Malaspina chapel, c.1438
Pen and ink on red prepared paper, 25.3 × 37.5 cm
Paris, Musée du Louvre, inv. 2631 recto

had begun in January of the previous year, bringing not only pope Eugenius, keen to achieve union – and bankrolling the whole event – but also the Greek patriarch of Constantinople Joseph II and the Byzantine emperor John VIII Palaeologus to Ferrara (fig. 1.35).[102] The city had been chosen, against the opposition of the Council of Basle, because it was acceptable to the Milanese, politically hostile to the pope. Eugenius was welcomed to the city on 27 January 1438 by the marquis Nicolò III d'Este, who, in February, also journeyed to Venice to meet the emperor. John VIII, who had, rather feebly, excused himself from an alliance with the hostile Council of Basle on the grounds that he was too tired by his sea journey to travel there on horseback, rode into Ferrara (in the pouring rain), accompanied by Nicolò and his sons Leonello and Borso on 4 March. With each party came a vast train of clerics, theologians and scholars. The solemn and magnificent opening of the Council took place in the cathedral of San Giorgio, on the Wednesday of Holy Week on 9 April; the exotic costume – and especially the hats – of the emperor and his brother Demetrius were much remarked upon.[103] However, after this ceremonial, events came to a standstill. The emperor was primarily interested in mustering political support and insisted on fruitless delays to give time for European rulers to make their way to Ferrara. From mid August he chose to live outside the city – where plague had broken out – spending much of his time hunting on a horse, imported from Russia, purchased for him by the pope.[104] Eventually the disgruntled Greeks and Italians (funds running low) set about debating the addition of 'Filioque' to the creed – attempting to agree a solution to the question of the origins of the Holy Spirit, disagreement about which had contributed significantly to the schism between the Churches. The Church of Rome believed that the Spirit 'proceeded' from the Father

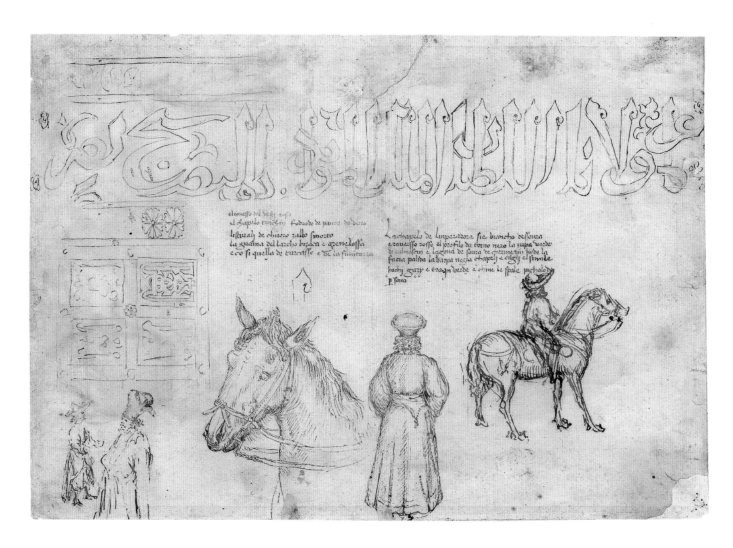

ABOVE
1.36 **Pisanello**
Arabic inscription, emperor John VIII Palaeologus on horseback,
members of his retinue, head of a horse, 1438
Pen and ink, 20 × 28.9 cm
Paris, Musée du Louvre, inv. MI 1062 recto

LEFT
1.37 **Pisanello**
Figures from the retinue of emperor John VIII Palaeologus, 1438
Pen and ink, 28.9 × 20 cm
Paris, Musée du Louvre, inv. MI 1062 verso

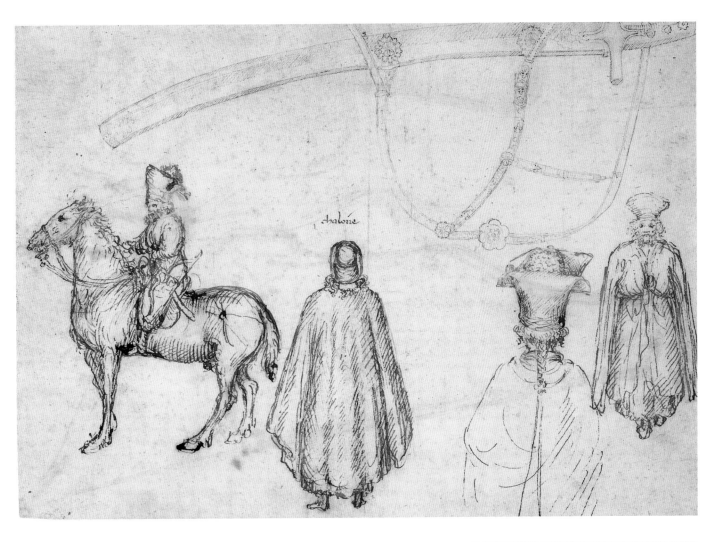

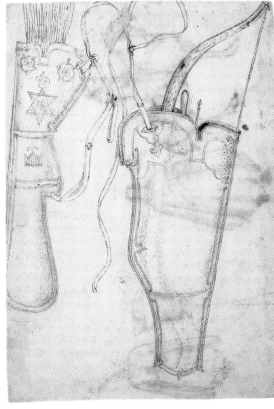

ABOVE
1.38 **Pisanello**
*Figures from the retinue of emperor John VIII
Palaeologus, a scabbard*, 1438
Pen and ink, 18.9 × 26.5 cm
Chicago, The Art Institute of Chicago,
Margaret Day Blake collection, inv. 1961.331 recto

RIGHT
1.39 **Pisanello**
Bowcase and quiver, 1438
Pen and ink, 26.5 × 18.9 cm
Chicago, The Art Institute of Chicago,
Margaret Day Blake collection, inv. 1961.331 verso

and the Son (*Filioque*), whereas the Greek Church held that the Spirit came from the Father alone – the original version of the dogma as proclaimed in the Nicene Creed. The last public discussion of this matter was conducted on 14 December. By then plague had been raging in the region for some time, and Eugenius was broke. He had been selling off territories belonging to the Holy See – Nicolò d'Este obtained three in this manner – and he had been given massive loans by the Medici banking family in Florence. Florentine blandishments were therefore hard to resist and the whole Council transferred itself to Florence in January 1439. It is possible, though by no means certain, that Pisanello travelled with it.

The Paris and Chicago sheets contain a series of sketches of John VIII and members of his entourage and testify to Pisanello's presence in Ferrara for at least some of this time.[105] They are therefore among the very few works by Pisanello that can be securely dated, and thus can be treated as touchstones of Pisanello's style as a draughtsman in this period. They were evidently intended as records of the details of the exotic costumes, hairstyles and headgear of the emperor and his fellow Greeks, of their horses, horse-trappings and hunting equipment. The verso of the Chicago drawing has a detailed study of a bow-case and quiver belonging, presumably, to John VIII or one of his huntsmen. The Paris drawing not only contains an Arabic inscription, taken probably from a textile, but records the long-backed Russian horse favoured by the emperor and includes detailed colour notes. Most of the figures and horses were evidently executed very rapidly, Pisanello finding an economic shorthand for subsidiary details – the folds of costume worn by the bearded man drawn in three quarters on the left of the verso of the Paris sheet for example – while employing dense and confident hatching techniques in other places, where lines that follow the contours of horses' flanks or a hat are crossed by his characteristic short parallel strokes of the pen. The bow and arrows and their container, on the other hand, have the same detailed delicacy as the portraits of horses he made for the Sant'Anastasia frescoes. It would seem that Pisanello had a painting in mind, perhaps one commissioned by his Este patrons to commemorate the events taking place in their dominion.

PISANELLO 'PENTOR REBELLO'

The frescoes of the Pellegrini chapel must have been completed in 1437–8, just before or at much the same time as Pisanello visited Ferrara, and, more importantly, before he became *persona non grata* in his home town. From 1439 onwards, Pisanello became embroiled in the war between Venice and Milan, making himself increasingly unwelcome in Verona as a result of his political affiliations. Although Verona was subject to Venice, there were close economic and social ties between the city and neighbouring Mantua. In this period, Mantua supported the Milanese claim to Verona, and, during the struggle for the city, there were some citizens who supported the marquis of Mantua, Gianfrancesco Gonzaga, when, fighting for the Milanese interest, he briefly occupied Verona on 17–20 November 1439. One of these was Pisanello.[106] His motivation for adopting an anti-Venetian stance is unclear, although he had worked for the Gonzaga

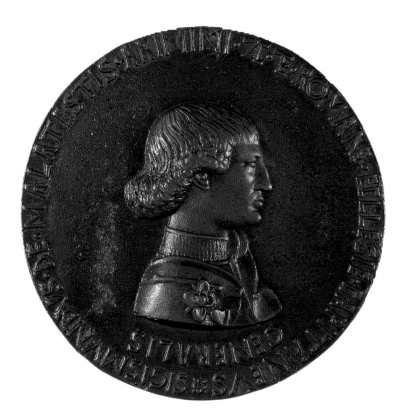

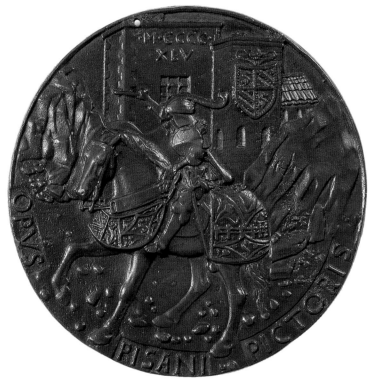

1.40a, b **Pisanello**
Portrait medal of Sigismondo Pandolfo Malatesta,
lord of Rimini, 1445
Cast bronze, diam. 10.5 cm
London, Victoria and Albert Museum,
inv. A.167-1910

in 1420s and again in May 1439, when he received a payment of 80 ducats, so their patronage may have been at stake[107]– also that of their employer, the Visconti duke of Milan. On 6 March 1440, Pisanello wrote to Francesco Sforza, who had re-occupied Verona on behalf of Venice in 1439, requesting a safe-conduct of the kind he had earlier received in order to reach the Gonzaga *castello* at Marmirolo to complete a work in the chapel.[108] He seems to have taken this opportunity to quit Verona, and on 11 May 1440 he is recorded as present in Milan, though his home was then in Mantua.[109] His removal must have underlined his anti-Venetian position. In December 1440, his goods were confiscated by the Venetians,[110] and, in July 1441, he was termed *'Pisan pentor rebello'* by the Veronese governing body in the list it sent to Venice of rebellious citizens.[111] These events would certainly have precluded his participation in the Malaspina project.

Pisanello may have come to regret his political actions, even if they kept him in favour with the Visconti and the Gonzaga. During the 1440s, his life was deeply circumscribed by the restrictive powers of the Venetian government. In the first two years of the decade his movements may have been closely monitored, but his work for enemies of the Venetian state does not appear to have been officially prevented: he continued to work in Mantua and Milan as well as for the Este in neutral Ferrara. It is likely that Pisanello's Arthurian frescoes in the Ducal Palace in Mantua (to be discussed in the next chapter) were painted at around this time.

Pisanello had made his first medals in the 1430s. His first is often claimed to be a piece with the portrait of John VIII Palaeologus (see fig. 1.35), though the suggestion that his 1431/2 letter to Filippo Maria Visconti refers to his portrait medal of the duke has also recently been revived (see further p. 114). His medals of the *condottieri* Niccolò Piccinino and Francesco Sforza (see figs. 3.37, 3.38), stylistically compatible and often treated as a

pair, certainly belong to the very early 1440s, since they are datable by the titles in the inscriptions that surround their portraits. Some time in 1441 Pisanello apparently painted the portrait of Leonello d'Este (see fig. 3.2), and Jacopo Bellini a rival one; Leonello's father, Nicolò, who died in December of that year, is reported to have preferred Bellini's (see p. 106). Pisanello's medals of Leonello, with and without his full title as marquis of Ferrara, Modena and Reggio, are likely to have been modelled just before and just after his succession. On 15 August 1441, Pisanello was sent by Nicolò d'Este to Mantua by boat,[112] and a payment in 1442 for an unspecified work, presumably executed around this time, is recorded in the Gonzaga accounts.[113] He was pardoned by the Venetians on 7 February 1442, on condition that he present himself in Venice.[114]

But Pisanello misbehaved again: on 17 October he used abusive language, probably against the Venetian state. Fortunately for him, the recommendation that he have his tongue cut out in Piazza San Marco was not approved, but this time the restraints on his movements appear to have been more severe. He was confined to Venice and forbidden to sell anything without permission.[115] On 21 November 1442, the Venetian authorities relaxed their edict to the extent that he was given permission to go to Ferrara for two months, though he was forbidden to go to Verona or Mantua or any of its territories.[116] If he had been working on the Mantua frescoes during this time, this would explain why they remained uncompleted. Pisanello was allowed to prolong his stay in Ferrara until September 1443, and was still there two months after that. He had inexplicably taken to Ferrara a canvas of 'Nostro Signor Dio' (either God the Father or Christ), presumably painted by himself, which belonged to Gianfrancesco Gonzaga, who wrote to him on 6 November 1443 saying he wanted it back.[117] In fact Pisanello seems to have made Ferrara his base for most of the rest of the decade, for he is said in a Veronese document to have been living there, in the parish of Santa Maria in Vado, in 1447.[118]

During this time he carried out various commissions for his Este patrons. A medal commemorating the second marriage of Leonello d'Este has the year of the wedding, 1444, on its reverse.[119] In 1445 he executed a painting (lost) for the Este villa at Belriguardo,[120] and was paid for an unspecified commission in 1447.[121] In a letter of 18 August 1448 to the scholar Pier Candido Decembrio, Leonello wrote, 'At last we have wrested from the hands of Pisano the painter the coin [numisma] with your face, and send it to you herewith ...'.[122] The medal was probably therefore just finished. On the other hand, it is likely that his work for the Gonzaga was curtailed and that any commissions for them were executed in absentia. The medal of Cecilia Gonzaga (see fig. 3.31) is dated 1447 on its reverse. Cecilia's brother, Lodovico Gonzaga, marquis of Mantua, became captain general of the Florentine troops in 1447; the title appears on Pisanello's medal (see fig. 2.25), which cannot therefore have been executed before then.[123] These two pieces, therefore, were made very probably in the same year, and they, like the contemporary medals of the late Gianfrancesco Gonzaga and the recently deceased scholar Vittorino da Feltre, were based, as we will see in succeeding chapters, on pre-existing painted portraits.

Pisanello's contacts during this period with the Malatesta cities of Rimini and Cesena in the Marches remain somewhat unaccountable. One of Pisanello's two medals of Sigismondo Malatesta (fig. 1.40) is dated 1445 on the reverse.[124] The medal

1.41 **Pisanello or workshop**
Designs for cannon, c.1449
Pen and ink, brown wash over black chalk, 29.3 × 20.8 cm
Paris, Musée du Louvre, inv. 2293

1.42 Pisanello
Sketches for a portrait medal of Alfonso V of Aragon,
king of Naples, 1449
Pen and ink over black chalk, 20.6 × 14.8 cm
Paris, Musée du Louvre, inv. 2306 recto

1.43 Pisanello or workshop
Design for an embroidery, c.1449
Pen and ink and brown wash over black chalk,
20.6 × 14.8 cm
Paris, Musée du Louvre, inv. 2306 verso

representing Domenico Malatesta Novello (see fig. 4.50) is usually dated to 1445 for no better reason than that one of the medals of his brother bears that date. It is, in fact, one of the most sensitively modelled, beautifully calculated, and intelligently and ambitiously composed of Pisanello's medals, and belongs later in his career (see p. 113). But there is no direct evidence of Pisanello's presence at any time in either Rimini or Cesena and the medals may perhaps have been made as gifts to be presented by his Este patron, based on drawings sent to the artist, rather than on sittings.

NAPLES: A COURT POSITION

His political juggling act probably took its toll on Pisanello. With the Venetian government breathing down his neck, the world of North Italy was no longer his oyster. Not surprisingly, he made attempts, as early, probably, as 1443,[125] to get as far away as possible, south to Naples, to exchange the vilification of the Venetians for the adulation of the Neapolitans – with the added attraction of an exceptionally large salary.

In the event Pisanello did not make it south until 1448–9, when he became court artist to Alfonso V of Aragon, king of Naples, accepted into his household circle ('*in familiarem nostrum recipimus*'). The 1449 'Privilege' of Alfonso V to Pisanello reveals the ruler's motives in placing in his court and rewarding with a large stipend (400 ducats a year) a craftsman ('*opifice*') of his natural talent and skill ('*ingenium atque artem*'): 'There is nothing more becoming to a prince than to pursue with honour, dignity and rewards men of virtue [*virtute*] and endowed with elegant and outstanding talent [*ingenio*], and to embrace them with benevolence and love; for thus it comes about that the minds of others are roused to virtue if they see the rewards bestowed on virtue'.[126] It is interesting to see how Pisanello was employed. Alfonso already had at least one painter, Leonardo da Besozzo, the son of Michelino.[127] Pisanello was evidently supposed to be something else; and there is no evidence that he undertook any major painting commissions during his time in Naples. On the contrary, the drawings by Pisanello and his workshop made at this time suggest that he was primarily exploited as a designer. His skills as a draughtsman came to the fore. Sculptures – '*monumenta insignia*' – are mentioned in the Privilege and, even if nothing large-scale can be traced to him, designs survive for three extant commemorative medals of Alfonso (fig. 1.42; see figs. 5.49, 5.54). There can be no doubt that Pisanello's medal of Iñigo d'Avalos, Alfonso's chancellor, belongs to this period. But drawings by Pisanello and his shop survive also for goldsmith's work – a series of designs for a dragon-shaped salt cellar or nef (see fig. 4.19), intended surely as part of an elaborate silver service – for embroideries (fig. 1.43), coins and cannon (fig. 1.41; see fig. 2.27) and even architecture: it has been convincingly argued that a drawing in Rotterdam of a triumphal arch (see fig. 5.57) can be related to the project to build a ceremonial entrance to Alfonso's Neapolitan residence, the Castelnuovo.[128]

After 1449 the documents once again fall silent. Although it is often assumed that he left Naples soon after his arrival, it is quite possible that Pisanello remained there longer. He was almost certainly still alive in July 1455 (though his whereabouts are unknown), when he was named as debtor of his brother-in-law (in Verona), Bartolomeo

1.44 Pisanello
Unfinished design for a medal of pope Nicholas V,
c.1450–5
Metalpoint over stylus, 20.8 × 11 cm
Paris, Musée du Louvre, inv. 2319 recto

della Levata.[129] But he was dead by October that year. He died probably in Rome, and
Carlo de' Medici recounted how he bought around thirty silver coins (probably ancient)
from one of Pisanello's assistants, the artist himself being but recently dead.[130] Pisanello
also seems to have done some work for pope Nicholas V (reigned 1447–55): a design for a
signed medal, certainly by his hand, may have been left unfinished (fig. 1.44) – the medal
was certainly never executed – after the Pope's demise earlier in the year, on 24 March.[131]
It is Pisanello's most poignant legacy.

It will have been noticed that some of the most important of Pisanello's surviving
works have been barely mentioned in this chronological account of his career. The
dates of his panel paintings in the Louvre and the National Gallery have been much
discussed – and will be again in chapters III and IV. Although a chronology of Pisanello's

medals has long been (tacitly) agreed, we will also see that the dates of some of the most celebrated – of John VIII Palaeologus, for example, Filippo Maria Visconti and Domenico Novello Malatesta – cannot be assumed. Even the painted portrait of Leonello d'Este in Bergamo might not necessarily be connected with the 1441 'competition' between Pisanello and Jacopo Bellini. Most controversial of all, however, is the incomplete chivalric fresco cycle in Mantua, which critics have dated at different points over a twenty-five year period, even if, as the next chapter will demonstrate, this problem can be clarified to some extent.

A large number of drawings – around 400 – by Pisanello and his workshop also survive. The bulk of them were owned in the early nineteenth century by Giuseppe Vallardi – the so-called Codex Vallardi – and were later purchased by the Louvre. Only one of his drawings is signed – a probable presentation drawing in the British Museum of what are thought to be members of the retinue of the emperor Sigismund when he visited Italy in 1433 (see fig. 2.33). Two early drawings can certainly be associated with this event: the rough sketch of the emperor Sigismund in his *chapka* (see fig. 3.17) and the more finished drawing of his profile (see fig. 3.18) with annotations of colour, which must have been made when the emperor was in Ferrara or Mantua in 1433 on his way back from Rome. The drawings made at the Council of Ferrara in 1438 (see figs. 1.36, 1.37, 1.38, 1.39) are also securely dated. Only one autograph drawing carries a date: the sheet with sketches for a medal of Alfonso V of Aragon of 1449 (see fig. 1.42). As we have seen, Pisanello made pattern drawings, which were not necessarily connected with a particular project, and which may sometimes have been considered as works of art in their own right. These are particularly difficult to place in Pisanello's œuvre. Typical of this category

ABOVE LEFT
1.45 **Pisanello**
Dead lapwing, c.1434–45
Pen and ink, watercolour and white heightening over leadpoint, 18.7 × 16.7 cm
Paris, Musée du Louvre, inv. 2464

ABOVE RIGHT
1.46 **Pisanello**
Wryneck and two goldfinches, c.1434–45
Pen and ink, brown wash, watercolour and white heightening over black chalk, 17.7 × 19.1 cm
Paris, Musée du Louvre, inv. 2466

of drawing is the watercolour of a wryneck and two goldfinches (fig. 1.46):[132] Pisanello has delicately coloured a black chalk or leadpoint underdrawing, adding the details of plumage in brown ink. Some of his watercolours of birds may have been made from dead specimens. Thus the drawing of a teal (see fig. 2.41), apparently swimming, might have been derived from a corpse, in the same way as Pisanello's lapwing (fig. 1.45) so evidently is.[133] Pisanello often studied features of birds and animals from unusual angles, looking up into beaks or down on to horses' teeth; he is celebrated, for example, for his views of horses seen from behind. These drawings might have been executed at almost any time in the later 1430s or 1440s. The difficulties of dating and attributing the drawings are compounded by the practice of copying within the workshop, and the fact that Pisanello demonstrably contributed to notebooks which were chiefly the work of his pupils and assistants (for which see chapter V).

This survey of Pisanello's career reveals him as a very particular kind of artist. He belonged to a different tradition to that embodied by his celebrated Tuscan contemporaries. It is a strange, but, in this context, not unhelpful coincidence that he died in Rome in the same year as the Florentine painter Fra Angelico. No two artists of the period could be more diametrically opposed. Fra Angelico was a Dominican friar who specialised exclusively in devotional works of all kinds – frescoes and manuscript illumination but also altarpieces – and whose career was defined by his life within a religious community. Like Pisanello's, his work could also be exquisite, but it was intended for an entirely different audience,[134] and his style depends on a particularly Florentine aesthetic, one codified in the sixteenth century by Giorgio Vasari as an especially Tuscan progression, moving from Giotto via Masaccio to Michelangelo. Although Pisanello certainly executed large-scale religious frescoes, in Verona and at the Lateran, their style and character were informed by his experience at the courts of northern Italy. His delight in naturalistic detail – plants and flowers, birds and animals, costume and armour – evident even in his painted portraits and medals (which were not Florentine genres in the first half of the fifteenth century) is a feature he inherited primarily from Gentile da Fabriano, and which flourished in the environment in which he was to spend the greater part of his working life – the court.

II The Culture of Chivalry in Italy

. . . the lord Lodovico does not practise the profession of arms for the greed of gain, but to obtain honour and fame

FILIPPO MARIA VISCONTI, duke of Milan, describing
Lodovico Gonzaga, marquis of Mantua, 1443

A knight ambles on horseback along a stony road, through an open, craggy landscape; behind him hills, dotted with trees, roll into the distance (fig. 2.2). He wears armour, a mantle and a tall hat that rises and falls forward from a hard brim; his horse is covered with a cloth on which are painted or embroidered his familial arms or individual devices. He is led by a richly dressed lady (on a curiously large scale) walking beside his horse, her hair concealed in a high, rounded headdress – the *balzo* – and her long train swirling around her feet. They are accompanied by a little cavalcade in full armour: another knight and two diminutive pages or dwarfs. Two of these riders bear lances and on their helmets are elaborate crests – *cimieri*. Their horses restlessly toss their heads, and a dog runs underneath, sniffing the ground, while another stands watching the procession go by. Two large birds (monstrous crows?) fly above them.[1]

Here are the ingredients of the chivalric myth: the knight with his retinue and lady-love riding to battle or to distinguish himself for her sake in a joust or tourney. Although it does not always figure prominently in discussions of Italian Renaissance thought, the chivalric value system was central to the construction of ideals of virtuous behaviour during much of the fifteenth century, not least at the courts of Northern Italy and Naples. The codes of gallantry and honour expected of the knightly class were developed and found greatest acceptance during the twelfth and thirteenth centuries in France and elsewhere in northern Europe, strengthened by the Crusades and by newly instituted orders of chivalry. Much-read literary models, taken above all from the legend of King Arthur and the Knights of the Round Table, reinforced the notion of the predestined hero, pure and righteous, who conquered fear and danger and overcame his enemies, inspired by his (chaste) love of a virtuous lady or by his Christian faith – his love of God. The search for the Holy Grail was the single most important quest undertaken by Arthur's knights; beside those paradigms of romance literature – Lancelot, Galahad and Gawain – the story of Saint George, the Princess and the dragon was a key ingredient in the forging of the concept of the Christian knight.

However, the precise subject of Pisanello's cavalcade drawing has not been satisfactorily identified. The knight has usually been taken to be an image, not of Galahad or Gawain, but of Gianfrancesco Gonzaga. The drawing is often assumed to have been made in connection with a Mantuan commission – for the chivalric frescoes, for the (lost)

OPPOSITE

2.1 (detail of 2.4) **Pisanello**
Sala del Pisanello (Arthurian frescoes), south-east wall, *The Tournament at the Castle of King Brangoire:* fallen knight

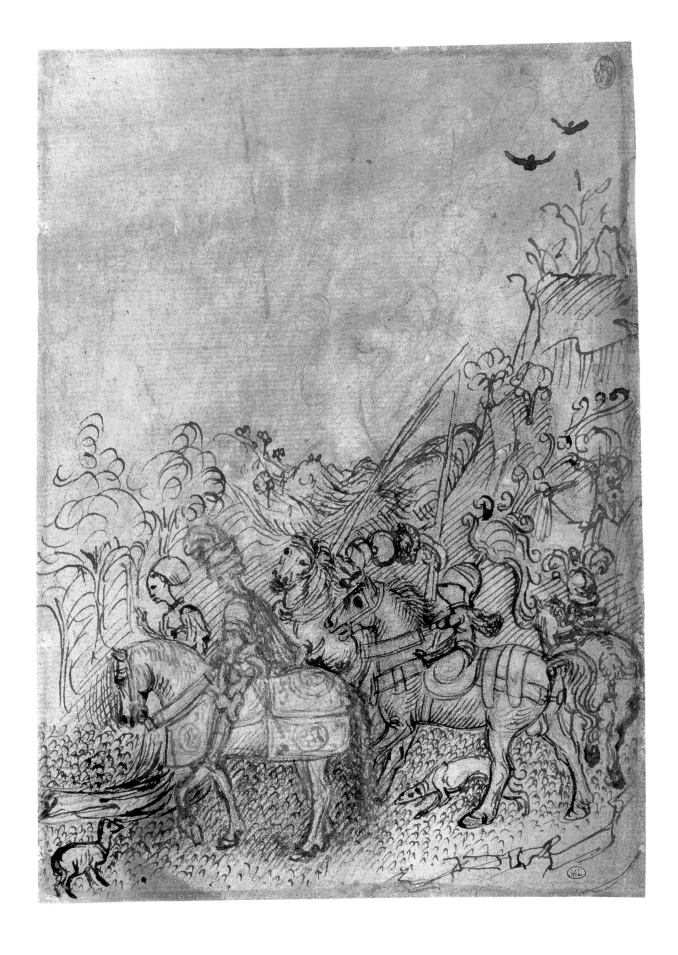

2.3a, b **Pisanello**
Portrait medal of Gianfrancesco Gonzaga,
marquis of Mantua, c.1447
Cast lead, diam. 10 cm
London, The British Museum, inv. 1912-3-6-1

OPPOSITE
2.2 **Pisanello**
A cavalcade, c.1439–42
Pen and ink over black chalk and stylus on
red prepared paper, 25.8 × 18.8 cm
Paris, Musée du Louvre, inv. 2595 verso

decoration of the Santa Croce chapel in the Ducal Palace or for paintings in a chapel (also lost) in the Gonzaga residence at Marmirolo. Any of these projects could have prompted Gianfrancesco's payment of 80 ducats to Pisanello in May 1439, a date which is plausible for the drawing.[2] Even though this is almost certainly not a scene documenting a moment in Gianfrancesco's life story, Pisanello used elements of the composition some years later, around 1447, for the equestrian portrait on the reverse of his medal of the marquis (fig. 2.3), an image which would surely have affected contemporary readings of any pre-existing painting in Mantuan territories.[3]

This drawing was executed at much the same time as another, still sketchier, composition, on the same type of paper, showing a similar group of horsemen encountering a woman, while a dragon lurks in the rocks behind her.[4] This is in the same scratchy style as the drawing connected with the Malaspina project (see figs. 1.34, 5.11), and can be similarly dated. The motifs (horses seen from various angles, pages, lances) that it has in common with the Sant'Anastasia frescoes, and the presence of the dragon, suggest that this may be a design for a scene in a Saint George mural cycle. Such a cycle may have been painted in the chapel of the Gonzaga residence at Marmirolo, documented in progress in a letter from Pisanello to Francesco Sforza of March 1440.[5] If the knight in the first of these drawings is George, however, then he has been turned into a very contemporary Gonzaga saint – a George who was also a Gianfrancesco. The drawing serves as an introduction to the way in which Pisanello rooted his narratives and devotional images precisely in contemporary Italy, by his pictorial documentation of the costumes, armour, horses and other animals possessed or hunted by his patrons – the rulers of Milan, Mantua, Ferrara and Naples.

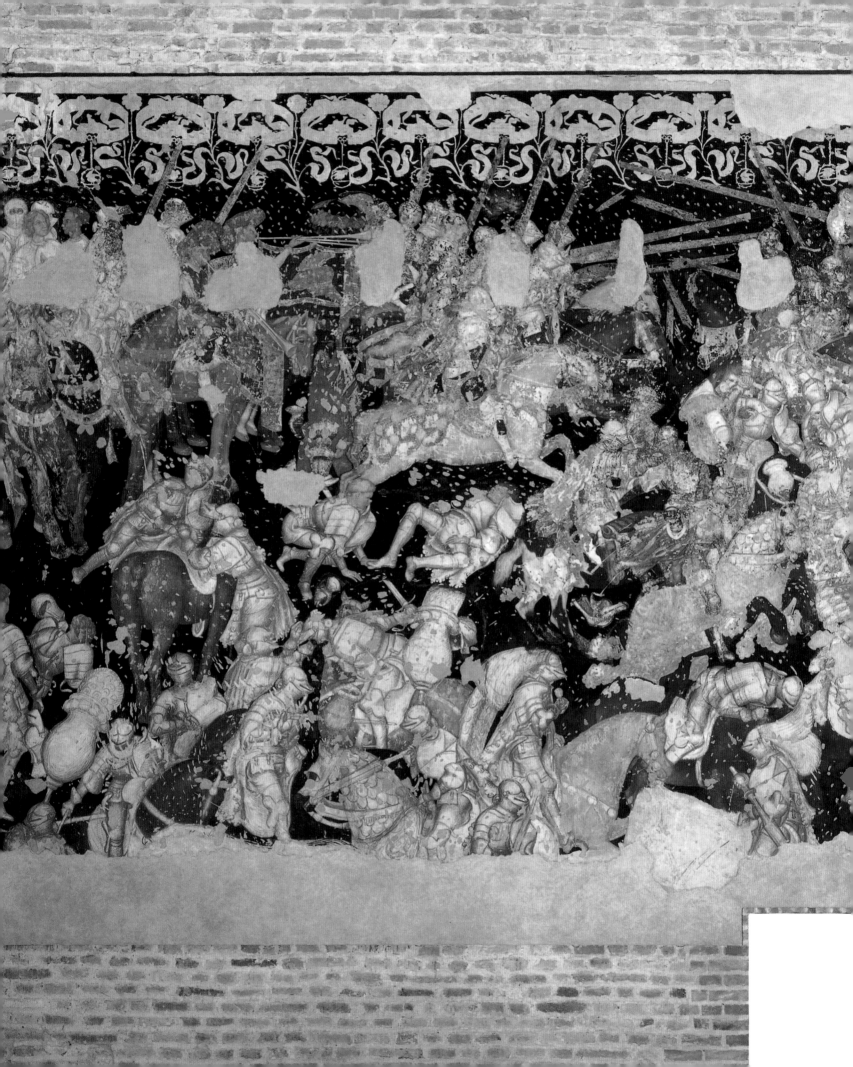

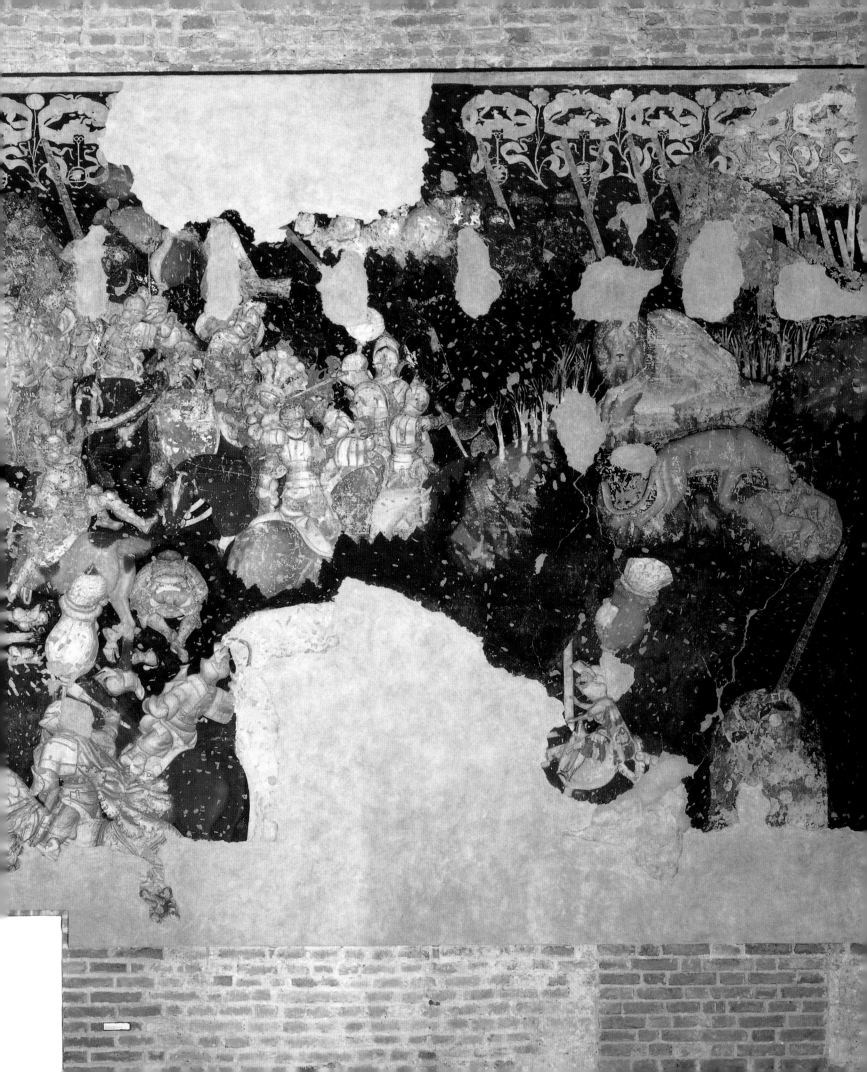

PREVIOUS PAGE
2.4 **Pisanello and workshop**
Sala del Pisanello (Arthurian frescoes), south-east
wall, *The Tournament at the Castle of King Brangoire*,
c.1439–42
Fresco
Mantua, Palazzo Ducale

BELOW LEFT
2.5 **Pisanello**
Head of a dead (or stunned) youth, c.1439–42
Pen and ink over black chalk on red prepared paper,
25.8 × 18.8 cm
Paris, Musée du Louvre, inv. 2595 recto

BELOW RIGHT
2.6 (detail of 2.4) **Pisanello**
Sala del Pisanello (Arthurian frescoes),
south-east wall, *The Tournament at the Castle of
King Brangoire*: stunned knight

On the recto of the sheet with the cavalcade drawing is a densely washed and cross-hatched study of the head of a youth seen from above as he lies on the ground (fig. 2.5). He may be dead, or merely stunned. Although it was not employed as a precise template, the drawing is related to the figure of a fallen combatant in the centre left of the only wall of Pisanello's tournament murals in the Ducal Palace in Mantua which fully reached the stage of its final painted layer (figs. 2.4, 2.6).[6] The physiognomy of the two heads is remarkably similar, and the former existence of a drawing of the same young man made at the same time for the mural may sensibly be deduced. Pisanello's frescoes were intended to decorate the hall which visitors entered first as they reached the living quarters on the first floor of the palace – the *piano nobile*. They remained for the most part at *sinopia* stage – compositional 'underdrawings' on which a further layer of plaster and paint would later have been applied. On two walls these 'underdrawings' survive fragmentarily (one on the north-east with a small area of fresco; fig. 2.7; see fig. 2.12), while the *sinopia* of the painted south-east wall has also been mostly recovered. The room measures 17.4 × 9.6 metres; its walls are 6.75 metres high.[7] It has been argued that the frescoes were begun in the mid-1420s at the period when Pisanello is first documented in Gonzaga employ. However, if they were begun so early in his career, there seems no good reason why they would have been left unfinished while the artist worked on other, later Gonzaga commissions. There is a cluster of documents from the period around 1440 showing that Pisanello was once again employed by Gianfrancesco, notably on decorations in a chapel at Marmirolo, and, moreover, that his ability to work in Mantua

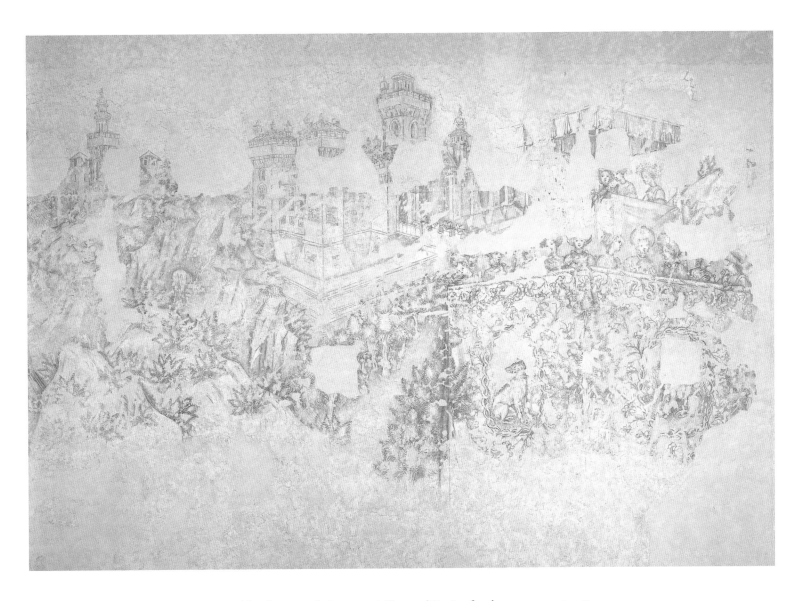

2.7 **Pisanello**
Sala del Pisanello (Arthurian frescoes),
north-east wall, *The Tournament at the Castle of
King Brangoire*
Fresco sinopia
Mantua, Palazzo Ducale

after October 1442 was compromised by the struggle between Milan and Venice for the possession of Verona. It might be argued that he would hardly be employed to work at Marmirolo while the important commission in the Ducal Palace languished, and thus that the commencement of the mural cycle must post-date the completion of the Marmirolo chapel decoration; but it remains possible that the works were to be executed in parallel. While the incomplete state of the Palazzo Ducale murals is explained by the restrictions on the artist's movements imposed by the Venetian authorities, these same restrictions are also an obstacle to the alternative dating, in the late 1440s, favoured by other critics.[8] All the medals made of the Gonzaga family in the later 1440s seems to have been based on pre-existing images. In any case both an earlier and a later date is unsatisfactory from the point of view of the style of the works: the extreme emphasis on naturalistic difficulty in Pisanello's certain contributions to these frescoes is entirely absent from his earlier style, for example that of his frescoes for the Brenzoni monument. More significantly, we have also seen a connection with drawings which seem to have been executed in the late 1430s or early in the next decade. A date for the frescoes between 1439 and 1442 seems comparatively secure.

The painted room was evidently soon known as the Sala del Pisanello: in December 1471 a courtier wrote to marquis Lodovico Gonzaga about Nicolò d'Este, son of Leonello, then staying in Mantua: 'The illustrious lord Nicolò d'Este has let me know that, for his greater security, he wishes to make his kitchen in the Sala del Pisanello where, up to now, his household has eaten I thought of telling him that the damage continually done in kitchens would rot the ceiling.'[9]

The fact that the room's use as a kitchen could be contemplated by that date may be an indication of the perceived value of the paintings by the second half of the fifteenth century (and part of the ceiling did indeed collapse, as predicted, in 1480). However, throughout Italy rooms in palaces were usually known by their decorative content – halls and chambers 'of Caesar', 'of the emperors' or, less ambitiously, of dogs, hares or elephants.[10] That the room should be known by the name of the artist who painted it is seemingly unique for the time, and is revealing of Pisanello's former status, possibly also of his procedure. In his own time Pisanello was extraordinarily famous, but the rubric may also derive from the way in which the murals were designed and executed. The head of the (dead?) youth is one of only a handful of preparatory drawings that can be connected, if rather loosely, with the murals, and only one of these, a beautifully observed, very finished, metalpoint study of the head of a black youth, is repeated verbatim in the finished painting (figs. 2.8, 2.9).[11] This particular drawing may well have been executed some years before, and kept as a pattern to be introduced where suitable into finished works by Pisanello and his shop; it was probably not made specifically for use in this mural. The lack of preparatory drawings may be explained as an accidental loss. Alternatively, and more probably, Pisanello drafted the frescoes on the walls themselves, using two colours – red and black – to design the figures and their composition and to make corrections (fig. 2.10). Although, of course, it is on a very different scale,

RIGHT
2.8 **Workshop of Pisanello**
Sala del Pisanello (Arthurian frescoes), north-east wall, *The Tournament at the Castle of King Brangoire*: tourneyers, one with straw hat, and black youth

FAR RIGHT
2.9 **Pisanello**
Head of a black youth, c.1430–5
Metalpoint on parchment, 7.8 × 5.5 cm
Paris, Musée du Louvre, inv. 2324

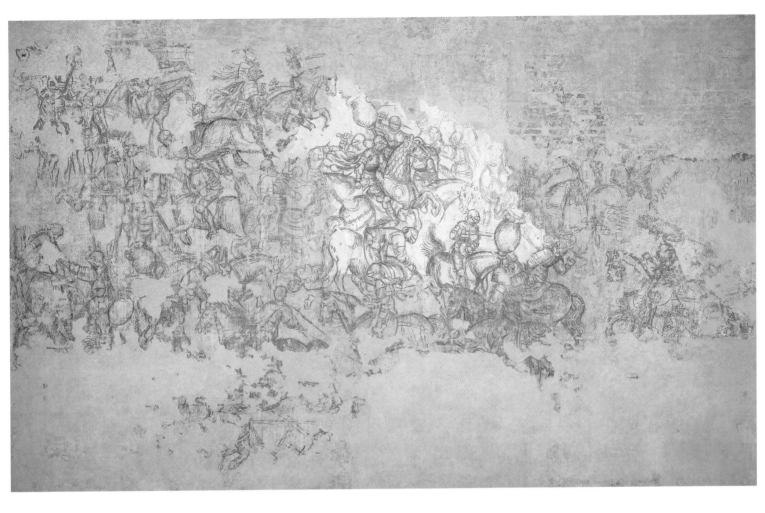

ABOVE
2.10 **Pisanello**
Sala del Pisanello (Arthurian frescoes),
south-east wall, *The Tournament at the Castle of
King Brangoire*
Fresco sinopia
Mantua, Palazzo Ducale

RIGHT
2.11 (detail of 2.4) **Pisanello and workshop**
Sala del Pisanello (Arthurian frescoes),
south-east wall, *The Tournament at the Castle of
King Brangoire*: mêlée

the freedom and energy of this 'underdrawing' is parallelled by the loose vigour with which he drew the cavalcade (see fig. 2.2 – very different from the study of the black youth, fig. 2.9).[12] Pisanello's method must have been seen almost as a kind of performance: the artist was creating before the eyes of his patrons.

That the painted areas do not follow the unusually detailed *sinopie* is an additional complication. Neither the stunned knight nor his fallen companion (see figs. 2.1, 2.6), for example, appear in Pisanello's first scheme. It has been pointed out that between *sinopia* and finished painting the level of engagement between the protagonists has been reduced, so that the narratives of their encounters have become less easy to read. Whereas the protagonists are engaged with one another in the *sinopia,* the painted figures have been transformed into small, self-contained groups, and have sometimes been combined with little regard for the logic of their actions (fig. 2.11). The painting therefore seems to have occurred piecemeal. Stylistically, it is markedly variable; in particular the difference in the quality of the various heads and of the horses is inescapable. The faces of the riders and trumpeters at the top left of the fresco are schematic, with large, low-set eyes and pointed features. The heads and faces of the fragmentary group of figures on the north-east wall, including the black knight, are similarly conventional, but rather different in character, rounder, less almond-eyed, slightly snub-nosed, smaller featured. The central, middle-ground figures of the knights knocked off their horses, including another placed to their left whose dramatically foreshortened rear is turned to the spectator, and the armoured figure seen from behind in the extreme left foreground, are palpably different again – their poses inventively conceived, their heads and hair penetratingly observed and naturalistically rendered. Were it not for the unified style of the *sinopie* (which in its layered drawing style is consistent with these last figures, which are certainly autograph) one might seek to explain these variations by proposing that the project was executed over a considerable period of time. Certainly the frescoes, which were built up in detail only once the frescoed *intonaco* was dry, could not have been painted at any great speed. It is more likely, however, that these different styles are the result of collaboration. Fidelity to the *sinopia*, where it has survived, seems rather greater in the upper part of the mural than at the bottom. There the painting challenges contained, for example, in the horses, mostly seen in profile, were not of such a high order. It seems probable, therefore, that Pisanello, who may have had three major Gonzaga commissions running more or less concurrently, delegated their painting to assistants, while he ensured that figures and horses in deliberately difficult poses, ones which displayed and emphasised his famous inventive and naturalistic powers, were highly visible in the lower levels of the wall. This seems to have been standard practice, but, surprisingly enough, has not previously been proposed in respect of Pisanello's Mantua project.[13]

If it was through those particular and individual talents of the artist that the room merited its name, that is not to say that the murals had no subject. The frescoes illustrate events from a chivalric text, the prose *Lancelot*, which was the third part (or branch) of a medieval French collection of Arthurian romances now known as the Vulgate Cycle. Pisanello depicted the tournament given at the castle of king Brangoire, at which the

hero Bohort, Lancelot's cousin, was declared the champion.[14] Brangoire had summoned one thousand knights and a number of damsels, who were to be allotted husbands from among the tournament victors; the most courageous of them was to wed the king's daughter. Bohort defeated all sixty of the knights ranged in opposition to him, under the gaze of the brides-to-be gathered in a tribune (fig. 2.12). But he declared that he had made a vow of chastity during the quest on which he was engaged – the quest for the Holy Grail. Nevertheless he requested the king to select brides for his companions, who then made their own vows, intended to demonstrate courage at arms or sexual forbearance and amorous loyalty. Bohort, however, was seduced by the king's daughter, assisted by a magic ring. Their son, the product of this brief union, was Helain le Blanc, future emperor of Constantinople.

The seduction scene is omitted – or does not survive. Bohort himself is missing from the painted scene of the tournament – though he is included in the *sinopia* for it, at the far right (see fig. 2.10), wearing the extravagantly brimmed hat which he had worn for his journey (rather than the helmet he would need for the fight). The story can nevertheless be identified with certainty on the basis of inscriptions naming five of the knights performing their deeds of derring-do on the *sinopie* of the other two walls (the north-east and north-west): [Sabi]*lor as Dures Mains, Arfassart li Gros*, [Sar]*droc* [li Blont], *Maliez de Lespine* and [Melidu]*ns li Envoissiez* (fig. 2.13). On the north-west wall, for example, Maliez de Lespine is shown in armour with a bare head and a mantle. He had sworn, 'For a year I shall not meet a maiden escorted by a knight without fighting her companion until I have won the maiden or have been overcome. All the maidens I win will be sent to your service.' Meliduns had vowed, 'I shall ride for a month wearing

2.12 **Workshop of Pisanello**
Sala del Pisanello (Arthurian frescoes), north-east wall,
The Tournament at the Castle of King Brangoire: maidens on a tribune
Fresco
Mantua, Palazzo Ducale

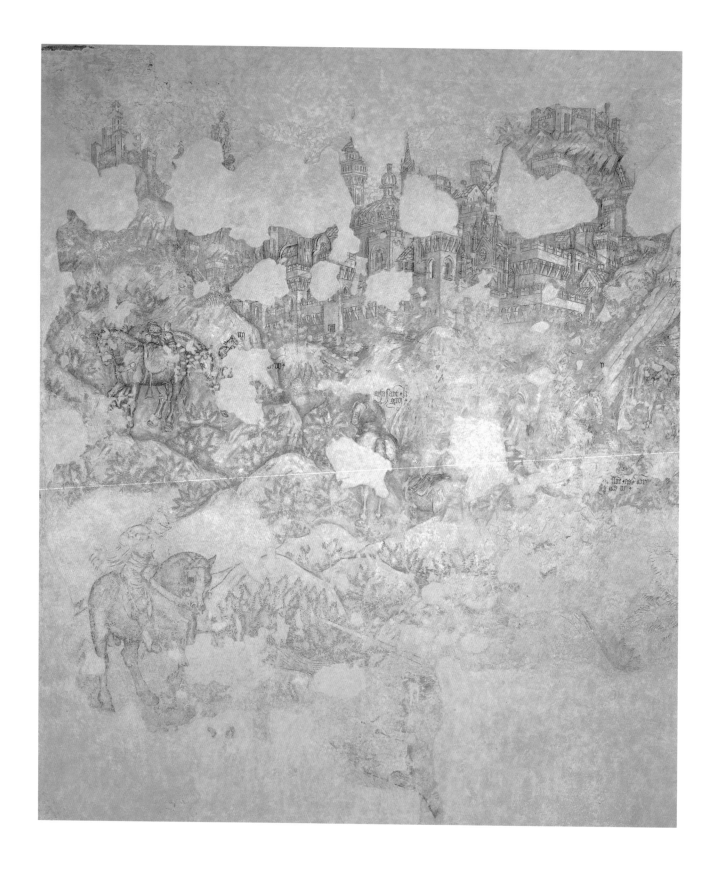

only shirt, helmet, shield, lance and sword; thus equipped, I shall fight all the knights I encounter. I shall send you the horses of those I defeat.' He is seen from behind, garbed and accoutred accordingly, riding off to Maliez's left.

The particular significance to the Gonzaga of this rather obscure episode remains mysterious. It might have had meaning in the political context of the day – the threat to Christian Constantinople and the presence in neighbouring Ferrara of the Byzantine emperor John VIII Palaeologus; the most important relic in Mantua was of the Holy Blood, which the Holy Grail had once contained.[15] On the other hand neither of these aspects is central to the events actually depicted. Meanwhile a striking feature of the mural is the emblematic frieze that runs across the top of the wall (see fig. 2.4). Its main ingredient is the repeated image of a collar, every other one decorated with the letter S, from which is suspended a pendant with a swan. These alternately frame two well-known Gonzaga devices, a hind and a muzzled dog with its head turned to look behind him. Between each collar is a long-stemmed flower, often identified as a marigold or sunflower, but quite possibly a daisy (*margherita* in Italian): it is white when it appears in a Gonzaga manuscript of *Writers of Imperial History* (*Scriptores historiae augustae*),[16] and Margherita was the name of Gianfrancesco's mother and daughter. The collars with the letter S involve a chivalric connection with a northern monarch, Henry VI of England, who in 1436 had granted Gianfrancesco Gonzaga permission to distribute fifty of his Lancaster SS collars to fifty of his best men.[17] A bronze roundel in the British Museum, formerly enamelled, shows that the image of the SS collar was combined with that of the swan of the Bohun family, to which Henry VI's consort belonged; and in 1416 the Gonzaga owned a 'gold jewel with a white swan in the form of a device of the King of England'.[18] These images of his Lancastrian connection were an important legitimation of Gianfrancesco's regime. The Arthurian tournament therefore becomes essentially Mantuan. A tapestry with the device of the muzzled hound is draped from the damsels' tribune in the *sinopia* (see fig. 2.7). Other emblems, the flower, collar and S, can found on the caparisons of the horses of several of the participants in the painted tournament. Others wear Gonzaga colours (green, red and white) on their mantles or helm-crests. The precise subject seems less important than the general message of Gonzaga military might, honed by the ideals of chivalry.

THE TOURNAMENT

Correspondence and library inventories attest that tales of chivalry were read for pleasure by the Gonzaga, Este and Visconti. In Mantua in 1407, for example, sixty-seven volumes in French could be found among the 392 manuscripts owned by Gianfrancesco, including seventeen Arthurian prose romances. The presence of chivalric texts in the Este library in 1436 was proportionately similar, and, even though in the vast Visconti library at Pavia (where nearly one thousand books were listed in 1426) there were only a handful of Arthurian narratives (some eight or ten of the ninety French volumes), the interest in chivalry in Milan seems to have been no less.[19] The preoccupation with the chivalric legend did not diminish as a result of the humanist education that the next

OPPOSITE
2.13 **Pisanello**
Sala del Pisanello (Arthurian frescoes),
north-west wall, *Knights errant in a landscape*
Fresco sinopia
Mantua, Palazzo Ducale

generation of Italian rulers received (see chapter III). Leonello d'Este, for example, commissioned illuminations for a *Lancelot*, and Arthurian romances were bound or rebound in Ferrara in 1447–8.[20]

This interest did not end with reading. Italian rulers named their children after the heroes and heroines of romance literature: among Nicolò d'Este's notoriously numerous offspring were a Meliaduse (Meliaduns), a Leonello (Lionel), a Borso (Bohort), a Ginevra (Guinivere) and two Isottas (Isolde).[21] They also physically recreated and re-enacted some of the key elements designed to demonstrate chivalric valour: tourneys such as that depicted by Pisanello – with two teams of tourneyers battling it out on the field – and jousts – in which two knights rode at one another with lances in the lists. Both were a feature of fourteenth- and early fifteenth-century life at the Gonzaga court: such events were staged in 1340, 1366, 1380 and 1410.[22] Indeed, although tournaments were increasingly associated with chivalric values imported from France, they sprung originally from a long-standing local tradition of organised games.

Visconti tournaments were particularly celebrated. They frequently accompanied weddings, victories and investitures. One was held in 1368 to mark the marriage of Lionel, duke of Clarence, to the daughter of Galeazzo II, and another in 1395 – an especially famous occasion – to celebrate the instalment of duke Giangaleazzo Visconti. Two hundred riders participated in the jousts following the ceremony and there were more than four hundred participants in the tourney the following day.[23] Three years earlier, in 1392, Alberto d'Este in Ferrara had been the sponsor of a tournament to commemorate the marriage between Francesco Novello da Carrara, lord of Padua, to a daughter of Francesco Gonzaga. Here the order was reversed and the tourney was followed by feasting and jousts.[24]

Success by the home side was obviously desirable on such occasions. In 1435, Filippo Maria Visconti celebrated the Milanese victory at the battle of Ponza (where Alfonso of Aragon and some four hundred Aragonese nobles were taken prisoner) by holding a series of jousts. Filippo was understandably keen to see one of his champions as the victor. But on the first two days Carlo Gonzaga, son of Gianfrancesco, took the honours. Visconti, his pride somewhat bruised, chose the incarcerated Venturino Benzone as his new representative. This 'Milanese' champion brought down Carlo and his horse on the third day and won his freedom in exchange.[25] Active participation by princes of noble houses was common, and even the ruler himself, despite or because of the very real danger involved, might enter the lists.

Jousts and tourneys were also a feature of the life of the court and city of Naples.[26] These might be very elaborate – even enacted as allegorical pageants. In 1423, for instance, a tournament was held in honour of a visiting Alfonso of Aragon, actively pursuing his future claim to the Neapolitan crown. The two sides were formed by Catalan and Neapolitan knights. In the centre of the field was a wooden elephant, on which was a platform where the Neapolitan team, cast as the villains, set men dressed as Turks or devils, to be opposed by Aragonese angels.[27] After the successful conclusion to his Neapolitan campaign Alfonso regularly mounted tournaments, in which he himself took part, to mark his daughters' marriages.[28] Probably the most splendid of all Neapolitan

jousts took place in April 1452, when emperor Frederick III, newly crowned in Rome and just married to Leonora of Portugal, Alfonso's fourteen-year-old niece, visited the city. These, too, lasted three days, the street of the Incoronata opposite the Castelnuovo being converted into lists. At either end of the street were set up wine fountains, one white, one red, and in a nearby space was built a miniature military camp. Alfonso himself opened the proceedings; others who took part included his son Ferrante, and the brothers Ercole and Sigismondo d'Este.[29]

These were not only symbolic events of chivalric re-enactment; they involved genuine demonstrations of fighting skills. The instance of Galeotto Bradaxi, an Aragonese knight, is illuminating in this respect. Galeotto gained fame across Europe for his victories in duels, jousts and tourneys. On one occasion Alfonso sent his herald, Calabria, to support him in Flanders, and subsequently would summon him to fight for him in battle, paying him a salary of 120 *oncie* per annum. His faith was rewarded when Galeotto distinguished himself at the battle of Piombino in 1448.[30] These rulers depended on such military prowess. Alfonso had taken the kingdom of Naples by force and continued to justify his authority by reference to his excellence as a warrior. In many cases, war was not merely an art or a political necessity, it was also a business. The Gonzaga, like many of their fellows, served as mercenary commanders – *condottieri*.[31] Between 1410 and 1530 the rulers of Mantua were contracted nine times to fight for the Venetian republic and nine times for the duchy of Milan (although for double the number of years). His *condotta* or contract with Venice in 1433 committed Gianfrancesco to provide 900 lances and 900 infantry. As part of an agreement the troops of the employer might be used to defend the *condottiere*'s own state, should the necessity arise: Lodovico Gonzaga reached such an accord with Filippo Maria Visconti in 1445.[32]

As the Gonzaga and their fellow soldier-princes showed off their military skills, they legitimated what might otherwise have been taken as a sordid, money-making concern by emphasising the chivalric roots of the tournament and joust. Such events justified rhetoric of the kind exemplified by Filippo Maria's 1443 description of Lodovico: '. . . the lord Lodovico does not practise the profession of arms for the greed of gain but to obtain honour and fame'.[33] The secular decoration of their residences reinforced this idealising message. Pisanello's Mantua frescoes were not unique in their conflation of legendary 'past' and present. The names given to rooms in the 1436 inventory of Este properties reveals a range of chivalric themes for wall-paintings. At the Palazzo di Piazza, for example, there was a *chamera di Lanziloto*, a Lancelot chamber, where Margherita Gonzaga, Leonello's wife, resided; at Palazzo Paradiso could be seen a room christened the Fountain of Love, while at the pleasure palace of Schifanoia, on the outskirts of the city, was a room dedicated to Saint George.[34]

FRANCO-BURGUNDIAN ART AND THE ITALIAN COURTS

None of these decorative schemes in dynastic works has survived and there is no way of exactly gauging the styles of these lost paintings. It is likely, however, that they shared at least some of their artistic idioms with Pisanello's work, to judge from approximately

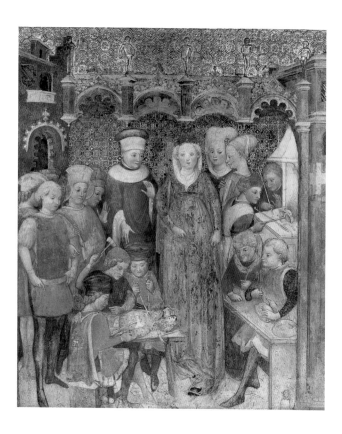

2.14 **Franceschino Zavattari and sons**
The Story of Queen Teodolinda:
Teodolinda orders the idols to be
destroyed, c.1444–6
Fresco
Monza, Duomo, Cappella di
Teodolinda

contemporary works of a similarly secular (though not necessarily chivalric) kind. These include the anonymous frescoes of ladies and gentlemen at play in the house of the patrician Borromeo family in Milan, perhaps painted in 1438, and – though in a religious setting – the mid-1440s historical cycle by the Milanese Zavattari family workshop in the cathedral at Monza (fig. 2.14),[35] telling the story of the queen of the Lombards, Teodolinda, in which portraits of Bianca Maria Visconti and her husband, the *condottiere* Francesco Sforza, are thought to appear. Like Pisanello's paintings, these works were often classified by art historians of the last century as 'International Gothic' – a style characterised as exquisite, refined, delightful, extravagant, decorative and precious. The miniatures by the Limbourg brothers in the *Très Riches Heures* (fig. 2.15), part-executed for Jean, duke of Berry, on which work stopped in 1416 when both the duke and the brothers died, and the paintings of Gentile da Fabriano, especially his 1423 *Adoration of the Magi* altarpiece (see fig. 1.17), are usually seen as typifying and defining the style. In many ways, however, 'International Gothic' is not a very helpful term (as well as being obviously anachronistic), since it tends to skate over both differences and details of transmission.[36] But the 'international' classification is to some extent justified by the process of mutual artistic exchange that occurred in the decades around 1400 between artists working in France and Burgundy and its dominions, on the one hand, and painters and illuminators active in North Italy, Lombardy in particular, on the other.[37]

Some of this exchange may have been enabled by trade between the two areas. However, it is also evident that the Valois courts of the kings of France and dukes of Burgundy, who could trace their lineage to the saintly crusader king Louis IX and beyond, were taken as models by significantly less powerful or more arriviste regimes in Italy. Both the Visconti and the Gonzaga, as we have seen, cultivated diplomatic friendships

with the kings of England. But political uncertainty in England as well as geographical proximity inevitably made France still more important. The Visconti, for example, established alliances with the French monarchy through marriage. In 1389 Giangaleazzo Visconti – who went under the French title of the comte de Vertus[38] – married his daughter Valentina to the French king's brother, Louis, duke of Orleans. His own first wife had been Isabelle of Valois, the daughter of Jean II the Good. In its turn, the Francophile Milanese court provided a model for the rulers of other, smaller or dependent,

2.15 **Limbourg brothers**
Les Très Riches Heures, folio 1v: *January*, 1413–16
Tempera on parchment, 29 × 21 cm
Chantilly, Musée Conde, inv. MS 65

city-states in Italy. The Gonzaga, in particular, connected by marriage to the Visconti, looked to Milan as a courtly paradigm. Francesco, the first Gonzaga ruler of Mantua, was the second cousin of Giangaleazzo through his somewhat disastrous marriage to the daughter of Bernabò Visconti, Agnese (executed in 1391 for adultery). Indeed he escorted Valentina to Paris to see her married. Nicolò d'Este also visited France, making two pilgrimages to the abbey of St-Antoine-en-Viennois, and in the 1467 inventory of his son Borso's library is recorded a chronicle of his journey to Paris in 1414 (as well as two accounts of his chivalric journey to the Holy Land in 1413).[39] Nicolò's successor, Leonello, established a still stronger connection with one of the Valois regimes by dispatching, in 1444, his illegitimate son Francesco to become resident at the Burgundian court in Brussels.[40]

Such political connections were, both naturally and deliberately, accompanied by a fashioning of cultural common denominators. The ritual of the tournament itself had been elaborated with reference to the practices of the French court. French was the language of chivalry, and the courts of France and Burgundy were seen as the inheritors and embodiments of the chivalric tradition. As a consequence, at a time when Italian rulers were self-consciously presenting themselves and their courts according to chivalric codes, one would expect Franco-Burgundian art to have provided the visual vocabulary for depictions of the chivalric court and its activities. Thus, when connections are perceived between features of Pisanello's Mantuan frescoes and the late works of the Limbourgs, they are logical, and stylistically well founded.[41] But the question remains: how and to what extent did Pisanello shape his style in the light of his knowledge of Franco-Burgundian art, and of the Limbourg brothers in particular?

This problem can be addressed in two ways: by examining specific citations of motif and style and, more broadly, by exploring the possibility of a shared approach. A notable example of the former are two drawings by Pisanello, of Saint Jerome and of his study (fig. 2.17), which are both evidently copies after the frontispiece of a *Bible moralisée* executed for Philip, duke of Burgundy (fig. 2.16).[42] How did Pisanello know this image? Since it is unlikely he had access to the manuscript or its inserted frontispiece directly, he might have known it from a drawn copy of the type assembled in so-called 'pattern books',[43] drawings of a kind that circulated widely. There are other cases besides this of specific motifs appearing both in France and Lombardy, although it is not always clear where they originated. French and Burgundian works were commissioned by Italian patrons: as we noted, there were ninety French manuscripts in the Visconti library at Pavia, and probably many in the Este and Gonzaga libraries, too. A Book of Hours survives illuminated in about 1411 by the Boucicaut Master and his workshop (very likely to have been based in Paris) for a Visconti patron – probably Filippo Maria.[45]

Other luxury objects made in France and the Burgundian Netherlands could be found in all the courts of Italy. Jewellery and other precious metalwork found its way south, and visitors to the north, to attend the wedding of Valentina, for example, would have encountered such pieces there. Valentina is recorded as the owner of a pendant ruby set into the Visconti emblem of a radiate dove and the motto *A bon droit* (Rightfully). Another piece, a clasp (*fermail*), had the motto *Plus haut* (Higher), and other jewels included images of a stag and of a pelican (see fig. 3.35 for an example of such a piece).[46]

Franco-Burgundian enamelled gold altarpieces and reliquaries were also sold to Italian rulers – two being purchased for considerable sums by Leonello d'Este from a German merchant in 1450, an altarpiece with a half-length Virgin and Child in a radiate cloud surrounded by angels and a reliquary with images of the Crucifixion, God the Father, angels and the Passion (in roundels) made of *émail en ronde bosse*. This second piece, which survives, was made in about 1400, and can be traced to Frederick IV of Tyrol and, before that, to the court of Burgundy.[47] There was quite possibly a similar trade in enamelled plate for secular purposes, which, to judge from the rare records of its appearance, featured many of the ingredients also to be found in works by Pisanello.[48] Parisian and German goldsmiths were certainly employed by Alfonso of Aragon in Naples.[49]

Alfonso also had tapestries regularly despatched to him from the Netherlands – one of them was given the wonderfully chivalric description '*de la vera honor*', of true honour.[50] Highly expensive imported tapestries, woven from silk and woollen thread as well as silk wound with strips of gold or silver-gilt foil, were the most important and visible indicators of the way in which French and Netherlandish art was privileged at the Italian courts (see figs. 2.40, 3.15). Their size, cost and luxurious materials explicitly signalled the wealth and splendour of their owners, but their subject-matter also had significance. Tapestries are

ABOVE LEFT

2.16 **Limbourg brothers (or copy after)**
Bible moralisée, folio 1: *Saint Jerome*, c.1410
(or c.1420)
Pen and ink on parchment, 41.5 × 29 cm
Paris, Bibliothèque nationale, inv. Ms. fr. 166

ABOVE RIGHT

2.17 **Pisanello**
Study of architecture after the frontispiece of the
Bible moralisée by the Limbourg brothers, c.1430–5
Pen and ink over metalpoint on parchment,
24.9 × 16.2 cm
Rotterdam, Museum Boymans Van Beuningen,
inv. I.526

recorded in Mantua from 1399 and masters from France and the Netherlands were employed by Gianfrancesco Gonzaga from the 1420s.[51] The fact that the first tapestry-weavers to arrive in Ferrara in the next decade were put to repair work suggests that the Este also possessed substantial tapestry holdings. In 1436 'Jacomo de Flandria de Angelo' came to the Ferrarese court and was quickly salaried. He was joined in 1441 by Pietro di Andrea di Fiandria.[52] The 1436 inventory of the goods of Nicolò d'Este confirms the abundant presence of tapestries.[53] Some of these hangings can be traced in a second, 1457 inventory, which contains much fuller descriptions of their appearance. Rather as one might expect, many of their subjects were chivalric – illustrations of romances and, indeed, depictions of tournaments and battles (a large tapestry which showed 'men in combat' is listed).[54] A tapestry of just this kind hangs behind the duke of Berry in the Limbourg brothers' miniature for the month of January in the *Très Riches Heures* (see fig. 2.15).

Pisanello's Mantuan murals and the secular cycles that ornamented other Italian palaces have rightly been seen as the painted equivalents of such tapestries, cheaper and (obviously) less portable, but works which, unlike tapestries, might accrue additional cachet by being executed by a famous artist. It is clear that Pisanello took such hangings as his culturally appropriate model in his method of composition in the tournament scene. Rather than suggest any spatial recession of his setting or of the figures within it, as he had done in the Sant'Anastasia frescoes (and indeed in the *sinopia* design for the story of the knights' quests on the north-east and north-west walls of the same room), Pisanello's figures are all painted on the same scale, whether they are close to the spectator or ostensibly in the background. The space is therefore intentionally impossible to read, the horses and soldiers in the upper level pressing down on the figures below to give the spectator the impression that he himself is in the middle of the mêlée.

The tapestry-like compositional system used by Pisanello in this work shows that the Italian artist did not look to Franco-Burgundian works simply to mine them for appropriate motifs. Just as importantly there was an equivalence in the aesthetic approach and artistic aims and methods of Pisanello and the Franco-Burgundian goldsmiths, weavers and illuminators whose works were so eagerly collected in northern Italy. One of the key elements of the Limbourg style, as it is demonstrated in particular in the *Très Riches Heures*, has been identified as its 'selective naturalism'.[55] The Limbourg brothers did not always aim to set their narratives in perspectively convincing spaces, on naturalistic 'stages', but instead presented highly detailed and accurate descriptions of individual elements, some natural – flora and fauna – others man-made and very contemporary. These circumstantial accounts of animals or objects might be combined with long-used and standardised patterns, either from their own stock or quoted from other artists, sometimes Italian. Such works therefore invited two complementary processes of visual recognition from their spectators: the identification of certain standard elements of 'art', which reinforced the aesthetic status of the image under view, and the empathy-inducing recognition of the things of high value which could be seen around them. Especially in their *Très Riches Heures*, the Limbourgs described the precise appearance not only of horses (themselves expensive) and landscape, but of details of costume, horse-trappings, weaponry or dining silver and gold plate. Given

that Pisanello clearly knew specimens of Franco-Burgundian illumination associated with the Limbourgs, it is likely that his similarly close observation of certain categories of creature and object was inspired by what would very likely have been seen as French practice. Since the intended meaning of many of his narrative works was determined by their reference to chivalric ideals, he chose a method which would make the associations with French art highly evident while, at the same time, demonstrating his own descriptive skills.

ARMOUR

It is noticeable that Pisanello (and the Limbourgs) concentrated their observational energies on those artefacts and animals that could be particularly associated with courtly virtues and activities – for example armour. Armour and weaponry were among the key purchases of the soldier princes of Italy. The up-to-dateness of their military equipment was crucial, not only as its design became more functionally efficient, but because its possession demonstrated how the ruler's spending power was allied with his knowledge of warfare. No makers of armour in Europe were more celebrated than those in Visconti Milan. The Missaglia family workshop, house and warehouse in via Spadari ('swordsmith street') was so famous that distinguished visitors to the city included it in their tourist itineraries; the multi-storey building proudly displayed the Missaglia armourer's marks on its façade, including their MY with a crown.[56] The Missaglia had clients in all the most important courts of Italy,[57] and their armour was among the most prestigious of gifts. Alfonso of Aragon, for example, gave the gentlemen fighting for him in a tournament in 1443 at Terracina suits of armour executed by Giovan Pietro Missaglia worth 1000 ducats. He had commissioned his own suit of armour from Missaglia in 1439.[58] The suit of armour now in the collection at Sludern (fig. 2.18), a very rare survival, was made by Tommaso Missaglia for Galeazzo d'Arco, the lord of a number of imperial fiefs in the Trentino, between 1445 and 1450.[59] The forms of the individual elements of similar suits of armour made for Lodovico Gonzaga (see fig. 2.25b), for Sigismondo Pandolfo (fig. 2.19)[60] and Domenico Novello Malatesta (see fig. 4.50b), for their fellow *condottieri* Niccolò Piccinino and Francesco Sforza (see figs. 3.37b, 3.38b) and for king Alfonso (see fig. 3.44b) were carefully studied by Pisanello and his shop; an accurate record of the armour of his time is a hallmark of his work.[61] These elements might even take on symbolic force, like the poleyns (knee-defences) suspended on the reverse of one of Pisanello's medals of Leonello d'Este (fig. 2.20). Pisanello apparently replicated armourers' marks in his 1440s portrait medals of Piccinino, Lodovico, and Alfonso – an AA which has not yet been identified.[62] This is very much the same style of armour that is worn by the battling knights in Pisanello's Mantua painting, a further factor which has been used to date the work to the early 1440s.[63]

The artist was equally punctilious in his attention to the helm-crests or *cimieri* worn by his figures. *Cimieri* – like the French mottoes that could be found on jewellery and dress – were cardinal signifiers of both identity and aspiration. Their colours might be symbolically important, as in the case of the page or dwarf in the Mantua frescoes

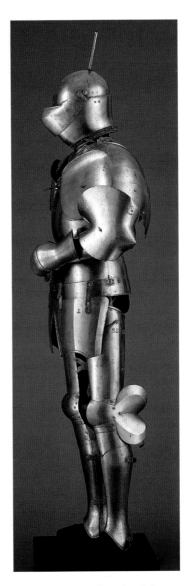

2.18 **Tommaso Missaglia and workshop**
Armour of Galeazzo d'Arco, 1445–50
Steel
Sludern, Schloss Churburg

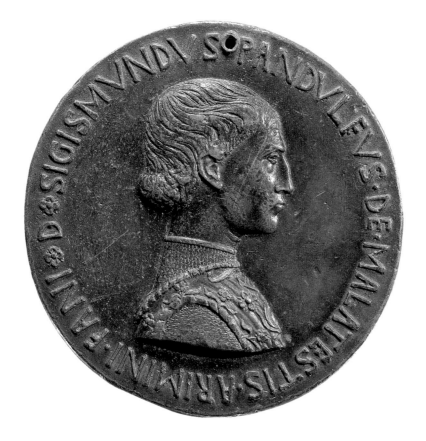

2.20 (detail of 5.46b) **Pisanello and/or workshop**
Portrait medal of Leonello d'Este, reverse:
three-headed putto and poleyns

2.19a, b **Pisanello**
Portrait medal of Sigismondo Pandolfo Malatesta,
lord of Rimini, c.1445
Cast lead, diam. 9.5 cm
London, The British Museum, inv. 1875-10-4-4

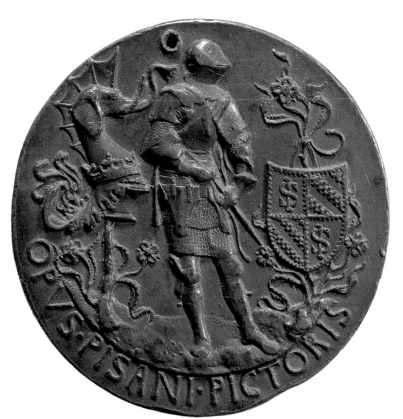

2.21 **Italian, probably Milanese**
Left poleyn (knee-defence), c.1450
Steel, 25.4 × 15 × 24; 620 g
Leeds, Royal Armouries Museum, inv. III.1286

RIGHT
2.22 **Italian (Tuscan?)**
Helm crest in the form of a winged dragon, c.1450
Embossed brass, gilded with some silvered details
Arezzo, Museo Medioevale

FAR RIGHT
2.23 **Tommaso Missaglia and workshop**
Tournament helmet, c.1445–50
Steel
Sludern, Schloss Churburg

who bears the Gonzaga green, red and white (standing for Faith, Hope and Charity) on his crest. *Cimiero* imagery might derive from familial heraldry or from individual presentation. Unsurprisingly, such images frequently depended on a chivalric repertoire. Few survive today, but the helm-crest in the shape of a winged dragon in Arezzo (fig. 2.22), made very probably by a Tuscan goldsmith in about 1450, is perhaps not untypical.[64] It compares well to an earlier Tuscan dragon crest of *cuir-bouilli* in the Bardini collection in Florence.[65] Fashioned from beaten copper, gilded with silvered detailing, the Arezzo dragon is no longer complete: between the wings are little tubes for fixing plumes to it. The associations with that perfect Christian knight, Saint George, are self-evident, and such as would be desired by various of Pisanello's patrons. Leonello d'Este, for example, identified himself with the saint when, among the other festivities for his marriage to Maria of Aragona in 1444, he had the main piazza transformed into an oak wood for a play devoted to Saint George.[66] It is possible that the Visconti *biscione* (a serpent swallowing a man), so closely observed on the reverse of Pisanello's portrait medal of Filippo Maria (fig. 2.31), similarly refers to the knightly defeat of evil.[67]

The Arezzo *cimiero* could be attached to different types of helmet and might therefore have been used either in battle or in a tournament. Armours for war and for the chivalric demonstration of soldierly skills were, however, of different kinds, providing greater or lesser degrees of protection and displaying different levels of ornament (fig. 2.23). Pisanello was careful to differentiate between the two types. The equestrian portraits on the reverses of the medals of Gianfrancesco Gonzaga and Sigismondo Malatesta, lord of Rimini (of 1445), for example (see figs. 2.3b, 1.40b), show them wearing field armour.[68] These are unequivocal images of the professional soldier. Domenico Malatesta (see fig. 4.50b) is also shown girt for war – in the act of making a pious vow during the 1444 battle of Montolmo.[69] The image therefore conveys the idea that he carried his religiosity on to the battlefield.

The reverse of Pisanello's medal of Filippo Maria Visconti, on the other hand, has a knight whose armour was made for the tournament (fig. 2.24).[70] With the *biscione* on his helmet this knight may have been intended to be identified as Filippo Maria himself. Alternatively it may stand for the duke's chivalric ideals, as he displayed them in his 1435

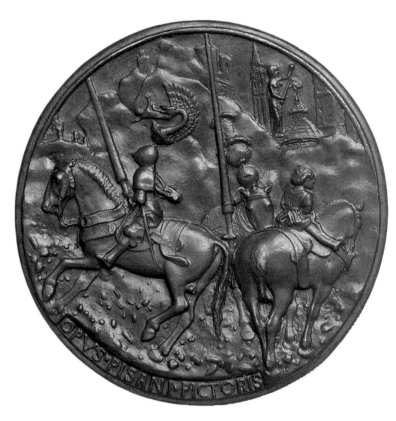

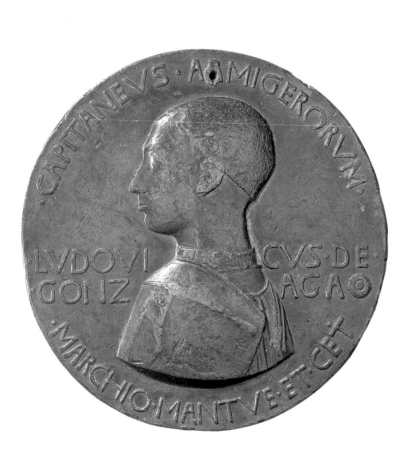

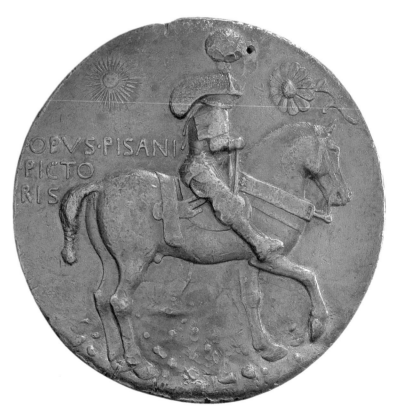

OPPOSITE
2.24a, b **Pisanello**
Portrait medal of Filippo Maria Visconti,
duke of Milan, c.1435–40
Cast bronze, diam. 10.2 cm
Milan, Gabinetto Numismatico Museo
Archeologico, inv. M.O.9.553

2.25a, b **Pisanello**
Portrait medal of Lodovico Gonzaga,
marquis of Mantua, c.1447
Cast lead, diam. 10.3 cm
London, The British Museum, inv. GIII, Mant. M5

jousts. Other medals combine images of tournament and combat armour to suggest the way in which chivalric values informed the professional lives of their subjects: on the reverse of Pisanello's second medal of Sigismondo Malatesta (see fig. 2.19), he stands full-length, once again dressed in field armour, but now he has a tournament helmet to one side.[71] The message of Pisanello's medal of Lodovico Gonzaga (fig. 2.25) is more subtle. On the obverse he wears field armour while on the reverse he is dressed for chivalry. His helmet is of a type especially made for the joust. His tournament armour, and the pose of both horse and rider, are so close to those of a mounted figure in the Mantuan wall-painting (fig. 2.26) that this figure might be identified with Lodovico himself.

Pisanello's observation may have resulted partly from some involvement in production. In his letter to Francesco Sforza asking for a safe-conduct so that he could complete the frescoes at Marmirolo he made it clear that, in return, he was making, designing or ornamenting a *cimiero* for him.[72] But for the most part Pisanello must have relied on drawing. The accuracy of his record drawings can be judged by comparing the helmet at the centre of a sketch made during his time in Naples with one surviving from the period (figs. 2.27, 2.28).[73] They differ only in the sight, which in the existing helmet is formed by the gap between the skull and visor, while in the one drawn by Pisanello the visor itself is pierced. The drawing also documents Alfonso of Aragon's adoption of the Arthurian 'siege perilous' as one of his emblems – the seat at king Arthur's Round Table that was kept empty for the knight destined to find the Holy Grail and fatal, because it burst into flames, for anyone else. It appears as two of these helmet crests. In 1450, about which time Pisanello's drawing was executed, the 'siege perilous' was described on a suit

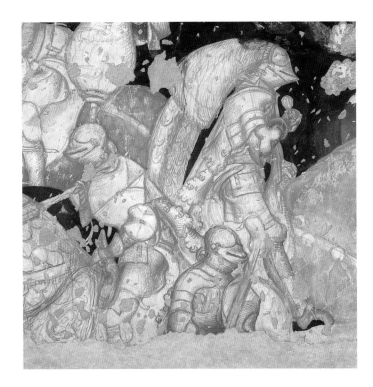

2.26 (detail of 2.4) **Pisanello and workshop**
Sala del Pisanello (Arthurian frescoes), south-east wall,
The Tournament at the Castle of King Brangoire: tourneyers

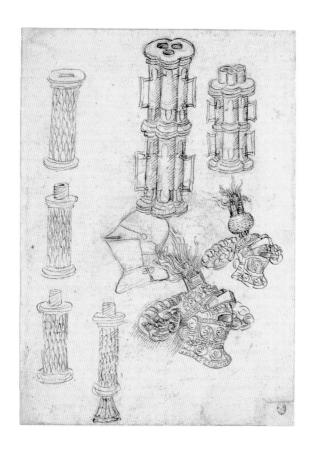

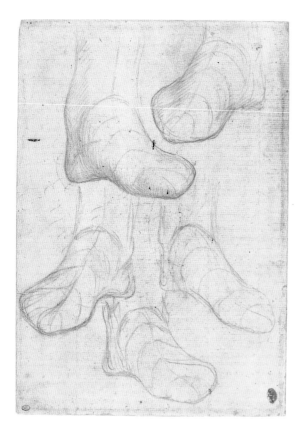

LEFT
2.27 **Pisanello**
Three helmets and their crests, six pieces of cannon, c.1448–9
Pen and ink over black chalk, 28.7 × 20.6 cm
Paris, Musée du Louvre, inv. 2295 recto

ABOVE
2.28 **Milanese**
Armet, c.1450
Steel, 25.5 × 18.5 × 28 cm; 3525 g
Leeds, Royal Armouries Museum, inv. IV.498

LEFT
2.29 **Pisanello**
Sabatons, c.1434–8
Metalpoint, 27.4 × 19.5 cm
Paris, Musée du Louvre, inv. 2281 recto

BELOW
2.30 **Italian**
Pair of sabatons, c.1450
Steel, each 11 × 14 × 30 cm; 645 g
Leeds, Royal Armouries Museum, inv. III.1348

OPPOSITE
2.31 (detail of 2.24b) **Pisanello**
Portrait medal of Filippo Maria Visconti, reverse:
knight with *biscione* crest

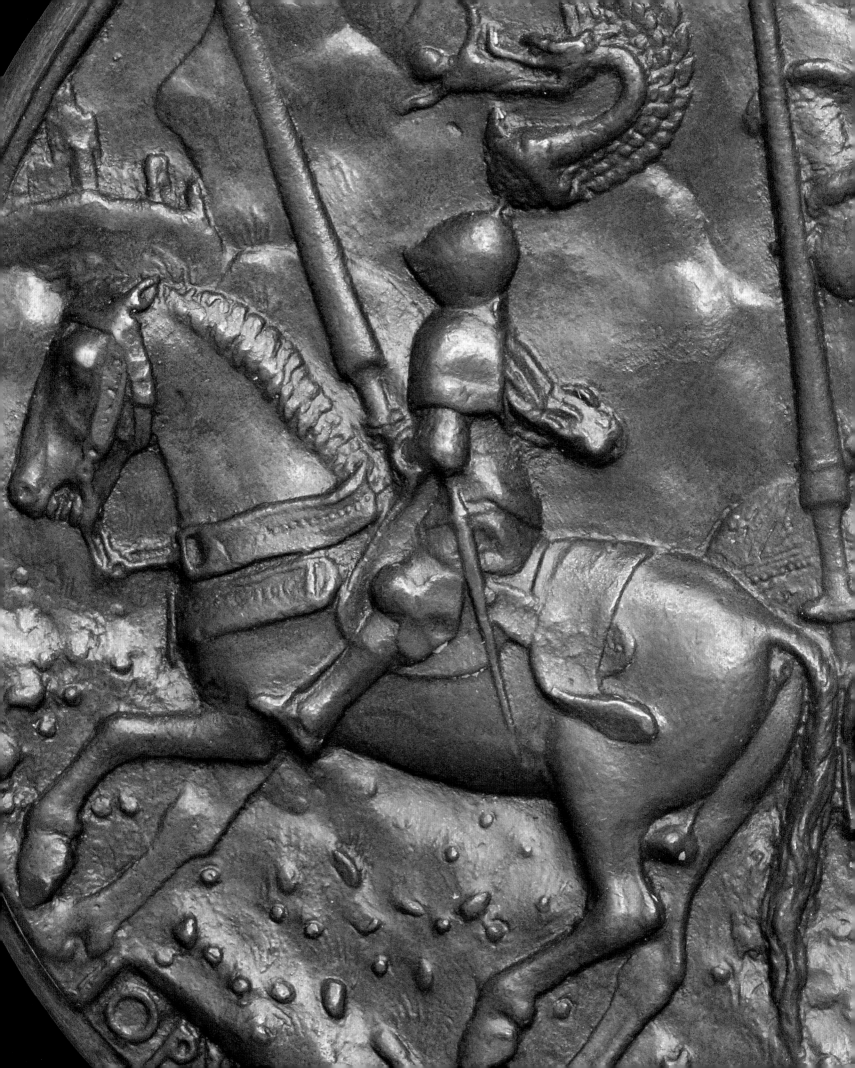

of tournament armour belonging to the king, which suggests that this is a record rather than a design.[74] Pisanello displayed a similar regard for accuracy in his sketch for sabatons (figs. 2.29, 2.30), a drawing associated with the frescoes at Sant'Anastasia (see p. 23).[75]

COSTUME

Drawing was certainly the means by which Pisanello studied the dress adopted by his patrons and their courts. Costume drawings survive by both Pisanello and his shop. The accurate rendition of current fashions was another tactic the artist could use to make his images of saints and heroes splendidly contemporary. The forms of the clothes themselves – and often their northern origins – may even have reinforced the language and message of the paintings by contributing to a Franco-Burgundian derived image of the chivalric court.

A partially coloured drawing in Oxford is a case in point (fig. 2.32). It belongs to the same family as an autograph costume study, similarly coloured, in Chantilly, but the stiffness of the line and the rather clumsy application of watercolour show that this is by a member of Pisanello's workshop, perhaps copying a model by the master, rather than by the master himself. These, and another drawing of the same type in Bayonne, show men and women dressed with extraordinary richness in clothes with flourishes and furbelows that know no bounds.[76] The women have their hair covered by the *balzo*, an exclusively Italian fashion, depicted by Pisanello in a series of life studies for the head of the princess in the Sant'Anastasia frescoes (see figs. 1.30, 1.31).[77] The device on the sleeve of the man on the right and the colours link the Oxford drawing to the Este court, and it is likely that all three drawings show fashions worn there. The device can be identified as one of the individual *imprese* of Borso d'Este, first referred to in 1450, though invented earlier, called a 'plank with nails fixed underneath'; it represents possibly a tool for carding flax or perhaps a torture instrument. The white, red and green seen on the sleeves were not the exclusive property of the Gonzaga, but are also recorded in use at the Este court.[78] In 1434–5 the embroiderer Giusto worked on the decoration of sleeves for one of Nicolò's mistresses, Camilla de' Roberti.[79] The garment, made out of seventy-four pieces of satin – sixty-four white, red and green, and ten woven with gold thread – must have resembled those in Pisanello's costume studies. The drawing in Chantilly shows such family colours moved from the overgarment to the legs. The colours of men's hose were noted as significant: Francesco Sforza, for example, at his marriage to Bianca Maria Visconti, the illegitimate daughter (and only child) of Filippo Maria, is recorded as having worn a red stocking on his right leg, and blue and white on his left.[80]

The most striking elements in all these drawings are the enormously rich and complicated overgarments worn by both men and women, with their huge, dragging sleeves, long trains and elaborate application of fur, jewels (especially pearls),[81] embroidered devices or mottoes, and dagging (decoratively cut and twisted textile strips – often of particular preciousness – sewn on to the edges of garments). By the end of the fifteenth century such extravagantly ornamented fashions had come to seem absurd. Leonardo da Vinci recalled them with satirical pleasure: 'And I remember having seen, in my

2.32 **Workshop of Pisanello**
Study of costumes, c.1432–5
Pen and ink with watercolour washes on
parchment, 18.3 × 24 cm
Oxford, Ashmolean Museum, inv. P.II.41

childhood, grown men and young boys going about with every single edge of their
clothing dagged, from head to toe and down right and left sides. At the time, it seemed
such a wonderful invention that they even dagged the dags In another era, sleeves
began to grow and were so huge that each one of them on its own was larger than the
main body of the garment.'[82] Pisanello, however, felt it his duty to understand the form
and structure of dagging. A sketch in the Louvre by a member of his shop (probably
copying a lost original by Pisanello himself) shows the way in which strips of cloths
were pinked into tabs, then twisted, before being applied to the hemline of a garment.[83]

These Ferrarese courtiers have much the same bird-profiles, with their great wing-
sleeves and layers of fabric at their shoulders, as the participants in the aristocratic
pastimes in the Limbourg calendar miniatures. This is no coincidence. These lavish

garments, worn by both men and women as overdresses covering more figure-hugging clothes beneath, were known in North Italy as *pellande*, a word derived from French *houppelande*.[84] The *pellanda* was the principal clothing element in any wealthy bride's dowry. Needing some ten *braccia* (about six metres) of cloth, they were enormously costly when made appropriately of the richest materials.[85] In 1441 Nicolò d'Este possessed thirty-six *pellande*. Many of them were cut from gold brocade and other gold cloths. The inventory of his wardrobe gives a sense of the variety of sleeve forms in his time, confirmed by the drawings by Pisanello and his shop. They included sleeves '*a gombedo*' (wide to the elbow, narrow to the wrist), '*a fogliami*' (in leaf shapes), '*affaldate*' (long and turned up), and '*abuxate*' (probably 'slashed').[86] Perhaps most popular of all were those poetically defined as winged – '*ad ala*'.

There can be no doubt that these fantastic costumes were intended as an expression of princely power and courtly magnificence.[87] As such they received their fair share of civic and clerical condemnation. What some saw as splendour, others perceived as vainglory. When between 1434 and 1438 Giovanni da Capestrano wrote a treatise condemning extravagance in dress, *On the Use of Every Ornament*, he was probably prompted by the task he had received from the bishop of Ferrara in October 1434 to promote the censure of long trains; only prostitutes were excepted.[88] In contrast to oligarchic cities like Florence or Venice, laws seeking to restrict overly lavish spending and inappropriate public display – so-called sumptuary legislation – were not a particularly prominent feature of dynastic states. In Milan, for example, the laws of 1396 were not followed up for many decades,[89] having been mostly ignored in the meantime; the silk industry was too profitable to allow fine feelings to get in the way.[90] Indeed the sumptuary laws for Fano promoted by the nobles on the city's council were actively opposed by Sigismondo Malatesta, whose ancestral claim to the territory was acknowledged by the pope in 1445; he claimed that allowing women to dress as ornately as they pleased would add to the splendour and beauty of the city.[91] Part of a ditty attributed to one Jacopo Sanguinacci, describing the dress of the young men of Venice, makes the point that splendid clothes were taken as signals of lordly status:

> On the benches of Rialto and in the Loggia
> I saw them standing in their clothes of silk,
> which sets off very well a fine figure,
> so as to make them seem born in the empyrean.

> Each one thought it fit to dress well:
> you would not tell the poor man from his betters;
> they all seem to me lords,
> endowed with land and cities and castles.[92]

French fashions had become particularly influential in Italy from the moment of the marriage of Valentina Visconti to the duke of Orleans in 1389. However, just as manuscript illuminators in France and Lombardy looked to each other for inspiration, so there was an interchange of French and North Italian fashions.[93] It is not clear whether by the 1430s the exaggerated costume styles influenced by fashions in northern Europe, above all the

courts of France and Burgundy, were all acknowledged as imports. Some Italian modes assuredly evolved autonomously from fourteenth-century styles. Nevertheless there remained a keen interest in the fashions of the north. In September 1440, for example, Bianca Maria Visconti journeyed to Ferrara by boat, but entered the city mounted on a white horse 'with a canopy of cloth-of-gold and she had on her back a Flemish mantle of blue cloth-of-gold, lined with ermine'.[94] Alfonso of Aragon was sent armour and costume from France, designated as 'for a knight'.[95] The geographical sources for other fashionable innovations in dress were clearly recognised. In Sanguinacci's account of the dandified fashions of Venice, he writes:

> The young seem to come from France
> or Catalonia, or foreign places,
> to such an extent are devised
> their garments of different fashion.[96]

Florentine sumptuary legislation of 1456 attempted specifically to combat the wearing of the Franco-Burgundian horned and saddle-shaped headdresses, adopted in the 1440s:[97] women 'cannot wear headgear or horns or saddles in the Flemish way and the French

2.33 **Pisanello**
Costumes (three courtiers), c.1433
Pen and ink and grey wash
over leadpoint on parchment,
24.8 × 33.8 cm
London, The British Museum,
inv. 1846-5-9-143

way [or] in any mode that popularly is called in the style of from over there [*alla di là*]'.[98]

Valentina Visconti may also have been one of the chief popularisers of the vogue for wearing clothes with French mottoes applied to them, a taste which could only have reminded its audience of the French genesis of these clothing styles as well as linking these forms of dress, once again, to chivalric endeavour. She owned a belt with the legend *Loy antepasse tout* (Law always takes precedence).[99] Similar verbal *imprese* could be found decorating Este clothes from the beginning of the century. In 1436 the embroiderer Giusto decorated the bust and sleeves of 'a garment of black velvet' for Nicolò's daughter Beatrice with 'two lambs on a green ground with big mottoes of silver thread'. Her motto appears to have been *Ainsi. doit. il* (It must be so), and her sisters used a whole range of similarly moralising French phrases.[100]

A drawing by Pisanello of three men in extraordinarily opulent costumes (fig. 2.33) both demonstrates how valued was his capacity for detailed observation of contemporary fashions and indicates the way in which fashions might be introduced into Italy from abroad, perhaps even becoming popular as a result of their inclusion in works of art.[101] It is an equivalent of Pisanello's highly finished drawings of birds and animals, exhibiting a similar concern for descriptive specificity, beautifully depicting the volume of the clothes and the textures of individual elements, while organising both the composition and the strokes of the pen with an exquisite sense of pattern. Though it is now much faded, Pisanello's account of the 'fluted' effect of these rich overgarments enables one to work out that narrow, triangular pieces must have been inserted between the waist and lower hem to make the 'skirts' stand out.[102] It is the only drawing to have come down to us that is deliberately signed by Pisanello – indicating that he and his audience saw it as a finished work of art in its own right. A costume study was thus converted into a proof of Pisanello's artistry, a piece to be sold to a discriminating collector or presented to a patron.

A Mantuan manuscript of Jacob ben Asher's *Four Orders* of 1435 has an illustration of a Jewish wedding suggesting that the cut and decoration of these mens' costumes had been introduced into Italy by the middle of the decade, and Pisanello drew such an overgarment from the back in a drawing that was made in either Mantua or Ferrara at about this time.[103] Nevertheless, that this was a fashion that continued to be seen as exotic is demonstrated by its appearance in Domenico Veneziano's tondo in Berlin of *The Adoration of the Magi*, a work which seems purposely to adopt a Pisanellesque idiom, and which uses the costume style to emphasise the wealth and status of the kings. Indeed it has been suggested that garments of this kind may have arrived in Italy between 1431 and 1433 in the train of the emperor Sigismund and that Pisanello, in fact, used three imperial courtiers as his models; the central figure does, it is true, have a very un-Italian moustache. Pisanello's drawing thus may have served initially as a pattern of exoticism of much the same kind as his portrait study of the black youth (see fig. 2.9). The costume therefore must have remained a kind of fancy dress, which, if worn by Italians in daily life or on ceremonial occasions, would have retained a significance bestowed by its foreign beginnings and imperial ancestry.

Another exceptional drawing, often attributed to Pisanello (fig. 2.34), seems to have functioned similarly, as a finished work of art and demonstration of artistic *virtù*.[104] It depicts a gentleman riding a mule, carrying a falcon on his wrist. He and his mount are as elaborately caparisoned as any of Sigismund's courtiers; his hands emerge from sleeves cut from gold cloth into which is woven a repeat pattern with the device of a ring in a font, and he has a jewelled *fermaglio* on his shoulder and a bizarrely huge hat on his head. The drawing is finished with an astonishing web of mordant-gold highlights, making its status as a finished work very evident. Identification of the rider has long been uncertain and is complicated by the presence of the Lancastrian SS *impresa*, normally associated with the Gonzaga, on the dagged horsecloth. However, the device of the ring in a font, or *batesimo*, on his costume identifies him almost certainly as Borso d'Este; also the jewel appears to be the same one that appears in Jacopo Lixignolo's 1460 portrait medal of Borso.[105] It seems, however, that Borso's *impresa* was not devised until after his succession to the Ferrarese marquisate in 1450 (it was described as new in 1451 and 1452). Thus, although there are unquestionable stylistic links to Pisanello's own work (in the dense and finicky hatching, for example, or the hooked strokes used to indicate the ground), this dating makes an attribution to Pisanello less plausible. Both figure and, especially, animals are relatively schematic, and the concern for beautiful surface pattern – in the hat or scalloped strips of fabric hanging down from the saddle – outweighs any desire to establish the figure's bulk. Its author must be regarded as a close follower of Pisanello (perhaps Borso's court painter in Ferrara, the Sienese Angelo Maccagnino, who worked in the city from 1444) rather than Pisanello himself.

The image nevertheless serves as pertinent reminder of another ingredient in Pisanello's artistic vocabulary and of its derivation. The drawing is partly a costume study, but just as importantly the image of a prince on the hunting field. Borso is known to have been a passionate huntsman, and his enthusiasm was shared by many, if not all, of his peers and predecessors. Princely devotion to the chase may well have directed artistic choices of painters called to record or reflect it. Pisanello's ability to paint birds and animals was highly praised in his lifetime. Many of the creatures that he drew or included in his works can be associated with hunting – both the pursuers and the prey. There were long-standing patterns for depicting many of these birds and animals, that were frequently used, perhaps partly because of their connotations, as decorative motifs.[106] This kind of model-book production is further exemplified by the marginal decoration of about 1380–1400 to a Latin treatise on the Vices written by a member of the Coccarelli family of Genoa. Only fragments of the manuscript survive (fig. 2.35).[107] The border shows some evidence of nature studies – observation of the flight formation of a flock of birds, for instance – but the birds and beasts otherwise seem to depend on copies that have not been refreshed by direct observation, on copies and copies of copies. Pisanello used his ability to draw from nature to transform this standardised model-book vocabulary of animals that his audience would recognise from the field and forest. His worked-up ink and watercolour drawing of a falcon is a case in point

Di mano del pittore
Cosmeto

OPPOSITE

2.34 Follower of Pisanello
Borso d'Este (?) hunting with a falcon,
c.1450
Pen and ink, brown wash and gold
heightening over black chalk on brown
prepared paper, 22.5 × 17.2 cm
Paris, Institut Néerlandais,
Collection Frits Lugt,
inv. 6164 (JBS 2N03)

RIGHT

2.35 Genoese
Fragment of a treatise on the Vices
by a member of the Coccarelli family
of Genoa, folio 1v: *Hunting scene,*
c.1380–1400
Tempera and gold on grey ground on
parchment, 16.5 × 10 cm
London, The British Library,
inv. Egerton 3127

LEFT
2.36 **Pisanello**
Young falcon, c.1434–45
Pen and ink, brown wash, watercolour and
white heightening over black chalk,
23.7 × 15.1 cm
Paris, Musée du Louvre, inv. 2453

TOP RIGHT
2.37 **Mantuan**
Falcon's hood, c.1450
Tooled leather, with traces of gilding,
7 × 6.5 cm
Mantua, Museo del Palazzo Ducale,
inv. 15885

ABOVE RIGHT
2.38 **Lombard or workshop of Pisanello**
Falcon, c.1434–5
Pen and ink, 21.9 × 17.1 cm
Trustees of the Chatsworth Settlement,
inv. 63 (Birds no. 30)

(fig. 2.36). Pisanello has re-envisaged a common pattern – of the kind that is typified by a drawing of much the same period (fig. 2.38)[108] – by copying its appearance from life. Even the hood that the falcon wears accurately records the appearance of hoods used at the time.[109] It can be compared to a mid-fifteenth-century Gonzaga falcon hood made of stamped leather which was found in the 1950s in the Palazzo Ducale in Mantua (fig. 2.37). Like that in Pisanello's drawing, it is made of three pieces sewn together in the shape of the head: the central part has an opening, like a little window, cut for beak and nostrils. Two types of cap were used: one kind was placed over the eyes of the falcon so that, when released, its sight should be more concentrated on its prey. The lack of 'tuft' and the width of the opening for the beak – enabling the bird to feed itself – shows that this one was not a hunting hood but used instead for training. It has the remains of gilding, and stamped into the leather are two pairs of Gonzaga daisies, on the side-pieces a bird floating on the waves – which, though very schematic, has been identified as a swan – and, more certainly, there once again appears the Lancastrian S. Such markings indicate the prestige attached to the sport.

Once again, there was no shortage of Franco-Burgundian art that celebrated the hunt (see figs. 4.41, 4.44–47). A drawing in Vienna by a member of Pisanello's workshop depicts two seated women with falcons, two quails and a little knight (fig. 2.39). The figures of the women (one, rather gruesomely, feeding a chicken leg to her falcon) depend on something like a coloured pattern drawing in the Louvre which has reasonably been attributed to Michelino da Besozzo. This, in its turn, apparently derives from something like the famous Southern Netherlandish tapestry on deposit in the Louvre of *The Gift of*

2.39 **Workshop of Pisanello**
Women with falcons, an armoured knight,
c.1431–40
Pen and ink on parchment, 18.4 × 25.7 cm
Vienna, Albertina, inv. 16

the Heart.[110] There were also opportunities for more direct north–south transmission. Many of the tapestries owned by the Este (and presumably also by their contemporaries) depicted hunting themes.[111] From their inventory descriptions these sound very like the famous so-called Devonshire hunting tapestries at the Victoria and Albert Museum, woven in Arras in the second quarter of the fifteenth century.[112] The 1457 inventory lists a hanging of a boar hunt with 'several figures of men and women at dogs, and a boar struck by a man in the breast', a piece that can also be traced in the 1436 inventory. It was clearly something like the tapestry woven in about 1450, taking motifs from the Devonshire boar hunt, now in Glasgow (fig. 2.40).[113] Another piece in Ferrara had an image of a falcon bathing in the waters of a fountain;[114] a similar motif can be found in two South Netherlandish tapestries in the Metropolitan Museum, New York.[115]

One particularly important piece was known as '*la chultrina del peraro*' or '*la Zanetta*' – a large hanging (3.35 × 9.71 metres) with, at its centre, a pavilion containing a caged parrot and surmounted by the arms of the marquis, surrounded by figures of huntsmen on horseback and on foot. The northern European tapestry huntsmen have become identifiably Estensi. It is not surprising to find that hunting was a subject employed for secular wall-paintings in Este residences. A now lost set of hunting frescoes, probably to be dated shortly after 1391, in a loggia at Belfiore, itself a hunting lodge, was described a hundred years later: 'One sees represented the illustrious memory of the much loved prince Alberto d'Este, with many gentlemen and ladies on horseback, hunting with leopards and hounds [*veltri*] after hares, bucks, stags and bears, where one sees the fierce kill of the animals hunted and the arrows leaving the Syrian bows drawn by the hands of the ladies with worthy and strong gestures.'[116] Similar, though much less ambitious, frescoes survive at Oreno, a lodge belonging to the Milanese Borromeo family.[117]

Hunting was seen as a noble activity throughout Italy, becoming in the late Middle Ages the privilege of the patrician and signorial classes.[118] Laws were introduced into Verona, for example, on the permissible times of the year and the rights of various classes of person to hunt different kinds of game.[119] The rulers of Milan, Ferrara and Mantua enclosed enormous hunting parks, from which, by the fifteenth century, the common people were firmly excluded.[120] The Visconti had parks at Milan and Cusago,[121] but their most important was at Pavia, a reserve created between the rivers Ticino and Lambro.[122] The Gonzaga park stretched between Marmirolo and their *castello* of Goito; it was divided into three zones: pleasure grounds, a space for small game and domestic animals, and an area for bigger, more valuable game. The boar hunt was a speciality.[123] The Este maintained a system of so-called *delizie* – villas or lodges where hunting and falconry were two of the prime activities.[124] On two of these sites – Visconti Pavia and Gonzaga Marmirolo – could be seen paintings by Pisanello.

Both grounds and animals were carefully preserved. Fines and other, worse, penalties were meted out for trespass and poaching. In 1404, for example, night trespassers in the park at Pavia would be fined 50 florins or have a foot amputated. Fines for poaching there ranged from the completely unaffordable 100 florins for a stag or buck down to two for a quail.[125] The establishment of such reserves stood for more than love of the chase. They also represented the lord's territorial power, and hunting was built into the

OPPOSITE
2.40 **Franco-Burgundian (Tournai or Arras)**
Boar hunt, c.1445
Tapestry, 396 × 361 cm
Glasgow, The Burrell Collection, inv. 46/57

system of fiefs. The obligations of the Este fief-holders at Corbola, for example, included not only the annual presentation of a seven-pound shoulder of pork but also the retention of a shield bearing the Este arms and of a dog and hunting equipment for the service of the marquis and his officials. The nobility's annual renders were more expensive, but followed the same themes, hunting and the tournament: horses, spurs and weapons such as lances or cross-bows.[126] The parks were kept artificially well-stocked and many animals were bred or captured to be used as prey. A prince's pleasure had more or less to be guaranteed, and prized boars and stags were carefully put in their way. At Belfiore most of the agricultural lands attached to the villa were turned over to cultivating food for game. In 1454 hay was delivered 'partly for the use of the stags, bucks, deer and hares of the enclosure in January at the time when there was no grass in the enclosure'. Acorns were brought in from Modena to feed ostriches and boars; wild ducks were kept within nets as prey for falcons.[127] Pisanello would have had ample opportunity to study all these birds and beasts in captivity (fig. 2.41).[128]

Huge sums might be spent on the accoutrements of the hunt. Alfonso of Aragon, for example, owned a large hunting-knife with a handle fashioned from gold and crimson silk.[129] Surviving examples of the type of object bought for the hunting field are rare. Nevertheless a delicate and beautiful set of hunting cutlery – used for eating in the field – made in Italy and owned by emperor Frederick III (figs. 2.42, 2.43), indicates the level of craftsmanship associated with such paraphernalia.[130] But the rulers of the Italian city-states valued the animals used for the hunt as highly any of their other, more durable possessions. A good horse might fetch anything between 500 and 1000 ducats. Horses, dogs and falcons were purchased from all over Europe. In 1426, for example, Filippo Maria Visconti ordered one Carrado del Carretto to bring back from Hungary four

2.41 **Pisanello**
Teal, c.1434–45
Pen and ink, watercolour, brown wash and white heightening over black chalk, 14 × 21.4 cm
Paris, Musée du Louvre, inv. 2461

RIGHT
2.42 **North Italian**
Hunting cutlery of emperor Frederick III,
c.1430–40
Steel, brass, horn and leather, from 18 to 36 cm long
Vienna, Kunsthistorisches Museum, inv. D 261

FAR RIGHT
2.43 (detail of 2.42)

hunting bows and to obtain several good goshawks. In 1429 he sent Damiano Poravesino to the king of Poland to get a good courser (a horse), eight bulldogs, four hounds for the chase and as many falcons as possible (as well as an expert falconer). He also swapped Milanese suits of armour for hawks.[131] Animals for the hunt also made good gifts. Dogs were presented to Alfonso of Aragon from Turkey, Tunis, Brittany, England and Corsica, and he, too, sent one of his senior huntsmen to Burgundy and Brittany to buy horses and falcons.[132] When a falcon went missing, a not infrequent occurrence, their owners made sure it could be identified as their property and could be returned.[133] Filippo Maria Visconti, for example, issued a proclamation in 1425 that the marquis of Monferrato had lost a beautiful peregrine falcon by the name of Cipriano which had his arms ('*insegne*'); the reward for its recovery was a healthy ten ducats.[134] The life of a professional huntsman was prestigious and profitable. The many Visconti falconers received tax exemptions and the 108 huntsmen in the employ of Alfonso of Aragon in 1445 were all freed from municipal taxation and jurisdiction. Alfonso even sent his senior, Spanish huntsmen on diplomatic missions.[135] That their status was high is indicated by the fact that in 1443 Leonello d'Este commissioned a votive portrait from the sculptor Nicolò Baroncelli of a much esteemed falconer.[136]

We have already noted that rulers liked to be guaranteed their sport. On occasions hunting could become still more symbolically ritualised. To celebrate the marriage of Leonello d'Este to Maria of Aragon in 1444, in addition to the Saint George play already mentioned, there was a joust followed by a 'hunt', with animals released into the piazza in the middle of the city of Ferrara.[137] Alfonso of Aragon marked the 1452 visit of emperor Frederick III in similar fashion – he took him hunting on the plain of Palma. As a climax to the hunt a last entertainment was organised in the royal park called the Astroni; animals of all kinds were gathered for a staged hunt. Female spectators on a dais were protected with an awning and surrounded by a palisade. The king's son and heir,

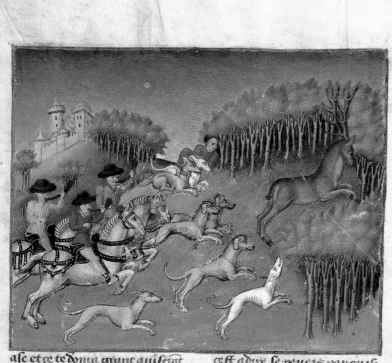

ase et ce te dowa grant auisemt
de toy retraire. Et prens garde
en chacant aquelle main le cerf
que tu chaceras se destournera
en fuyant ou a destre ou a sene
stre car il est de certain que en
faisant ses vises il se destorne
voulentiers a une main z celle
ou il se destorne main tient
tout le iour comunement.
¶ Ces deux choses que ie tay
dites doinent grant auisemt
en chacant ce st de saue les
brisees pendans et dimon
auisement aquelle main ilz
se destournent. Car se les
chiens chacent se contre ongle

cest a dire se reuers par ou ilz
seront alez tu le sauras par les
brisees pendans et si doinent
auisement de retraire ses chies
pour desfaire sa vise. Puis
nous dirons coment sen doit
relaissier au cerf ce que len
chace ¶ Quant len enuoye
ses chiens au relais len y doit
enuoier tel qui ait congnois
sance du roy des sarges chiens
et la cause si est que si loyent
venir aucune partie des chies
chacant combien que tous
ceulx que len auoit laissie
courre ny feussent mez zil
my eust maure de chiens et y

84

Ferrante, the master of the hunt, blew his horn and the 'hunt' began: wild goats were released to be pursued by greyhounds; boar were sent out next, including a particularly vicious one, 'as big as an ox', which was finished off with daggers by Ferrante and Frederick. The huntsmen were then provided with hares, deer, a couple of bears and a porcupine.[138]

Given that hunting was a lordly privilege, one which could, once again, be associated with the great regimes in England, France and Burgundy, it also received courtly and chivalric glosses.[139] Hunting is a central metaphor of Renaissance romance literature.[140] The activity was also viewed practically both as a way in which the leisured classes might virtuously defeat idleness and as a means of honing military skills in times of peace. Although their works do not appear in contemporary inventories, this image of the activity was very likely informed by treatises by French writers on hunting. In his *Livre de Chasse* (Book of Hunting) Gaston III, count of Foix, called Gaston Phébus, claimed that a good huntsman could never be prey to any of the Seven Deadly Sins; by avoiding idleness and pursuing the hard life of hunting diligently he avoided all occasion for sin.[141] Gaston took the theme (and his chapters on dismembering deer and boar) from the earlier *Livre du roy Modus et de la royne Ratio* (Book of King Practice and Queen Theory). Manuscripts of each of these texts were plentifully produced; there are, for example, forty-four, mostly fifteenth-century, surviving manuscripts of Gaston Phébus's *Livre de Chasse*.[142] An unillustrated copy of the *Roy Modus* now in the Biblioteca Estense in Modena is thought to have belonged to Nicolò III.[143] The two texts might bear interchangeable illuminations: miniatures from the canonical version of the *Livre de Chasse*, executed in about 1407, now in the Bibliothèque nationale de France, were copied, for example, in a mid-fifteenth-century manuscript of the *Roy Modus* now in the Pierpont Morgan Library (fig. 2.44). It is clear that such miniatures were also known in Italy. Both Gentile da Fabriano in his *Adoration of the Magi* (see fig. 1.17) and Pisanello in the dragon part of the Sant'Anastasia fresco (see fig. 1.21) derived the motif of a deer with its forelegs raised from patterns established by the *Livre de Chasse*.[144]

In the fourteenth century, the king of Castile, Alfonso XI (ruled 1312–50), echoing the ancient author Xenophon, wrote: 'For a knight should always engage in anything to do with arms or chivalry and, if he cannot do so in war, he should do so in activities which resemble war. And the chase is most similar to war for these reasons: war demands expense met without complaint; one must be well horsed and well armed; one must be vigorous, and do without sleep, suffer lack of good food and drink, rise early, sometimes have a poor bed, undergo heat and cold, and conceal one's fear.'[145] That this thinking was common currency also in the mid fifteenth century is demonstrated by its reiteration in Leon Battista Alberti's dialogue *On the Family*.[146]

Pisanello's works need to be understood against this courtly, chivalric background. The motifs that he studied from life and reproduced in his works were far from arbitrary choices. His imagery reflected his experience of the life of the Italian courts at their most magnificently self-conscious. His extraordinary observational skills were formed to transmit these messages as effectively as possible. The language of chivalry was dominant and Pisanello's style and vocabulary were formed to give it visual expression.

OPPOSITE

2.44 **French**

Henri de Ferrières, *Le Livre du roy Modus et de la royne Ratio* (The Book of King Practice and Queen Theory), folio 12: *Stag hunt*, c.1465

Tempera on parchment, 29.5 × 22.3 cm

New York, The Pierpont Morgan Library, inv. M.820

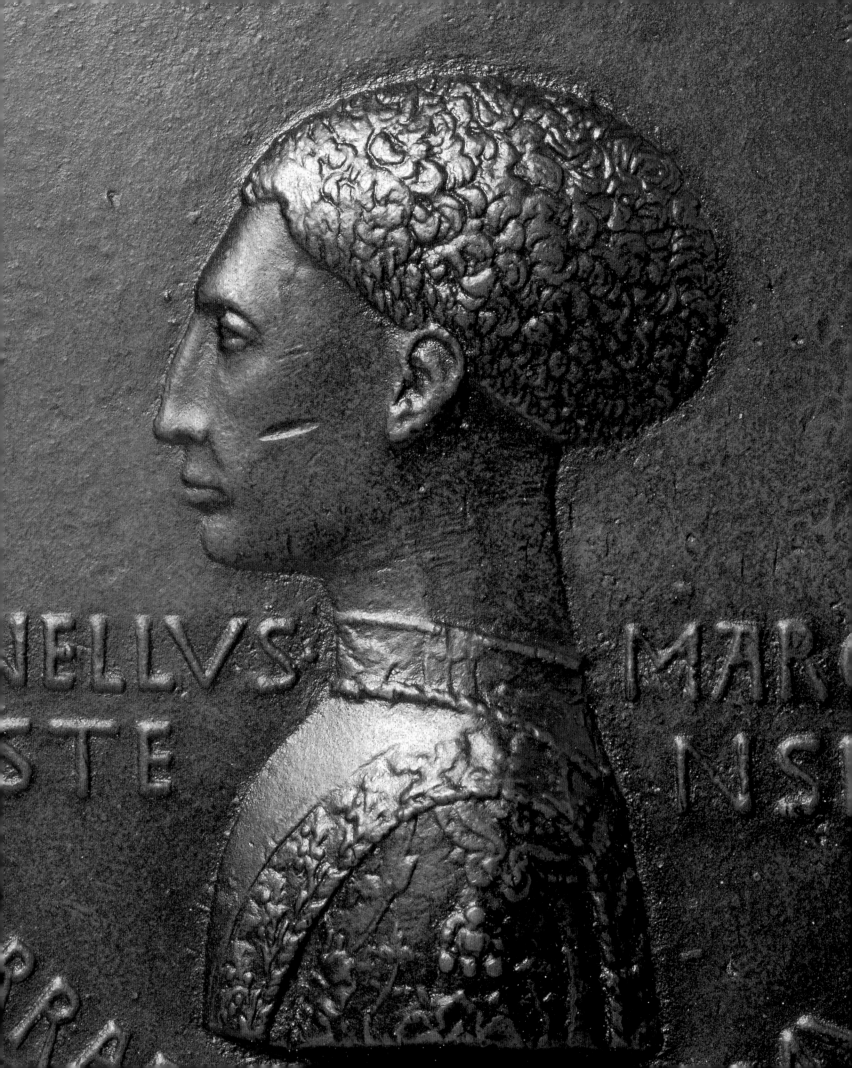

III Classical Learning and Court Art

. . . because you wish to depict my face in a fine work of art, I must be grateful to you in no small measure. If my reputation survives for many years in no other fashion, at least it will live on by the favour of your work

TITO VESPASIANO STROZZI, humanist poet,
poem dedicated to Pisanello, c.1443

If the self-conscious adoption of chivalric values by the dynastic rulers of Italian city-states was a key element in forming the aesthetic to which Pisanello and his patrons subscribed, this was not the only ingredient of courtly thinking which affected attitudes to art production. It was famously during this period – the third, fourth and fifth decades of the fifteenth century – that the study of the ancient Greek and Roman civilisations spread from the universities to the courts to became a formative feature in the behaviour and self-presentation of a new generation. The development of the autonomous portrait, painted and medallic, is a case in point.

LEONELLO D'ESTE AND ALEXANDER THE GREAT

Leonello d'Este was not necessarily particularly handsome.[1] The painted portrait profile executed in about 1447 by Giovanni da Oriolo (fl. 1439–80/8; fig. 3.4)[2] and the bronze medal, which may have been its source, cast before Leonello's succession and signed by 'Nicholaus' (fig. 3.3)[3] both depict their subject as heavy-jawed, with the eye set high above an exceedingly long nose and a protruding, fleshy lower lip and a forehead sloping at a dramatic angle into the stringy mop of hair. Neither of these portraitists enjoyed any reputation during their lifetimes (or subsequently), and one might suppose that their skills were limited to the mere factual recording of appearance. The two images are a far cry from the geometrically balanced, subtly interpreted solution to his features in the painted and medallic portraits by Pisanello. In the painted portrait (fig. 3.2) the artist has lifted and lengthened the brow, shortened the nose (adding a pleasing little dip exactly halfway down its length) so that it now measures the same, and substantially reduced the rounded jaw. His portrait now resembles much less the all too solid images of his predecessor, father Nicolò, and successor, brother Borso.[4]

Four of Pisanello's six medals of Leonello modify his features along much the same lines – for example that cast shortly after Leonello's succession in late December 1441, which proudly insists on his full titles as marquis of Ferrara, Modena and Reggio (fig. 3.5). The forehead and nose are of equal length, and, although the brow once again recedes, the slope is here rendered graceful by reflecting the curve of the inscription border and the medal's edge. The height of the head and neck has been slightly reduced, while the bushy hair extends a little further at the back, so that the vertical and horizontal internal

OPPOSITE
3.1 (detail of 3.5a) **Pisanello**
Portrait medal of Leonello d'Este, obverse

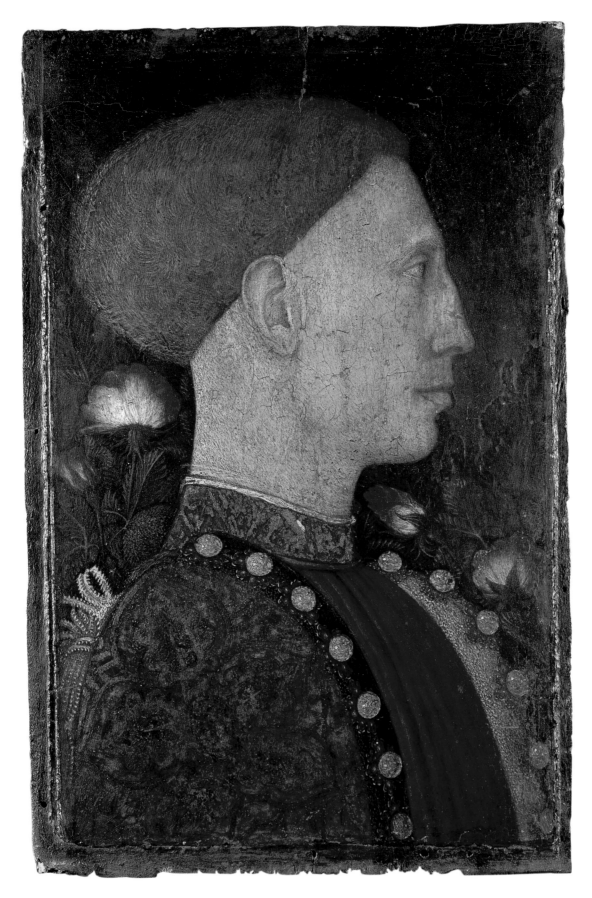

3.2 **Pisanello**
Leonello d'Este, marquis of Ferrara, c.1441
Tempera on panel, 28 × 19 cm
Bergamo, Accademia Carrara di
Belle Arti

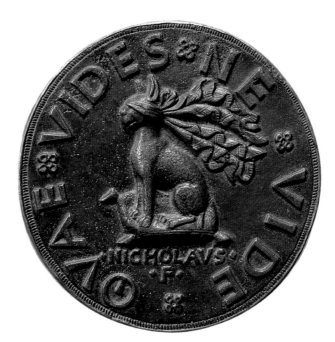

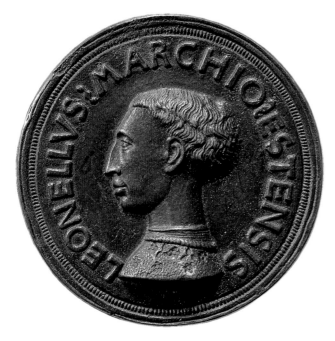

3.3a, b **'Nicholaus'**
Portrait medal of Leonello d'Este, marquis of Ferrara
Cast bronze, diam. 8.3 cm
London, British Museum

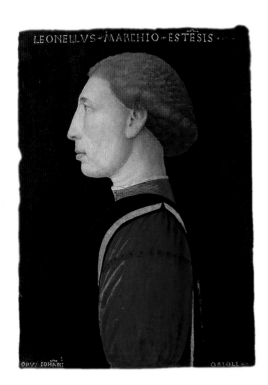

3.4 **Giovanni da Oriolo**
Leonello d'Este, marquis of Ferrara, probably 1447
Egg tempera on wood, 57.6 × 39.5 cm
London, National Gallery, inv. NG770

measurements are in the equilibrium demanded by the perfectly circular ground. The geometrical elegance of this image conveys its own harmonious message.

There are further subtleties to this portrait. The curliness of Leonello's hair has been accentuated in order, it seems, to give it the appearance of a lion's mane,[5] not only to play on his name ('little lion') but also, by the parallel with the king of beasts, to make a physiognomical allusion to his status and style as ruler. Further, his sturdy yet angular features as adjusted by Pisanello bear a suggestive resemblance to a drawing (fig. 3.6)[6] copying a coin of the ancient Macedonian empire-builder Alexander the Great (fig. 3.9). On the front of the coin is a head of Hercules wearing his lionskin. At the Este court it seems to have been considered a portrait of Alexander himself, in which he was establishing a visual and conceptual connection to the legendary hero, from whom he claimed descent. Leonello's 'mane', therefore, makes a further, significant pun with the lionskin.[7] Pisanello presents Leonello as a modern, Herculean, Alexander the Great.

Alexander's portrait strategy was expounded in a range of ancient texts, among them Pliny the Elder's *Natural History*[8] and Valerius Maximus' *Memorable Acts and Sayings of the Ancient Romans*.[9] Alexander, it is said, recognised that only through the particular and extraordinary talents of the painter Apelles and the sculptor Lysippus would he both ensure proper but flattering likenesses and, by association with their skill, augment his own fame; only they therefore were to paint and sculpt his portraits. The version of this story in Plutarch's *Parallel Lives* throws further light on the appropriateness of the connection of Leonello with Alexander, and on its corollary, Pisanello's artistic parity with his celebrated ancient forebears. In Plutarch's words, '. . . Alexander decreed that only Lysippus should make his portrait. For only Lysippus, it seems, brought out his real character in the bronze and gave form to his essential excellence. Others, in their

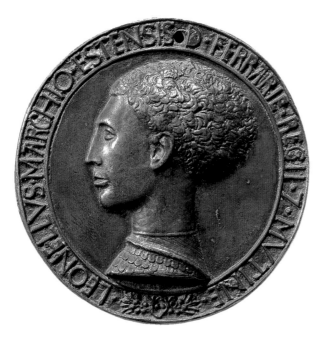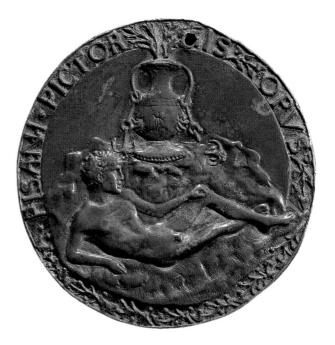

eagerness to imitate the turn of his neck and the expressive, liquid glance of his eyes, failed to preserve his manly and leonine quality.'[10] Thus the depiction of Leonello as lion-like not only makes him even more self-consciously Alexandrine, it also turns his portraitist into a new Lysippus. Since the work is so prominently signed by 'Pisano, the painter', its author can also be viewed as a modern Apelles. And by this re-enactment of Alexander's relationship with his favoured artists, Leonello adds a further ingredient to his *all'antica* self-presentation, that of discriminating patronage.

Below his head on the obverse of the medal is a sprig of juniper. This was a plant special to Leonello. A covered way of juniper bushes was planted for Leonello and his bride at his 1435 wedding to Margherita Gonzaga, his first wife, the oldest daughter of the marquis of Mantua, and it appears with his portrait on other medals.[11] Later in the century, juniper was said to stand for happiness and peace.[12] But Pliny placed it, rather less joyfully, among the trees which never bloom: 'The juniper, also, is destitute of blossom . . . all junipers always present the same sombre appearance. So, too, in life, the fortunes of many men are ever without their time of blossoming.'[13] Thus the image might be taken as a mildly gloomy reference to the fickle ways of Fortune, without necessarily losing its other, more celebratory meaning.[14]

This reading might be important when we attempt to decipher the designedly riddling reverse. A nude youth reclines on rocky ground below one of the many devices or *imprese* used by Leonello: a vase through the sides of which protrude the roots of a plant – difficult to identify – and from the handles of which dangle two anchors; one of their chains is broken. Because its main part was termed the *corpus*, or body, the vase, it has been argued, represents the human body.[15] The two anchors and the plant perhaps develop the themes of body (linked to the earth) and soul (rising to the heavens), of life and death (the broken and intact chains); or, given the apparent message of various of his other devices,[16] the chained anchors express an antithetical image of the voyage of the soul: the disciplined strength of acquired and innate human virtue, set against the unpredictable, potentially disastrous control chance or fortune exercise over men's lives. The nude, expanding the image of the

3.5a, b **Pisanello**
Portrait medal of Leonello d'Este, marquis of Ferrara, *c*.1442
Cast bronze, diam. 6.8 cm
London, The British Museum, inv. GIII, Ferrara M26

'body' of the vase by the display of his body, and stripped of worldly vanities, like the soul at the Last Judgment, may stand for the essential human condition, wise through his worldly poverty. Viewers would, very likely, have also recognised a reinforcing visual reference to contemporary depictions of the creation of Adam.[17]

However, the youth's pose is classical as well as biblical. He lies in much the same position as a sculpted Roman river-god recorded in a drawing by Pisanello (figs. 3.10, 3.11, 3.12). At the time of the drawing and medal this figure was not yet identified as a river-god;[18] he had been mistaken for a Bacchus in the thirteenth century, and was praised as such by the court humanist in Ferrara, Angelo Decembrio.[19] The sculpture was removed, with its companion, from its original position on the Quirinal Hill to the Capitol in 1517. Once it had been recognised as a river god, it was given attributes to identify it as the personification of the River Tiber (it was originally a Tigris). Pisanello's is not a straightforward citation: the figure is fully naked, observed from life, with none of the heroic stoniness of his source, and has no beard. But it might be as well to note that the plant growing in the border below the signature is ivy – a plant sacred to Bacchus.[20] If this is indeed an element within the image's meaning – turning the generalised 'human' into a specific deity – it is worth reminding ourselves of Alexander the Great's identification with Bacchus, fellow conqueror of India.[21] Fortune and the possession of virtue would dictate Leonello's capacity to rival or emulate the ancient ruler.

BELOW LEFT
3.6 **Pisanello**
Studies after three ancient coins and an ancient gem, c.1434–8
Pen and ink and brown wash over black chalk on red prepared paper, 21.7 × 19.3 cm
Paris, Musée du Louvre, inv. 2315 recto

BELOW, FROM LEFT TO RIGHT
3.7 **Roman**
Republican coin of Octavian with posthumous portrait of Julius Caesar, obverse, c.38 BC
Struck bronze, diam. 3.1 cm
London, The British Museum, inv. 1872-7-9-432

3.8 **Roman**
Imperial coin of Tiberius with posthumous portrait of emperor Augustus, obverse, c.14–37 AD
Struck bronze, diam. 2.9 cm
London, The British Museum, inv. BMC Tiberius 155

3.9 **Macedonian**
Tetradrachm of Alexander the Great of Macedonia with image of Hercules, obverse, c.336–323 BC
Struck silver, diam. 2.4 cm
London, The British Museum, inv. 1929-8-11-42

ABOVE
3.12 (detail of 3.5b) **Pisanello**
Portrait medal of Leonello d'Este,
marquis of Ferrara, reverse

LEFT
3.11 **Roman**
River Tiber (formerly *Tigris*),
Marble
Rome, Campidoglio

3.10 **Pisanello**
Study of ancient sculpted *River Tigris*, c.1431–2
Pen and ink and wash over metalpoint on
parchment, 13.7 × 20.5 cm
Berlin, Staatliche Museen zu Berlin,
Kupferstichkabinett, inv. KdZ 1359

All of this may seem over-interpretative or mutually contradictory and – as far as the reverse is concerned – the combination of philosophically and historically based readings may not be right. However, even if the details of this interpretation are mistaken, the approach is legitimate since the object itself clearly invites it – by its deliberately mysterious iconography, its incongruous combination of elements. It is often hoped that a text may one day turn up to crack the codes of this and the few other equally baffling medal reverses by Pisanello. However, a single explanation may never have existed: the meaning of an image might be nuanced, shifting, fugitive, a deliberate challenge to beholders, who would be able to propose differing interpretations according to their particular level of visual and textual knowledge, of the kind that Leonello had at his fingertips.

GUARINO AND VITTORINO: HUMANIST EDUCATIONS

The right of Leonello d'Este to succeed to the marquisate of Ferrara was by no means clear-cut. He was an illegitimate son, the product of one of Nicolò's many promiscuous liaisons, and he had legitimate younger brothers. He had not always been the heir designate; but his older brother, Ugo, had been executed in 1425 for an adulterous affair with the second of Nicolò's three consorts.[22] Although Leonello had been legitimised before the birth of his legitimate half-brother, his succession had to be justified by more than primogeniture. In the will he made on his deathbed, leaving all his territories to Leonello and his heirs, Nicolò justified his decision partly on the grounds of Leonello's personal qualities, calling him 'beloved and the oldest among his lay sons, his universal heir and true, undoubted and only successor as more apt and more suitable, because of his good and holy living, for the conservation and government of his state and dominion and by far more pleasing and desired by all his peoples and subjects. In this very dear son the same testator always placed his whole mind and all his thoughts and many years previously elected and made him the free arranger, governor and director of all his things and of his whole state and dominion, on account of the vigilance of the illustrious Lord Leonello with his mature foresight and his wonderful justice.'[23]

These are terms and concepts which in part derive from the chivalric value system explored in the previous chapter, but the execution of justice or good government, for example, was increasingly understood to depend on the emulation of other precedents – on the imitation of ancient men and women whose actions and sayings were thought to manifest the ideal virtues of a ruler. This was the essence of court humanism, which ran alongside, supplementing and modifying, the established chivalric tradition. Nicolò d'Este arranged the legitimisation of Leonello in 1429. At the same time he contracted his son's prestigious marriage with Margherita Gonzaga, which would take place six years later.[24] It was also in 1429 that he persuaded Guarino da Verona, eminent scholar of the *litterae humaniores* (fig. 3.13), to enter his service as tutor to Leonello.

Although Nicolò had received some sort of humanist education, from Donato degli Albanzani, he was not a humanist himself. A 1436 inventory of his library demonstrates its primarily religious flavour,[25] and the fact that Donato had dedicated to him an Italian translation of Petrarch's Latin *Of Famous Men* when he married for the first time suggests

that he preferred to read in the vernacular.[26] Nevertheless, he was prepared to pay in order to enable his heir to equip himself properly with the virtues that would derive from the study of Greek and Latin history, poetry and philosophy. Guarino had studied at the university of Padua and spent five years (1403–8) in Constantinople mastering Greek. Promoting his own activities, he went so far as to write: 'I hardly believe that someone is a human being if he does not honour letters, does not love them, does not embrace them, does not seize them and completely immerse himself in them',[27] and his view that humans become human – and better – by studying was beginning to be widely accepted. Of course, the education of a prince was not a matter of long hours spent poring over books.[28] He had to be taught to govern, and to fight. But the study of exemplary figures from the past was thought to induce a desire to behave comparably, and the soldier, too, could learn from the actions of his 'ancestors'. Guarino believed, for example, that, when reading the works of Sallust 'we are influenced by his images [*imagines*] and spurred into action'.[29] The prince therefore needed to have knowledge of both arms and letters.[30] Leonello, indeed, had fought under the famed commander Braccio da Montone well before Guarino came into his life.

Nicolò d'Este was not the first ruler to propose a humanist education for his children, and perhaps could count himself lucky to have secured Guarino's services. Guarino, then comfortably settled in Verona, had earlier turned down an invitation from Gianfrancesco Gonzaga, who in 1423 had turned instead to Vittorino da Feltre, to whom Guarino had taught Greek, and who had taught beside Guarino in Venice.[31] He, too, is

3.13a, b **Matteo de' Pasti**
Portrait medal of Guarino da Verona, c.1450
Cast bronze, diam. 9.5 cm
London, The British Museum, inv. GIII, Ill. P., 419

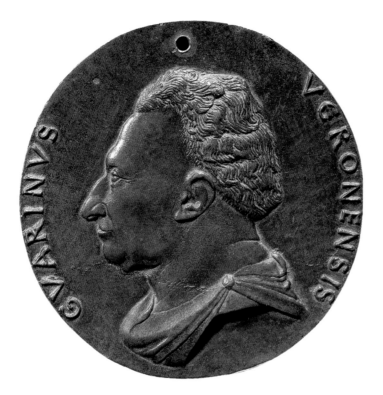

said initially to have declined, wishing to avoid the lasciviousness and ambition of splendid court life.[32] After some arm-twisting he changed his mind, and his school was to become perhaps the most famous in Italy: his several biographers (many of them his former pupils) ensured that he was revered throughout the century as a model dedicated teacher.[33] When Vittorino had studied at the university of Padua his subjects had been grammar, literature, rhetoric and composition, but more unusually he had also taken up mathematics, under the tutelage of Biagio Pellicano.

In Mantua Vittorino performed a manifold rôle. In the first place he taught, having the children of Gianfrancesco Gonzaga – Ludovico (the heir), Carlo, Gianlucido and their sisters Margherita and Cecilia – as his charges. He had justified his court employment, according to one biography, on the grounds that 'by forming an excellent prince, ornamented by a splendid culture and by splendid customs, he would have splendidly educated also the entire city and the state over which he ruled'. The Gonzaga siblings were not, however, his only pupils in the villa he had been given for his school by the Gonzaga – interchangeably named *La Gioiosa* (Joyful) or *La Giocosa* (Merry). Many of Vittorino's fellow humanists, including Guarino, sent their sons to him. Other, Mantuan children, of humbler origin, were exempted tuition fees.

Secondly, however, Vittorino's studious presence was perceived as adding to the *fama* (reputation) of the court, and as a demonstration of Gianfrancesco's own wisdom.[34] Moreover, according to one of his former pupils, Francesco Prendilacqua, Vittorino became the conscience incarnate of Gianfrancesco and his regime. He is said to have stated at the outset: 'I accept the post only on the understanding that you require from me nothing that should be in any way unworthy of either of us; and I will continue to serve you so long as your own life shall command respect.'[35] This indeed was a rôle that the Gonzaga themselves were keen to promote for him.

The humanist syllabus included devotional, especially Patristic texts (writings of the Fathers of the Church); Vittorino was celebrated for his Christian piety, especially in the teaching of his pupils.[36] Such Christian texts were supplemented, however, by the detailed study and imitation of pagan ones. Latin history was central: useful *exempla*, or praise-worthy actions, were described in the works of Sallust, Quintus Curtius, Suetonius and Valerius Maximus. The Latin learned was classical Latin. The recitation by the young Carlo Gonzaga of hexameters he had composed in the style of Virgil (Mantua's most famous citizen) during the pageants accompanying emperor Sigismund's visit to the city in 1433 was deemed astonishing. Pupils had drummed into them the marks of sound rhetorical composition: *compositio, elegantia, dignitas*. They also learnt philological concern for the accuracy of their language; Guarino was the author of a much used grammar.[37] Vittorino advised Gianfrancesco on the expansion of the Gonzaga library, in which, Gianfrancesco wrote, 'we do not care whether books are lavish, or of refined script, so long as they are good and [textually] correct'.[38] Some pupils were also instructed in ancient Greek; in this Vittorino was assisted by the Byzantine George of Trebizond. Cecilia Gonzaga was learning Greek grammar by the age of seven.[39] Among the Greek texts studied, Plutarch's biographies had a prominent place. His *Parallel Lives* was one of the first books acquired in 1425 by Vittorino from Giovanni Aurispa, book-dealer and

petulant tutor to Leonello's brother Meliaduse, and it was copied for him again in 1429.[40] Nevertheless most humanist-trained adults must have read Plutarch and other Greek authors in Latin translation.

Translations into both Latin and Italian, philologically accurate reconstructions of ancient texts, commentaries upon them and the dedications they bear give a sense of what Leonello and the young Gonzaga, as well as other humanistically educated rulers of Italy, may have been reading or, at the very least, what their teachers knew. A project, led by Guarino, to restore the text of Pliny was actively encouraged by Leonello.[41] The commentary on the text includes references to chivalric romances – to the story, for example, of Guinevere.[42] Guarino also worked on the text of Julius Caesar's *Commentaries on the Gallic War*, said to have been Leonello's favourite book,[43] and he dedicated to Leonello in 1435, on the eve of his marriage to Margherita, a treatise arguing the supremacy of Caesar among ancient warriors.[44] Indeed, the only surviving manuscript identifiable in the inventories of the Este library of this period is an illuminated Caesar.[45] Latin histories were still easier to read if they had been translated into Italian. *The Lives of the Caesars* by Suetonius and Caesar's *Commentaries* were translated into the vernacular by the Milanese humanists Antonio dal Rho and Pier Candido Decembrio respectively.[46] Decembrio also made the biography of Alexander the Great more widely available by his 1438 Italian translation of the life written in Latin by Quintus Curtius.[47]

Decembrio also translated Greek into Latin. He dedicated his version of Plato's *Republic* jointly to Leonello d'Este in 1440, commending him in a letter to his brother Angelo as 'a very keen student of letters'.[48] Giovanni Aurispa dedicated his translation into Latin of works by Lucian, including the famous account of Apelles' lost painting of *Calumny*, jointly to Leonello and Ludovico Gonzaga.[49] Guarino's series of translations began before 1408 with, tellingly, Plutarch's biography of Alexander.[50] It is not surprising that he followed it up with the life Plutarch paralleled to Alexander's, Julius Caesar's. Settled in Ferrara, Guarino continued with Plutarch, presenting Leonello with his translations of Plutarch's parallel *Lives* of Lysander and Sulla, also on the occasion of his marriage to Margherita Gonzaga,[51] and with another pair two years later. Leonello probably also knew Arrian's biography of Alexander, which was certainly in Vittorino's library by 1432;[52] this, too, contains instructive references to Alexander's relationship with artists. It had been translated, or rather rewritten in a simplified Latin that would be comprehensible to the emperor Sigismund, who had commissioned the work, by Pier Paolo Vergerio, another educationalist. A revision of Vergerio's text (and amplification using Plutarch) was the last project of Bartolomeo Facio, a former pupil of Guarino, now best known for his survey of contemporary art.[53]

A VISUAL CULTURE OF HUMANISM?

Our reading of Pisanello's medallic portrait of Leonello is not, therefore, far-fetched. Leonello was evidently well versed in precisely those sources which would legitimate and explain such a visual emulation, and Guarino seems to have been on intimate terms

with Pisanello: in a poem the court humanist claimed to own a painting of Saint Jerome which Pisanello had given him.[54] He would also have known the passages in Suetonius which reveal the inspirational part played by the image of Alexander in the actions of Julius Caesar and of the emperor Augustus.[55] He may also have read in Diodorus' *Histories* (a work that appears on a list of books offered for sale by Aurispa in 1424)[56] of the triumph held by Pompey after his subjugation of the kingdom of Pontus, in which he displayed a representation of the inhabited world, and, significantly, wore a cloak claimed to have been Alexander's.[57] Moreover, Pisanello's visual presentation of Leonello as Alexander had a precedent in a literary analogy of the 1430s. Piero Andrea de' Bassi, not a particularly erudite member of Nicolò d'Este's court, compared his patron to Philip of Macedon, Leonello to Alexander and, tellingly, Guarino to Aristotle. He wrote: 'And since the aforesaid Guarino forms his [Leonello's] powerful nature, I will see him obtain the primacy among the other princes. Of this Guarino you could say what great Philip, king of Macedonia, wrote to Aristotle at the birth of Alexander, in these words, "I am delighted that I have a son, [and] it gives me more happiness that he has been born in your time".'[58]

It remains to ask to what extent court painters and sculptors – Pisanello above all – were expected to emulate the artists employed by their patrons' ancient rôle-models. Was Pisanello meant to *behave* like a Lysippus and Apelles rolled into one, by establishing a succession of 'exclusive' relationships with his patrons? Was he, in addition, supposed to adopt their ancient vocabulary (to the extent that it could be re-envisaged)? How well informed were his patrons about the visual and material cultures of Greece and Rome, and, in any case, was the quotation of ancient sources the only criterion for looking 'antique'? Might not another criterion be the ability to copy nature with the same skill as the greatest ancients?

Some interest in the visual arts is indicated by the fact that drawing was taught at Vittorino's school in Mantua, primarily as part of the study of geometry.[59] 'Painters', perhaps manuscript illuminators, are listed by Francesco Prendilacqua among the visiting specialist teachers and La Giocosa was decorated with invigorating wall-paintings of boys at play, displacing the traditionally lavish silver and tapestries Vittorino had found there. This was not only a rejection of an earlier brand of courtly culture but indicates a belief that imagery could be inspirational.[60] Aristotle's opinion that drawing from nature could turn pupils into arbiters of human beauty was known: we find it somewhat garbled by Vergerio, pointing out that knowledge of drawing 'contributed much to comprehending the beauty and grace of objects, both natural and artificial. These are things it is proper for men of distinction to be able to discuss with each other and appreciate.'[61] Here is a consideration to be kept in mind when looking at the fluent depictions of the male and female nude – an 'antique' form – in Pisanello's works.

Neither Vittorino nor Guarino evinced any particular interest, however, in the material remains of the ancient world. Guarino and his pupils may have praised Pisanello as having surpassed Apelles, Praxiteles, Zeuxis, Phidias and other famous Greek artists, but neither teacher left any evidence to show that their philological reconstructions of Latin language and grammar were parallelled in the sphere of art.

Pisanello's own works themselves and other works of art purchased or commissioned by his patrons suggest that an interest, initially rather limited, in re-creating the ancient style on the basis of observation of antiquities ran in happy conjunction with the prevalent and powerful chivalric visual tradition. Ancient writings had long fed into romance literature, and it seems evident that particularly popular narratives determined, to some extent, the level of scholarly attention paid to specific figures from the past: humanism was thus to some extent grafted on to a dominant culture. These two parallel systems of thought informed one another, and, by a blending of the chivalric and antique in the 1430s and 1440s, Pisanello's patrons created a literary and visual culture in which Arthurs and Alexanders could be considered as approximate equivalents. Indeed the Nine Worthies – the *Neuf Preux* – of romance tradition consisted of three groups of canonical heroes: three Christians – king Arthur, Charlemagne and the crusader Godfrey of Bouillon; three Jews – David, Joshua and Judas Maccabaeus; and three pagans – Hector, Alexander and Julius Caesar. Their representation in fourteenth-century tapestries was common and, at the beginning of the fifteenth century, a particularly splendid example of such a series was painted at Manta in the Piedmont, in the castle belonging to the father of Ricciarda da Saluzzo, third wife of Nicolò d'Este (fig. 3.14).[62] Neither Hector, who is shown with the motto *LEIT*, belonging to Valerano da Saluzzo, and possibly his

3.14 **Piedmontese**
The Nine Worthies: Hector and Alexander the Great, c.1420–40
Fresco
Manta, Castello

3.15 **Franco-Burgundian**
Hercules on Mount Olympus, c.1425–50
Tapestry, 398 × 462 cm
Glasgow, Burrell Collection, inv. 48.60

features as well, nor Alexander, with his short brown beard, have anything to do either with the study of ancient art or with Aristotelian drawing from life. However, their presence shows that the later and contemporary humanist examination of such figures represents a continuum rather than a break with the past.

In 1431 Ricciarda gave birth to a son. He was christened Ercole, an indication of the growing importance of classical history and mythology at the Ferrarese court. Hercules had been commonly represented in Este territories from the end of the fourteenth century,[63] but became essential to Este image-making at about the time of Ercole's birth. And Hercules could be both chivalric and ancient. In the 1430s Piero Andrea de' Bassi composed a long, typical romance narrative describing the Labours of Hercules.[64] Hercules becomes a Christian knight and he is dressed like one, his lionskin worn as an 'honorevole zornea [giornea]', a mantle of honour, over his armour. The Hydra has lost six of its seven heads, and is equivalent to Saint George's dragon. Hercules is here envisaged in much the same way as he appears in a tapestry (fig. 3.15) woven in Arras or Tournai in the second quarter of the fifteenth century from the same cartoon as one of a set of hangings described in a 1457 inventory of the Este tapestry holdings.[65] Hercules, labelled, is depicted in armour on horseback in 'a tournament of men on horseback with batons in hand' among which are two queens, between whom is Hercules, looking no more all'antica than the Manta Hector and Alexander. The queens, Amazons in courtly dress, are labelled 'orchias' and 'menalipe'. Other figures are named as Theseus and Hyppolita. The event is the foundation by Hercules of the Olympic Games. This hanging was a purchase made by Leonello, perhaps for the celebrations of his second marriage in 1444, when a small fortune was spent on tapestries, and seems to be the first Este acquisition of a mythological tapestry.

Hercules could even be seen, on one occasion, parading through the streets – in a masquerade, a parade of gods led by Apollo with Hercules bringing up the rear, staged in Ferrara in 1433.[66] In this instance Hercules was 'wearing the skin of a lion and holding a club in his hand'. By the 1440s he may well been painted classically nude. Leonello, like Alexander, held Hercules in special reverence. In 1447 Angelo Decembrio wrote that in Leonello's rooms could be seen 'the painted image of the same Hercules, distinguished by a lionskin, killing the Hydra'.[67] Since he compared the image to an antique sculpted Bacchus, there is no doubt armoured and lion-skinned Herculeses could co-exist.

This, then, was the world in which Pisanello was to perform as an artist – a culture in which he continued to pay obeisance to the values, moral and visual, of the courtly tradition of chivalry while presenting himself in such a way that he could receive humanist approbation. Some of this was a matter of applying humanist glosses to an existing style derived from his Veneto-Lombard training and the account he had taken of painting and tapestry styles imported from the North. But at the same time Pisanello sometimes took a more deliberately all'antica approach, superimposing visual elements derived from his examination of Greek and Roman art and artefacts. We will also see that he modified these motifs by drawing from nature, an activity endorsed by the ancients. His approach is beautifully demonstrated by his portraits, both painted and medallic.

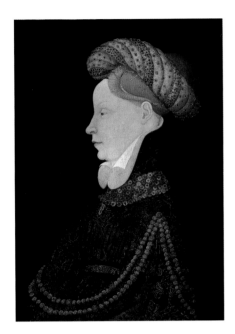

3.16 **Attributed to the circle of the Limbourg brothers**
Profile portrait of a lady, c.1410–25
Oil or tempera on paper or parchment on panel,
53 × 37.6 cm
Washington, D.C., National Gallery of Art,
inv. 1937.1.23: Andrew W. Mellon Collection

The genesis of the autonomous painted portrait has been much discussed. The form is commonly assumed to have originated in Italy. The earliest of these independent portraits are in profile, apparently reflecting the visual tradition of full-length, small-scale figures of donors shown beside saints in altarpieces of the previous century and a growing scholarly appreciation of ancient Roman coins. Such portraits have sometimes been regarded as a Florentine invention of the 1430s.[68] In fact neither the Italian inception nor the relative priority of Florentine and non-Tuscan profile portraits is at all proven; most, if not all, of the Florentine examples date almost certainly to the 1440s at the earliest, whereas they were painted in the Italian courts at least a decade earlier. Another factor is usually overlooked – the existence of earlier ruler portraits from France and Burgundy, which were also in profile. These were made in a variety of media and contexts, and a few examples must suffice, not least because their survival rate is pitiful.[69] Not itself an autonomous portrait, but suggesting that it was taken from such a prototype, is the emphatic profile of the duke of Berry feasting in the January scene of the Limbourg brothers' *Très Riches Heures* of 1413–16 (see fig. 2.15). John the Fearless of Burgundy is shown in profile on an enamelled ring of much the same date in the Louvre.[70] One conspicuous example is the much repainted portrait of a lady in Washington (fig. 3.16), painted on parchment or paper on panel, once given to Pisanello himself, though certainly Franco-Burgundian, and now attributed to the circle of the Limbourgs and dated to the 1420s.[71] Independent profile portraits seem almost certainly to have been produced first in northern Europe, and the concept then exported to Italy.

In fact one of the first securely dateable, large-scale Italian profile portraits is a drawing by Pisanello, and it is surely significant that his sitter was from the north. In September 1433, the Holy Roman Emperor Sigismund visited both Ferrara and Mantua on his return from the ritual of coronation by the pope in Rome. It is not known in which city he sat for Pisanello, whose work, as we have seen (see pp. 18–19), he already knew. Pisanello essayed a rapid sketch of the aged emperor wearing a characteristic fur hat (fig. 3.17) and followed it up with a considerably more elaborated study containing colour notes, in which his sitter is bare-headed (fig. 3.18).[72] It is likely that he converted the latter into a panel portrait. One cannot, of course, be sure who chose the profile format, but it is probable that Pisanello was asked to conform to an established convention as understood by Sigismund. It was a formula that could readily be applied to his Italian courtly sitters, since, as in so many other instances, he and his patrons looked to France and Burgundy for models. From the courts of northern Italy the fashion spread to Florence, just as the medal was to do later in the century. Thus, at the start, the thinking behind Pisanello's painted portraits of Italians was not, in all likelihood, either humanist or antiquarian.

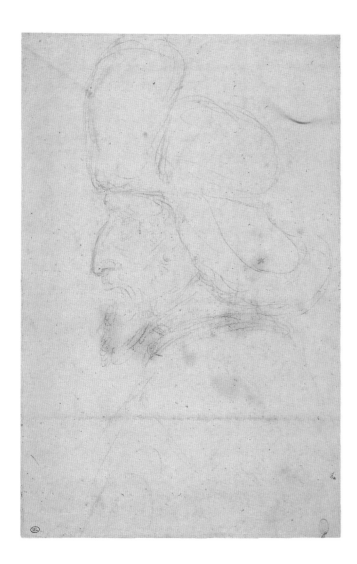

TWO ESTE PORTRAITS

Pisanello painted a whole series of portraits, depicting many of the leading figures, rulers, warriors and intellectuals in Italy. A lost portrait of Francesco Sforza is mentioned in his correspondence; the existence of others can be inferred from various pieces of humanist praise directed at them.[73] Sadly, only two survive: the Leonello in Bergamo with which this chapter opened (see fig. 3.2), and a probably very slightly earlier, much better preserved portrait of a young woman in the Louvre (fig. 3.19).

The subject of the Louvre picture remains controversial.[74] She is depicted in profile against a background of butterflies, pinks and columbines, and has been identified – among others less credible – as one of Leonello's sisters, Ginevra or Lucia d'Este (who were twins), and as his bride, Margherita Gonzaga. The dating of the work does not help, since it is hard to pin down precisely. However, in his medals Pisanello seems increasingly to combine and control his intense naturalistic observation with a geometrical abstraction, and to that extent the portrait appears to be later than the head (fictional, though based on life studies) of the Princess of Silena in the Sant'Anastasia fresco.

ABOVE LEFT
3.17 **Pisanello**
Study for a portrait of emperor Sigismund IV, 1433
Black chalk, 31.4 × 20.7 cm
Paris, Musée du Louvre, inv. 2479 recto

ABOVE RIGHT
3.18 **Pisanello**
Study for a portrait of emperor Sigismund IV, 1433
Black chalk with some pen and ink, 33.3 × 21.1 cm
Paris, Musée du Louvre, inv. 2339

OPPOSITE
3.19 **Pisanello**
Margherita Gonzaga, c.1438–40
Egg tempera on panel, 42 × 29. 6 cm
Paris, Musée du Louvre

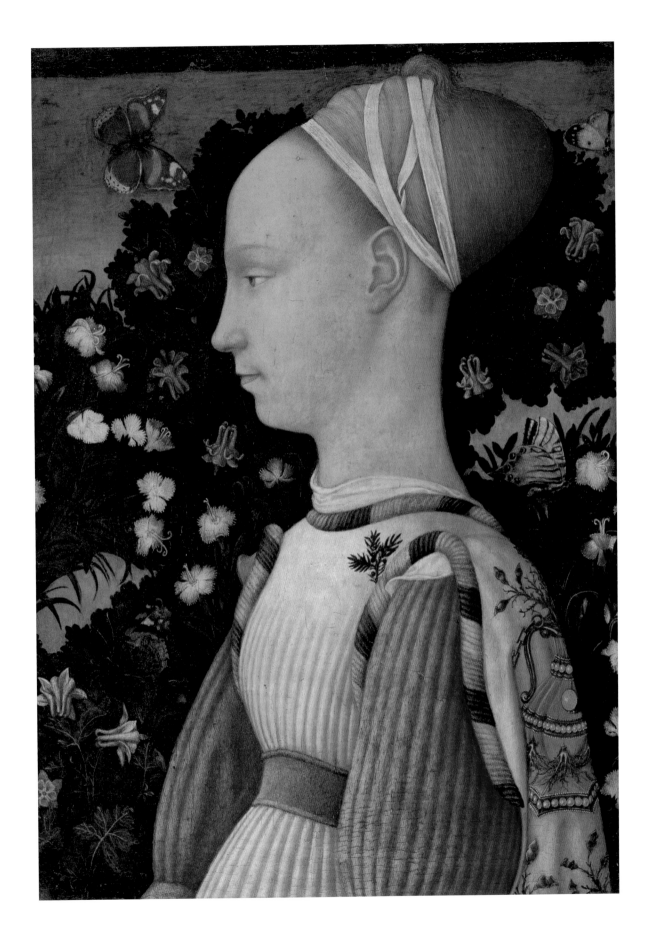

It is compatible in terms of technique and approach with the Bergamo portrait of Leonello, which can be dated in or a little before 1441. A date in the late 1430s or perhaps very early 1440s therefore seems likely.

This, however, does not rule out any of the possible candidates, and the meanings of the individual elements in the work are therefore crucial – the flowers and the butterflies, the *impresa* of the vase (and additions to it), the colours of her dress, the sprig of juniper tucked into her sleeve (fig. 3.23). This last ingredient, read as a pun on her name, has proved persuasive: juniper, *ginepro* in Italian, converts to Ginevra.[75] The play on words was a tactic used by Pisanello elsewhere. However, since, as we have seen, juniper was also especially associated with Leonello, its presence cannot be regarded as unequivocal proof that the subject is Ginevra d'Este. The colours – white, green and red – were certainly adopted by the Gonzaga family: we have encountered them on the *cimiero* worn by a page or dwarf in the Mantua chivalric fresco. They stand for the virtues of Faith, Hope and Charity, and it is not very surprising that they were employed by other families – including, as the Ashmolean workshop drawing (see fig. 2.32) has demonstrated, the Este. Perhaps it would be best to look for a figure who connects the two families. This might rule out Leonello's sister Ginevra, who married Sigismondo Pandolfo Malatesta in 1433–4. Both Lucia, who married Carlo Gonzaga in 1437,[76] and Margherita, Leonello's bride, are more plausible candidates. It has been argued that an image of Lucia in an illuminated genealogy produced in the mid 1470s looks not unlike the Louvre portrait, but, while there is no doubt that this is so – and conversely that the 'Margherita' in the same book looks nothing like her – it cannot be said that the Este Genealogy is a very reliable source.[77] There are many women in the first generations of the family, of whom there can have been no authentic images, who also bear a generic likeness to the Paris picture. And if, as now, Pisanello's picture was unlabelled, it might well have been used as a source for the illuminator as an image of a woman with evident Este associations, but whose identity had already been forgotten.

RIGHT
3.22 (detail of 3.19) **Pisanello**
Margherita Gonzaga: sleeve with vase *impresa*

BELOW
3.23 (detail of 3.19) **Pisanello**
Margherita Gonzaga: juniper

Leonello's vase *impresa* is of more assistance (fig. 3.22). A device was not the same as a familial coat of arms. It belonged to an individual and so, while he might want it worn by his supporters, and though it might be inherited, it cannot be taken as a straightforward indication of clan membership.[78] It is very unlikely that it would have been worn by either of his sisters. His wife, on the other hand, might well display it on her costume – a signal of his 'ownership'. And the fact that pearls, uniquely, have replaced the metal beading on the vase, while another hangs prominently against its '*corpus*', may clinch the matter, for the word 'pearl' translates into Latin and Greek as *margarita*.[79] Here then is the allusion to her name: Margherita rather than Ginevra. Margherita died in July 1439. It has been proposed that the image is posthumous,[80] the butterflies relating to Petrarch's image of the soul of his dead Laura.[81] The pinks and columbines, like them, are symbols of the Passion of Christ. Is this then the equivalent of Guarino's funeral oration for Margherita?[82] We cannot know. Plant and animal symbolism was not very consistent, and the pink was also a well-known emblem of betrothal and marriage.

Even if the portrait was painted before Margherita's death, its capacity to preserve her appearance and her fame would certainly have been noted as a function appropriate for a classically inspired portrait. The literary history of Pisanello's second surviving panel – the Bergamo profile of Leonello against a background of roses (see fig. 3.2) – shows that in the minds of contemporary commentators this was an equivalent to the lost portraits of Alexander by Apelles.[83] In 1442 Ulisse degli Aleotti, a Venetian jurist employed as an Este administrator, penned a sonnet ('On a Famous Contest', *Pro insigni*

certamine) describing a competition between the celebrated painter Jacopo Bellini, a fellow Venetian, and Pisanello to paint the portrait of Leonello. He wrote:

> When the Pisan, among his famous enterprises,
> took it upon himself to contend with nature
> and convert the image into painting
> of the new marquis, the illustrious Leonello,
> he had already taken six months
> to give proper form to the figure
> when spiteful Fortune, who steals
> human glories with diverse attacks,
> so wrought it that from the worthy and salty bank [of Venice]
> there came the great painter Bellini,
> a new Phidias for our blind world:
> he made his true image come alive
> in the judgement of paternal love:
> so he was first, and then the Pisan, second.[84]

It has been suggested that this sonnet presents a literary fiction rather than a competition that actually occurred.[85] It is no coincidence that such events were described by Pliny.[86] But the fact that Bellini was in the right place at the right time (though his picture is lost)[87] and, of course, the existence of the Pisanello portrait suggest that the artists were indeed placed in some sort of competition. Such public rivalries were a feature of the lives of (often quarrelsome) humanists. In 1437 Leonello was requested by George of Trebizond to sponsor a public debate between himself and Guarino to determine which of them was the more learned.[88] Painters may well have been keen to enter similar lists. The competitive comparison was certainly made, reflected in a well-known passage in Angelo Decembrio's dialogue *On Literary Elegance*, written some fifteen to twenty years after the pictures were painted. Angelo put these words in Leonello's mouth: 'You recall that the Pisan and the Venetian, the greatest painters of our age, were recently at variance in their depiction of my features; for the one added too much thinness to my pallor, while the other made my face look pale rather than thin, which scarcely met with my wishes.'[89]

It is, of course, possible that the two portraits were contrasted only after they had both been executed, that the poem is a literary gloss on less planned events. Bellini probably painted his picture of Leonello in 1441; Pisanello's may be a little earlier. He had been in contact with Leonello since the early 1430s, and it may be noted that much the same roses as those in his portrait appear in the Brenzoni monument frescoes (figs. 3.24, 3.25). But, if it was painted earlier than 1441, it was not by much. Though gravely damaged, it shows the remains of the same meticulous technique, the same abstracting tendencies as the *Margherita*. As for the roses (perhaps symbolising his sitter's self-proclaimed devotion to Venus or to the Virgin Mary), Pisanello seems to have re-studied these especially in preparation for the portrait: there survive two metalpoint sketches which in style and technique are very close to portrait drawings of Borso d'Este and Tommaso Parentucelli, bishop of Bologna, sheets which belong to the early 1440s.[90]

FAR LEFT
3.24 (detail of 1.4) **Pisanello**
The Brenzoni monument, San Fermo: roses on trellis

LEFT
3.25 (detail of 3.2) **Pisanello**
Leonello d'Este: rose in the background

Thus Pisanello's two surviving painted portraits, although different in size (and so not a pair), are likely to have been executed more or less simultaneously. Patriotism may have inspired Ulisse degli Aleotti to give the prize to his fellow Venetian, but there is no doubt that for Ulisse, both Nicolò, the putative judge, and Leonello, the sitter, were behaving as Alexander, and Bellini and Pisanello as his artists.

Therefore, even if the antique was not their direct inspiration, Pisanello's portraits could be read according to humanist criteria. The use of the profile was sanctioned by Pliny's account of the invention of the portrait – the moment when the potter Butades modelled a portrait in clay of his daughter's lover from the outline she had drawn using his shadow.[91] Thus some of the 'ancient' functions of the portrait distinguished by the humanist Leon Battista Alberti are likely to have been recognised by the rulers of Mantua, Ferrara and Rimini, whose patronage he carefully cultivated. In 1435 Alberti dedicated the Latin text of his treatise *On Painting* to Gianfrancesco Gonzaga, in which the following concepts appear: 'Painting possesses a truly divine power in that not only does it make the absent present (as they say of friendship), but it also represents the dead to the living many centuries later, so that they are recognised with pleasure and deep admiration for the artist.'[92] An artist of Pisanello's stature could, in other words, confer immortality on his subject. The Ferrarese humanist poet Tito Vespasiano Strozzi, another pupil of Guarino, certainly saw Pisanello's portraits in that light. In a particularly evocative poem dedicated before September 1443 'to the outstanding painter of Pisa' he wrote: 'But because you wish to depict my face in a fine work of art, I must be grateful to you in no small measure. If my reputation survives for many years in no other fashion, at least it will live on by your favour in your work.'[93] Ironically there is now no trace of Pisanello's portrait of Strozzi, and a portrait of the Neapolitan poet Giovannantonio de' Pandoni, called Porcellio, if it ever existed, has also been lost. In another poem, however, Porcellio enthused: 'See how handsomely he has portrayed the face of Prince Leonello and that of the snake-bearing duke [Filippo Maria Visconti] . . . and has fashioned a thousand other effigies with amazing novelty. The image of Porcellio will live among these.'[94]

All of these functions could perfectly well be applied to portraits which made no explicit visual reference to antique precedent. It is worth asking, however, to what extent Pisanello added elements which conformed self-consciously to contemporary notions of the ancient portrait. What specifically 'ancient' qualities were such immortalising

images supposed to have? It is evident, for a start, that the physical and emotional or spiritual 'presence' of the sitter was crucial. He or she had to be recognisable and the preservation of likeness was essential. Alberti cited a portrait of Alexander the Great so powerful that beholders 'trembled all over at the sight' of it as an instance of the potential power of ruler portraiture.[95] This commonplace was repeated a decade or so after the death of Leonello d'Este when the Ferrarese poet Lodovico Carbone contended that he could not gaze upon the portrait of Leonello by Pisanello without tears coming to his eyes, so great was its resemblance to the dead marquis.[96] But, once again, these may be *post facto* literary glosses. It is in the area of idealisation that Pisanello seems to come closest to humanist precepts. While artists were expected to adhere to a likeness, at the same time they were to clean up blemishes: according to Alberti, 'Apelles painted the portrait of Antigonus only from the side of his face away from his bad eye. They say that Pericles had a rather long, misshapen head, and so he used to have his portrait done by painters and sculptors, not like other people with head bare, but wearing his helmet.' Alberti went on to report Plutarch (yet again) as saying that 'the ancient painters, when painting kings who had some physical defect, did not wish this to appear to have been overlooked, but they corrected it as far as possible while still maintaining the likeness'.[97] As we have seen, this seems to have been exactly Pisanello's policy with regard to Leonello.

There survive more clues to the correcting – or idealising – a portrait may have received, and the aims and meaning of such alterations. The Latin word *vultus* (face) was interpreted by some humanists as referring to the soul and the will of man, suggested by its root, the Latin verb *volo*, 'I want'.[98] Thus it might be proposed that the soul should show itself in a person's features. The *impresa* and other symbols, such as the flowers in both Pisanello's portraits, could be used as a shorthand for the soul. Bartolomeo Facio explored another option in his *Of Famous Men*. His terms are self-consciously derived from the preface to the Greek writer Philostratus's *Images*. He wrote: '. . . to master the art [of painting] properly one must understand human nature well, and be able to distinguish, even when they are silent, the signs of men's character, what is revealed in the state of their cheeks, in the expression of their eyes, in the character of their eyebrows and, in short, whatever has to do with the mind It is as much the painter's task as the poet's to represent these properties of their subjects, and it is in that very thing that the talent and capability of each is most recognised. For if he who wishes to portray a mean man has likened him to a lion or eagle, or a generous man to a wolf or kite, he would certainly, whether poet or painter, seem to be proceeding foolishly.'[99] These sentiments not only justify a physiognomical reading of Leonello's mane of hair as deliberately kingly, but suggest that Pisanello fashioned his portraits with the principles of physiognomy in mind.

The critical terminology for the humanist reception of Pisanello's portraits was mined from ancient texts. Many of these 'antique' aspects, and especially the desired eternity of the images, would be more evident if they were cast in metal, in a form that could be linked to the category of portrait which had endured in largest numbers from antiquity – the gold, silver and bronze coins of the Greeks and Romans. Given such a precedent, the invention of the portrait medal was almost inevitable – and thanks to the skills of Pisanello its popularity spread rapidly through the courts of Italy. Pisanello's medals came to be paradigmatic: on the obverse a more or less idealised portrait in profile labelled in Latin (or occasionally Greek), the reverse, signed, bearing an image, sometimes with an accompanying explanatory text, which would assist the reading of the subject's features – an allegory or device proclaiming his liberality, sagacity, courage or fortitude or her modesty and chastity. The Italian word *medaglia* was applied indiscriminately to denote both ancient coins and modern medals, while the Latin term *numisma*, coin, was used to describe Pisanello's modern productions. Even though their discussion does not appear to have been a defining feature of the teaching of either Guarino or Vittorino, coins were studied by many of their humanist friends, acquaintances and disciples as the adjuncts and proofs of textual history. The relative beauties of coins of Constantine, Constans and Berenice were assessed, for example, by Ambrogio Traversari, who visited both Guarino and Vittorino, and who was in Ferrara for the 1438 Council.[100] The merchant antiquarian Ciriaco d'Ancona had been there at the same time and later, in 1442, would compose Nicolò d'Este's *all'antica* funerary inscription.[101] Ciriaco loved coins as he did other antiquities. He plainly believed that, as portraits of exemplary figures from the past, coin effigies could be inspirational, the physical equivalent of the exhortatory 'images' in Guarino's Sallust. In Siena in 1433 he gave the emperor Sigismund a coin of the emperor Trajan 'as showing the features of a rightful prince and an example to follow'.[102]

Above all coins were used as illustrations of history. In 1444 a leading humanist, Flavio Biondo, sent Leonello d'Este a group of ancient coins to enable him better to understand excerpts from his *Rome Restored*, in which he discussed the first coins struck, showing types of Roman chariot – the *biga* drawn by two horses and the *quadriga* drawn by four.[103] Leonello seems to have been an enthusiastic numismatist, and imperial Roman coins form part of the original nucleus of what is now the Medagliere Estense in Modena.[104] The way in which their study was conceived in parallel to textual researches is illustrated by the painted illuminations of a now badly damaged manuscript of biographies of Roman emperors (fig. 3.26), made for the Gonzaga some time after 1433. Its illuminations compare well with drawings of costume such as the signed parchment in the British Museum (see fig. 2.33), the coloured study in Oxford (see fig. 2.32) and, especially, a sheet including a knight and dragon in Milan;[105] the coin portraits (fig. 3.27) bear more than a passing resemblance to the sheet of such drawings in the Louvre (see fig. 3.6) and to a little sketch of the empress Faustina the Elder on another sheet of the early to mid-1430s.[106]

ABOVE
3.27 (detail of 3.26)

LEFT
3.26 **Attributed to workshop of Pisanello**
Scriptores historiae augustae (Writers of Imperial History),
folio 85, *c.*1435–45
Tempera and gold on parchment, *c.*27 × *c.*19 cm
(maximum)
Turin, Biblioteca Nazionale, inv. Ms.E.III.19

These illuminations have been sometimes attributed to Pisanello,[107] although in
fact a number of different hands seem to have been involved. Many of the borders,
however, do indeed have features in common with Pisanello's certain works: the roses,
which are very like those in Leonello's portrait, and the Gonzaga daisies, interspersed
with little vignettes of men and women in elaborate court costume, which are close to
a number of drawings by Pisanello and his shop. The particular problems attached to
the attribution of manuscript illuminations to Pisanello will be discussed in chapter V.
Here it is enough to point out that the combination of courtly and classical elements
is entirely in accord with Gonzaga taste, as attested by Pisanello's own works for
Gianfrancesco and Lodovico.

The drawing of ancient coins in the Louvre (see fig. 3.6) is an admirable witness
to Pisanello's own numismatic interests. Although its autograph status is sometimes
doubted, it can be connected with his life study of the head of a 'dead' youth (see fig. 2.5);
the technique, a dense use of black chalk and pen and ink, with wash used further to
define the relief and reinforce his typically hatched grounds, is very close. The wash of

red chalk applied to the whole page is a common feature of drawings by both Pisanello and his shop, drawings which seem to belong to the second half of the 1430s and the first years of the next decade. The fact that the two drawings share a watermark is also encouraging. These factors are sufficient to indicate Pisanello's authorship of at least the first three heads. There is a sequence of rulers, Julius Caesar, the emperor Augustus, Alexander, followed by a bearded Hercules (which may be by another, later draftsman, and which is copied from a gem now in the Museo Archeologico in Florence).[108] Here again is a canonical group of ancient exemplars. The exact sources for these images can be discovered in coins struck by Octavian, Tiberius and Alexander (see figs. 3.7, 3.8, 3.9). The prototypes may even have belonged to Pisanello, since, as we have seen (see p. 39), he is documented as the owner of probably ancient coins.[109] Pisanello may also have converted such images into new works of art of his own. In 1435, doubtless as a companion piece to Guarino's treatise on Julius Caesar (see p. 96), and in the same spirit as Ciriaco's present to Sigismund, Pisanello gave Leonello d'Este as a wedding gift an image of Caesar, and was rewarded with two ducats.[110] The present may conceivably have been an ancient coin, but it is more likely to have been Pisanello's own work, whether a painting on parchment or panel, a finished drawing, or a medal. The fact of its presentation assists in the reading of his series of portraits of Leonello himself.

There can be little doubt that medals by Pisanello and his followers were cast with the conscious intention of reviving this ancient art form (in a period with no base-metal currency, only gold and silver, the bronze coins of the ancients were valued primarily for their perceived commemorative function). They were made, in small editions, for precisely the same clique of scholars who collected ancient coins, and, like these, would find their home in the study. In his letter accompanying a gift of coins to Leonello in 1444, Flavio Biondo relayed a piece of gossip, according to which Leonello had 'ordered about ten thousand bronze coins . . . to be struck after the fashion of the ancient Roman emperors with on one side [his] name inscribed next to the representation of [his] head'.[111] Since this letter cannot refer to coinage as such, it appears that Biondo had misunderstood Leonello's prolific medal-making policy (in any case the numbers are grotesquely exaggerated). The parallel between ancient and modern is made yet more explicit in a letter which slightly postdates Pisanello's death. In 1461, the lord of Rimini, Sigismondo Malatesta (or rather his court humanist) wrote to the sultan of Turkey, Mehmed II, introducing the Veronese medallist Matteo de' Pasti, on his way, abortively, to enter Mehmed's service.[112] Matteo, as we will see in chapter V, was almost certainly Pisanello's pupil. The letter provides a rare insight into the motives of a patron who wished to have medals made. First the context is stated: the fascination of portrait sculptures (in which category he must include coins) of past princes, generals and notables. Then the primary interest is outlined: the virtues of the portrait as the means of bestowing immortality on the subject. Thirdly, a parallel (now familiar) is drawn between Mehmed's potential employment of Matteo as a portraitist and the use made of the painter Apelles and the sculptor Lysippus by Alexander the Great.

However, in many important ways the medals by Pisanello (or Matteo) do not look antique. They are certainly not straightforward reproductions of ancient coins. They

may revive the concept, but they do not slavishly imitate the form. Their method of manufacture was different, for a start – cast from wax models rather than struck, as ancient coins were. They are also all significantly bigger. The use of wax had precedent in Pliny's description of the ancestor portraits displayed in ancient Roman houses.[113] These were not, of course, medals, but a similar requirement of display may well have dictated the larger size of Pisanello's works. Their casting in bronze may also reflect Pliny's view that this was the most worthy metal.[114] The choice of technique was deliberate, for smaller struck pieces had been made in medieval Italy – at the end of the thirteenth century dies had been engraved to strike medals of the lord of Padua, Francesco II da Carrara; the technology existed.[115] Pisanello's patrons may have been attempting the revival of two different ancient art forms at the same time: coins and funerary portraits. The form of a self-portrait plaque by Leon Battista Alberti, modelled in wax and cast (perhaps somewhat later) in bronze (fig. 3.28), combines references to both these prototypes. It has often been described as a proto-medal.[116] Although it is oval and has nothing on the back, it unites profile portrait and emblem – a winged eye – in a way which has analogies with the portrait of Margherita Gonzaga and with the obverses and reverses of Pisanello's medals. Small wonder recent scholars have suggested that behind Pisanello's 'invention' of the 'first' medal lies the hidden hand of Alberti.[117] Alberti was in Ferrara at the time of the Council, and had also overlapped with Pisanello in Rome, where they were both employed by pope Eugenius IV.[118] However, making Alberti – or Leonello, Ciriaco, Ambrogio Traversari or Pisanello himself – the single 'inventor' of the medal is almost certainly overstating the case. Instead we should see the medal as the result of a confluence of antiquarian, artistic and literary investigation of the past.

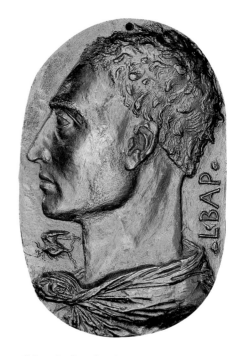

3.28 **Leon Battista Alberti**
Self-portrait plaque, c.1430–5
Cast bronze, 20 × 13.5 cm
Washington, D.C., National Gallery of Art,
inv. 1957.14.125: Samuel H. Kress Collection

THE PORTRAIT MEDAL: IDEOLOGY

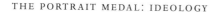

The desire to recreate these two ancient art forms in a single object type may be a part of the explanation of the unclassical elements in Pisanello's medals. But it is not the only reason. It is more than likely, for example, that Pisanello's early medals in particular were preceded by painted portraits of the subject, and that this was the usual sequence. That was certainly the case with Francesco Sforza, whose (lost) picture was planned in March 1440 and whose medal must date after October 1441, when he became lord of Cremona, a title which appears on the medal.[119] Leonello's painted and medallic portraits show the way in which Pisanello used his painted images as the starting points for his sculpted reliefs. His subjects may be labelled in an ancient language, but, by contrast to the toga-wearing Alberti, no attempt is made to alter the contemporaneity of the image; the rulers of Italy remain Christian knights as defined in the previous chapter, portrayed according to painting conventions imported from the north. The interpretation of medallic portaits may have been 'humanist', as might some of Pisanello's idealising tactics, but the messages of many of his reverses, as we also saw in chapter II, depend on the subject-matter and visual presentation of the chivalric tradition. Indeed the reverse *impresa* finds precedents in heraldic images adopted in France, alluding to the virtues of the Christian soldier, his hopes and endeavours (the chivalric vow was called *l'emprise*).[120]

These *imprese*, too, could become vehicles for humanist thought: equestrian portraits on medallic reverses are a case in point. Alberti, in his treatise *On the Horse*, dedicated to Leonello d'Este in 1443,[121] carefully cited the Greek author Xenophon and the Roman Vegetius, stating explicitly that the treatise was prompted by his rôle in judging another competition – between sculptors battling to gain the commission for a life-size equestrian monument to Nicolò d'Este, commissioned by Leonello. This was to be a modern equivalent to the famous sculpture then at the Lateran in Rome, not yet identified as Marcus Aurelius.[122] But Nicolò was sculpted in contemporary costume, like the equestrian portraits on the reverses of Pisanello's medals – the medal of Sigismondo Malatesta dated 1445 (see fig. 1.40) and the pair of medals, of about 1447, of Lodovico Gonzaga and his father Gianfrancesco (see figs. 2.25, 2.3).

Pisanello's medal of Lodovico's father Gianfrancesco must have been modelled posthumously, at the same time as the medal of his son. Gianfrancesco's somewhat stiff and wooden obverse portrait, depicting a young man, must copy a much earlier source – probably by Pisanello himself – and the general approach, the large scale of the horsemen in proportion to the surface area of the medal (much larger than those of the reverses of the earlier Visconti and Sigismondo Malatesta medals), the placing of the device on the reverse and the arrangement of the inscription on the obverse suggest that the father's medal can at most be only marginally earlier than the Lodovico portrait.

Pisanello's equally chivalric medal representing Domenico Malatesta Novello (see fig. 4.50) is usually dated 1445 for no better reason than that one of the medals of his brother Sigismondo bears that date.[123] But, as we noted earlier, it is one of the most beautifully composed of Pisanello's medals, and it belongs later in his career. This judgement depends on, for example, the very even lettering of the inscriptions and the fact that, in common with the Gonzaga medals, the piece is not mentioned by the poet Basinio da Parma in his homage to Pisanello of 1447 or early 1448, in which he listed the artist's portraits in a way that seems to have been intended to be comprehensive. The reverse of the medal depicts Malatesta Novello, in his armour, embracing a sculpted crucifixion, and has been connected with his pious (and typically chivalric) vow to build a hospital dedicated to the Holy Crucifix, which he made after the 1444 Battle of Montolmo. He fulfilled this promise in 1452 and the medal may even have been cast to commemorate the completed task.[124] There is no evidence of Pisanello's presence at any time either in Rimini or Cesena and the Malatesta medals may well have been based on drawings sent to the artist rather than on sittings.

It is not surprising to find that the reverses of both of the two medals sometimes claimed as Pisanello's first – that of the penultimate Byzantine emperor, John VIII Palaeologus, and that of Filippo Maria Visconti – share an equestrian iconography. Pisanello's medal of John VIII (see fig. 1.35) has regularly been called the 'first Renaissance medal'. Its obverse is surrounded by the emperor's name and titles in Greek. Its reverse shows him brought to a halt, during one of the hunting expeditions for which he was notorious, by the sight of a cross, to which he prays. The cross is surely to be read as a symbol of the attempt to unite the Greek and Latin Churches. The image is related to a similar scene of revelation in the National Gallery painting of *The Vision of St Eustace*

(see fig. 4.35), and it seems as if the emperor, easily diverted from the business of Church unification by the pleasures of the field, is being presented as a modern Saint Eustace. It has often been supposed that, while John VIII was still in Italy, the presence of the emperor inspired Pisanello to make, or one of his patrons to have him make, a version of two 'antique' medals of the Christian emperors Constantine and Heraclius (figs. 3.29, 3.30).[125] It is possible, however, that the medal was executed only after the successful union of the churches had been apparently achieved in Florence in July 1439 (although it had crumbled immediately following the emperor's return to Constantinople); the message might be celebratory rather than aspirational. The two drawings connected with it have colour notes, suggesting, once again, a lost painting, and stylistically (unconventional though it is to say so), the medal seems to be closer in date to a 1444 marriage medal of Leonello (fig. 3.43) than to Pisanello's earlier medallic portraits of the marquis.

Whatever the precise date of the medal of John VIII, there can be no doubt that Pisanello knew the medals of Constantine and Heraclius. He refers to them not only in the Palaeologus medal but also in other, later pieces, which borrow the equestrian portrait, the horizontal placing of some of the legends, the semi-nude woman or the triumphal cart. The pair were executed at the beginning of the fifteenth century by a goldsmith in the employ of the duke of Berry, copying two pieces in his substantial numismatic collection, medals which may have looked rather different from their reproductions. These can be shown to have circulated widely in Italy, and two silver specimens of the Heraclius medal are recorded in an inventory of the goods of Nicolò d'Este as early as 1432.[126] Numismatists only recognised that these were modern 'forgeries' in the mid seventeenth century, and throughout the sixteenth century they were published as antique. It is usually argued, therefore, that in adopting both the size and technique of these large, cast medals Pisanello believed himself to be copying antiquities. The associations of both emperors with the discovery of the True Cross and its use in battle to defeat a pagan enemy certainly make them appropriate models for John VIII. However, it may be that Pisanello and Nicolò were aware of their Franco-Burgundian origins. The commissioning of the Palaeologus medal by Leonello (if this was, in fact, an Este project, and if it can be dated after the emperor's departure) may be seen as another instance of an Italian ruler behaving like one of his northern counterparts. The style of the duke of Berry's medals is so close to that of manuscript illuminations by the Limbourg brothers that they have even, rather ambitiously, been attributed to them.[127] It is therefore perfectly possible that Pisanello observed the shared style of medals and manuscripts, choosing to adapt them not because he thought them ancient, but because they had desirable northern and courtly connotations.

The other medal sometimes promoted as Pisanello's first is his piece commemorating Filippo Maria Visconti (see fig. 2.24). The artist is recorded in Milan in May 1440 and the medal is usually dated to 1440 or 1441. However, in June 1431 or 1432 Pisanello had promised to send a bronze object from Rome to Filippo Maria Visconti in Milan and it has been proposed that he was referring to the medal.[128] Though this is probably too early a date, there is no denying the closeness of the reverse composition to the

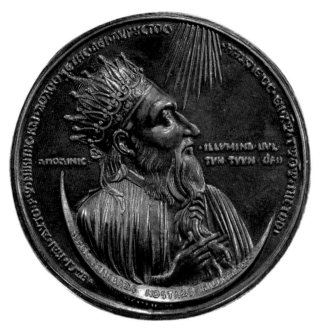

3.29a, b **French**
Portrait medal of emperor Heraclius, c.1402
Cast bronze, diam. 9.8 cm
London, The British Museum, inv. M0268

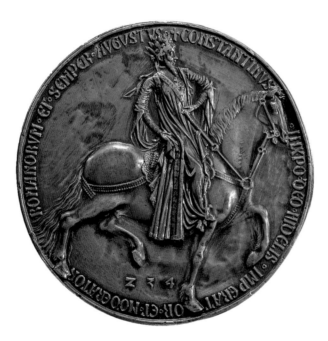

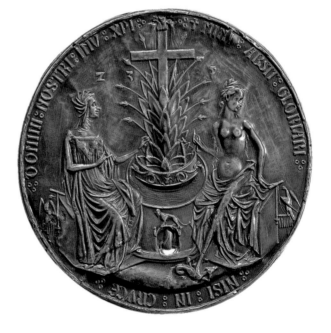

3.30a, b **French**
Portrait medal of emperor Constantine, c.1402
Joined repoussé silver plates, diam. 8.9 cm
London, The British Museum, inv. M0269

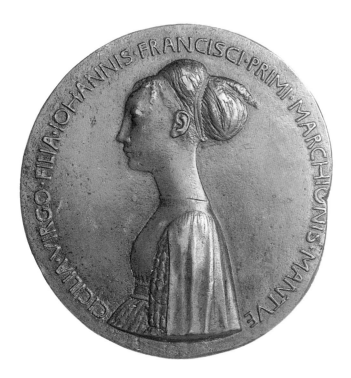

3.31a, b **Pisanello**
Portrait medal of Cecilia Gonzaga, 1447
Cast bronze, diam. 8.8 cm
Milan, Gabinetto Numismatico Museo
Archeologico, inv. M.0.9.1417

Sant'Anastasia fresco (see fig. 1.21), a meaningful appropriation given that Visconti, like Saint George, is being presented as a paradigm of Christian militarism. A date in the mid to late 1430s seems right. In his posthumous biography of the Milanese duke, written in Ferrara in 1447, his erstwhile secretary Pier Candido Decembrio recounted that Visconti, embarassed by his physical imperfections (he was horribly overweight and was unable to raise his chin from his chest) would allow only Pisanello to portray him.[129] The statement has the ring of truth given that all subsequent portraits of Visconti depend on Pisanello's model, and Pisanello certainly flatters him by giving his portrait a columnar strength. However, it seems unlikely that the duke would have waited until 1440 to have his portrait taken. In his list of Pisanello's portraits, Basinio da Parma included a painting of the duke of Milan, and this perhaps formed the basis for the medal. Pisanello thus married two pre-existing images, on both obverse and reverse, in an 'ancient' medium, in such a way as to justify Decembrio's classicising allusion to the portrait-making (once again) of Alexander.

As we have seen, Pisanello's patrons were keen to present themselves according to chivalric codes, and by doing so they were not sacrificing the connection established by the medallic medium with Greek and Roman antiquity. To take another example, in his only medal of a female subject, Cecilia Gonzaga (fig. 3.31), dated 1447, Pisanello combined a variety of elements to make her appear as both Christian princess and Roman virgin.[130] Cecilia, who like her sister Margherita was educated by Vittorino, was celebrated throughout Italy for her renunciation of marriage (to the particularly vicious Oddantonio da Montefeltro of Urbino) and for her decision, encouraged by Vittorino though opposed by her father, to enter the Clarissan convent of Santa Paola in February 1445.[131] Contemporary accounts celebrate her learning, her virtue and her beauty.[132] By the date of the medal's execution, she had already spent two years in the nunnery and was therefore unable to offer a sitting to Pisanello; the

Clarissans were an order *in clausura*. Pisanello must therefore have based his portrait on a pre-existing image.

Indeed Cecilia is in court dress. This fact already gives a strong indication of the unreliability of the image as a contemporary likeness. She is identified as a virgin in the obverse inscription, but the medal makes no mention of the fact that Cecilia was a nun. The image is abstracted from the particular circumstances of her virginity and so takes on a generalised exemplary character. Her outer beauty would have been read as an indication of her inner virtue. It is not very likely that this beauty was particularly her own, given her similarity to Pisanello's princess in the Sant'Anastasia fresco, and, in particular, to his little sketch (based rather loosely on a coin but apparently intended for a panel painting) of Faustina the Elder, the highly regarded consort of Antoninus Pius.[133] Women were subject to even greater idealisation in portraits during this period than men.

The medal turns Cecilia into an exemplar of desirable female virtue, Christian and antique. The reverse expands the message of the portrait, and adds the constituent of specific biography missing from the obverse. It bears a traditional image of Chastity – the maiden taming the unicorn – to which have been added classicising elements, so that it can transmit the same layered message as the front. The legend of the fierce unicorn which could only be captured by a virgin derives from the late antique and medieval bestiary tradition.[134] The tradition imbued the fable with Christian connotations: the unicorn stood for God the Father and Christ the Son (the two in the 'one' of the unicorn's horn), and the maiden for the Virgin Mary. Pisanello clearly knew this literature, which describes the unicorn as a single-horned goat (Pisanello re-used a drawing of a goat, executed probably in the mid-1430s) rather than the horse-like creature described by Aristotle. The image therefore presents Cecilia as a generic exemplar of Chastity but also specifically makes reference to her marriage to Christ – nuns are, of course, considered the 'brides of Christ'. Chastity is also represented *all'antica* by the virgin goddess Diana, whose crescent moon floats in the sky; she has been depicted partially nude in a pose derived, probably, from a Roman sarcophagus relief.[135]

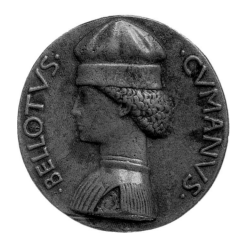

3.32a, b **Workshop of Pisanello**
Portrait medal of Bellotto Cumano, 1447
Cast bronze, diam. 5.8 cm
Milan, Gabinetto Numismatico Museo
Archeologico, inv. M.0.9.1402

Pisanello made three medals of humanists – and painted portraits of more of them. The medals, like that of Cecilia, combine medieval Christian imagery with humanist glosses. The smallest, that of another Vittorino pupil, the Paduan prodigy Bellotto Cumano, is dated 1447 (fig. 3.32).[136] Its reverse has an ermine – both a pun on his name (ermine is *bellus* in Latin and *bellotula* or *bellora* in some Italian dialects)[137] and a symbol of moral probity.[138] To Pier Candido Decembrio in August 1448 Leonello d'Este sent a specimen (one of two) of the medal ('*numisma*') he had commissioned of his '*vultus*' (face) during Decembrio's stay in Ferrara after the death of his employer, Filippo Maria Visconti (fig. 3.33).[139] He retained the other himself. Its reverse shows an open book, beautifully ornamented with its ribbon markers. On the best surviving casts the words *LIBER SUM* (which translates either as 'I am a book' or as 'I am free') appear inscribed on the open pages, suggesting that the book, an obvious allusion to Decembrio's humanist activities, was also more specifically a Bible, the object of pious scholarship.

Pisanello's medal of Vittorino da Feltre (fig. 3.34) was almost certainly executed shortly after his death in February 1446, probably at much the same time as the Cecilia.[140] On the reverse appears a little Gonzaga daisy, linking Vittorino's *fama* to the family's; Vittorino, like Cecilia, was being promoted as a Gonzaga exemplar. Pisanello had already painted a portrait of Vittorino, which his pupil Basinio da Parma described as follows: 'Father Vittorino, glory of the Roman language, you, too, will live by the skill of Pisano: the same expression, the same face as on the man; and he has also portrayed with skill the *gravitas* of a Caesar and his white hair; the seriousness of his face is the same, and so is his head; and you might believe that he could even speak through his mouth; the portrait struck terror even in me, who was his pupil, and admonished boldness of

3.33a, b **Pisanello**
Portrait medal of Pier Candido Decembrio, 1448
Cast lead, diam. 8.1 cm
London, The British Museum, inv. 1906-11-3-139

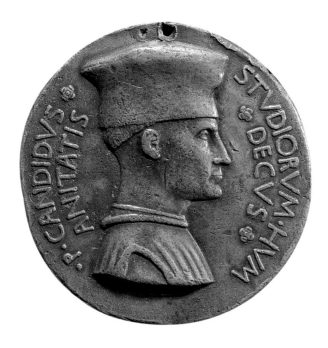

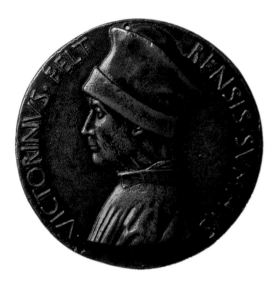
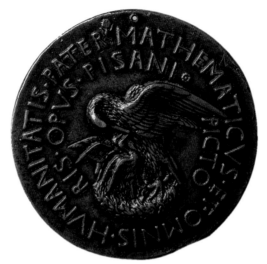

spirit; and I was dumbstruck, out of my mind, and I was overjoyed to think that you, too, great Vittorino, were alive.'[141] The existence of this painted image is confirmed by Francesco Prendilacqua: Vittorino, he said, was depicted by Pisanello 'among the ancient philosophers';[142] at his feet was a phoenix – presumably to signal the uniqueness of his master and the posthumous survival of his reputation. Prendilacqua's identification of the bird seems somewhat perverse if it was the same device that appears on the reverse of his medal – which is clearly a pelican; but it may have been another deliberate misreading to make the image more 'humanist'. The pelican feeding her young with blood drawn from her own breast was an immediately recognisable emblem of Christian sacrifice; the image was current both in Italy and internationally, and Pisanello's depiction of the motif has the same beautiful detail as found in a mid-fifteenth-century brooch of Franco-Burgundian workmanship (fig. 3.35), but modified by Pisanello's characteristically more naturalistic observation of the bird's feathers.[143] Indeed the bird appears on a sheet of model drawings by a member of his shop.[144] The basic intention of the reverse was to pay homage to Vittorino's famous piety. However, this is not where its message ends. The inscription, running without interruption from the obverse to reverse, calls the renowned educator 'most distinguished mathematician and father of all the humanities'. The word 'father' (PATER) implies Vittorino's teaching rôle. The educator certainly saw himself in that light in relation to his pupils: in a copy of Xenophon given to Sassolo da Prato on his leaving the Mantuan school he called his pupil his 'disciple and son' ('discipulo et filio').[145] The pelican therefore also stands for his legendary devotion to his students, and the particular stress on his mathematical abilities suggests further a visual pun on the name of his own teacher, the mathematician Biagio Pellicano.

Thus it is clear that while Pisanello's medallic medium may have been *all'antica*, the vocabulary of many of his medals was not. It is only on the earliest of Pisanello's medals that he made direct allusions to his most obvious precedents, to Greek and Roman coins, rather than employing long-standing medieval symbols. Apart from the 'Alexandrian' fashioning of Leonello's profile (and assuming that he knew the

LEFT
3.34a, b **Pisanello**
Portrait medal of Vittorino da Feltre, c.1446
Cast bronze, diam. 6.7 cm
Berlin, Staatliche Museen zu Berlin, Münzkabinett,
inv. 22

ABOVE
3.35 **Franco-Burgundian (?)**
Pendant in the form of a pelican
Cast and chased gold set with ruby and
black letter inscription, c.1440–60
London, The British Museum,
inv. Franks Bequest AF 2767

Constantine and Heraclius medals were not ancient), he used antique numismatic sources for his two medals of the rival commanders Francesco Sforza and Niccolò Piccinino – both belonging to the very beginning of the 1440s (figs. 3.38, 3.37). The two are similar in style, and the latter can be dated between Piccinino's adoption in 1439 by Filippo Maria Visconti, whose surname is included in the identifying inscription, and his re-adoption in 1442 by Alfonso of Aragon. The medal reverse for Francesco is intended to suggest his ideal possession of both arms and letters: the book contrasted with the sword and the horse's head. This last apparently derives from coins of the Hellenistic kings Seleucus I and his son Antiochus I, which may have arrived in Italy thanks to the Near Eastern wanderings of someone like Ciriaco, or in the pocket of a visiting Byzantine scholar (fig. 3.39).[146] These Hellenistic coin reverses bear the head of Alexander's horse the horned Bucephalus, a symbol of the Seleucids' succession to his eastern empire. By placing a 'Bucephalus' on the reverse of the medal of Francesco Sforza, a modern soldier, deliberate reference is made, once again, to the greatest warrior of antiquity. The medal may have a second numismatic source, nearer to home, one which would confer a Roman legitimacy on the claims to power made by the increasingly powerful *condottiere*. A truncated horse's head, in a form close to that on the medal, also appears with the inscription ROMA on the reverse of a Roman republican silver coin with a helmeted Hercules on the obverse.[147] Pisanello's source for Piccinino's medal reverse was all too apt: another republican coin, one combining a Hercules on the front with a reverse image of the she-wolf who nursed Romulus and Remus (fig. 3.36).[148] Pisanello's

3.36 **Roman**
Republican coin with image of the She-wolf (*Lupa*) of Rome, reverse, early 3rd century BC
Struck silver, diam. 2 cm
London, The British Museum,
inv. BMC Romano-Camp. 28

3.37a, b **Pisanello**
Portrait medal of Niccolò Piccinino, c.1439–42
Cast bronze, diam. 8.9 cm
London, Victoria and Albert Museum,
inv. A.170-1910

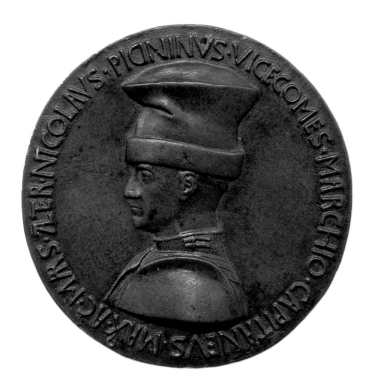

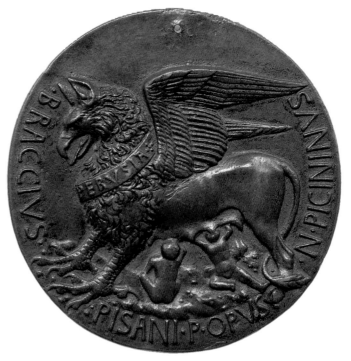

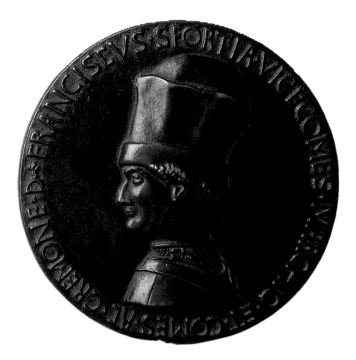

medal casts him as the modern equivalent of one of the twin founders of Rome. Paired with his fellow warrior from Perugia, Braccio di Montone, he suckles at the teat of the griffin, the heraldic symbol of their native city. Pisanello has altered the exact poses of the two boys from those of the coin, but elements like the arrangement of the griffin's tail and the treatment of the rib-cage and haunches show that Pisanello was sufficiently faithful to his source to ensure its recognition.

Even though they are both layered and classically derived, the imagery of these two medal reverses is no more complicated than Lodovico's equestrian portrait, Vittorino's pelican or Cecilia's unicorn. Leonello's medallic obscurantism begins to look somewhat isolated. All of his medals seem designed as recondite challenges and only two have been satisfactorily explained. No-one knows, for example, what the paired nude figures represent on the reverses of two medals executed just before his succession to the marquisate (figs. 3.40, 3.42). On the former, the paired nude figures (one old, one young) stand head to head, carrying baskets containing branches, while rain falls on two cauldrons behind. On the latter, the same nude figures seem posed in debate or discussion in front of another of Leonello's devices, a column (of fortitude?) and a sail (of fortune?).[149] The reverse of a third medal (see fig. 5.46), perhaps the earliest in the sequence, with a three-faced putto flanked by branches of juniper from which are suspended armoured knee-defences (poleyns), is equally obscure.[150] The device had existed at least since 1435, when it appeared on a signet ring.[151] The putto may have started life as an image of the Trinity, which had been the chief bone of contention at the Council of Ferrara.[152] The Council's resolution and the consequent increased resolve to battle the threat of the Turk might therefore turn the whole device, including the knee-pieces, into an image pertaining to the task of the Christian knight.[153] Alternatively, the reference might be to the Muse of epic verse, Calliope, who, Guarino prescribed in 1447, should be painted with three faces, corresponding to her threefold subject, 'men, heroes and gods'.[154]

3.38a, b **Pisanello**
Portrait medal of Francesco Sforza, c.1441
Cast bronze, diam. 8.7 cm
Berlin, Staatliche Museen zu Berlin, Münzkabinett, inv. 9.1

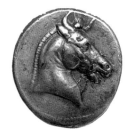

3.39a, b **Seleucid**
Tetradrachm of king Seleucus I of Syria (Mint of Pergamum or Ephesus), obverse (with Bucephalus) and reverse (with elephant with star and anchor), 281–280 BC
Struck silver, diam. 3.5 cm
Boston, Museum of Fine Arts, inv. 1997.91: Theodora Wilbour Fund in memory of Zoe Wilbour

Or perhaps by 1447, with the effective failure of the Churches' union and the Council receding into the past, the image could be reinterpreted and converted into something humanistically antique.

A less puzzling instance of such a shifting meaning can be adduced, in the blind-folded lynx on the reverse of another of Pisanello's medals of Leonello, made after his succession (fig. 3.41).[155] Once more, the device was not the artist's invention; it had appeared on the reverse of Nicholaus's medal of Leonello (see fig. 3.3b) with the Latin motto *Quae videns, ne vide* (Seeing these things, do not see them), an illustration, in other words, of the diplomatic art of selective vision. However, the lynx was also reputed to have sight so keen it could see through walls, thus making light work of a blindfold.[156]

3.40a, b **Pisanello**
Portrait medal of Leonello d'Este, marquis of Ferrara, c.1441
Cast bronze, diam. 6.9 cm
London, Victoria and Albert Museum, inv. 678-1865

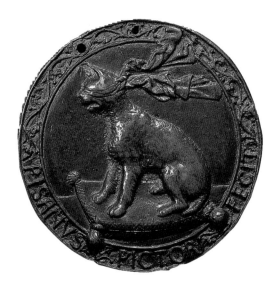

FAR LEFT
3.41 **Pisanello**
Portrait medal of Leonello d'Este, marquis of Ferrara, reverse, c.1442
Cast bronze, diam. 6.8 cm
London, The British Museum, inv. GIII, Ferrara M27

LEFT
3.42 **Pisanello**
Portrait medal of Leonello d'Este, marquis of Ferrara, reverse, c.1441
Cast bronze, diam. 6.8 cm
London, The British Museum, inv. GIII, Ferrara M25

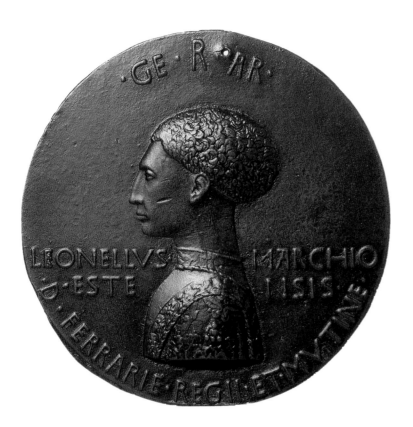

The animal becomes therefore at the same time judiciously blind and all-seeing.

The last of Pisanello's medals of the marquis, dated 1444, is an admirable indication of how Leonello's mind worked (fig. 3.43). Here is a reverse that can be decoded. Love, in the form of Cupid or Amor, is teaching the lion (Leonello) to sing.[157] On the front Leonello is labelled the son-in-law of Alfonso: evidently the medal was modelled for the occasion of Leonello's second, prestigious marriage to Alfonso of Aragon's illegitimate daughter Maria. Amor and Leonello himself were the central protagonists in two surviving sonnet fragments by the marquis, poems which show off his poetic concerns and his allegorical turn of thought.[158] The identity of the Leonello–lion is made explicit by the stele with his column-sail *impresa* behind his head and by the Este eagle perched on a branch above him. Cupid's scroll has authentic notes on it, though it is not known if it reproduces a real piece of music – not unlikely, since Leonello was reputed a musician of no mean talent. He sometimes entertained the court with performances on the lute and chapel organ, and a dance tune was even dubbed the 'Leoncello' in his honour.[159] The medal presents Leonello, therefore, in the dual rôle of king of beasts and lord of love.

MEDALS OF ALFONSO OF ARAGON

The medals Pisanello made for Leonello, with his peculiarly scholarly concerns, were unusually cryptic. It may be no coincidence that the reverse of Matteo de' Pasti's extra-ordinary medal of Guarino (see fig. 3.13) has proved similarly difficult to understand.[160] Only one other of Pisanello's patrons demanded the same level of erudite reference in his medals. In late 1448 Pisanello fulfilled his long-held ambition to work for Alfonso of Aragon, king of Naples and effective ruler of a western Mediterranean empire including

3.43a, b **Pisanello**
Portrait medal of Leonello d'Este,
marquis of Ferrara, 1444
Cast bronze, diam. 10.1 cm
London, Victoria and Albert Museum,
inv. A.165-1910

Sicily, Sardinia, Corsica, the Balearic Islands and Catalonia.[161] As we have seen, Alfonso was as imbued with the chivalric culture of the hunt and the tournament as any of his fellow rulers in Italy, and he was as keen a purchaser of northern European luxury goods – goldsmiths' work and tapestries. However, his patronage of the arts was no less determined by his humanist concerns than by his status as chivalric warrior.[162] The Latinist skills of this 'rey y cavallero', this paragon of Prudence, Temperance and Justice, were promoted in conjunction with his abilities as a warrior in a 1444 poem about the Battle of Ponza, written in the Catalan vernacular by Iñigo López de Mendoza, marquis of Santilliana.[163] In a letter to Alfonso of 1443 Flavio Biondo reinforced the symbolic message of such learning, stating, 'Only those adorned by letters deserve to be called true kings and princes'.[164] Alfonso reputedly had Livy's histories read aloud to him while preparing for battle. His library was famous and he paid very high prices for ancient texts.[165] He founded an academy in 1447.[166] Moreover, he saw a need for men of letters at his court to record his fame for posterity, just as Augustus, Trajan and Hadrian had done, and he gathered around him a notably fractious group of humanist scholars.[167] As in Mantua and Ferrara, they worked in various capacities, but one of their primary tasks was the writing of Alfonso's biography. They were not best pleased to be pipped to the post by Alfonso's physician, Gaspare Pellegrino, whose 1443 life of Alfonso was roundly condemned by the great philologist Lorenzo Valla, who had come to Naples in about 1435 after teaching at Pavia, and was busily engaged on a similar task. Antonio Beccadelli, called Panormita, is said to have been paid 1000 *monete d'oro* for his Latin biography of Alfonso, *On the Sayings and Deeds of King Alfonso*, which drew upon such ancient authors as Valerius Maximus, Plutarch, Suetonius and, possibly, Xenophon. Panormita was careful to associate Alfonso with the two Spanish-born Roman emperors, Trajan and Hadrian, the latter a famously ardent huntsman.[168] The work was completed in 1455.[169] The biography by Bartolomeo Facio, *On the Deeds of Alfonso, the First King of the Neapolitans*, was also completed in 1455.[170]

Pisanello's three medals of Alfonso were intended as the tangible equivalents of these biographies, artefacts to be studied in conjunction with texts. It is surely telling that Pisanello's salary in Naples compares well with those paid to the king's humanist biographers.[171] Alfonso's fondness for history was reputedly matched by his passion for ancient coins. He is said by Panormita to have averred that his coins of Julius Caesar 'did marvellously delight him and . . . influence him with a passion for virtue and glory'.[172] In his commentary on Panormita's biography the humanist Enea Silvio Piccolomini (later pope Pius II) pointedly capped many of Panormita's stories with little tales intended to imply his close acquaintance with Alfonso, recounting, for example, the king's pleasure in the discovery at Pozzuoli of a coin of Nero.[173] Alfonso is also thought to have been the owner of an exceptionally large and famous cameo, now known as the Tazza Farnese,[174] of which the size and prestige might explain the increased dimensions of Pisanello's medals of the king.

The portraits on these medals once again obey the physiognomical stipulations (see p. 108) laid down by the court humanist Bartolomeo Facio (who had arrived in Naples in 1444). They also accord with Piccolomini's description of Alfonso at time of the emperor

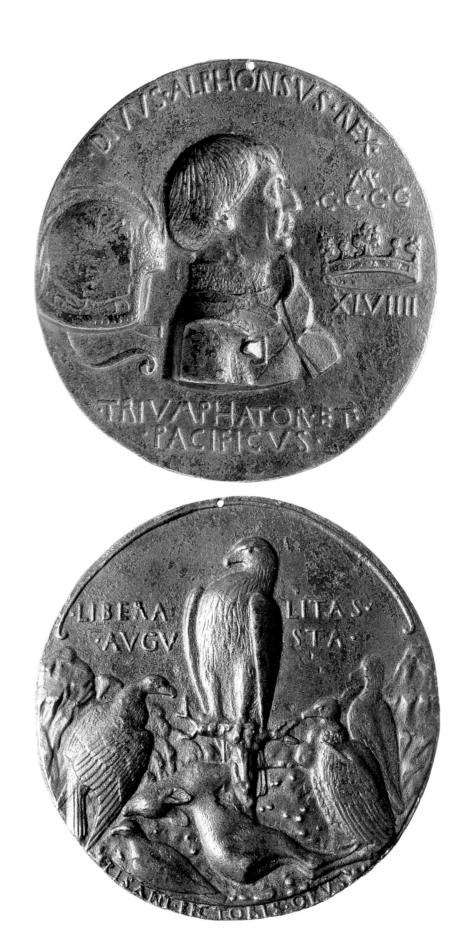

3.44a, b **Workshop of Pisanello**
Portrait medal of Alfonso V of Aragon, king of
Naples, 1449
Cast bronze, diam. 11 cm
Berlin, Staatliche Museen zu Berlin,
Münzkabinett, inv. 24

Frederick III's entry into Naples in 1452 – mentioning specifically the king's aquiline nose.[175] Likeness and meaning were thus blithely combined. The reverses similarly combine fact with classicising fiction. The medals transmit messages of the monarch's liberality, his triumphal status as warrior and peacemaker, his fortitude and his courage as a ruler (fig. 3.44). The first of them, dated 1449, advertises its subject as *DIVVS*, or deified like a Roman emperor, and as *TRIVMPHATOR ET PACIFICUS*.[176] His crown is placed to one side of his portrait (rather than on his head), signalling Alfonso's royal status, but in a way which suggests it is the result of his individual virtues rather than merely his birth. On the other side is a helmet and an open book on its side. On some, later casts of the medal, the book bears the inscription *VIR SAPIENS DOMINABITVR ASTRIS*, A wise man submits to the stars. The *impresa* was glossed by Panormita: 'The book, and indeed its being open, he bore as a sign that he understood that a knowledge of the good arts was especially fitting for kings – a knowledge, of course, that is thoroughly learnt from the handling and unrolling of books; and so he was wont to praise Plato among the first, because he said that kings should be either learned in letters, or at least lovers of lettered men.'[177] The message of Alfonso's aquiline profile is expanded on the medal's reverse. An eagle stands proudly above a freshly killed doe (a motif Pisanello had already used in his Sant'Anastasia frescoes – there the victim of the dragon). He is surrounded by lesser birds of prey, who wait to feed, referring to a passage in Pliny's *Natural History* where it is claimed that the eagle ('king' of birds – and an enduring imperial emblem) killed not only to sate its own appetite but to ensure other birds should feed. It thus illustrates *LIBERALITAS AUGUSTA*, imperial generosity. Alfonso's liberality was a central theme in Panormita's biography.[178] It may also be relevant, given Alfonso's vaunted devotion to Augustus, that one of the alternative solutions for the origins and etymology of the emperor Augustus' surname proposed by Suetonius linked it to the movements or feeding of the birds ('*avium gestus gustusve*').[179]

Various possible sources have been identified for Pisanello's reverse, each with a particular relevance and resonance. It may reflect knowledge of a group of Greek silver coins struck (appropriately) in Sicily, in Agrigentum, with an eagle seen in profile devouring a hare. Tellingly, the image had been already been revived by an earlier ruler of the region, the emperor Frederick II Hohenstaufen, who had left behind at the Palazzo Reale in Palermo a mosaic of a crowned imperial eagle with a hare at its feet.[180]

Alfonso's other medals were, in a sense, more biographical. On 26 February 1443 he was borne through the streets of Naples in a triumph – a procession conceived as reviving ancient Roman practice, imitating descriptions in Livy and Suetonius. Alfonso rode on a four-wheeled triumphal car made to resemble a fortress with battlements (which was later preserved over the main portal in the church of San Lorenzo Maggiore), garlanded with a golden wreath, enthroned in a 'Roman' high official's chair with a sceptre and dressed in an embroidered tunic and toga adorned with palms. The crimson velvet robe he wore for the occasion was also preserved.[181] He wore his Order of the Lily – a golden griffin – around his neck. His cart was preceded by a series of floats: the second of these, for example, bore a personification of Justice; the third carried seven allegorical figures and a turning globe, presided over by an armed Caesar, also with a

sceptre and wreath, proclaiming Alfonso as his successor. In the second part of the procession, the Catalan float carried Alfonso's Arthurian device of the 'siege perilous', illustrating once again that, in common with so many of his peers, he maintained a double devotion to the chivalric tradition and to the images and ideas thrown up by humanist investigation of ancient texts. This event surely inspired the reverse of Pisanello's second medal (fig. 3.46).[182] Alfonso's accoutrements for the triumph were already preserved like holy relics and had featured prominently in Alfonso's various biographies. The details have been altered only slightly. Here an angel carries a sword of Justice, and there is the legend *FORTITVDO MEA ET LAVS MEA DOMINVS ET FACTVS EST MICHI IN SALVTEM* (The Lord is my strength and my song and is become my salvation).[183] This piece, uniquely, is not signed in its first edition (though a signature was later added) and the implication of this fact for Pisanello's authorship of it (and of the *LIBERALITAS* medal) will be discussed in chapter V.

Before we turn to the third of Pisanello's medallic portraits of Alfonso, it may be as well first to consider a medal of one of Alfonso's most trusted allies and advisers, the very beautiful piece depicting Iñigo d'Avalos (fig. 3.45).[184] Iñigo had fought with the king at the Battle of Ponza and had been his fellow prisoner in Milan. In 1449, at just the time this medal was made, he succeeded his brother-in-law as the king's master chamberlain – the director of all state finances.[185] The Avalos family claimed Roman ancestry and Iñigo's interest in commemorating himself in *all'antica* fashion was, especially at Alfonso's humanist court, more or less a given. An early sixteenth-century poem in praise of Pisanello by one Giuseppe Castiglione of Ancona, addressed to Iñigo's descendant Tommaso d'Avalos, is often thought to provide the solution to the medal's meaning. In an extended (and imaginative) description of the medal reverse, the poet links the image of the globe with Homer's description of the shield of Achilles in the *Iliad*, a wonderfully

3.45a, b **Pisanello**
Portrait medal of Iñigo d'Avalos, 1449–50
Cast bronze, diam. 7.7 cm
Berlin, Staatliche Museen zu Berlin,
Münzkabinett, inv. 25

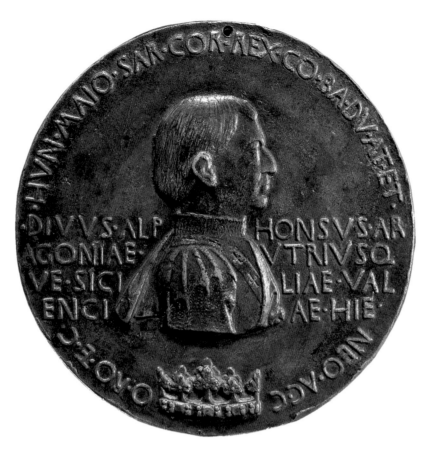

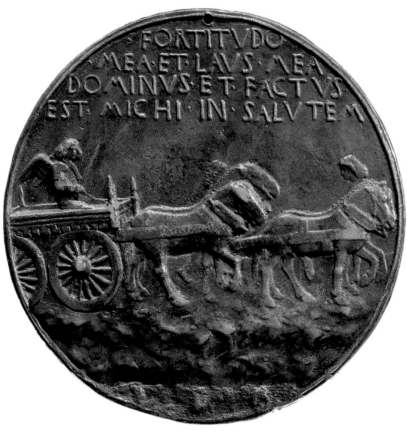

3.46a, b **Pisanello and workshop**
Portrait medal of Alfonso V of Aragon, king of
Naples, c.1449–50
Cast bronze, diam. 11.2 cm
London, The British Museum, inv. GIII, Naples 2

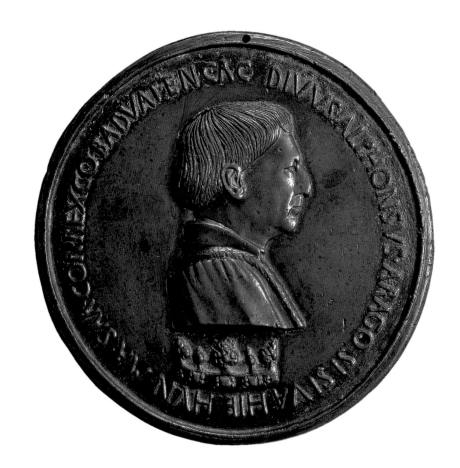

3.47a, b **Pisanello and workshop**
Portrait medal of Alfonso V of Aragon, king of
Naples, c.1449
Cast bronze, diam. 10.8 cm
London, The British Museum, inv. GIII, Naples 3

impossible object as it is recounted.[186] It has been proposed that in the reverse of his medal Pisanello attempted to rival this description sculpturally (or pictorially), but it has not been explained in what way the image might relate to Iñigo. The Homeric reference may in fact be another instance of the migration of meaning so common in these figures. Instead, the presence of a similar globe in Alfonso's triumphal procession might make this reverse an image of imperial conquest – a homage by Iñigo to his master and a statement of his own part in building Alfonso's empire. It is clear that in the ancient world the image of the globe was associated with ever more ambitious conquest. Virgil in the *Aeneid*, for example, identified Augustus as the culmination of Roman history and the principal architect of empire. He drew parallels with Bacchus and Hercules. Augustus' subjugation, however, went even further than Hercules'. His power stretched beyond the edge of the world to encompass not only Mount Atlas, the *axis mundi*, but even the stars (as on the medal) and the sun.[187] The legend below the globe, the only one to appear on a medal by Pisanello that is not in a classical language – PER VVI SE FA – is normally regarded as poorly spelled Italian and translated as 'for you it is made', a message that would certainly make sense in relation to Alfonso and Iñigo.[188] If, however, as seems more likely, the motto is in the Catalan vernacular used at the Neapolitan court, it is properly spelled and reads 'it is done even today', a statement of present and future imperial ambitions.[189]

In Pisanello's third medal for Alfonso (fig. 3.47) he seems to present the king as not so much Augustan as Herculean. We know that Alfonso, just like John VIII Palaeologus, was an ardent huntsman. But while Pisanello depicted the Byzantine emperor in the field in an ostensibly documentary image, on the reverse of his Alfonso medal he converted the biographical fact into an allegory of the king's valour. On the obverse of the piece Alfonso is labelled with a lengthy list of his titles. On the reverse he is shown again, instantly recognisable by his nose and his pudding-basin haircut, but rejuvenated and stripped of (most of) his clothes, about to stab a ferocious boar. Above his head is a Latin legend which translates as 'courageous huntsman'. He may actually wear a decorous little pair of underpants, but he is also presented as classically nude. As in the medals of Leonello, his nakedness may illustrate the state of his soul – therefore indicating an essential, rather than merely reactive, courage. But there are also direct parallels to be drawn with legend of Hercules. It has long been realised that the reverse is loosely derived from the many hunting scenes on ancient Roman sarcophagi. Some of these, like the well-known late third-century sarcophagus now at Woburn Abbey, depict Hercules' hunt of the Calydonian Boar.[190] The comparison must have been irresistible.

DRAWINGS AFTER THE ANTIQUE

More specifically, however, the scene on the medal has been connected with a second-century sarcophagus, depicting the death of Adonis, then in Rome and now in the Palazzo Ducale in Mantua (fig. 3.49).[191] Although Pisanello himself is not the author of the parchment drawing in Berlin which copies (and 'restores') it (fig. 3.48), a drawing by him was probably the source for the draftsman, a member of his shop.[192] It is evidently

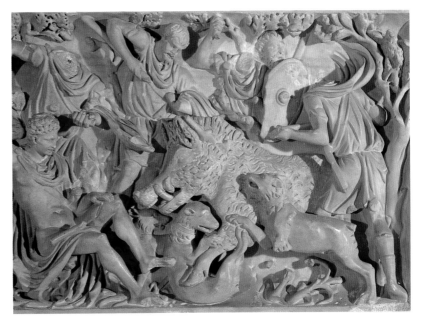

ABOVE

3.49 **Roman**
Sarcophagus relief: *The Death of Adonis* (detail), 2nd century
Marble
Mantua, Palazzo Ducale, inv. Gen 6734

LEFT

3.48 **Workshop of Pisanello**
Study of figures from *The Death of Adonis* from an ancient
sarcophagus, c.1431–40
Pen and ink over metalpoint on parchment, 18.8 × 11.9 cm
Berlin, Staatliche Museen zu Berlin, Kupferstichkabinett,
inv. 1358 recto

an important source for the medal, in particular for the pose of the boar, but Pisanello has not copied any part of the sarcophagus literally. Indeed he has made the king more antique than the antique source by rendering his protagonist heroically nude.[193] But, as he did with the 'Bacchus' on the reverse of his medal of Leonello with which we started this chapter, he has also made him believably human. In fact, although he is in a different pose, his youthful 'Alfonso' is usefully compared with Pisanello's life studies of two male nudes (with a saint or Prophet) – a sheet also in Berlin (figs. 3.50, 3.51).[194] The figures have the same build (and underwear), and display the same artistic treatment of the back. Their hair is even cut in the same way. This drawing is difficult to date (and has sometimes been doubted). It appears to be amongst the earliest to survive. However, its existence suggests others of the same kind, any of which might have been revisited by Pisanello when he was constructing Alfonso's medal. It is interesting (though perhaps coincidental) that its style and technique closely resemble his drawing of a wild boar, also an early work, now in Cambridge (see fig. 4.16).[195] By applying the fruits of his observation of nature to his investigation of the antique, Pisanello has similarly modified – naturalised – his ancient source.

 This medal is an admirable demonstration of Pisanello's approach to the antique. If the making of medals and portraits of Alfonso and his fellow rulers and the ways in which they were described by the humanists show that the artist was expected to

3.51 (detail of 3.47b) **Pisanello**
Portrait medal of Alfonso V of Aragon,
king of Naples, reverse

OPPOSITE
3.50 **Pisanello**
Two youths, a standing saint or Prophet, c.1430–5
Pen and ink over metalpoint on parchment,
28.3 × 19.1 cm
Berlin, Staatliche Museen zu Berlin,
Kupferstichkabinett, inv. 487 recto

perform as a modern Apelles or Lysippus, here was an appropriate visual language. Pisanello was looking to just the right kind of ancient artefact, but in imitating the antique he was also improving his sources by the very means advocated in ancient texts – by the truthful depiction of nature. He seems to have been following exactly the practice codified (though not invented) by Alberti in his treatise *On Painting*, of which the aim in part was to encourage a classically founded modern idiom for the representation of 'things seen'.[196] Alberti refers to only one surviving ancient artefact during the course of his text, when he relays the praise bestowed on an ancient sarcophagus relief with the dead Meleager, then to be seen in Rome. He further submitted, 'If it is a help to imitate the works of others, because they have greater stability of appearance than living things, I prefer you to take as your model a mediocre [ancient] sculpture rather than an excellent painting, for from painted objects we train our hand only to make a likeness, whereas from sculptures we learn to represent both likeness and the correct incidence of light'.[197] However, in discussing the 'composition of surfaces', Alberti identified a model that should take priority even over extant antiquities – nature: 'In order to achieve this [grace and beauty], there seems to me no surer way than to look at nature and observe, long and carefully, how she, the wonderful maker of things, has composed the surfaces in beautiful members.' In a later passage he wrote, 'The painter . . . must know all about movements of the body, which I believe he must take from nature with great skill'. These are only two of several statements of this kind.

Pisanello almost certainly drew from sarcophagi and other ancient remains in just the manner suggested by Alberti's text, although most of the drawings after the antique rendered in his style are actually by other hands. The group of parchment drawings in the so-called *Taccuino di viaggio* were executed largely by members of his workshop (the issue of their authorship will be debated in chapter V).[198] They are evidently copied after existing studies, for not only do they often combine motifs derived from different objects then at a variety of sites in Rome, they also exhibit otherwise inexplicable misunderstandings of their sources. A drawing in Oxford of two Maenads (with the costume study on the verso by another hand, see fig. 2.32) shows this clearly (fig. 3.52).[199] The figures derive originally from a Bacchic sarcophagus now in the Allard Pierson Museum in Amsterdam (fig. 3.53).[200] But the position of the two women has been switched and the draftsman has evidently been baffled by specific details within his source. The breasts of the woman playing a tambourine have been shifted into curious profile and are wrapped in a very peculiar sling, whereas in the sarcophagus they are draped in accordance with the rest of her costume and are placed in a more rational position on her torso. The pose of her companion, with her arms raised above her head, is weighted in the drawing in such a way that her posture ceases to make much sense. This is not simply a question of artistic reinvention of missing elements, though this, too, was a feature of most of the drawings, and can be seen, for example, in a drawing in the Ambrosiana in Milan (fig. 3.55), recording a rearing horseman from a sarcophagus fragment which originally depicted the Indian Triumph of Bacchus (fig. 3.54) now at Grottaferrata.[201] In the drawing the horse's legs and the right arm of its rider are complete. The fishy dragon on the right comes from the same family as a monster under the

celebrated relief in Ravenna of the Throne of Neptune.[202] Another drawing in Milan (see fig. 5.35), which copies, at one remove, a Bacchic relief now in the Vatican,[203] records parts of the composition: a three-figure group is reproduced in more or less the same relation to one another. But here, too, there are changes and misunderstandings. Bacchus's particularly inebriated pose has been sobered, his hair shortened and a cup with the profile of another celebrant behind it turned into a swirl of drapery in his left hand. His supporter has been slimmed down and given a vine-leaf wreath, and a nymph's tambourine has been removed and converted into a rather peculiar fold of drapery. Another more fragmentary figure, originally to the left of this group, has been moved to

3.52 **Workshop of Pisanello**
Studies of *Maenads*, c.1431–5
Pen and ink on parchment,
18.3 × 24 cm
Oxford, Ashmolean Museum,
inv. P.II.41 verso

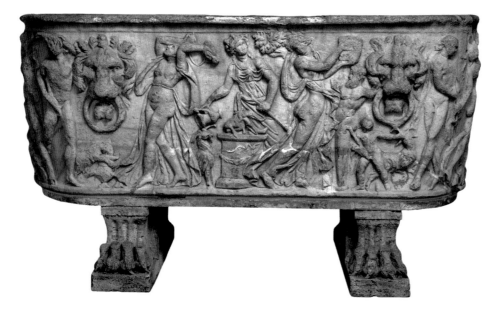

3.53 **Roman**
Sarcophagus with reliefs showing
Bacchic revels, c.200
Marble, 86 × 229.5 × 103 cm
Amsterdam, Allard Pierson Museum,
inv. 10854

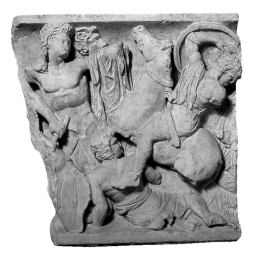

ABOVE
3.54 **Roman**
Sarcophagus relief: *The Indian Triumph of Bacchus*,
2nd century
Marble, 69 × 70 cm
Grottaferrata, Museo del Monumento Nazionale
della Badia Greca

RIGHT
3.55 **Workshop of Pisanello**
Study of figures from *The Indian Triumph of Bacchus*;
a dragon, c.1431–40
Pen and ink and brown wash over metalpoint on
parchment, 16.3 × 22 cm
Milan, Pinacoteca Ambrosiana, inv. F.214 inf. 14 recto

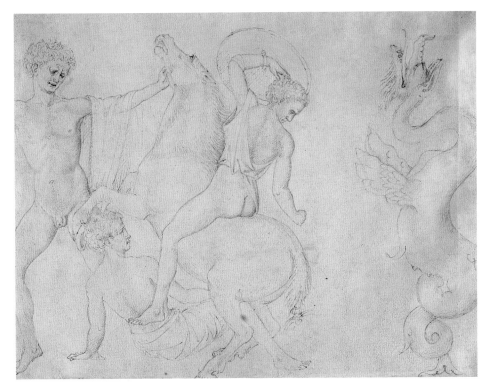

the right. Perhaps the fact that Bacchus appears to wear a lionskin in the relief (eliminated in the drawing) has suggested the addition of a Herculean club. Pisanello also seems to have studied two of the ancient sculptures most celebrated during the fifteenth century: his (lost) study must have been the source for a workshop drawing, also in the Ambrosiana (fig. 3.56), of one of the pair of 'Horse-tamers' (fig. 3.57) – representing the Dioscuri, Castor and Pollux – on the Quirinal in Rome (on the same site, at that time, as the reclining Bacchus–river-god, see p. 91).[204] This appreciation was partly due to the fact that the two then unidentified youths, struggling to control the horses in their charge, have erroneous inscriptions on their bases: *OPVS FIDIAE* (the work of Phidias) and *OPVS PRAXITELIS* (the work of Praxiteles). They were therefore considered as works by great artists, whose art had been described in detail in Pliny's *Natural History*, written about by humanists and imitated by painters and sculptors.

If these are copies after copies, can we be sure that the original copyist was Pisanello? It is hard to be certain. Only very few drawings after the antique have any claim to be Pisanello's. A parchment sheet in Rotterdam has on its recto figures from a sarcophagus with Jason and Medea now in Ancona (see fig. 5.6) and on its verso two Naiads riding sea-monsters and a Season, taken from other Roman reliefs (see fig. 4.8).[205] These drawings, which have much in common with the Berlin study of the 'Bacchus' related to the Leonello reverse with the reclining nude (see fig. 3.12), displays an energy and capacity for instinctive pattern-making which seem close to Pisanello's own works – the figures are excitingly combined, and the lion's head, for example, has a three-dimensionality alien to Pisanello's assistant. They are therefore plausible models for the type of drawing which Pisanello might have made available to his assistant or pupil. Indeed part of the function of such drawings may well have been teaching, in the way that the Paduan painter Francesco Squarcione was to use copies from the antique in his '*studium*'.[206]

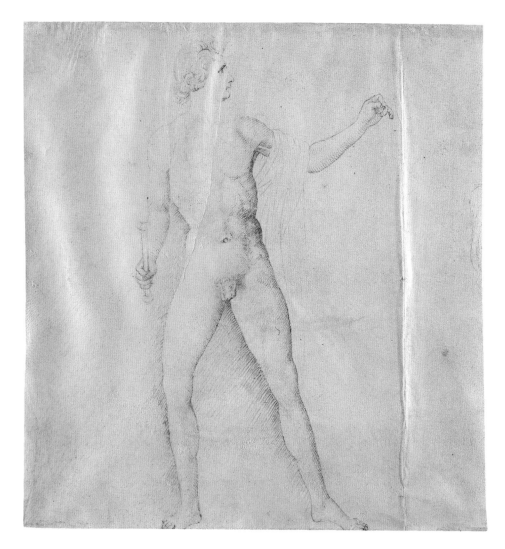

ABOVE

3.57 'Phidias' (Roman after a 5th-century Greek prototype)
'Horse-tamer' (Dioscurus)
Marble, 5.28 m high
Rome, Piazza del Quirinale

LEFT

3.56 **Workshop of Pisanello**
Study of the 'Phidias' 'Horse-Tamer' (Dioscurus)
(detail), c.1431–40
Pen and ink over metalpoint (for Dioscurus)
on parchment, 23 × 36 cm
Milan, Pinacoteca Ambrosiana,
inv. F.214 inf. 10 verso

There is, however, only one instance of a literal quotation from the antique in any of Pisanello surviving painted works. On the verso of his drawing of Greek and Roman coins (see fig. 3.6) is the head of a bearded man in a (faintly sketched) turban (fig. 3.58).[207] Pisanello's authorship of both recto and verso has been doubted, but it, too, appears sufficiently close in technique to the drawing of the stunned youth (see fig. 2.5) that it can probably be accepted as the master's. It has been convincingly proposed that it copies an antique sculpture, although it must be admitted that the precise source has not been recognised – perhaps a bronze bearded Bacchus in Modena.[208] It seems to have been made for one of the figures standing in a group in the middle ground of the Sant'Anastasia fresco (see fig. 1.21). It is exactly the same size, functioning perhaps as a sort of secondary cartoon (a drawing made to work out the details of a particular motif within a wider composition). It has been sensibly proposed that, by including this head, Pisanello was performing as another artist whose works were described by Pliny: Polygnotus of Thasus. Polygnotus was famous for his depiction of subtleties of expression and the display of his subjects' teeth; Pisanello's Saint George, too, shows his teeth. Although this motif may derive in the first instance from Gentile (for example in the *Adoration of the Magi*, see fig. 1.17), the figure of the saint dismounting (or mounting) his horse also recalls another

3.58 **Pisanello**
Head of a bearded man, c.1434–8
Pen and ink over black chalk on
red prepared paper, 21.7 × 19.3 cm
Paris, Musée du Louvre, inv. 2315 verso

description of a painting by Polygnotus, of a man whose stance suggests that he might
be either ascending or descending; thus this act of reverence reinforces the notion of
Pisanello as an 'ancient' artist.[209]

More usually, it is impossible to cite a direct antique source for Pisanello's works.
He viewed antiquity through the eyes of a painter of nature. This may have been a skill
developed partly as a result of the influence of the Limbourgs, but there was also an
ingredient that made Pisanello worthy of humanist praise. As we will see in the following
chapter, the descriptions of Pisanello's paintings praise his ability to depict nature above
all. These accounts followed a tradition connected with a famous description of Apelles'
picture *Calumny* (which had been translated into Latin by Guarino when he was still in
Constantinople) by the ancient author Lucian. To live up to such descriptions, to become
the modern Apelles that his patrons desired, Pisanello had to take account of ancient
precedent as it manifested itself in physical remains – but also of the ancient concept of
the painter as the talented recorder of nature.

IV Devotion, Poetry and Pleasure: The London Panel Paintings

*To Pisano of Verona has been ascribed almost a poet's talent for painting
the forms of things and representing feelings. But in painting horses and other
animals he has, in the opinion of experts, surpassed all others...*

BARTOLOMEO FACIO, biography of Pisanello, 1456

Only four undisputed panel paintings by Pisanello survive. Two of them, as we have
seen, are portraits (see figs. 3.2 and 3.19). The other two are religious paintings: *The Virgin
and Child with Saints Anthony Abbot and George* and *The Vision of Saint Eustace*, both in the
National Gallery. These exquisite, small-scale works may be typical of his several lost
panel paintings.[1] It is remarkable, however, that the sources make no mention of any
large-scale altarpiece, and none seems ever to have been executed, although two tiny
drawings for what seem to be altarpieces survive; one of these is connected with the
Malaspina chapel (see fig. 1.34).[2] Pisanello specialised primarily in frescoes on the one
hand and, on the other, in small, beautifully crafted paintings (and medals), in both cases
working (except early in his career in Venice and Rome) for private individuals rather
than ecclesiastic or civic institutions.

During the fifteenth century paintings of a certain category, much like gems, coins
or illuminated manuscripts, were viewed as collectors' items for individual delectation.
They were often valued as much for their aesthetic beauty as for their religious content.
The painting that pope Eugenius gave to Sigismund was, for example, described by
a fifteenth-century chronicler as amongst the 'noble jewels' given to the emperor.[3]
And when, in 1432 or 1433, Leonello wrote to his brother Meliaduse asking him to
send from Rome Pisanello's painting of the Virgin, he said he wanted it badly, both
to admire the skill of the painter (*'excellenti pictoris ingenio'*) and out of devotion to
the Virgin.[4] Although the concept of *ingenium*, describing the talent or ingenuity of
a painter, was relatively standard in the fifteenth century, it was also intimately linked
with the desire to put contemporary artists on a par with Pliny's heroes of ancient art:
this was the word regularly applied, for example, by humanist scholars to the antique
sculptures of the Dioscuri, known as 'Horse-tamers', on the Quirinal hill (see fig. 3.57).
During the fifteenth century, too, the scope of the visual arts, particularly vis-à-vis
literature, was a constant subject of humanist debate. So when, in 1462, Lodovico
Gonzaga was sent a small painting by Pisanello, which he had been pestering one
Prospero Canogli to acquire, described as being by the Homer of painting (*'opus Homeri
pictorum'*),[5] this simultaneously placed Pisanello at the forefront of both ancient and
contemporary artists and asserted his successful attainment of the status accorded
to ancient poets.

OPPOSITE
4.1 (detail of 4.35) **Pisanello**
The Vision of Saint Eustace: Saint Eustace

The Virgin and Child with Saints Anthony Abbot and George in the National Gallery (fig. 4.4) is an enigmatic work: no-one has fathomed its precise meaning, its date is uncertain, and the patron for whom it was painted is unknown. Even the signature on the painting, *Pisanus pi*[nxit] (fig. 4.2), is highly unusual by its disguise as plants growing on the pebbled foreground.[6]

4.2 (detail of 4.4) **Pisanello**
The Virgin and Child with Saints Anthony Abbot and George: Pisanello's signature

Superficially, the subject of the painting is straightforward, and its individual elements clearly identifiable. In the sky is a half-length Virgin holding the Child, who looks lovingly up into her face. They are both enclosed within a sun which emanates ripples of golden rays. Beneath them, in front of a forest, stands Saint Anthony Abbot. The saint traditionally carries a staff and bell and is accompanied by a pig: a bell was used for collecting alms, and pigs belonging to the Order of Saint Anthony were allowed to roam freely.[7] However, idiosyncratically in this picture, the saint has a fierce expression, and is brandishing his bell; instead of a plump and homely hog, there accompanies him a wild boar from the woods – presumably to convey the wilderness in which Anthony lived his eremitic life. Facing Saint Anthony is Saint George (fig. 4.7); his pose, resting on one foot, the other poised to move, is a mirror image of the Saint Raphael (fig. 4.6) in the San Fermo frescoes. He is dressed in field armour with a cross on his back, and behind him are two horses' heads, indicating that he is accompanied by a squire, as befits an equestrian knight.[8] Like that of Saint Anthony, the iconography of Saint George is somewhat unusual. His attribute of a dragon, curled around his feet, is not docile as in other examples in North Italian painting, but snarling at the boar.[9] The saint seems to have been deliberately secularised in that he is wearing a glorious straw hat with two feathers in place of a halo. As we have seen, another such hat is worn by a tourneyer in Pisanello's Mantuan mural (see fig. 2.8); they were greatly in mode at the time, probably following a northern fashion (fig. 4.5). They were known in Italy as 'Flemish hats', although Cremona in Lombardy became a centre of their specialised production. In a petition made to the court of Nicolò d'Este two Cremonese who wanted to set up a shop in Ferrara selling straw hats stated that they wanted to keep more beautiful things than other shopkeepers.[10] In 1451, Francesco Sforza ordered several of them through his treasurer Antonio da Trezzo – some for him, others for the marquis of Ferrara, the bishop of Modena and Sigismondo Pandolfo Malatesta.[11]

4.3 **Pisanello**
The Virgin and Child with Saints Anthony Abbot and George (see fig. 4.4) in its 19th-century frame

These departures from traditional iconography suggest that the painting was made to commission for a specific patron. It was always a single panel, an object to be admired for its aesthetic qualities, and originally had a gilded frame, which was removed at an unknown date.[12] The present elaborate gilded frame, containing casts of medals, the portraits of Pisanello and of Leonello d'Este (fig. 4.3), was constructed in the late nineteenth century. The paint surface of the picture was evidently intended by Pisanello to be highly decorative, with the use of gold leaf for the sun, gilded *pastiglia* for the horses' bridles, and silver leaf for Saint George's armour. However, its original beauty has been somewhat compromised by extensive restoration in the nineteenth century, when it was in the collection of the first director of the National Gallery, Sir Charles

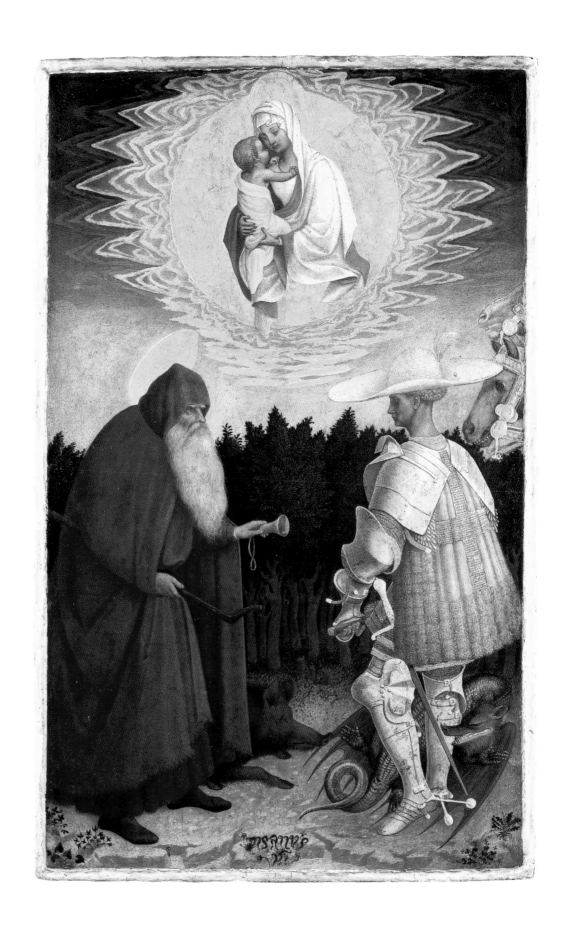

4.4 **Pisanello**
The Virgin and Child with Saints Anthony Abbot and George, c.1435–41
Egg tempera on wood, 46.5 × 31 cm
London, National Gallery, inv. NG776

4.5 **French**
Christine de Pisan, *Collected Works*, folio 95v (detail):
The Goddess Othea presenting her Epistle to
Hector of Troy, c.1400
Tempera on parchment
London, The British Library, inv. Harley 4431

4.6 (detail of 1.5) **Pisanello**
The Brenzoni monument, San Fermo:
the Archangel Raphael

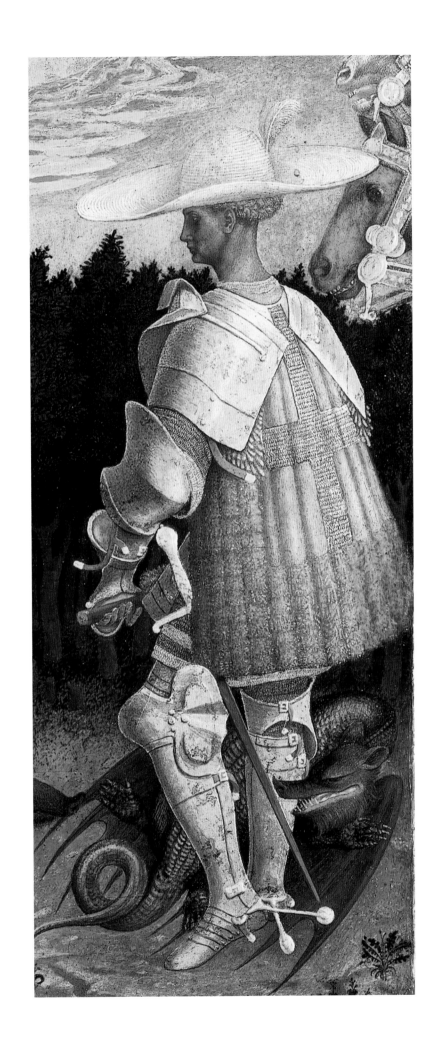

4.7 (detail of 4.4) **Pisanello**
The Virgin and Child with Saints Anthony Abbot and George: Saint George

ABOVE
4.9 (detail of 4.8)

LEFT
4.8 **Pisanello**
Studies of *Two Naiads riding sea-monsters* and
a *Season* from ancient sarcophagi, c.1431–2
Pen and ink and brown wash over metalpoint
on parchment, 21.2 × 15.6 cm
Rotterdam, Museum Boymans Van Beuningen,
inv. I.523 verso

Eastlake, by the Italian restorer Giuseppe Molteni.[13] The restoration by Molteni means that
very little of the present upper surface of the painting is original, although examination
under magnification reveals clearly where original paint remains.[14] Molteni appears to
have followed Pisanello's painting reasonably faithfully, usually reconstructing on the
basis of and often over original layers of paint. There are fragments of original gold at
the edge of the Child's head and on the bit of the lower horse at the right, but the rays of
the sun have been redone in gold paint and the rest of the gold in the painting has been
regilded. The sky, too, has been heavily repainted using, probably, Prussian blue, which
is a poor match for the original ultramarine, and the foliage of the wood behind has also
been extensively repainted. The flesh tones of the Virgin and Child are very worn; what
is visible seems to be the underdrawing, reinforced by Molteni with thin scumbles. The
Child's profile has been slightly distorted by Molteni and his hair repainted. The lining
of the Virgin's robe, which was originally ultramarine, has been considerably repainted.
Saint Anthony Abbot's habit is abraded and repainted throughout, although the textured
effect of his cloak is original. His face and beard have been heavily restored (though his
original expression is preserved), as have his hands, with the exception of the tip of his
left thumb, which is original. Saint George's armour has been entirely renewed with small
pieces of metal leaf (probably not silver, since it remains untarnished), as has the incised
pattern of the cross and its mail effect. The saint's hat has been repainted, particularly at
the left brim, but traces of original paint, particularly in the crown and feathers, show that

4.10 (detail of 5.6) **Pisanello**
Studies of figures from an ancient sarcophagus of *Jason
and Medea*: head and torso of one of Medea's children
Rotterdam, Museum Boymans Van Beuningen,
inv. I.523 recto

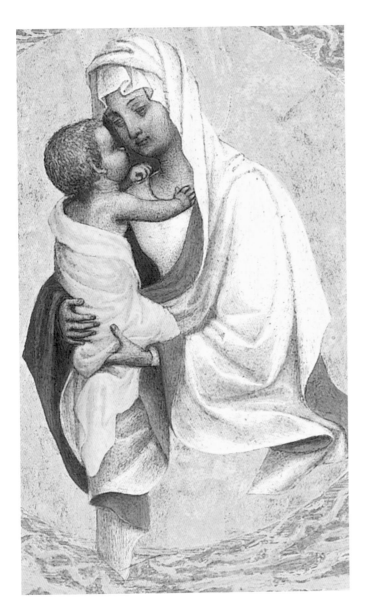

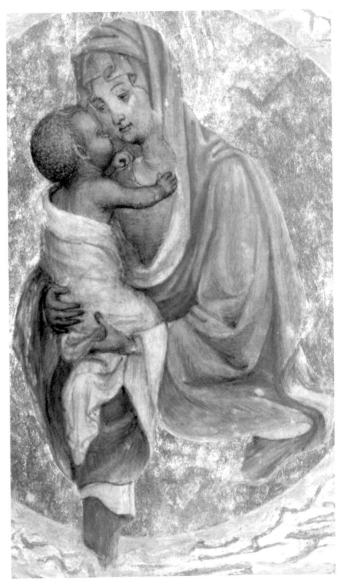

ABOVE LEFT
4.11 (detail of 4.4) **Pisanello**
The Virgin and Child with Saints Anthony Abbot and George: the Virgin and Child

ABOVE RIGHT
4.12 **Pisanello**
The Virgin and Child with Saints Anthony Abbot and George: infra-red reflectogram: the Virgin and Child

the restorer has been faithful to the original appearance. The contours of his face are essentially original but from the tip of his nose downward the sky has been retouched, encroaching upon and distorting the profile.

The underdrawing of the Virgin and Child, much more visible with infra-red reflectography (fig. 4.12), is stylistically very close to drawings in the so-called *Taccuino di viaggio*, an album of drawings by Pisanello and (mostly) his workshop (discussed on pp. 197–202). Amongst its copies after the antique is the sheet attributable to Pisanello himself with Jason and Medea and a dragon on the recto (see fig. 5.6) and two Naiads riding a sea-monster on the verso (fig. 4.8).[15] The apparent discrepancies between the two drawings are due to the fact that one is drawn on the smooth (flesh) side and one on the rougher (hair) side of the parchment. The three-quarter profile of the Virgin in the panel painting is close to the figure of a Season on the verso (figs. 4.9, 4.11, 4.12), and the profile of the Child, with its curiously pointed ear, is close to the child emerging from the dragon on the recto (fig. 4.10).

As we have seen, drawing was for Pisanello an essential part of the creative process. On a surviving sheet (figs. 4.13, 4.14) he seems to have made a preparatory drawing for the Virgin and Child (now barely visible), which he rubbed out, re-using the sheet the other way up for the study of a leg, a squid and a plant.[16] All the rest of the surviving drawings that can be related to the picture are, however, stock patterns. For example, the relatively docile boar in the painting (fig. 4.15) is close to two studies that Pisanello evidently made earlier, one at least from life (figs. 4.16, 4.17).[17] The watercolour of the boar in the Louvre (see fig. 4.17) is one of Pisanello's most remarkable achievements, and very close in procedure to his work in tempera and fresco. First he did an underdrawing in black chalk and metalpoint. The outlines are kept to a minimum – around the eye, snout, hooves and hocks. Then the bristles of the boar, conveying the structure of its body, are built up entirely with layer upon layer of ink hatching and cross-hatching over coloured washes, the extremely fine strokes changing in density and direction to create ear, jaw, haunches and so on, with tiny, almost imperceptible traces of white heightening on the inside of the ear, around the eye, along the cheek and over the black along the bottom of the jaw. The ground is indicated with small hooked strokes, against which the solid form of the boar stands out – we find the same contrast in Pisanello's study of a hoopoe (see fig. 4.73). The dragon in the painting (fig. 4.18) is close in type to that in the

BELOW LEFT

4.13 Pisanello
Studies of a squid, a human leg, flowers, the Virgin and Child, c.1435–41
Pen and ink over metalpoint or black chalk, with watercolour (for the squid); for the Virgin and Child metalpoint or black chalk only, 24.4 × 18.5 cm
Paris, Musée du Louvre, inv. 2262

BELOW
4.14 (detail, rotated, of 4.13)

ABOVE
4.15 (detail of 4.4) **Pisanello**
The Virgin and Child with Saints Anthony Abbot and George: Saint Anthony's boar

ABOVE RIGHT
4.16 **Pisanello**
Wild boar, c.1430–5
Pen and ink and brown wash on parchment,
9.9 × 16.8 cm
Cambridge, Fitzwilliam Museum, inv. PD. 124-1961

RIGHT
4.17 **Pisanello**
Wild boar, c.1434–45
Pen and ink, watercolour, and white heightening
over black chalk or metalpoint, 14 × 20 cm
Paris, Musée du Louvre, inv. 2417

ABOVE
4.18 (detail of 4.4) **Pisanello**
The Virgin and Child with Saints Anthony Abbot and George:
Saint George's dragon

RIGHT
4.19 **Pisanello**
Design for a dragon salt cellar, c.1448–9
Pen and ink and brown wash over black chalk, 19.4 × 28.3 cm
Paris, Musée du Louvre, Inv. 2289

Sant'Anastasia fresco (see fig. 1.21) and again to a design of a dragon salt cellar made by Pisanello late in his career (fig. 4.19);[18] all three may derive from a single original.

Pisanello made numerous drawings of horses, evidently from life, and used these studies variously in his paintings, adapting them to the scale required. The two horses in the National Gallery painting relate to drawings of horses' heads belonging to a group that can also associated with the Sant'Anastasia frescoes (see p. 29). Three such drawings, all from the same sketchbook, are attributable to Pisanello himself.[19] A Louvre drawing (fig. 4.20) is one of several in which Pisanello studied the nostrils of horses, with their tongues and teeth, sometimes with bit and sometimes bridle. Here with short, dense, directional strokes, Pisanello conveys the different textures on the horse's head, studying on a single sheet the calmness of a closed mouth and then the effect when the mouth is forcibly opened by the insertion of a bit, causing the nostrils to wrinkle – seen from two different angles. A differing weight of line conveys whiskers on the outer chin or jaw and the hairs of the horse's coat and the direction of its growth, the paper being left blank to indicate raised veins. Another study (fig. 4.22), with the mouth open, showing the bit, is a more developed version. Both drawings relate to the grey horse behind Saint George in the panel painting; this is a reduced version of the horse with open mouth and raised tongue in the Sant'Anastasia frescoes (fig. 4.24), for which the drawings were also used. A third and still more developed drawing (fig. 4.23) relates to the brown horse in the panel painting. The jaws of the grey horse reappear on the reverse of the medal of Francesco Sforza (see fig. 3.38b), which can plausibly be dated

to around the period of his marriage to Bianca Maria Visconti on 28 October 1441.[20]

This series of drawings of horses' heads may have been made in the first instance with the creation of the Sant'Anastasia frescoes in mind, and these, as we have seen, can be placed between 1434 and 1438 (see p. 22). Although *The Virgin and Child with Saints Anthony Abbot and George* has been dated variously from the early 1430s to the late 1440s,[21] the link via these drawings with the frescoes suggest that in fact it was made either concurrently or, more likely, very soon after them. Furthermore, the two horses' heads at the side break into the composition just as in the fresco, and the placing of the figures on the creviced, pebbled ground and their unnaturalistic relationship to the forest forming a screen in the background are also very similar. In the panel painting, however, the figures are placed in a subtler diagonal relationship. Saint Anthony faces forward in three-quarter view opposite Saint George seen from the back in three-quarter view. The forests in both painting and fresco are very alike – trees with spindly trunks and small, dense leaves; much of the profile of the forest in the panel painting has been repainted, but enough of the original remains to reveal a close match with the foliage in the fresco.

Indeed the woodland in both works finds its source in French manuscript illumination, in particular that of the Limbourg brothers (fig. 4.25), whose work, as we have seen, Pisanello copied (see figs. 2.16, 2.17 and p. 60).[22] Both the division of the composition into two halves and the iconography of the Virgin and Child in a sunburst derive from a composition by the Limbourg brothers in their *Très Riches Heures* of *The Tiburtine Sibyl*

ABOVE LEFT
4.20 **Pisanello**
Studies of the mouth and nostrils of a horse,
c.1434–8
Pen and ink over black chalk,
17.2 × 23.8 cm
Paris, Musée du Louvre, inv. 2352

ABOVE
4.21 (detail of 4.4) **Pisanello**
The Virgin and Child with Saints Anthony Abbot and George: horses' heads

ABOVE LEFT

4.22 **Pisanello**
Head of a horse, c.1434–8
Pen and ink over metal- or leadpoint,
23.5 × 16 cm
Paris, Musée du Louvre, inv. 2355

ABOVE

4.23 **Pisanello**
Horses' heads, c.1434–8
Pen and ink over black chalk,
29.1 × 18.4 cm
Paris, Musée du Louvre, inv. 2354

4.24 (detail of 1.21) **Pisanello**
Saint George and the Princess of Silena,
Sant'Anastasia: horses' heads

showing the emperor Augustus the Virgin and Child (figs. 4.27, 4.28)[23] – she was revealed to Augustus '*in circulo iuxta solem*' (in a circle beside the sun), a vision that was iconographically fused with the description in Apocalypse 12:1, of '*mulier amicta sole*' (a woman clothed with the sun). Related compositions are seen, for example, in the Limbourgs' *Belles Heures* of the New York Cloisters (figs. 4.30, 4.31). The position of the Virgin's hands, especially the left hand, in Pisanello's painting is particularly close to those of the Virgin and Child in a Book of Hours of around 1420 from the Limbourg circle (fig. 4.26),[24] of which a version was drawn by a member of Pisanello's workshop (fig. 4.29), who presumably based it on a variant put at his disposal by the master.[25]

4.25 **Limbourg brothers**
Les Très Riches Heures, folio 5v: *May*, 1413–16
Tempera and gold on parchment, 29 × 21 cm
Chantilly, Musée Condé, inv. MS 65

4.26 **Circle of Limbourg brothers**
Book of Hours, folio 225r: *The Virgin and Child*, c.1420
Tempera on parchment, 22 × 15.5 cm
Philadelphia, The Free Library of Philadelphia,
Rare Book Department, inv. Widener MS. 6

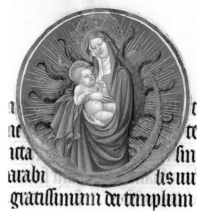

ABOVE
4.28 (detail of 4.27)

LEFT
4.27 **Limbourg brothers**
Les Très Riches Heures, folio 22v: *The Tiburtine Sibyl
showing the emperor Augustus the Virgin and Child*,
c.1413–16
Tempera and gold on parchment, 29 × 21 cm
Chantilly, Musée Condé, inv. MS 1284

4.29 **Workshop of Pisanello**
The Virgin and Child, c.1434–8
Pen and ink over black chalk on
red prepared paper, 19.1 × 26.2 cm
Paris, Musée du Louvre, inv. 2623

ABOVE
4.31 (detail of 4.30)

LEFT
4.30 **Limbourg brothers**
Les Belles Heures, folio 26v: *The Tiburtine Sibyl showing
the emperor Augustus the Virgin and Child*, c.1406–9
Tempera and gold leaf on parchment, 23.8 × 16.8 cm
New York, Metropolitan Museum of Art,
The Cloisters, inv. MS 54.11.1.

The Virgin and Child with Saints Anthony Abbot and George is very much like a manuscript illumination of the kind made for French rulers, and a number of attempts have been made to link it with Pisanello's court patrons, primarily the Gonzaga and the Este. The painting had been acquired by Giovanni Battista Costabili from the Pasetti collection, probably in Ferrara, at an unknown date, and Pisanello's portrait of Leonello d'Este (see fig. 3.2) was also owned by him. Because of the Ferrarese provenance it has been suggested that this might be the painting of the Virgin that Leonello d'Este asked his brother Meliaduse to send,[26] but the subject does not correspond precisely enough: no mention is made of the saints (although the Child might be taken as read). It has been suggested that in any case it was commissioned by Leonello d'Este, whose profile (see figs. 3.40, 3.43) has been seen in that of Saint George.[27] However, Saint George's profile, even before Molteni's restoration, bears only a vague resemblance to Leonello, and Pisanello's desire for consistency as a portrait painter would surely have ensured that it would very precisely resemble his other images of Leonello had it been intended to do so. It has also, for the same reason, been identified with a painting for the Este palace of Belriguardo for which Pisanello was paid 50 gold ducats by Leonello in 1445.[28] However, the subject of that painting is not specified, making the identification impossible to confirm, and the sum of 50 ducats implies a larger and grander commission. The iconography of the National Gallery work does not contradict a Ferrarese origin. Ferrara possessed a relic of Saint George, who was a patron saint of the city, and devotion to him and to Saint Anthony was widespread there. In the fifteenth century solemn processions requiring the attendance of the guilds and the officials of the commune took place in honour of Saint George, Saint Dominic and Saint Anthony Abbot.[29] There was close contact between the Este family and the Order of Saint Anthony in Ferrara,[30] and Nicolò d'Este made pilgrimages to the abbey of St-Antoine-en-Viennois in 1414 and 1434.[31] But the case is by no means made.

It has also been suggested that Saint George is a patron-portrait of Lodovico Gonzaga,[32] although again the profile in Pisanello's portrait medal (see fig. 2.25) and the original profile of Saint George in the painting bear little resemblance to each other. However, it is possible that this was a Gonzaga commission. The Gonzaga had the arms of Saint George added to their own in 1433, and one critic has cited numerous instances in the Gonzaga inventories of arms and objects bearing the arms of Saint George in favour of the idea that the National Gallery painting was a Gonzaga commission of about 1447–8.[33] By this argument a drawing of the Virgin and Child which appears on a sheet with Gonzaga emblems (fig. 4.32) has been considered a preparatory drawing for *The Virgin and Child with Saints Anthony Abbot and George*; however, the study is for a Madonna of Humility, seated on the ground, with God the Father and angels above on either side, and the hint of a border at the left indicates that this is probably a study for a painted page.[34]

Perhaps the most likely patron of this painting, however, though he has not hitherto been associated with it, is Filippo Maria Visconti, duke of Milan, whose portrait Pisanello painted, as well as cast in a medal (see fig. 2.24). One of the most important Visconti

emblems was the blazing sun: it radiates from almost every one of the illuminations of the Visconti Hours, painted for Giangaleazzo Visconti (died 1402) by Giovannino and Salomone de' Grassi around 1388–91. The blazing sun is usually placed at the top of the page, or integrated with the scene depicted. The motif inevitably became associated with the Vision of Augustus, as she appears in the margin of the illumination of the Sermon on the Mount (fig. 4.33, 4.34).[35] Giangaleazzo's patron saint was Saint Anthony Abbot: in his will he desired his viscera to be buried in St-Antoine-en-Viennois.[36] Filippo Maria inherited from his father both the emblem of the blazing sun[37] and his cult of Saint Anthony, who is named first in the list of saints to whom he was devoted by Pier Candido Decembrio in his biography of the duke.[38] It is not impossible that the painting was commissioned on the occasion of the marriage of Bianca Maria Visconti to Francesco Sforza on 28 October 1441. The warrior saint could easily be associated with the bellicose *condottiere* and certainly, once Sforza attained power in Milan, Saint George's day became an occasion for important civic ritual.[39]

4.32 **Pisanello**
The Virgin of Humility,
Gonzaga arms, two courtiers,
ornamental motifs
Pen and ink, 27.7 × 19.5 cm
Paris, Musée du Louvre,
inv. 2278

FAR LEFT
4.33 (detail of 4.34)

LEFT
4.34 **Giovannino de' Grassi**
The Visconti Hours,
folio 150v: The Sermon
on the Mount; the Tiburtine
Sibyl showing the emperor
Augustus the Virgin and Child,
c.1388–91
Ink, tempera and gold leaf on
parchment, 24.7 × 17.5 cm
Florence, Biblioteca
Nazionale, Banco Rari 397

However, devotion to Saints George and Anthony was widespread in northern Italy, and they often appear together.[40] A case can therefore be made that the National Gallery picture may have been destined for almost any of the northern cities in which Pisanello worked during his peripatetic life. Nevertheless it is rare for Saint Anthony and Saint George to be combined alone, and the specific way in which they are depicted, and the placing of the figures within the composition, might imply a particular motivation behind the commission. Despite the fact that the Virgin and Child have been shown to derive from the Limbourgs' *Apparition of the Virgin and Child to Augustus*, the painting is not a narrative; it in no sense depicts a vision revealed to the saints. Indeed it has been widely remarked that they appear to be utterly oblivious to the Virgin and Child. The iconography of the Virgin and Child in a sunburst is a device for isolating them in glory in the sky for the benefit of the viewer, looking at the painting for aesthetic or devotional reasons. However, although this is not a narrative as such, there is a significant action in the foreground: Saint Anthony is shaking his bell aggressively and the dragon, supposedly wounded by Saint George, is baring its teeth at the boar. One can interpret this confrontation in several ways, and the painting was probably intended to be read on several different levels. The two saints may represent, for example, the contrast between the ascetic and courtly way of life, the contemplative versus the active. It has been proposed that they represent the binding together of the monastic and courtly ideals, linked by the Virgin and Child.[41]

Like *The Virgin and Child with Saints Anthony Abbot and George*, *The Vision of Saint Eustace* (fig. 4.35) is a small panel painting created ostensibly for private religious contemplation in a domestic context. Again, the patron and the date of the painting are not known, and it has been dated by various scholars to almost every stage in Pisanello's professional life.[42]

The Vision of Saint Eustace has always been an autonomous painting. The panel has been cut at the top: the X-radiograph shows that ragged rectangular patches of canvas were applied irregularly over the surface, possibly to cover knots in the wood, and one such, now a triangle remaining at the top right-hand corner, indicates that the panel was originally a taller oblong. The original shape of the painting before it was cut down is reflected in the painting formerly in the Cini collection, Venice (fig. 4.36), now lost to sight, which appears to be a sixteenth-century copy made in northern Europe (though it has also been suggested that it is a nineteenth-century copy of a copy). The copyist has made some radical changes: he has altered the costume of Saint Eustace to conform to northern sixteenth-century fashion, and inserted a Netherlandish style of landscape and a chamois behind the main focus of the narrative; apparently unhappy with the unnaturalistic background and discrepancies in scale of the original, he adjusted the composition by moving birds around to different positions. For example, the swan has been moved from the top left to the centre front, the bird in flight in the forest above the fleeing hare has been moved to the right behind the crucifix, and the bird in flight above the crucifix to the centre in front of the horse's head. The stork has been moved from the central background to the bottom right-hand corner. The most radical change is the shift of the stag, well above the saint in the Cini picture. But that the painting probably reflects the original whole of the National Gallery picture is confirmed by the inclusion of a heron immediately behind the stork in the bottom right-hand corner, with its neck and beak stretched upwards: this detail is not found in the picture in its present state but is found in a workshop drawing which clearly repeats Pisanello's models (fig. 4.37).[43]

The condition of *The Vision of Saint Eustace* is somewhat deceptive.[44] Like *The Virgin and Child with Saints Anthony Abbot and George*, it has been considerably repainted. The surface has suffered in the figure of Saint Eustace and in the animals and birds: these are abraded and have mostly been extensively retouched, although the original forms have been faithfully followed. The landscape background is less rubbed but has darkened considerably, obscuring much of the detail, probably because Pisanello, it seems, underpainted areas of green with black, and also because malachite, which tends to darken, was the main green pigment; the paint is raised in places, partly owing to the thick and crusty nature of malachite. The background is well preserved, particularly the flowers and foliage around the horse and hounds. The pale, pebbled foreground has been extensively repainted; a very few fragments of original paint remain. In Saint Eustace and his horse all the gold has been renewed, possibly over traces of original gold: the saint's jacket has been completed regilded, incised with a pattern and the folds

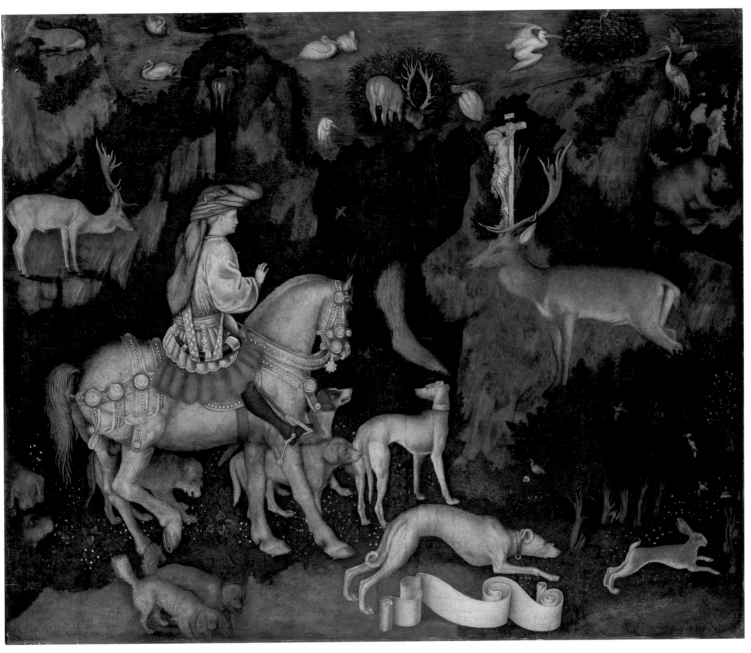

4.35 **Pisanello**
The Vision of Saint Eustace, c.1438–42
Egg tempera on poplar, 54.8 × 65.5 cm
London, National Gallery, inv. NG1436

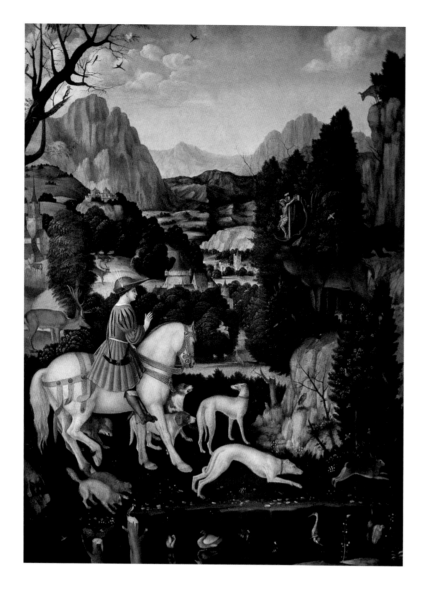

FAR LEFT
4.36 **Netherlandish or German (?) after Pisanello**
The Vision of Saint Eustace,
16th (or 19th?) century
Formerly Cini Collection, Venice

LEFT
4.37 (detail of 5.4) **Pisanello**
Herons: standing heron
Paris, Musée du Louvre,
inv. 2471 recto

modelled in a brownish glaze. The areas of *pastiglia* have been regilded but the *pastiglia* itself is clearly original. The saint's hat and face are largely well preserved, with minor retouchings, while the fur of his jacket has been entirely repainted over traces of original paint, as has his hose. His horse was originally a whitish grey, but the extensive retouching has discoloured, resulting in a brownish, dappled effect.

In contrast to the thick painting of the landscape background, the animals were relatively thinly painted, in order to maintain the reflectance of the underlying surface. Some have been almost entirely repainted, such as the bear at the top right, with a paint that is now reddish brown used elsewhere by the restorer, for example in the stag with the crucifix, the hare, the stag behind Saint Eustace, the hound standing behind the saint. Another distinctive feature of the restoration is the use of a white paint with a viscous texture, used to reconstruct for example the white velvetting near the top of the left antler of the stag with the crucifix (whereas the white velvetting of the upper part of the antler or the antlers of the other stag is original and has been subtly done), the left end of the scroll, and the white highlight along the top of its central part. The scroll's right end is original. There is no remaining evidence that it ever bore any lettering.

Pisanello depicts Saint Eustace, dressed in the height of court fashion in a golden fur-edged jacket and a blue headdress, with a decorated hunting horn with gilded mounts, out hunting with his hounds, one of which is coursing a hare. Pisanello's characteristic authenticity extends even to the gilded rowel-spurs worn by the saint, so close to surviving examples of the period (figs. 4.38, 4.39). Before him is a stag with a crucifix between its antlers, the cross inscribed INRI (*Jesus Nazarenus Rex Iudeorum*, Jesus of Nazareth king of the Jews). Eustace's story, like those of Saint George and Saint Anthony Abbot, is told in the *Golden Legend*: while out hunting, Placidus, a soldier of the emperor Trajan known for his good works, had a vision of a stag with a glowing cross with an image of Christ between its antlers. Christ spoke to him (either through the stag's mouth or through the image), saying: 'O Placidus, why are you pursuing me? For your sake I have appeared to you in this animal. I am the Christ whom you worship without knowing it. Your alms have risen before me, and for this purpose I have come, that through this deer which you hunted, I myself might hunt you.' Placidus was converted to Christianity, changing his name to Eustace.[45]

Pisanello has closely followed the details of the *Golden Legend*. A similar story of a vision of a stag with the crucifix between its antlers is told of Saint Hubert.[46] The identification of the National Gallery figure as Saint Eustace rather than Saint Hubert depends largely on the similarities of the painting to the story told in the *Golden Legend* and on the fact that Pisanello painted Saint Eustace opposite Saint George in Sant'Anastasia (see p. 22). Saint Hubert is anyway less likely to be painted in Italian art of this period. Saint Eustace, like Saint George, embodied the ideals of the Christian knight. The painting provided the patron with the opportunity to identify both with those ideals and with Eustace as a huntsman, since, as we have seen (pp. 75–85), hunting was a favourite, and value-laden, aristocratic pastime. Once again the chivalric ideology enshrined in the image is related to northern art. The animals are not painted to scale, but dotted around the landscape in a manner reminiscent of some Netherlandish tapestries

ABOVE
4.38 **Italian**
Rowel-spur, c. 1460
Tinned steel, 4 × 7.5 × 23 cm; 135g
Leeds, Royal Armouries Museum, inv. VI.322a

RIGHT
4.39 (detail of 4.35) **Pisanello**
The Vision of Saint Eustace: Saint Eustace's spur

4.40 **Netherlandish**
Tapestry, 2nd quarter 15th century
Wool and silk on woollen warps,
114.3 × 194.3 cm
London, Victoria and Albert Museum,
inv. T37-1914

(such as fig. 4.40), of which Pisanello would have seen numerous examples in the courts he frequented. This type of tipped-up landscape can also be found in French manuscript illumination by the Limbourg brothers and others, and indeed the panel painting is very much like the painted pages of the many hunting treatises then in circulation.

Not an altarpiece, not merely a narrative, but a pretext for showing Pisanello's skill in depicting different animals and for the patron to marvel at their poetic variety and at the mystery of the inhabitants of the wooded landscape. Around the central figures of Eustace and the stag are two more stags, and a doe in the upper left part of the picture; to the right a bear creeps slyly away. The various birds and animals on either side of the wooded ravine which divides the composition include a hoopoe, swan and stork, pelicans and herons. Although this is ostensibly a religious painting, it probably originated in the context of secular patronage. For Pisanello has painted not a Roman soldier but a fifteenth-century Italian prince, out hunting alone with his hounds. The painting would have evoked hunting treatises such as *Le Livre du roy Modus et de la royne Ratio* (see p. 85 and fig. 2.44), which describes the vision of Saint Eustace in detail, linking the ten-pronged antlers of the stag to the Ten Commandments.[47] Indeed Pisanello's painting is informed by knowledge of the illuminations in the canonical manuscript of that other famous hunting treatise, the *Livre de Chasse* by Gaston Phébus.[48] The position and pose of the bear at the right-hand side of the painting (fig. 4.43) appears to have been derived from an illumination in a manuscript of this treatise (fig. 4.42).[49] The treatise also covers the hunting of hares and stags, amongst other animals, and the forest is recommended as the best location for tracking down the stag.[50] The different breeds of dog accompanying

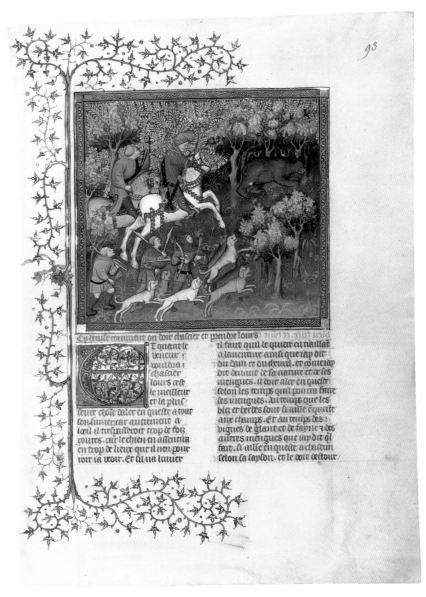

4.42 **French**
Gaston Phébus, *Le Livre de Chasse* (Book of Hunting),
folio 93v: *Bear hunt*, 1387–9
Tempera and gold on parchment, 35.7 × 25 cm
Paris, Bibliothèque nationale, inv. Ms français 616

ABOVE LEFT
4.41 **Pisanello**
Two studies of a bear, *c.*1434–42
Black chalk over stylus, traces of pen and ink,
24.3 × 17.2 cm
Paris, Musée du Louvre, inv. 2414 recto

LEFT
4.43 (detail of 4.35) **Pisanello**
The Vision of Saint Eustace: bear

4.44 folio 46v (detail)l: *Greyhounds ('levriers')*

4.45 folio 47v (detail): *Running hounds ('chiens courants')*

4.46 folio 45v (detail): *Alaunts ('alanz')*

4.47 folio 50r (detail): *Spaniels ('chiens doysel')*

4.44–4.47 **French**
Gaston Phébus, *Le Livre de Chasse* (Book of Hunting), 1387–9
Tempera and gold on parchment, 35.7 × 25 cm
Paris, Bibliothèque nationale, inv. Ms français 616

Eustace were especially prized for their skills in hunting specific quarry:[51] the greyhound ('*levrier*') coursing the hare (fig. 4.44) and the brown greyhound behind it were esteemed for their swiftness;[52] behind the latter seems to be a running hound ('*chien courant*') (fig. 4.45), which pursued their quarry not by sight but scent, and were particularly used in the hunting of stags.[53] At the horse's hindquarters may be an alaunt ('*alanz*') (fig. 4.46): these were more massive, especially in the head, and were used for hunting bears, wild boars and wolves.[54] At the bottom left-hand corner are spaniels ('*chiens doysel*') (fig. 4.47), used for flushing out birds and small game, especially partridge and quail.[55]

The patrons suggested for the painting have been almost as various as the dates proposed. They include inevitably the Gonzaga.[56] It might equally have been made for Filippo Maria Visconti, whose love of hunting Decembrio stressed in his biography.[57] That it was commissioned by a member of the Este family is just as plausible. Certainly Leonello was as keen on hunting as any of his contemporaries and the passion of his younger brother, Borso, was so great that he ennobled his falconer and the keeper of his hounds.[58] In addition, the compositional and thematic relationship of the picture to the reverse of Pisanello's medal of John VIII Palaeologus (see fig. 1.35b) might suggest that it was commissioned in the context of the Council of Ferrara. Both images show famously keen huntsmen stopped in their tracks by the image of a cross.[59] It is possible, of course, that the compositional similarities of the two works may result from this closeness of subject-matter. However, it is conceivable that the emperor, on the medal, is being presented as a secular Saint Eustace, diverted from worldly pleasure (albeit a pleasure which showed off his military skills) and filled with the religious zeal for a Church union that would combat the encroaching Turk.

It is quite wrong to suppose that, in his description of Saint Eustace in the Pellegrini chapel, Vasari was referring to this painting,[60] although it remains a possibility that a member of the Pellegrini family commissioned it for private use. However, one preparatory sketch for *The Vision of Saint Eustace* connects the picture with the frescoes of Sant'Anastasia, a link which may be helpful in dating the National Gallery picture. This is a rapid sketch of a horseman (fig. 4.51):[61] Pisanello has turned the page in order to represent the full length of the horse's body, but has omitted the rider's head, which was presumably the subject of a separate study, now lost. This sheet has on its verso (fig. 4.48) a number of sketches for the body of the crucified Christ, ranging from an extraordinarily schematic head and torso to two highly finished studies for the two outstretched, but clenching, hands, all the more remarkable considering the small scale of the crucifix in the final painting (fig. 4.49); Christ's right hand is barely visible there. This drawing was later cannibalised for the reverse of the medal of Domenico Malatesta (fig. 4.50). To the right of the sheet is a summary sketch for a figure hanging from a gibbet: the hanged men were included by Pisanello in the background to the fresco of Saint George and the Princess. Moreover, a rapid sketch of flying egrets (fig. 4.52) made for the fresco has been adapted, with a change in the position of the bird's wings, to show the flight of a pelican for the painting (fig. 4.53).[62]

The planning of *The Vision of Saint Eustace* can be followed in the several other surviving drawings of individual motifs, these apparently unconnected with the

4.48 **Pisanello**
Studies for a crucifix, a gibbet,
c.1434–8
Pen and ink over black chalk on red
prepared paper, 26 × 19.5 cm
Paris, Musée du Louvre,
inv. 2368 verso

4.49 (detail of 4.35) **Pisanello**
The Vision of Saint Eustace: the crucifix between
the antlers of the stag

4.50a, b **Pisanello**
Portrait medal of Domenico Malatesta Novello,
lord of Cesena, c.1446–52
Cast bronze, diam. 8.6 cm
London, Victoria and Albert Museum,
inv. 4577-1857

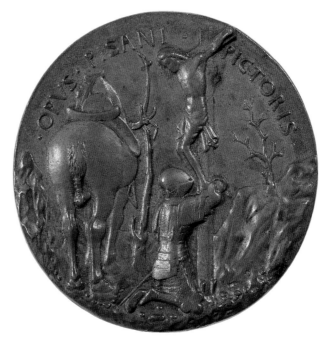

4.51 **Pisanello**
Horse and rider, c.1434–8
Pen and ink on red prepared paper, 19.5 × 26 cm
Paris, Musée du Louvre, inv. 2368 recto

4.53 (detail of 4.35) **Pisanello**
The Vision of Saint Eustace: pelican

4.52 **Pisanello**
Flying egrets, c.1434–8
Pen and ink, 16.5 × 24.7 cm
Paris, Musée du Louvre, inv. 2469 recto

Sant'Anastasia frescoes. Pisanello's sources fall into three approximate categories: rapid and apparently spontaneous sketches for the composition, like those described above; detailed studies from nature, apparently made specifically for this painting; and re-used pattern-book drawings, some revisiting earlier patterns by other artists. They vary in the media used, suggesting an eclectic and sporadic process of conceptualisation.

Pisanello's skill in depicting a hound coursing a hare (fig. 4.57; see fig. 4.81) is mentioned in eulogising poems (see below), and was a popular one in North Italian painting. The earliest occurrence of the motif in Pisanello's ambience seems to be a copy, either autograph or (more likely) by a member of his workshop, after a Lombard artist (figs. 4.54, 4.55).[63] Pisanello's watercolour of a running hare (fig. 4.58) also derives in the first instance very probably from a pattern drawing, such as the one in the sketch-book of Giovannino de' Grassi (fig. 4.56).[64] Pisanello adapted it, and made it more natural, by drawing a dead hare, reversed in the painting (fig. 4.57).[65] The drawing may be unfinished, since there is a lack of detail in the back of the legs and the stomach. Probably a stock pattern, it shows Pisanello's characteristic concern with the depiction of movement and texture.

A black-chalk drawing of a bear (fig. 4.41),[66] which seems to derive from a standard illumination in a French hunting treatise, shows the same animal drawn twice: the upper bear is a revision of the lower one, moving the head and neck further forward and the neck higher, and its humped back is more convincing; Pisanello has paid particular attention to creating expression in its eye. In the same medium and on paper with the same watermark is a hound evidently drawn from nature, seen slightly from the back, turning his head away as if from the crucifix in the finished painting (figs. 4.59, 4.60);[67] there is a pentiment in the drawing of the foreleg, which was originally stepping forward.

4.54 **Lombard**
Hound coursing a hare, c.1400
Pen and ink and watercolour with white heightening
on parchment, 25.3 × 17.1 cm
Paris, Musée du Louvre, inv. 2568

4.55 **Pisanello or workshop**
Hound coursing a hare, c.1430–5
Pen and ink and brown wash over black chalk,
27.2 × 19.5 cm
Paris, Musée du Louvre, inv. 2547

4.56 **Giovannino de' Grassi**
Roebuck, hare, wolf, leopard, c.1389–98
Pen and washes, silverpoint with white heightening
on parchment, 26 × 17.5 cm
Bergamo, Civica Biblioteca Angelo Mai,
inv. MS D. VII. 14 (formerly Cassaf. 1.21), folio 16

BIBLIOTECA CIVICA DI BERGAMO

BELOW LEFT
4.57 (detail of 4.35) **Pisanello**
The Vision of Saint Eustace: hare

BELOW
4.58 **Pisanello**
Running hare, c.1430–42
Watercolour over black chalk,
13.7 × 22.3 cm
Paris, Musée du Louvre, inv. 2445

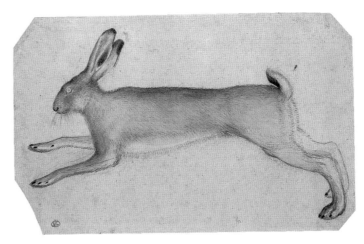

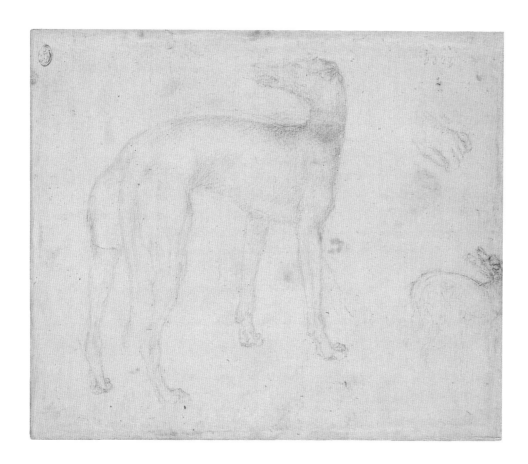

ABOVE
4.60 (detail of 4.35) **Pisanello**
The Vision of Saint Eustace: hound

LEFT
4.59 **Pisanello**
Hound, c.1438–42
Black chalk, 18.2 × 21.9 cm
Paris, Musée du Louvre, inv. 2429 verso

4.61 **Pisanello**
Head of a hound, c.1438–42
Leadpoint, brown wash and watercolour,
18.2 × 21.9 cm
Paris, Musée du Louvre, inv. 2429 recto

This study was evidently made specifically for the painting, because it includes a minimal sketch for a left hand in a position to hold reins, although in the event Saint Eustace's left hand was not shown. On the recto of this sheet (fig. 4.61) is a delicate sketch of a hound's head in which the nose, eye and mouth have been filled in with watercolour, conveying the texture of the muzzle in a pale pink wash, and introducing animation into the eye, which has a dark brown centre surrounded by concentric rings of light green, purple and a pale pink wash. Similarly, in a sheet showing a horse's head and leg (fig. 4.62), the details of the nose, eyes and hoof have been completed in watercolour,[68] and in a study of a horse's hindquarters (fig. 4.64) the testicles and anus have also been coloured.[69] Pisanello also made for the painting a drawing of a horse's head in lost profile, which is even closer to the finished picture (figs. 4.67, 4.68). Characteristic is the sensitivity of the drawn line, conveying differing features of the horse – the folds of skin along the jaw, the musculature of the neck, the coarseness of mane and forelock. In the study of a

4.62 **Pisanello**
Horse's head and hoof, c.1434–42
Pen and ink, brown wash and watercolour over stylus, 25.8 × 19.7 cm
Paris, Musée du Louvre, inv. 2356

OVERLEAF
4.63 (detail of 4.35) **Pisanello**
The Vision of Saint Eustace: Saint Eustace confronts the stag

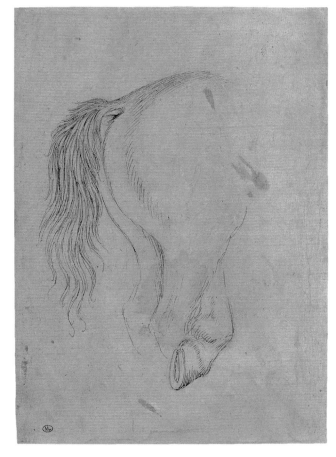

ABOVE LEFT
4.64 **Pisanello**
Croup of a horse, c.1434–42
Pen and ink, light-brown wash and watercolour
over stylus, 25.6 × 20.2 cm
Paris, Musée du Louvre, inv. 2366

ABOVE RIGHT
4.65 **Pisanello**
Croup of a horse, a hoof, c.1434–42
Pen and ink over metalpoint (?) on
red prepared paper, 23.8 × 17.6 cm
Paris, Musée du Louvre, inv. 2365 recto

4.66 (detail of 4.35) **Pisanello**
The Vision of Saint Eustace: croup and
rear hooves of the horse

ABOVE
4.67 (detail of 4.35) **Pisanello**
The Vision of Saint Eustace: horse's head

RIGHT
4.68 **Pisanello**
Head of a horse, c.1434–42
Pen and ink over black chalk, 26.6 × 17.1 cm
Paris, Musée du Louvre, inv. 2359

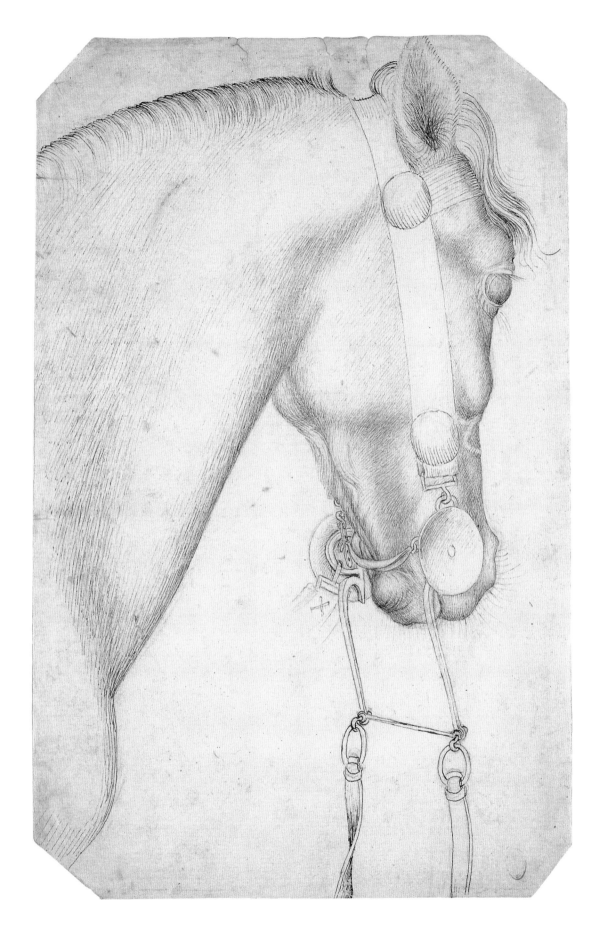

OPPOSITE
4.69 **Pisanello**
Study of plants, c.1438–42
Pen and ink, brown wash and white heightening
on red prepared paper, 23.3 × 17.6 cm
Montauban, Musée Ingres, inv. MIC69.2.D verso

horse's hindquarters (fig. 4.65),[70] the hind leg has been studied individually, placed against the haunch in an unnatural way. Pisanello is seemingly trying to arrive at a solution to the position of the hind legs of the mount of Saint Eustace (fig. 4.66) that will convey the horse's arrested motion. This study is made on the same kind of orange-red-coloured paper as two studies of plants, in Montauban (fig. 4.69) and in the Louvre (inv. 2264), which appear to have been made specifically for the foreground of the painting.[71] In the painting the plants are actually quite tiny (fig. 4.70), and the two drawings are indicative of Pisanello's almost obsessive attention to detail.

A similar process of miniaturisation is evident in his use of a pattern drawing of a hoopoe (fig. 4.73).[72] The bird appears twice on the sheet, evidently studied intricately from life from two different angles and using two different techniques. It demonstrates the evolution of Pisanello's studies: first came a preparatory drawing in metalpoint, which he then outlined in pale-brown ink; in the second study he used a pale-brown wash for the neck and head and a darker brown for the body and tail, followed by small hatched strokes building up in darker brown, and finishing with white highlights; the background around the hoopoes is densely filled with small looped hatching strokes of the pen, making the birds stand out. It is indicative that this has nothing on the verso, but was probably intended as an independent work of art. Pisanello used this large-scale study for the tiny hoopoe included in the lower right-hand corner of the painting (fig. 4.74). There is an equally tiny kingfisher in the painting – perhaps based on another drawing made earlier, much less resolved (figs. 4.71, 4.72).[73] The inclusion of the hoopoe may even have been standard in depictions of hunting: one also appears in the Coccarelli manuscript already mentioned (see fig. 2.35). Pisanello's hoopoe is on paper with the same watermark as that used for other studies connected with *Saint Eustace*, such as that of a recumbent

4.70 (detail of 4.35) **Pisanello**
The Vision of Saint Eustace: plants

ABOVE

4.72 (detail of 4.35) **Pisanello**
The Vision of Saint Eustace: kingfisher

LEFT

4.71 **Pisanello or workshop**
Studies of a kingfisher, c.1434–42
Pen and ink over black chalk or lead point
on red prepared paper, 24.9 × 18 cm
Paris, Musée du Louvre, inv. 2509 recto

stag (fig 4.75) – extremely lightly sketched with cross-hatching and diagonal hatching around the edges to indicate shoulder musculature.[74]

As we have seen, many of these studies from nature were made in series; one was then singled out for inclusion in a painting. For example, three stags' heads (figs. 4.76, 4.77) are very similar in style to the series of horses' heads discussed above.[75] These extremely fine studies were first outlined in black chalk and then inked over, in smooth continuous outlines around the head, tiny diagonal strokes to indicate the hair of the ears, and more sweeping lines for the neck, where there is extraordinarily fine hatching following the direction of the fur, varying in density to indicate a change of plane, and displaying a preoccupation with the prominent veins along the jaw.

The nature of a painting like *The Vision of Saint Eustace* suggests that it was owned by a discriminating patron and might be seen only by a privileged few. Nonetheless the three drawings of the subject in the two sketchbooks executed in parallel in the late 1440s, 1450s or 1460s by Jacopo Bellini seem to reflect a knowledge of Pisanello's painting.[76] The leadpoint sketch on folio 26 of the London sketchbook (fig. 4.78) is especially close. Bellini may have used it as the basis of his more developed pen-and-ink drawing of Saint Eustace in the Paris album (fig. 4.80). Both follow Pisanello's lead by depicting the horse in lost profile and inserting a dog between its forelegs. Just as in Pisanello's painting (and in contrast to other drawings of saints in the album) the costume of the saint in the Paris drawing is richly contemporary. Intriguingly, in the background is a single figure on a gibbet, a motif which seems related to the gibbet in the sketch in the Louvre for the

4.73 **Pisanello**
Two studies of a hoopoe, 1434–42
Pen and ink over leadpoint (for the right-hand study), brown wash and watercolour with white heightening (for the left-hand study),
16.1 × 21.7 cm
Paris, Musée du Louvre, inv. 2467

4.74 (detail of 4.35) **Pisanello**
The Vision of Saint Eustace: hoopoe

4.75 Pisanello
A deer seen from behind, c.1438–42
Pen and ink over stylus and metalpoint,
20.2 × 27.5 cm
Paris, Musée du Louvre, inv. 2489

4.76 **Pisanello**
Three studies of deers' heads, c.1438–42
Pen and ink over black chalk,
15.8 × 20.8 cm
Paris, Musée du Louvre, inv. 2490

4.77 (detail of 4.35) **Pisanello**
The Vision of Saint Eustace: stag's head

4.78 **Jacopo Bellini**
The London Sketchbook, folio 26:
The Vision of Saint Eustace, c.1445–60
Leadpoint on paper, 51.4 × 78 cm
London, The British Museum, inv. 1855-8-11

4.79 **Jacopo Bellini**
The London Sketchbook, folio 71:
The Vision of Saint Eustace, c.1445–60
Leadpoint on paper, 51.4 × 78 cm
London, The British Museum, inv. 1855-8-11

4.80 **Jacopo Bellini**
The Paris Sketchbook, folios 41 verso, 42:
The Vision of Saint Eustace, c.1445–60
Pen and ink over metalpoint (?) on
parchment, 58 × 42.7 cm
Paris, Musée du Louvre

Sant'Anastasia hanged men (see fig. 1.27) and to the sketch for the crucified Christ (see fig. 4.48). Might Bellini have known preparatory drawings for the painting? Or might the National Gallery painting have included this motif in its lost upper part?

Bellini was Pisanello's perceived rival, as the sonnet by Ulisse degli Aliotti on the 1441 portrait 'competition' demonstrates (see p. 106), and he worked for the Este on at least two occasions.[77] His second drawing, on folio 71 of the London sketchbook (fig. 4.79), resumes the composition but makes it more complex by showing both stag and rider foreshortened. The drawing could be read as Bellini's competitive response to Pisanello's model. At any rate, it seems most likely that Bellini saw Pisanello's painting in

Ferrara, which might support the theory of an Este patron. It may be no coincidence that *The Vision of Saint Eustace* also conforms in many respects to the paintings by Pisanello eulogised in poetry by court humanists in Ferrara. Perhaps they saw the picture there.

LANDSCAPE AND POETRY

The most peculiar feature of *The Vision of Saint Eustace* is the prominent scroll in the foreground (fig. 4.81). It might be thought that it was intended to carry the words spoken by Christ to Saint Eustace.[78] Certainly it suggests the presence of an explanatory inscription. Yet it seems always to have been blank. It may therefore allude to the contemporary humanist debate on the relative efficacy of word and image. That humanists such as Guarino (fig. 4.82) and Tito Vespasiano Strozzi should have praised Pisanello's work is remarkable, given that many of them had little personal interest in painting and even, when reviving the commonplace of the rivalry between the visual and the written arts, concluded that literary descriptions were superior to artistic ones. One of their points was that painters, unlike writers of prose or poetry, were unable to convey transient effects such as noises heard in nature and living speech. A letter, possibly written in 1416, by Guarino cites this among the disadvantages of painting as opposed to literature.[79] Pisanello's blank scroll was perhaps deliberately intended to point out the power of an image even when not accompanied by sounds or words.

Yet humanist poets sometimes appear to lay aside their rivalry with painters, and concentrate their energies instead on praise (occasionally double-edged) of the output of their artistic peers. It was Guarino who introduced to Italy a poetic genre that included praise of Pisanello's depiction of landscape. Guarino's poem was designed in part to show off the poet's superior powers of evocative description, more potent even than those of the paintings he was ostensibly using as his subject-matter, and the mode was soon taken up by a number of other poets, including some of his pupils. Guarino's poem, written in the 1420s or 1430s, served as a model for those which followed. It has

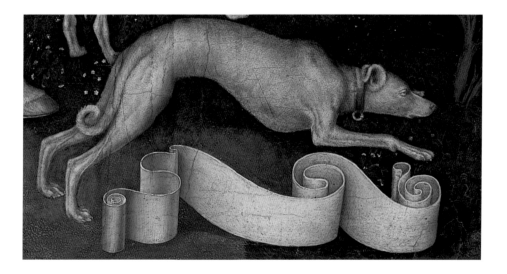

4.81 (detail of 4.35) **Pisanello**
The Vision of Saint Eustace: hound and blank scroll

already been seen how much praise humanist writers came to lavish on Pisanello's portraits; however, they were equally concerned in their poetry and prose to laud his painting of landscape. On the one hand his painting of landscape was celebrated on precisely the same grounds as his portraits – his ability to imitate reality, to rival nature by his truth to appearances. Even though he had elsewhere stated earlier that such effects were impossible to achieve in art, here Guarino commends Pisanello's ability to capture in line and colour noises heard in nature, including the sounds of the sea, of battle and of birdsong, and the subtlety with which he captures the different atmospheric effects of the day and the seasons, of night-time and of winter and spring. We read:

4.82 (detail of 3.13a) **Matteo de' Pasti** Portrait medal of Guarino da Verona, obverse, c.1450

> . . . you equal Nature's works, whether you are depicting birds or beasts, perilous straits and calm seas; we would swear we saw the spray gleaming and heard the breakers roar. I put out a hand to wipe the sweat from the brow of a labouring peasant; we seem to hear the whinny of a war horse and tremble at the blare of trumpets. When you paint a nocturnal scene you make the night-birds flit about and not one of the birds of the day is to be seen; you pick out the stars, the moon's sphere, the sunless darkness. If you paint a winter scene everything bristles with frost and the leafless trees grate in the wind. If you set the action in spring, varied flowers smile in the green meadows, the old brilliance returns to the trees, and the hills bloom; here the air quivers with the songs of birds.[80]

Elsewhere in the poem he reiterates Pisanello's ability to capture fleeting natural effects, his success in rendering shadows and light, and achieving a sense of distance or recession. While Guarino certainly stresses Pisanello's capacity faithfully to reproduce the appearance of the natural world, what comes out still more strongly is Guarino's admiration for the artist's fecund imagination. The reader is presented with a catalogue of the things in nature to which Pisanello has turned his hand, and the result is an overwhelming sense of the variety of Pisanello's work, as endless as nature herself. According to Guarino, Pisanello could depict both sea and land, and many different sorts of trees, flowers, birds and animals. At the same time all the various elements cohere; there is an internal consistency. To depict the night, for instance, Pisanello not only paints the dark sky, the moon and the stars but also makes sure not to depict any bird that would be seen during the day. This point is also emphasised near the start of the poem: the poet gasps with admiration before the knowledge with which Pisanello conveys a great harmony among the parts.[81] Commentators on the poem have sometimes assumed that Guarino was describing a painting known to him but no longer extant. The evocation of spring in the last lines quoted certainly brings to mind the landscape in *The Vision of Saint Eustace*. But it seems just as likely that, rather than attempting to describe one particular painting by Pisanello, the poem seeks to convey the distinctive quality and the range of the painter's performance in general.

Guarino learned a mode of description called *ekphrasis* during his time in Constantinople in the first years of the fifteenth century.[82] Ekphrasis was defined by the second-century rhetorician Hermogenes of Tarsus as 'an account with detail; it is visible, so to speak, and brings before the eyes that which is to be shown. Ekphrases are

of people, actions, times, places, seasons, and many other things The special virtues of ekphrasis are clarity and visibility; the style must contrive to bring about seeing through hearing. However, it is equally important that expression should fit the subject: if the subject is florid, let the style be florid, too, and, if the subject is dry, let the style be the same.'[83] Most commonly, ancient ekphrastic descriptions concentrated on a single object, moment or work of art rather than combining accounts of diverse things. A celebrated example of this type, which was much read in Pisanello's time, was the second-century writer Lucian's account of a picture by Alexander the Great's favourite painter, the *Calumny* of Apelles. In their turn Byzantine humanists took up such exercises, sometimes turning to individual works of art, such as the tapestry described by emperor Manuel II Palaeologus at the turn of the fourteenth and fifteenth centuries. Guarino followed this form in some of his ekphrastic passages, although on other occasions, as in his poem dedicated to Pisanello, he preferred a more generalised enumeration of landscape elements, apparently to be found in a range of this artist's paintings – a mode he had learnt from his teacher Manuel Chrysoloras.

Subsequent humanist praise of Pisanello follows much the same pattern as Guarino's: using a typical, and typically insincere, modesty topos, the poet usually asserts his own insufficiency in celebrating the artist, who is worthy of immortality and comparison with the greatest practitioners of the past. Many of these writers praise him for his virtues as a man and all of them praise his qualities as an artist. This combination is very much the point of Pisanello's 'self-portrait' medal (see fig. 1.2). They refer to individual portraits, but describe his landscapes more generically. The most important of these poems, spelling out this rich variety in Pisanello's painting, is by Tito Vespasiano Strozzi, a pupil of Guarino, written before September 1443. Strozzi begins by saying that Pisanello, in his representations of man, wild animals and nature generally, is superior to the best painters of ancient Greece, Zeuxis and Apelles, as well as to ancient goldsmiths and sculptors. He continues:

> How shall I tell of the living birds or gliding rivers, the seas with their shores? I seem to hear the roaring waves there, and the scaly tribe cleave the blue water. Prating frogs croak beneath the muddy runnel; you make boars lurk in the valley and bears on the mountain. You wrap soft verges round the clear springs, and green grass mingles with fragrant flowers. We see two nymphs wandering in the shady woods, one with a hunting-net on her shoulder, the other bearing spears, and in another part baying dogs flushing roe-buck from their dens and snapping their savage jaws. Yonder the swift hound is intent on the hare's destruction; here the rearing horse neighs and champs at its bit.[84]

In a later, printed edition (Aldine, 1513), another two couplets are added by a lesser poet: 'We see frogs swim in the lake, lions wander in the woods, fierce boars on their way in the deep valley. A bear appears at the cave with her accompanying cubs. The martial wolf makes his way to the full sheep-pen.'[85]

This description immediately brings to mind drawings and parts of paintings by Pisanello. The hare that tries to escape a dog features in *The Vision of Saint Eustace*, so does the bear.[86] The Sant'Anastasia frescoes, *The Vision of Saint Eustace* and numerous

drawings show birds in flight;[87] fleeing game is a motif in the background at Sant'Anastasia and a lion and lioness are found in the Mantuan chivalric frescoes.[88] That Strozzi is also asserting his poetic superiority is indicated by the fact that he includes elements, notably nymphs, which appear neither in nature nor, as far as one can tell, in Pisanello's work. Moreover, Strozzi's poem has elaborated on Guarino's model, making the poetic element still more apparent. His shorter poem is also more coherent.

Basinio da Parma, a pupil of Vittorino rather than Guarino, but friendly with Strozzi, composed his poem in praise of Pisanello in Ferrara, before his departure for Rimini in 1449.[89] There is an evocative description of the natural world Pisanello depicts: he captures stars bright in the firmament, porpoises and dolphins fleeing through 'true' waves, trees bent by the wind, birds in the air; an eagle snatching a terrified hare, dogs coursing after beasts; stags whipping up clouds of dust; hideous bears howling in the mountains, the roar of tigers and lions; and lions warring with boars, seemingly real. His list of animals is close to Strozzi's (hares, dogs, boars, bears and lions). His mention of a tree bent crooked by the wind recalls an image by Gentile da Fabriano described by Bartolomeo Facio. The medal of Iñigo d'Avalos (see fig. 3.45b) shows stars in the sky; and there is a drawing of a sturgeon in the Louvre (inv. 2391r) which may have been mistaken for a dolphin.

Other eulogistic poems include one by Porcellio, written before August 1448, which adds no new ingredients,[90] and an epigram by Leonardo Dati, written probably between 1447–8 and late 1455.[91] Dati, who otherwise rehearses elements by then standard, says he knew poets had lauded Pisanello for rivalling nature herself, but until he saw his work for himself he had been unwilling to add his praise to theirs. If one may say it, says Dati, Pisanello has surpassed Prometheus. Pisanello's remarkable representations of heroes, horses and all kinds of wild animals has changed his reticence into loud praise.

Praise of Pisanello was not restricted to the poetic. Bartolomeo Facio was a pupil of Guarino's in Verona between 1420 and 1426, when Pisanello was working in San Fermo; he went to Venice in the late 1420s as tutor to the Doge's son, and saw Gentile's and Pisanello's frescoes in the Doge's Palace. Thereafter he moved between Florence, Genoa, Lucca and Naples. In *Of Famous Men*, written in Naples in 1456, he included a section on painters, and in it reaffirmed many of Guarino's values, including 'variety'.[92] His chosen painters were Jan van Eyck, Rogier van der Weyden, Gentile da Fabriano and Pisanello. Facio praised Gentile's capturing the effects of a whirlwind: 'In the same city [Venice] he also painted a whirlwind uprooting trees and the like, and its appearance is such as to strike the beholder with horror and fear.' Pisanello he associates above all with animals: 'To Pisano of Verona has been ascribed almost a poet's talent for painting the forms of things and representing feelings. But in painting horses and other animals he has, in the opinion of experts, surpassed all others Other examples of his talent and art are a number of pictures on panels and parchment . . . [including] a wilderness in which are many animals of different kinds that you would think were alive.'[93]

In his discussion of Pisanello, in the second, 1568 edition of *The Lives of the Artists*, written more than a century after his death, Vasari recorded that several 'very important men and exceptional writers' had put pen to paper to praise Pisanello,[94] a literary

attention of a kind that was new and that he was the first artist to attract. The aims and methods of Pisanello's painting and drawing may partly explain this: in effect, like the humanists practising ekphrasis, he was attempting a 'clear' and lifelike account of phenomena of nature – particularly those found interesting at courts where hunting was actively pursued – 'bringing about seeing', or evoking, through painting rather than words. Once this evocation had been successful for them (as Leonardo Dati explicitly relates), then the humanists attempted their own evocation, in parallel – an evocation not of any individual painting by Pisanello, which as an object did not concern these literary men, but of the kind of things that Pisanello successfully evoked. As we noted above, *The Vision of Saint Eustace*, the surviving painting that best corresponds to the aspect of Pisanello's art these poets favoured, is not a realistic narrative, not a kind of fictive stage-set, but a rich array of motifs, laid out not unlike a tapestry. While its focus remains Saint Eustace fixed in his vision, the painting is almost cinematographic in encouraging the eye to feast first in one place and then in another. The poets' descriptions are similarly cinematographic – for them the things in the painting move and appear in succession before them. Pisanello has succeeded in making his picture equivalent. Although, unlike a film, his painting presents all the motifs simultaneously, it encourages sequential gazing by the viewer. Pisanello has induced the viewer to supply an element of time that is a feature of poetry.

Perhaps, too, Pisanello responded to the challenge, as artists later in the century also would, of attempting in art what the poets were saying art could not do. This is surely the point of the blank scroll in *The Vision of Saint Eustace*. The poets in turn then embraced this response to their agenda. Guarino, for example, had further points against the visual arts – that they could not adequately transmit personal fame, because they were unlabelled and were not easily transported; these were certainly answered by the invention of the portrait medal, a visual vehicle of fame in which Guarino, too, would later acquiesce. Subsequent writers claim that they can 'hear' in Pisanello's paintings sounds like lions roaring, as if explicitly to refute the commonplace that its 'silence' was an inadequacy of painting. It may not be coincidental that in Angelo Decembrio's mid-fifteenth-century dialogue *On Literary Elegance* Leonello d'Este is made to claim that painters could not equal poets such as Virgil and Homer in the description of nature,[95] and a few years later Pisanello is called 'the Homer of painting' by Lodovico Gonzaga.[96] The remains of a rainbow in the damaged sky of the Sant'Anastasia frescoes (see fig. 1.27) suggest that Pisanello, too, represented atmospheric effects and landscapes subject to light and weather, as Gentile da Fabriano had done before him – given the evidence both of the predella of his *Adoration of the Magi* (see fig. 1.17) and of Facio's remark – and as Jacopo Bellini seems to have done after him. It is certainly remarkable that Facio describes Pisanello's talent (*ingenium*) as 'almost a poet's' – this would appear to record a perception that Pisanello had appropriated new territory for art, terrain formerly unique to literature.

v Artistic Individuality and the Workshop Tradition

Having first accustomed yourself to drawing ... you should labour and delight in always copying the best things that you can find by the hand of the great masters But I counsel you: guard that you always choose the best and the one who has the greatest fame...

CENNINO CENNINI, *The Craftsman's Handbook, c.*1385–90

Pisanello was clearly the focus of a particular kind of humanist approbation: Guarino and his followers expressed the view that he epitomised the ideal artist with unique and identifiable talents. Moreover the literary attitude of scholars clearly affected the reception of Pisanello's works by his patrons. The sophisticated awareness of classical precedent at the Este court may have resulted in a particular emphasis on his artistic individuality there. Certainly the fact that Pisanello's and Jacopo Bellini's 1441 portraits of Leonello d'Este were placed in some kind of competition (see p. 106) suggests an interest by the leading patrons of the time in the individual styles of the two artists.[1] This kind of celebratory thinking also lies behind the seemingly unique designation of the room containing Pisanello's chivalric frescoes in the Palazzo Ducale in Mantua not by their subject but by their artist (see p. 50). Moreover, the terms of Alfonso d'Aragona's 1449 'Privilege' show that Pisanello's recognised 'natural talent (*ingenium*) and skill' could command a substantial salary.[2]

An analysis of the style and iconography of the two National Gallery paintings, *The Virgin and Child with Saints Anthony Abbot and George* and *The Vision of Saint Eustace*, has shown that both were pictures which set out to display the *ingenium* of their author within a context of sometimes complicated, nuanced image making. Here were pictures – 'jewels' – offering precious proofs of Pisanello's artistry, in which the values associated with Franco-Burgundian painting could be appreciated and where all his *all'antica* powers of naturalistic observation could be discovered. The very prominent signatures on his medals (and the smaller signature on a costume study, see fig. 2.33), in which much the same set of aesthetic ingredients were combined, reinforced the message that these works were to be seen as the product of a single famous painter. What was celebrated was individual talent. But does this imply an expectation that his works would be individually produced – entirely designed and executed by Pisanello himself?

Throughout the preceding chapters there have been numerous references to drawings by Pisanello's workshop. The existence of these drawings implies that Pisanello received assistance for certain projects – and perhaps particular categories of work. It therefore appears that in the figure of Pisanello is married a response to the distinctly '*all'antica*' admiration for artistic individuality and expression with the employment of traditional methods of art production through hierarchical collaboration. Given this seeming

OPPOSITE
5.1 (detail of 5.29) **Workshop of Pisanello and an unidentified Veronese illuminator**
The Conversion of Saint Paul

contradiction between intellectual expectation and the realities of practice apparently accepted by his patrons, it is important to re-examine the evidence for his workshop, to make some effort to understand who its members were and what they actually did.

Documentary evidence is, unfortunately, minimal. In the papal safe-conduct of 1432 reference is made to Pisanello's '*socii et familiares*', associates and household servants,[3] the payment from Leonello d'Este for the 1435 image of Julius Caesar was made to one of his servants,[4] and it was from a '*garzone*' of Pisanello (an assistant or pupil) that Carlo de' Medici purchased the thirty silver '*medagle*' (*sic*) in 1455, after the artist's death.[5] There is, of course, no certainty that all or any of these people painted or sculpted, but it seems more likely than not that at least some did. If Pisanello's working practice accorded with that of other migrant artists working in fifteenth-century Italy, his workshop was made up both of assistants and pupils who moved with him from city to city and of other practitioners, already trained, whom he recruited locally for particular commissions.[6]

More tangible evidence is to be found in the huge body of surviving drawings that employ Pisanello's animal and figure types, or that are executed using versions of his drawing techniques. Pisanello's own style for quick studies, both observational and for specific projects, is documented by his first sketch for the portrait of emperor Sigismund (see fig. 3.17), the rapid drawings made for *The Vision of Saint Eustace* and the frescoes in Sant'Anastasia – the hanged men, the flying egrets, the head of the Princess (see figs. 1.26, 4.52, 1.31) – and the two sheets of sketches of John VIII Palaeologus and his retinue (see figs. 1.36, 1.37, 1.38, 1.39). The sequence of drawings for the hanged men include a sketch in the National Gallery of Scotland (see fig. 1.25) probably of a *garzone* adopting the pose of one of the dead men, which in itself is evidence of the presence of assistants in Pisanello's shop. However, the drawings connected with the Sant'Anastasia frescoes, for example, fall into several distinct categories. Not only did Pisanello sometimes work up his rough sketches into more perfected studies, as he did with the head of the Princess (see fig. 1.31), he also made regular use of other equally or even more finished pattern drawings.

Many of his drawings, such as the coloured studies of birds and animals, are unlikely to have been made with any single work in mind. Others, executed with a particular end in view, could be re-employed as models. These were the repeatable patterns for the motifs that most clearly defined Pisanello's individual style – the birds and animals for whose naturalistic depiction he was so consistently praised in his lifetime. They establish the qualitative standard against which other works on paper or parchment attributed to Pisanello or his workshop must be judged today, but they were also profitably exploited as part of the equipment of a workshop – motifs for both master and assistant to insert into his finished works. They must also have been employed as teaching tools for his pupils. Cennino Cennini in his so-called *Craftsman's Handbook* of about 1385–90 described the method and purpose of copying from earlier masters – copies of the kind that Pisanello himself evidently made of motifs by the Limbourg brothers: 'Having first accustomed yourself to drawing . . . you should labour and delight in always copying the best things that you can find by the hand of the great masters. And if you are in a place where there have been many great masters, so much the better for you. But I counsel

you: guard that you always choose the best and the one who has the greatest fame, and proceeding thus, day in and day out, it would be unnatural for you not to come close to his manner and to his air [*aria*]: because if you endeavour to copy one artist today and another tomorrow, you will not acquire the manner of either of them'[7] By reproducing his models (even if they were sometimes second-hand), Pisanello's apprentices would not only absorb his artistic vocabulary but also learn his method of drawing, gaining the eye-to-hand skills to enable them to make life drawings of their own – in their master's style. Trained workshop members might then be entrusted with the invention of parts of Pisanello's works – without their ceasing to be Pisanello's (or Pisanellos) – and indeed to produce workshop models of their own. The number of drawings in which aspects of Pisanello's art have been copied, and the various styles and competencies they exhibit, demonstrate unmistakably that Pisanello, over a period of time, employed a considerable number of assistants and pupils within the shop.

Unfortunately, however, the lack of an agreed chronology and different scholarly views of Pisanello's draftsmanship have created their own obstacles; there has been little accord over what, precisely, makes up Pisanello's autograph drawings corpus. This, in its turn, has hampered analysis of the functions of the drawings attributed to Pisanello's workshop. It is crucial, for example, to distinguish between copies after his completed works and drawings which demonstrate workshop involvement in their planning. Moreover, once that distinction has been made, it is just as important to differentiate workshop copies, which constitute evidence of the learning processes within an artist's shop, from copies made as the result of the circulation of Pisanello's patterns – and indeed his medals – beyond the confines of his shop.

IMITATION FROM AFAR

Cennini's instructions imply a process of copying that might take place at one remove from the workshop, and it seems that a young painter (or other craftsman) was expected to learn his art by the selection of appropriate models in the finished works he could see around him. Thus copies might be made of Pisanello's paintings or medals or – after his death – of his drawings by artists with no direct connection to his shop. As we have seen by the example of Pisanello himself, the citation of tropes from works by an older artist or by contemporaries does not turn the imitator into a pupil. Thus some drawings – those which show no concern with reproducing method as well as motif – should be classified as by 'followers' of Pisanello.

For Pisanello's 'followers', his medals were evidently the most generally available models, and the images on them were copied and adapted by artists working in a whole range of media. Although the medals might be cast initially in an extremely small 'first edition' – Leonello d'Este commissioned only two specimens of the portrait of Pier Candido Decembrio – they were easily multiplied. Not only were master casts probably kept in the workshop to cast further editions for the burgeoning collectors' market (including perhaps some of the remarkable lead casts illustrated in this book), new moulds could be taken by more or less anyone from medals sent out into the world, to

produce so-called aftercasts. These second-, third- or fourth-generation medals (copies were cast from copies) are recognisable by their diminished size and, frequently, by a loss of detail. The practice started early. In 1459, a German student at university of Padua, Ulrich Gossembrot, sent a present of a group of lead medals to his father in Augsburg.[8] They bore the portraits, he said, of his teachers, including Guarino, Francesco Filelfo and Giovanni Pietro d'Avenza of Lucca.[9] Only the last of these can be connected with Pisanello (and was probably made by a member of his shop); the first medal was the work of Matteo de' Pasti (see fig. 3.13) and the second by the Florentine goldsmith, sculptor and architect Antonio Filarete.[10] They cannot, therefore, have come from a single workshop, and must have been aftercasts. In the 1460s, pope Paul II, who, as cardinal Pietro Barbo, had wrested Pisanello's silver coins from Carlo de' Medici (see p. 39), had, inexplicably, the obverses of the LIBERALITAS AVGVSTA medal of Alfonso of Aragon (see fig. 3.44a) and of the medal of Pisanello himself (see fig. 1.2a) cast into lead tiles for the roof of the church of San Marco in Rome.[11] Casts for collectors continued to be made well into the nineteenth century. Aftercasts of Pisanello's medals were not only made from lead or bronze. In about 1500 painted clay casts of medals of Niccolò Piccinino (see fig. 3.37) and Iñigo d'Avalos (see fig. 3.45) were attached to the sides of a pharmacy

5.2 **Deruta (?)**
Majolica jug, set with ceramic casts taken from Pisanello's portrait medals of Niccolò Piccinino and Iñigo d'Avalos, c. 1500
Tin-glazed ceramic
Property of H.S.H. The Prince Francesco d'Avalos, Naples

jar thrown and decorated probably in the Umbrian pottery town of Deruta (fig. 5.2).[12]

To judge from the many surviving specimens – of widely ranging quality – now preserved in collections in Europe and America, the John VIII Palaeologus was one of most frequently re-cast of Pisanello's medals;[13] the other most commonly encountered is his Niccolò Piccinino. The fact that the emperor's portrait appears so frequently in paintings and illuminations executed in the mid fifteenth century throughout the Italian peninsula suggests that this practice began early. The prolific Veronese painter Giovanni Badile, for example, reproduced a group of Pisanello medals in grisaille as part of the painted decoration of the window embrasures of the chapel of Saint Jerome in the church of Santa Maria della Scala in Verona. The frescoes there are dated, by documentary evidence, to 1443–4, although, since the medals cited include Pisanello's 1445 medal of Sigismondo Malatesta, the grisaille decoration of the window must have been painted at least a year later.[14] Piero della Francesca used the medal less literally, copying the head of the emperor for its symbolic meaning – both for the Heraclius in his Arezzo frescoes and for Pontius Pilate in his Urbino *Flagellation of Christ*.[15] The fact that both copied his medals rather than his other painted or graphic works speaks volumes both for their impact as (novel) works of art and for their circulation. This impression is confirmed by an album of drawings in Trent, on both parchment and paper, now thought to have been made in the Verona region in about 1450.[16] On folio 26v are quite detailed and accurate renditions of the reverses of the Palaeologus and Piccinino medals. Although other pages are broadly 'Pisanellesque', it is revealing that once again Pisanello's direct impact was conveyed through the medium of the medal.

WORKSHOP DRAWINGS

In fact only one or two independent artists who worked primarily as painters of large-scale works seem to have looked beyond Pisanello's medallic production for models.[17] His painting style seems quickly have become unfashionable in North Italy after his death and perhaps even before, after his removal south – to such an extent that even those pupils he had trained were apparently not keen to retain or repeat his lessons. Instead the style promoted by Francesco Squarcione and his pupils, especially Andrea Mantegna, became dominant. This phenomenon compounds the difficulty of relating the various styles of the pupils and assistants at work in his shop to extant works by artists active in those regions of Italy where Pisanello's impact might have been felt. It seems logical to propose that sheets in which a real, and relatively unadulterated, understanding of his visual language can be demonstrated are likely to have been executed by his pupils – as opposed to ones which display merely typological similarities. And there is no shortage of works in the first category. Nevertheless it has proved enormously difficult to tie any of these hands to any surviving finished paintings, or even to arrive at a sensible estimate of the number of pupils and assistants in Pisanello's shop.

However, even if the task of quantifying and differentiating the members of Pisanello's shop is problematic, it is slightly easier to classify the types of drawing they were making. Some are straightforward renditions of model-book patterns, reproductive

5.3 **Workshop of Pisanello**
Herons, c.1434–45
Pen and ink with areas of green wash on parchment, 18.1 × 27 cm
Paris, Musée du Louvre, inv. 2472

exercises undertaken to learn Pisanello's types and drawing style. A delicate, though unadventurous drawing of herons seen in various stances and from different angles (fig. 5.3) belongs to the same family as another sheet of herons, by another, equally deliberate hand (and with some rather crude colouring), in which one bird is in exactly the same pose (fig. 5.4).[18] Both were certainly made as assemblages of some of Pisanello's favoured motifs. It may also be possible to distinguish between large coloured studies of birds by Pisanello himself and similar ones made by members of his shop. The pen-and-ink underdrawing in a damaged sheet with a pair of teal (fig. 5.5) seems somewhat more evenly pressured and mechanical than, for example, in the study of a single teal by Pisanello (see fig. 2.41) – a drawing using exactly the same materials.[19] This is a drawing of the kind that the assistant would probably have used as his source; the application of watercolour has a similar slapdash character to the coloured costume study in Oxford discussed in chapter II (see fig. 2.32). These are only three examples of the many workshop drawings which copy Pisanello's famous animal motifs.

It is likely that Pisanello's figurative and drapery patterns were learned and transmitted in much the same way. Although there survive only very few such pattern drawings of the human body (whether nude or clothed) by Pisanello himself, drawings of stock types – heads and full-length figures – attributed to members of his shop suggest that

they may once have existed more plentifully. Into this category comes, for instance, a study in Vienna of two old men in monastic habit carrying staffs (fig. 5.7), closely related to Saint Anthony in Pisanello's National Gallery painting and to his sketch of the same saint in his design for a retable for Antonio Malaspina (see fig. 1.34).[20] So, too, does the rather stiffly rendered pen-and-ink drawing of *The Virgin and Child* (see fig. 4.29) in almost exactly the same Limbourg poses as their counterparts in the same National Gallery picture.[21] In addition to these pattern drawings, another category can be identified: drawings that mostly belong to the end of Pisanello's career. A series of designs – for medals, goldsmiths' work, textiles and cannon – made during Pisanello's time at the Neapolitan court, indicate that members of the workshop, having learned Pisanello's style and repertoire, seem to have been granted a degree of autonomy in the planning stages for a whole range of objects. These drawings both reproduce Pisanello's pen-and-ink technique and depend on an established vocabulary – Pisanello's dragon makes repeated reappearances for example (see figs. 3.55, 4.19).[22]

Though it may be possible to isolate five or six hands at the very least within the corpus of drawings reasonably attributed to the Pisanello workshop, it may be useful to focus on the two groups of drawings that in the past have been discussed as self-contained, drawings set apart by virtue of the fact that they derive from two dismembered albums.

ABOVE LEFT
5.4 **Workshop of Pisanello**
Herons, c.1434–45
Pen and ink over leadpoint, watercolour (for the coloured heron) and white heightening, 20 × 16.1 cm
Paris, Musée du Louvre, inv. 2471 recto

ABOVE RIGHT
5.5 **Workshop of Pisanello**
Two teal, c.1434–45
Pen and ink, watercolour and brown wash over black chalk, 20 × 16.1 cm
Paris, Musée du Louvre, inv. 2463

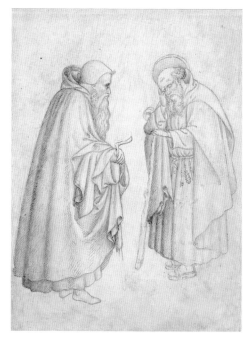

ABOVE
5.7 **Workshop of Pisanello**
Two standing figures in monastic habits, c.1431–40
Pen and ink and wash on parchment, 21.1 × 16 cm
Vienna, Albertina, inv. 5 verso

LEFT
5.6 **Pisanello**
Studies of figures from an ancient sarcophagus of
Jason and Medea, c.1431–2
Pen and ink and brown wash over metalpoint
on parchment, 21.2 × 15.6 cm
Rotterdam, Museum Boymans Van Beuningen,
inv. I.523 recto

Some forty-two parchment sheets, now scattered, made up the so-called *Taccuino di viaggio*
('travel sketchbook'), which, though it has been associated with Gentile da Fabriano, is
best attributed to Pisanello's workshop.[23] The link with Pisanello is demonstrated in
the first place by the fact that it contained autograph works by him (though very few).
The extraordinary life drawing of female nudes in the poses of ancient statuary (with an
Annunciation at the top of the sheet) in the Museum Boymans Van Beuningen (fig. 5.8)
has been almost universally accepted as one of Pisanello's earliest surviving essays,
probably dating from the end of the 1420s or the beginning of the next decade, and
sometimes associated with his San Fermo frescoes (see fig. 1.4).[24] This drawing does not,
at first sight, seem to have much to do stylistically with a second Boymans drawing
(fig. 5.6; see fig. 4.8), the two-sided study after figures in Roman sarcophagus reliefs.[25]

5.8 **Pisanello**
Six nude women, the Annunciation, c.1428–32
Pen and ink on parchment, 22.1 × 16.5 cm
Rotterdam, Museum Boymans Van Beuningen,
inv. I.520

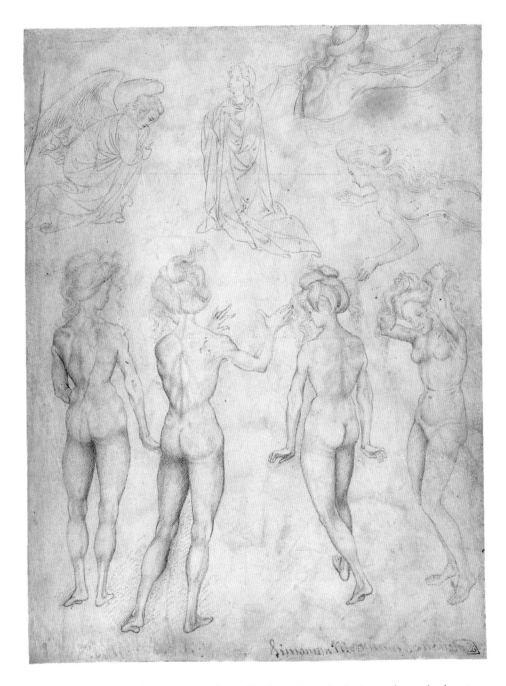

However, its autograph status is confirmed by its striking similarity to the underdrawing
of the National Gallery *Virgin and Child with Saints Anthony Abbot and George*; the different
method of hatching used to establish the figures' volume might be explained by the
different demands made of the draftsman in drawing from a live model and in copying
stone sculpture. This, in turn, supports the attribution to Pisanello of the drawing in
Berlin of the reclining river-god (see fig. 3.10), which he used as a source for one of
the reverses of his Leonello d'Este medals.[26] Only two other drawings from the album,
both in the Louvre, have the quality and qualities associated with Pisanello himself: an
heraldic eagle (itself the source for a workshop drawing in the British Museum)[27] and
the Saint Jerome and his architectural setting copied by Pisanello from the Limbourg-
designed frontispiece of the *Bible moralisée* (see fig. 2.17).[28] These latter set the tone of the

album. It contained, it is true, a handful of what appear to be preparatory drawings, albeit ones which are thoroughly considered, and, uniquely, on a double page with one of the Dioscuri (see fig. 3.56), quick sketches of peacocks.[29] These might have had a useful afterlife as patterns. The rest of the drawings are copies after existing models of different kinds, some after the antique, others after modern works by Pisanello and other artists. The album was either assembled or filled in the 1430s: apart from the autograph drawings, which should reasonably be associated with Pisanello's Roman sojourn, one page (Louvre inv. 2398) copies elements from *The Adoration of the Magi* by Stefano da Verona (see fig. 1.16), painted probably in 1435,[30] and two others (Berlin, Staatliche Museen zu Berlin, inv. 1358, and fig. 5.9) reproduce some of the dancing putti on the pulpit by Donatello set up in Prato in 1438.[31] It is more than possible, of course, that these and some other drawings copy, at second hand, transcriptions made by Pisanello himself after works by ancient Roman sculptors or by his painter and sculptor contemporaries.

5.9 **Workshop of Pisanello**
Dancing putti, copied from Donatello's Prato pulpit relief, c.1438–40
Pen and ink over metalpoint on red prepared paper, 19.4 × 27.5 cm
Milan, Pinacoteca Ambrosiana, inv. F.214 inf. 13 verso

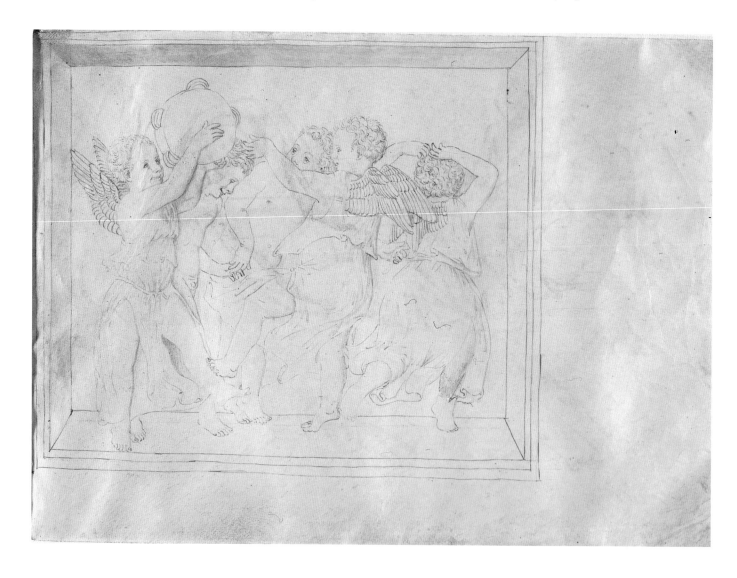

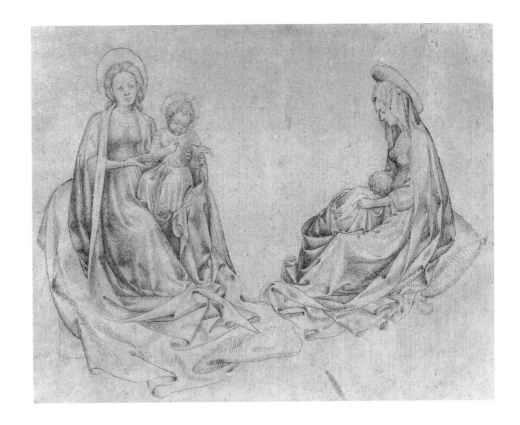

5.10 **Workshop of Pisanello**
Two studies of the Virgin and Child, c.1431–40
Pen and ink over metalpoint on
red prepared paper, 19.9 × 26 cm
Milan, Pinacoteca Ambrosiana, inv. F.214 inf. 8

It is important to stress that, despite occasional attempts to associate the album with a single draftsman, the drawings it once contained were in fact executed by a number of hands. Indeed the recto and verso of the same piece of parchment might have been drawn on by two different artists. On the verso of Pisanello's Rotterdam life drawing there are drawn the figures of a number of somewhat mournful Amazons and their victorious foe, copied from sarcophagus reliefs now in the British Museum and the Belvedere courtyard in the Vatican.[32] This rather inexpert drawing is characterised by its limited sense of volume and the unusually wide spacing of the short, parallel hatching lines. It is not, of course, by Pisanello, but the fact that it is to be found on the verso of an autograph Pisanello drawing places its author firmly within the artist's shop. Another draftsman, the author of the page from the *Taccuino* in which are depicted, among other things, two aristocratic women in courtly costume feeding their falcons (see fig. 2.39), also seems to have made drawings after the antique: the typological and technical similarity of the women in this drawing to two fragmentary female Victories in a sketch in Berlin (the recto of the parchment sheet with Pisanello's drawing of the reclining river-god on the verso) is telling.[33] However, neither of these was the draftsman responsible for the largest group of drawings after the antique in the album: the Ashmolean Maenads (see fig. 3.52) and the drawings in the Ambrosiana after the Bacchic sarcophagus at the Vatican (see fig. 5.35), the Dioscurus (see fig. 3.56) and the Grottaferrata Bacchic relief (see fig. 3.54).[34] This artist, however, certainly executed two drawings on paper (therefore not from the *Taccuino*) with charmingly domestic images of the Virgin and Child (fig. 5.10).[35] Here is a draftsman who has learned Pisanello's system of combining parallel hatching for shading and other hatching lines which follow the curves of the body – which, together, establish the volume, the light and shade and, where appropriate, the

textures of his subjects. However, one need only compare these works with the Rotterdam drawing of female nudes to see that, although he may sometimes have been reproducing earlier drawings by Pisanello himself, he has not entirely understood how to apply the technique. The lighting of the figures is frequently illogical – the same level of shadow on each side of the body – and the hatching lines, intended to define the curves of the human anatomies, instead give some of his figures the appearance of being covered in a pelt of hair. A distinctive feature of works by this draftsman is the peculiarly melancholic cast he frequently gives to the features of his figures: women and, especially, men with down-turned mouths and worried, knitted brows. Although only parallel hatching is used for shading, and the proportions of the figures differ slightly (their large, neckless heads, missing in the sarcophagus, are 'restorations'), the reappearance of some of these features in the Berlin drawing after the boar hunt of the Mantua Adonis sarcophagus (see fig. 3.48) makes it likely to be by the same hand.

A similarly dismembered album of drawings, now all in the Louvre, has been notionally reconstructed and entitled 'The Red Album'.[36] Here one hand is dominant. His work consists mostly of large pen-and-ink studies of heads – human and equine – drawn on orange-red prepared paper, and is characterised by contour lines that have a consistent strength (suggesting careful, mechanical copying) and by short, heavy hatching lines, which have none of Pisanello's sensitive regard for appropriate variation of pressure and his consequent subtle, graduated contrasts – here key features and subsidiary details are sometimes uniformly described. The veins in the muzzles of the horses, for example, have become exaggeratedly apparent, contrasting with Pisanello's more integrated approach, and, in drawing the human heads, features like eyes and eyebrows, lips and beards, are rendered so schematically that the faces almost always appear somewhat wooden and mask-like.

Once again, there can be no doubt that these drawings emanated from Pisanello's shop. Certain drawings in the album (such as Louvre 2629r, 2628) depend on models which Pisanello had employed in the Sant'Anastasia frescoes, and one of them – the head of the horseman in ermine (see fig. 1.29) – was first envisaged by Pisanello himself for this project.[37] Pisanello also roughed out his ideas for the decoration of the Malaspina chapel on a double page opposite one of the bridled horses' heads by a member of his workshop (fig. 5.11). These two autograph interventions approximately date the album to the late 1430s and early in the next decade.

BONO DA FERRARA

It is small wonder that various attempts have been made to assign all or parts of both albums of drawings, as well as other pages not associated with them, such as the Louvre drawing of the Virgin and Child (see fig. 4.29) that are by yet other hands,[38] to the one painter, Bono da Ferrara, whose presence in Pisanello's shop can be unequivocally established.[39] Bono's two known works, a panel in the National Gallery and a fresco in the Ovetari chapel in the Eremitani church in Padua, destroyed in 1944, go some way to proving the rule that Pisanello's pupils quite quickly abandoned their master's style after

becoming independent painters. The panel in the National Gallery (fig. 5.12), representing *Saint Jerome in a landscape*, is signed *BONUS FERARIENSIS PISANI DISIPULUS*, Bono of Ferrara, disciple (or pupil) of Pisano.[40] The picture has a Ferrarese provenance, coming, like *The Virgin and Child with Saints Anthony Abbot and George* and the portrait of Leonello d'Este, from the Costabili collection, and, like the National Gallery picture, it was restored by Molteni. His restoration does not hinder appreciation of Bono's acknowledged debt to Pisanello. Jerome sits, wearing a monastic habit,[41] his cardinal's hat perched on his rocky seat, his lion at his feet, in a mountainous landscape. The terrain is of the type familiar from the Louvre cavalcade drawing (see fig. 2.2), and the painting technique, involving the delicate but dense use of tempera hatching, combining colours in a single area to describe texture and volume, is also copied from his master. The work displays all the attention to naturalistic detail one might expect from a pupil of Pisanello: Bono has carefully depicted Jerome's books and writing equipment, the shadow cast by the corner of a sheet of paper attached to the rock, the golden light shining from the doorway of the church in the background, the stumps of felled trees (so like the ones behind Saints

5.11 **Pisanello and workshop**
Horse's head (by a member of the workshop);
sketches for the Malaspina chapel (by Pisanello),
c.1438
Pen and ink over black chalk on
red prepared paper, 25.3 x 37.5 cm
Paris, Musée du Louvre, inv. 2631 recto

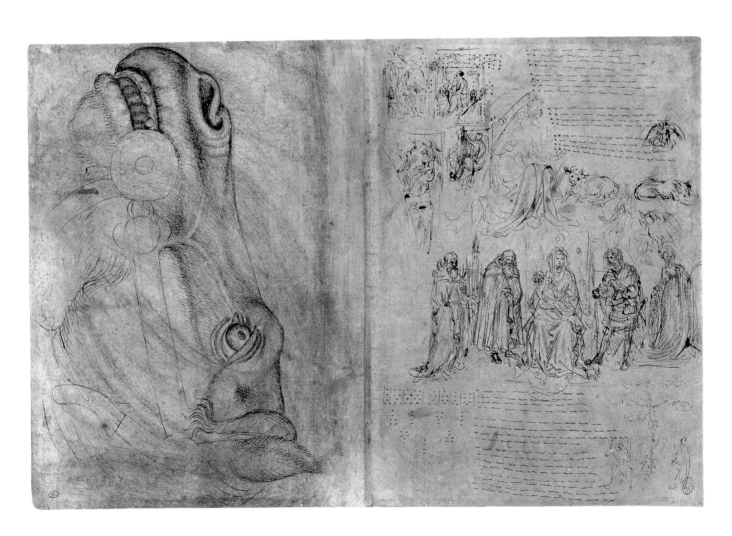

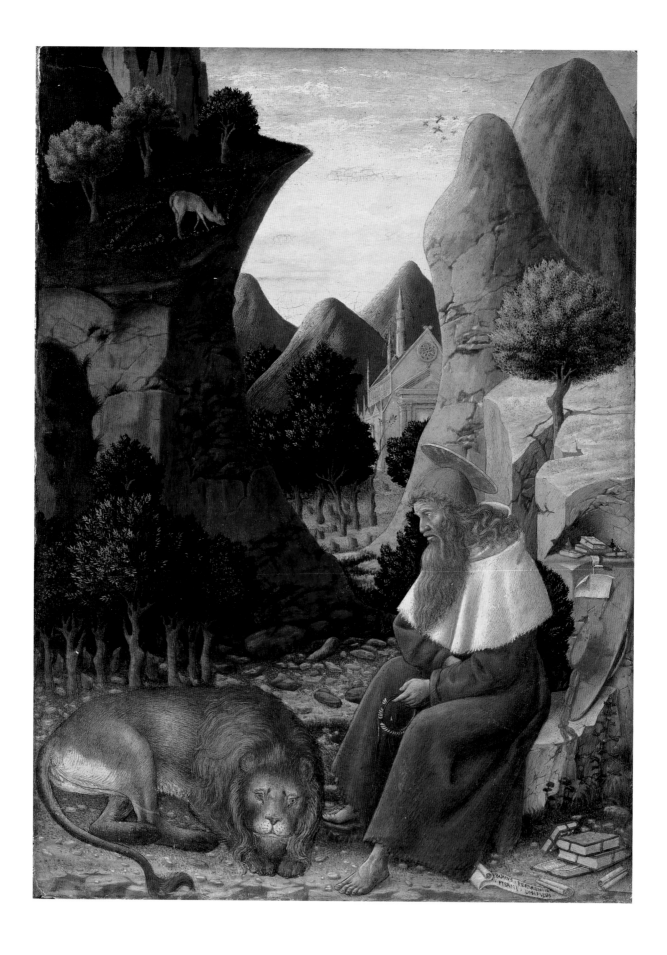

OPPOSITE

5.12 **Bono da Ferrara**
Saint Jerome in a landscape, c.1440
Egg tempera on wood, 53.5 × 39.6 cm
London, National Gallery, inv. NG771

Anthony and George in the National Gallery painting), the gazelle and the flight of birds. The pose of the saint is close to Pisanello's tiny compositional sketch for the figure of Saint Jerome (see fig. 5.11), one of the Doctors of the Church to be included in the Malaspina chapel; his lion is very like the lion of Saint Mark on the same sheet, which supports the view that the starting point for the painting is to be identified in a lost Pisanello painting. The cult of Saint Jerome, scholar-saint and translator of the Bible into Latin, was particularly nurtured by the humanists at the court of Ferrara. Guarino lavishly praised a lost *Saint Jerome* by Pisanello,[42] Bartolomeo Facio described a work by Pisanello showing 'Jerome adoring Christ affixed to the cross, venerable in both pose and the dignity of his expression'.[43] In the 1440s Angelo Decembrio mentioned a painting of Saint Jerome in his hermitage, without naming its author, as a particularly suitable ornament for Leonello's library – a work perhaps by Pisanello or even this picture.[44]

Bono's painting must adapt a lost work by Pisanello, and the signature makes deliberate play of his stylistic debt to his master. '*Disipolo*' is the term used in payment documents for two of the Florentine sculptor Donatello's assistants in Padua in the 1440s – Giacomo da Prato and Giovanni da Padova.[45] But the word also had humanist associations; it will be remembered that Vittorino dedicated a copy of a Xenophon to

5.13 **Bono da Ferrara**
Saint Christopher, 1451
Fresco
Destroyed, formerly Padua,
Chiesa degli Eremitani

Sassolo da Prato, his 'disciple and son' (see p. 119).[46] Thus, when Jacopo Bellini similarly signed a lost panel of Saint Michael painted in 1430 for the church of San Michele Arcangelo in Padua with the inscription *JACOPUS DE VENETIIS DISCEPULUS GENTILI FABRIANI PINXIT* he was melding the concept of straightforward pupilage to the more rarefied notion of discipleship.[47] Bono's use of Pisanello's types and technique was intended to back up the message of the signature, they were to be discernibly his master's.

The *Saint Jerome* was painted in all likelihood in the late 1430s or in the early 1440s. The signature does not imply that Bono was still in Pisanello's workshop when the work was executed – and there are no grounds for believing that he was the courier of the reward for Pisanello's 1435 Julius Caesar (see p. 111)[48] – but it is probable that its execution did not significantly postdate his departure. He was working as an independent master by January 1442, when painting the vaults of the cathedral in Siena; and he was there again in 1461.[49] In the meantime he was active at the Ferrarese court from 1450 to 1452, earning quite substantial sums for his labours. His only other known work belongs to a period he spent in Padua. He owned a house in the city from at least 1449, and in July

BELOW LEFT
5.14 **Workshop of Pisanello**
Studies of ancient sculpture: *head of Jupiter, lion's head, feet, c.1432–40*
Pen and ink, brown wash and metalpoint on parchment, 17.9 × 12.8 cm
Rotterdam, Museum Boymans Van Beuningen, inv. I.521 recto

BELOW RIGHT
5.15, 5.16 (details of 5.12) **Bono da Ferrara**
Saint Jerome in a landscape: Saint Jerome's feet and lion; head of Saint Jerome

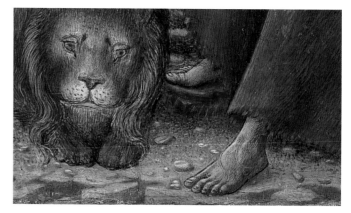

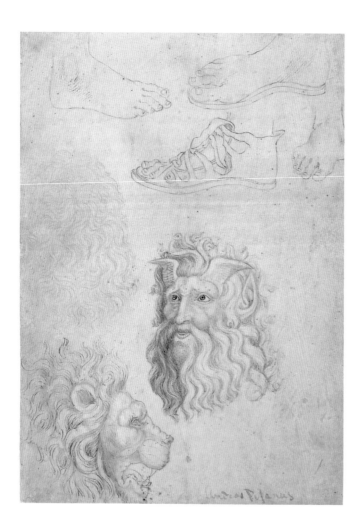

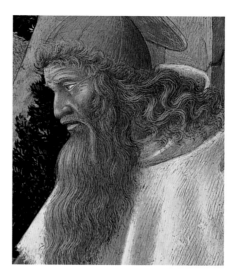

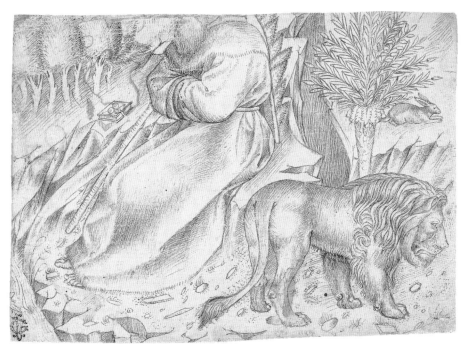

ABOVE LEFT
5.17 **Bono da Ferrara**
Saint Jerome in a landscape (fig. 5.11): infra-red
reflectogram of Saint Jerome

ABOVE RIGHT
5.18 **Bono da Ferrara**
Saint Jerome in a landscape, c.1440
Pen and ink, 20.3 × 29.5 cm
Paris, Institut Néerlandais, Collection Frits Lugt,
inv. 1344

1451 he was paid 18 ducats for his fresco of Saint Christopher (fig. 5.13) in the Ovetari Chapel at the church of the Eremitani, where he was employed alongside Andrea Mantegna.[50] He signed the fresco OPVS BONI, and just as there is no longer any verbal reference to his master, so, too, his idiom has changed entirely. Even if the stag and doe in the background still remind one – generically – of Pisanello, Bono was by then wholeheartedly imitating the style of the Paduan painter Francesco Squarcione and his pupils. Andrea Mantegna, Squarcione's most celebrated student, had executed his first commission for Leonello d'Este in 1449. Even before Pisanello's death, it seems, one of his self-proclaimed pupils could decide to abandon almost entirely his allegiance to his master.

The evidence of only two painted works (and they so unlike each other) is little enough to go on in any endeavour to identify Bono's drawings. However, even if neither has proved to be correct (and they are mutually contradictory), the connections that have been made between Bono's paintings and drawings both from the *Taccuino* and from the Red Album are of great assistance in understanding how typical Bono may have been as a pupil or assistant of Pisanello. One page from the *Taccuino*, for example (fig. 5.14), gives a clue how members of Pisanello's workshop might have learnt his types.[51] At the top of the sheet are four studies of feet, perhaps copies of ancient sculptural fragments or of existing drawings, just the kind of drawings that might have served Bono in painting and designing the feet of Saint Jerome (fig. 5.15). There is, moreover, a marked similarity between the heavy-browed, long-nosed (winged) antique head in the drawing and the bearded saint with his serpentine locks flowing behind him (fig. 5.16);

the drawing shows how Pisanello's ancient sources might be translated into a finished, modern composition. Nevertheless, there is no compelling technical reason for associating the page with Bono in particular, and the aspects common to drawing and painting can be credibly explained by the common education of their two artists: Bono and this anonymous draftsman undertook the reproduction of Pisanello's models on the same basis and arrived, therefore, at similar solutions.

It has also been proposed that Bono was the main contributor to the Red Album.[52] The putative dating of this group might be thought to fit well with what little is known of Bono's career, and it is true that their gracelessness and relentless hardness of line have something in common with Bono's cloddish Saint Christopher. However, the drawings exhibit none of the delicate hatching technique Bono employed (in tempera) in his Saint Jerome, and infra-red reflectography (fig. 5.17) reveals that the underdrawing of the painting is very different from any of the drawings from the Album. The light but insistent contour lines and illogically directed hatching in the underdrawing have very much more to do with a drawing in the Frits Lugt collection in Paris (fig. 5.18).[53] Indeed

BELOW LEFT
5.19 **Attributed to Bono da Ferrara**
Seated man in monastic habit, c.1440–5
Pen and ink over metalpoint, 27.2 × 19.5 cm
Paris, Musée du Louvre, inv. 2332 verso

BELOW RIGHT
5.20 **Attributed to Bono da Ferrara**
Seated man in monastic habit, c.1440
Pen and ink over metalpoint, 27.2 × 19.5 cm
Paris, Musée du Louvre, inv. 2332 recto

this appears to be the surviving lower half of a compositional drawing made for the London panel, in which the artist tried out the relative positions of the seated saint and the lion. While the more central positioning of the saint has squeezed the lion rather uncomfortably into the corner – demanding the change that occurred between the drawing and the execution of the painting – the little copse in the middle ground has not been moved. The Lugt drawing must therefore be judged the first touchstone in the search for other drawings by Bono.

In view of certain stylistic and technical affinities it may in fact be possible to connect a small group of drawings to the Saint Jerome compositional drawing and thus to Bono. Three drawings, two on the same sheet in the Louvre and another in the British Museum (figs. 5.19, 5.20, 5.21) of men in monks' habits, seated on a bench, seen from opposite angles, may show Bono establishing the pose of the hermit saint.[54] The model is untonsured and is therefore unlikely himself to be a monk – which makes it likely that he was drawn from life. The figures are shaded using light, feathery, rather drifting hatching-lines. Certainly they are more logically directed (though their system of parallels sometimes

BELOW LEFT
5.21 **Attributed to Bono da Ferrara**
Seated man in monastic habit, c.1440
Pen and ink, 18.8 × 11.7 cm
London, The British Museum, inv. 1946-7-13-206

BELOW RIGHT
5.22 **Attributed to Bono da Ferrara**
Heron, c.1440–5
Pen and ink over leadpoint, 24.3 × 17.5 cm
Paris, Musée du Louvre, inv. 2450

FAR LEFT

5.23 (detail of 2.12) **Pisanello and workshop**
Sala del Pisanello (Arthurian frescoes), north-east
wall: maiden on tribune

LEFT

5.24 **Workshop of Pisanello**
Head of a young woman, c.1434–42
Pen and ink over black chalk on
red prepared paper, 28.1 × 20 cm
Paris, Musée du Louvre, inv. 2589 verso

breaks down) than those in the Lugt drawing or the Saint Jerome underdrawing, as they
are in three other drawings that appear to have been executed by the same hand: studies
of a hare (Louvre 2439), a young man looking down, turning the top of his head to the
viewer (Louvre 2299), and a standing heron (fig. 5.22).[55] But a tentative feel to their
hatching is a common feature and it may be possible to explain their different application
in the Lugt drawing and the group centred around the Louvre and British Museum
'hermit' sketches by the different functions of these drawings. While the Louvre and
British Museum 'hermits' were sketched in order to learn how the features, body and
drapery of a man dressed in long robes might work, with the intention of using the
resultant drawings, if deemed successful, as patterns, the Lugt drawing was made in
order to find a way to fit the figure into the landscape and establish his relationship with
other elements in the painting.

Even if Bono's authorship of no more than the Lugt drawing is admitted, another
solution to the authorship of the drawings in the Red Album must be sought. Connections
have been found with the Mantua chivalric frescoes;[56] for example, a head of a woman
with plaits wound around her head (fig. 5.24) is particularly close in type to one of the
women on the tribune in the Mantua frescoes (fig. 5.23). A link has also been made
between the figures in the topmost part of the principal fresco and a little group of
drawings of pipers and trumpeters.[57] Given that the wall-paintings and the album were
executed at much the same time, the draftsman may have been one of the assistants that
were undoubtedly used for the Mantua frescoes. The suggestion can only be tentative,

but the drawn heads and their counterparts in the frescoes share a simplified, schematic character, the same mask-like quality, so unlike the sinopia drawings underneath.

MANUSCRIPT ILLUMINATORS

Even if in some cases workshop drawings may be linked with finished paintings, these instances remain isolated. With the possible exception of the Sant'Anastasia frescoes, no workshop intervention can be discerned in any other surviving pictures by Pisanello. And the abandonment of Pisanello's style by the next generation of painters, some of whom may well have been taught by him, may not be the only reason why endeavours to associate drawings with paintings have proved so arduous. Critics may have been looking at the wrong category of art production. The energies of Pisanello's pupils, assistants and collaborators may not always have been directed at large-scale painting either on panel or in fresco, but to manuscript illumination. The question of Pisanello's own involvement in manuscript illumination remains controversial. The theory that Pisanello painted miniatures rests on a somewhat gnomic statement in Facio's short biography of the artist that 'Also exemplifying his talent and art [are] a certain number of paintings on panel and on parchment'.[58] These 'paintings on parchment' might be highly finished, coloured drawings of animals, but it is equally possible Facio was referring to illuminations. Critics have attributed to Pisanello a number of manuscript illuminations which, in different ways, resemble his known paintings, drawings and medals – even if their painting techniques rule out their production by a single illuminator.

Among these are two 'portrait' miniatures in the first of three volumes of the Latin translation of Plutarch's *Parallel Lives* commissioned by Domenico Malatesta Novello for his library at Cesena.[59] The formation of Domenico's library began when he was wounded in battle in 1447, after which he was forced to concentrate on more sedentary

BELOW LEFT
5.25 **Workshop of Pisanello**
Plutarch, *Parallel Lives (Vitae virorum illustrium)*, folio 29: *Julius Caesar*, c.1446–8
Tempera on parchment, 36.2 × 24.7 cm
Cesena, Biblioteca Malatestiana, inv. Ms.S.XV.1

BELOW CENTRE
5.26 **Workshop of Pisanello**
Plutarch, *Parallel Lives (Vitae virorum illustrium)*, folio 1r: *Alexander the Great*, c.1446–8
Tempera on parchment, 36.2 × 24.7 cm
Cesena, Biblioteca Malatestiana, inv. Ms.S.XV.1

BELOW RIGHT
5.27 (detail of 5.9) **Workshop of Pisanello**
Dancing putti, copied from Donatello's Prato pulpit relief: left-hand putto

activities. The scribe for the first two volumes and part of the third was Jacopo da Pergola, who is known to have been employed by Domenico from 1446, suggesting a date for the earliest of the miniatures in the first volume. The project continued into the 1450s, by which time at least six illuminators had been commissioned to execute portrait heads to accompany Plutarch's biographies. Many of them show knowledge of Pisanello's works. The *Theseus* on folio 189v of volume II, for example, is a far from radical reworking of Pisanello's medallic portrait of John VIII Palaeologus.[60] But this is no more than another example of the long-distance imitation of Pisanello's models, made possible by the circulation of his medals.

The first two illuminations, however, might be thought more plausibly to have had some direct connection with Pisanello himself: the damaged frontispiece portrait of Alexander the Great (fig. 5.26), and the image, by the same painter, of Julius Caesar on folio 29 (fig. 5.25). Pisanello's portrait medal of Domenico proves that he worked for him in the late 1440s or early in the next decade, and these two ancient rulers, as we have seen (chapter III), were central to Pisanello's image production. Qualitatively, these are not only the most impressive of the illuminations in the Plutarch, they are also executed with greater finesse and sensitivity than any others ever attributed to Pisanello. However, their high quality alone does not prove Pisanello's authorship, and it is worrying that their technique, exquisite though it is, is so different from, for example, Pisanello's coloured drawings of birds and animals; there is no sign here of Pisanello's layered hatching method. Although Caesar's chiselled profile, and the introduction of the shadow behind it, reproduce the relief of Pisanello's medals, the organisation of the necks and shoulders of the ancient heroes have nothing in common with the busts of Pisanello's portraits of contemporaries, whether paintings or medals.

But if these miniatures are not, in fact, by Pisanello himself, there can be no doubt that their author had access to drawings by him. A drawing (fig. 5.28) of a laurel-wreathed profile – one of two facing each other on the same sheet – resembles the manuscript Caesar; and his head and shoulders are arranged in a similar way.[61] Although the drawing has been generally attributed to Pisanello, its heavy-handedness suggests that it may in fact be a sketch executed by a member of his shop (a rapid copy perhaps of Pisanello's 1435 Julius Caesar, see p. 111). Both the Caesar and, especially, the Alexander also seem to depend on Pisanello's drawings copying a series of coin 'portraits' of ancient rulers (see fig. 3.6). The existence of a sheet from the Red Album (Louvre 2266v) in which another pupil or assistant has made somewhat ham-fisted copies of the heads of Alexander and Augustus shows how such drawings after antique coins must have circulated within the shop.[62] This workshop drawing is too poor to be linked directly with the first illuminator of the Cesena manuscript. But two drawings from the *Taccuino di viaggio* after Donatello's Prato pulpit (see fig. 5.9) are of an altogether different quality, the draftsman capturing the lively expressions of the dancing putti and rendering them with a fine, confident line. It is therefore intriguing that a tambourine-playing infant from one of these (fig. 5.27) reappears, his cheerfulness intact, on the pediment of the little tabernacle framing the head of Alexander. It does not seem unreasonable to attribute these two drawings, associated with Pisanello's workshop, to the first illuminator of the Plutarch.

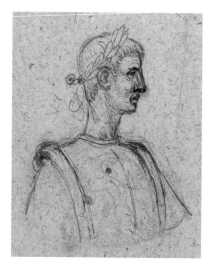

5.28 **Workshop of Pisanello**
Julius Caesar (detail), c.1435–45
Pen and ink over black chalk, 14.5 × 17.4 cm
Paris, Musée du Louvre, inv. 2265

There is a case, then, that some of Pisanello's pupils or associates were active as manuscript illuminators. Given the artist's employment by Domenico Malatesta as a medallist, these miniatures may even have been executed under Pisanello's supervision. The drawing with a sketchy Madonna of Humility (see fig. 4.32) may have been a design for an assistant to follow. The proposal that Pisanello may likewise have coordinated the group of illuminators charged by either Gianfrancesco or Lodovico Gonzaga with the borders of the Turin *Writers of Imperial History* (see fig. 3.27) also looks feasible.[63] The combination of ancient coin portraits in roundels, beautifully observed flowers and foliage, gambolling putti, and men and women in the fashionable costume of the court links the borders to Pisanello and his shop. The fact that the various illuminators, though distinguishable from one another by their technique, all employ ingredients from the same repertoire implies that they had been provided with models from a single source. That some of these motifs turn up in other illuminations by artists working between Venice, Verona and Mantua suggests that theirs may be the hands responsible for the large group of unassigned drawings connected with Pisanello's shop.[64]

The attribution of another miniature (fig. 5.29) which has been regularly, but unsatisfactorily, given to Pisanello himself may be resolved similarly.[65] *The Conversion of Saint Paul* in the J. Paul Getty Museum in Los Angeles is an initial cut from a lost gradual, probably painted in the late 1430s or 1440s.[66] Since it contains both Gonzaga colours (red, white and green on the knight's cloak and the page-boy's crest) and emblems (the radiate sun) it is thought to have been executed in Mantua. The figures and horses are undeniably 'Pisanellesque' – particularly close to the Gonzaga medal reverses and to the cavalcade drawings (see figs. 2.25b, 2.2). Their hatched technique is very reminiscent of Pisanello's coloured drawings of birds and animals. However, the quality of the drawing does not match Pisanello's own. The situation is complicated by the fact that the patch of landscape and cloudy sky at the top right is so technically (as well as stylistically) different from the figures and the foreground that it must be by another hand altogether; this is painting much more typical of a professional illuminator. The hooked pen-strokes under the uniform green of the foreground contrast with the gloriously sketchy variegation of the hills and vegetation in the background. A connection has also been made between the Getty miniature and a group of miniatures attributed to a single master working in Venice and Verona, known as the Master of the Antiphonal Q of San Giorgio Maggiore after the miniatures of an antiphonal in this Venetian monastery.[67] In fact the group of works associated with this 'name' is rather disparate, and their single authorship may be doubted. It is clear in any case that two artists worked together on the Getty *Conversion*, precluding its straight-forward inclusion in the group.

In point of fact, there is an undeniable similarity between the landscape in the Getty fragment (fig. 5.31), so unlike anything to be found in Pisanello's secure works, and the hills and sky in another detached miniature, *Christ calling Saint Andrew*, now in the Victoria and Albert Museum, London (fig. 5.30), cut from a manuscript commissioned in about 1440 by an Augustinian monastery in Verona.[68] This illumination has been erroneously grouped with the miniatures in the San Giorgio antiphonal. The figure of Christ is quite

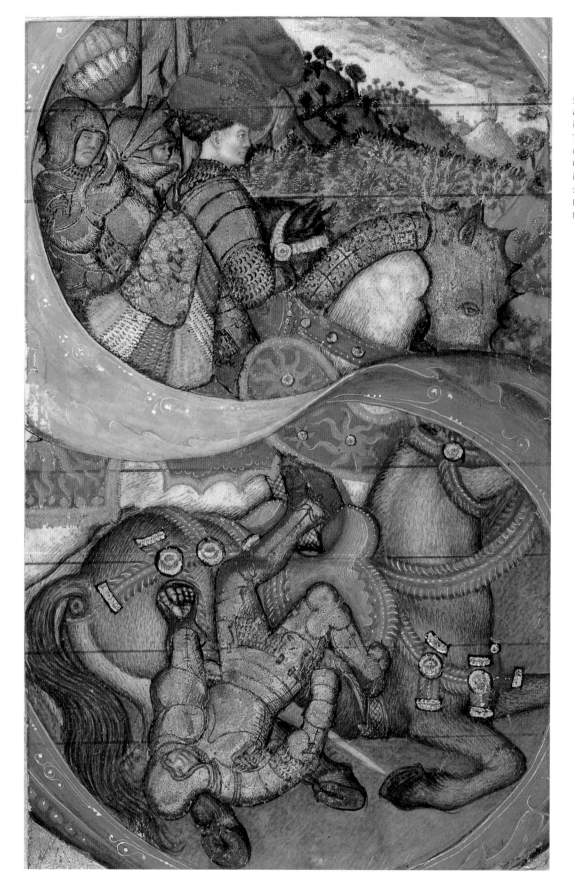

5.29 **Workshop of Pisanello
and unidentified Veronese
illuminator**
The Conversion of Saint Paul,
c.1438–50
Gold leaf, gold paint, silver leaf,
ink and tempera on parchment,
14.2 × 9 cm
Los Angeles, The J. Paul Getty
Museum, inv. 91.Ms.5 verso

unlike that of the Getty horsemen and has little in common with Pisanello. What seems likely therefore is that the painter of the Veronese miniature in the Victoria and Albert Museum was called upon to supply a landscape – perhaps a particular specialism – for the armoured figures and the horses of the Getty fragment, which were valuable as images because, even if they were not by Pisanello himself, they contained all the elements for which he was so celebrated. Either the landscape painter may have had a specialist function within Pisanello's shop, in which case it might be useful to seek his hand among the workshop drawings, or, just as likely, he was an independent Veronese specialist illuminator who was called upon to collaborate either with Pisanello himself, who then delegated his share of the work to an assistant, or with an erstwhile assistant or pupil of Pisanello's by now working independently. Either way, Pisanello's ties to manuscript painters and their production seem further demonstrated.

In fact there is evidence that it was Pisanello's workshop, rather than a former pupil, that was involved in the Getty illumination. Another unmistakably 'Pisanellesque' illumination, an image of *The Triumph of Caesar* framed by the G initial on the first page, occurs in a manuscript of Caesar's *Commentaries* in the British Library, London (figs. 5.32, 5.33). The scene particularly resembles the triumphal car on the reverse of one of the medals of Alfonso of Aragon (fig.5.34).[69] Unsurprisingly, it has also been attributed to Pisanello, but once again it is better associated with his workshop. The manuscript has

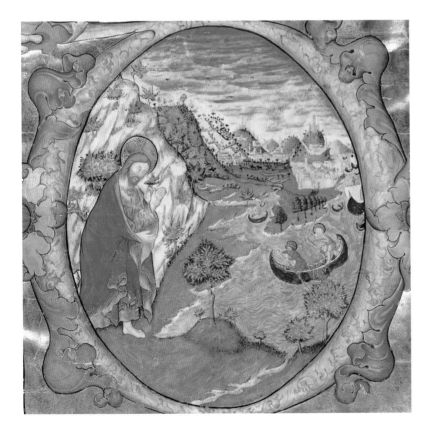

ABOVE
5.31 (detail of 5.29) **Workshop of Pisanello and unidentified Veronese illuminator**
The Conversion of Saint Paul: landscape background

LEFT
5.30 **Unidentified Veronese illuminator**
The Calling of Saint Andrew, c.1440
Tempera and gold on parchment
London, Victoria and Albert Museum, inv. I.30A

5.32 **Workshop of Pisanello**
Julius Caesar, *Commentaries*
(*De bello gallico*), folio 1r,
c.1438–50
Tempera on parchment,
37 × 27 cm
London, The British Library,
inv. Harley 2683

been dated to the 1440s – though it may be slightly earlier or later – and, although the Piccolomini arms of pope Pius II were added to it after his accession to the papacy in 1458, it may have originated from Mantua or Ferrara. Any theory of its patronage needs to take account of the barely visible motto, *Plus* [h]*aut*, which is painted on the side of Caesar's wagon – an *impresa* which we know (see p. 60) to have been used by at least one member of the Visconti family. Another, very unusual detail might also provide a clue as to the commissioner's identity. On the front of the carriage is inscribed a fragment of music: an F clef followed by two musical notes which could be read as either E and F or mi and fa. The line is filled out at the end with a bit of decoration of no musical significance. If this a code of some kind, it has so far resisted decipherment.[70]

Here, even if the initial letter seems to be by another hand, the whole scene, with its landscape recalling the stylised and part-gilded mountains in Bono's *Saint Jerome* (see fig. 5.12), is by a single illuminator, and it is immediately apparent that he is also the painter of the figures in the Getty fragment. The horses which pull the emperor's carriage are the same shaggy beasts which bear Saint Paul's retinue and from which the saint himself has been so dramatically thrown. Caesar has the exaggeratedly mournful expression – the strangely down-turned mouth – familiar from the last helmeted rider in

LEFT
5.33 (detail of 5.32) **Workshop of Pisanello**
Julius Caesar, *Commentaries (De bello gallico)*,
folio 1r: *The Triumph of Caesar*

BELOW
5.34 (detail of 3.46b) **Pisanello and workshop**
Portrait medal of Alfonso V of Aragon, king of Naples,
reverse: triumphal car

5.35 **Workshop of Pisanello**
Study of *Bacchus with satyrs and Maenads*
from an ancient sarcophagus, *c*.1431–40
Pen and ink over metalpoint on parchment,
19.5 × 27.4 cm
Milan, Pinacoteca Ambrosiana,
inv. F.214 inf. 15 recto

Paul's cavalcade, whose gloom seems equally inappropriate. This last stylistic mannerism is suggestively reminiscent of many of the figures by the principal draftsman of the group of studies after the antique in the *Taccuino di viaggio*. In fact it seems possible to suggest that this body of drawings and the figures in the two manuscripts were produced by the same personality within Pisanello's shop. Other types are consistent. Paul's fallen horse has very much the same proportions and, though it is revolved slightly, the same pose as the warrior's rearing mount, also noticeably shaggy, in the copy after the Grottaferrata Bacchus relief (see fig. 3.55). The page-boy's profile is close to the putti in other drawings. Moreover the penmanship, where it is visible, in the two illuminations has the same 'hairiness', the same evenness of hatching as the *Taccuino* drawings. The same distinctive use of facial expression and hatching technique are evident in the Ambrosiana drawing of the Vatican Bacchic sarcophagus relief (fig. 5.35).

TADDEO CRIVELLI AND MANUSCRIPTS IN FERRARA

This connection seems to demonstrate that it was possible for a painter who had received his training in Pisanello's workshop to turn his hand to manuscript illumination. Assessed as a group, moreover, the four examples of manuscript painting discussed above show how Pisanello might have fitted into a wider network of specialist illuminators who had access to his designs and were instrumental in promulgating them within their tight-knit artistic community. One should examine against that background those manuscripts painted in the 1450s and 1460s that show, at least in their peripheral imagery, a continuing

debt to Pisanello's patterns. It has been suggested, for example, that Taddeo Crivelli, the leading illuminator in Ferrara in that period, was Pisanello's pupil.[71] Crivelli, Ferrarese by birth, is first recorded working as an illuminator in 1452, fulfilling a commission for Domenico Malatesta Novello.[72] A training in Ferrara under Pisanello is chronologically entirely possible, and innumerable quotations from Pisanello's works can be found in the pages he contributed to Borso d'Este's prestigious and expensive Bible, illuminated between 1455 and 1461 – Taddeo's first uncontroversially identified works.[73] Some of his sources were medallic: he copied, for example, the eagle and dead doe from the reverse of one of the medals of Alfonso of Aragon (see fig. 3.44b). He could then be classed as a 'long-distance' imitator. However, other motifs in the borders of the Bible, primarily the birds and animals – monkeys and dogs, for example – can be directly correlated with autograph drawings (for example Louvre 2389v, 2390r, 2513).[74] Other Pisanello motifs he quoted, his various herons for example, copy images known from workshop renditions.

Crivelli continued to profit from these patterns in subsequent projects. The largest and most elaborate of the illuminations in a manuscript of Boccaccio's *Decameron* in Oxford (fig. 5.38) contains two major citations, in border and miniature:[75] the swan

FAR LEFT
5.36 **Taddeo Crivelli**
The Gualenghi-d'Este Hours, folio 174: *Saint Jerome kneeling before the Cross*, c.1469
Gold leaf, gold paint and tempera on parchment, 10.8 × 7.9 cm
Los Angeles, The J. Paul Getty Museum, inv. 83. ML.109

LEFT
5.37 (detail of 4.50b) **Pisanello**
Portrait medal of Domenico Malatesta Novello, lord of Cesena, reverse

Comincia illibro chiamato decameron cognominato prencipe galeotto nelquale sicontengono cento nouelle in dieci di dette da sette donne e da tre giouani huomini :: Proemio ::

Vmana cosa e la uere compassione agliaffricti et come che ad ciascheduna persona sta bene ad coloro maximamente e richiesto liquali gia anno di conforto mestieri auto e trouato lo trouaro in alcuno. fra ghquali se alcuno mai nebbe bisogno o glisu caro o gia ne riceuette piacere. io sono uno di quegli percio che dala mia prima giouanecça insino ad questo tempo oltre amodo essendo stato acceso da altissimo et nobile amore forse piu assai chella mia bassa conditione non parrebbe narrandolo io sirichiedesse quantunque appo coloro che discreti erano. et alla cui notitia peruenne io ne fossi lodato e da molto piu reputato non dimeno mi fu egli di grandissima fatica a sofferire. Certo non per crudelta de la donna amata ma per soperchio amore nella mente concepto da poco regolato appetito ilquale percio caninno conueneuole termine mi lascia contento stare piu di noia che bisogno nomera ispesse uolte sentire mi faceuan. Nella qual noia tanto refrigerio mi porsono ipiaceuoli ragionamenti dalcuno amico e lesue laureuoli consolationi cheio porto certissima oppinione per quello essere aduenuto che non sia morto. Ma si come ad colui piacque ilquale essendo egli infinito diete per legge incomutabile ad tutte le cose mondane auere fine. il mio amore oltre aognaltro feruentemente et ilquale niuna força diproponimento o di consiglio o diuergogna euidente o pericolo che seguire neportesse auea potuto nerompere nepiegare perse medesimo in

processo di tempo sidiminui inguisa che se solo dise nellamente ma alpresente lasciato quel piacere cheusato diporgere ad chi troppo nonsimette nesuoi piu cupi pelaghi e nauicando per che doue faticoso essere solea ogni affanno togliendouia delecteuole isento essere rimaso ma quantunque cessata sia la pena non percio e la memoria fuggita debensici gia riceuuti datiui da coloro da quali per beniuolença da coloro ad me portata. Erano gram le mie fatiche ne passera mai si como credo senon per morte. Et pero chella grattitudine secondo cheio credo fiala tra uirtu e sommamente da comendare e ilcontrario da biasimare per non parere ingrato o mecostesso proposto uiuolere inquel poco che pme sipuo incambio uicio chio riceuetti oza che libero dire mi posso e se non ad coloro che me atarono aliquali peraduentura p lo loro seno o p la loro buona uentura non be sogni ad quegli almeno aquali fa luogo alcuno alleggiamento prestare. Et quatun que il mio sostenimento o conforto che uogliamo dire possa essere e sia abisognosi assai poco. Non dimeno parmi quello douersi piu tosto porgere doue ilbisogno appansce magiore. siche pche piu utilita usara essi anchora p che piu insia caro auuto. Et chi neghera que sto quantunque egli sisia non molto piu alle uaghe donne che ad gliuomini conuenirsi donare. Et se dentro adiliati petti temeno e uergognando tenghono lamorose fiame nascose lequali quanto piu di força amo chelle palesi coloro ilsanno chelano prouato e prouano. Et oltre adcio ristrette da uoleri da piaceri da comandamenti de padri delle madri de fratelli e de mariti impicciol tempo nel loro cerchuito delle loro camere racchiuse si morano et quasi ociose setendosi uolento e non uolento in una medesim hora seclo ri uolgono diuersi pensieri. liquali non e possibile che sempre siano allegri. Esse per quello mossa da focoso disio alcuna malinconia soprauiene nelle loro menti inquelle conuiene che congraue noia sidimori se da nuoui ragionamenti non e rimossa sença chelle sono molto meno forti che gliuomini a sostenere. il che degli inamorati huomini non auiene si come noi possiamo apertame te uedere essi se alcuna malinconia o graueça

5.39 **Pisanello**
Swan, c.1434–8
Pen and ink over black chalk on
red prepared paper, 12.7 × 14.2 cm
Modena, Galleria Estense, inv. 895

5.40 **Franco dei Russi**
Bible of Borso d'Este, vol. 1, folio 88v
Tempera and gold on parchment,
37.5 × 26.4 cm
Modena, Biblioteca Estense
Universitaria, inv. Lat. 422.ms.V.G.12

OPPOSITE
5.38 **Taddeo Crivelli**
Boccaccio, *Decameron*, folio 5v: *The Meeting in
Santa Maria Novella*, 1467
Tempera and gold on parchment
Oxford, Bodleian Library, inv. MS. Holkham misc. 49

reproduces a pen-and-ink study in Modena (fig. 5.39), executed by Pisanello (though with a knot in its neck) at the time he was making drawings for the Sant'Anastasia frescoes. The costumes, especially those seen from the side, of the elaborately dressed men in the miniature seem to depend on the signed drawing in the British Museum (see fig. 2.33), or a version of it. A page from the Gualenghi-d'Este Hours of 1469 (fig. 5.36) (on which Crivelli collaborated with Guglielmo Giraldi) also combines motifs from two sources.[76] The miniature, *Saint Jerome adoring the Crucifix*, is a reworking of the beautifully composed reverse to Pisanello's medal of Domenico Malatesta (fig. 5.37): Christ on the cross is depicted from precisely the same angle and the saint has taken the place of the armoured knight. Crivelli may even have known the painting in which Pisanello first included the crucifix. The hare and hound in the border are lifted from *The Vision of Saint Eustace* (see figs. 4.57, 4.81). However, if Taddeo Crivelli was taught by Pisanello, there is precious little evidence of it in the Pekingese-like little lion which accompanies Saint Jerome. The lions in Bono's National Gallery painting (see fig. 5.12) and Pisanello's own reverse to the marriage medal of Leonello (see fig. 3.43b) show that their naturalistic depiction was quite as much a feature of Pisanello's shop as accurate accounts of dogs, hares or herons. Crivelli seems therefore to have had only limited access to Pisanello's models. His adaptation of the crucifix medal reverse may, for example, have been the result of his earlier work for Domenico Malatesta. He surely, however, had sight of some drawings by Pisanello or copies after them. But then so did other illuminators working in Ferrara at the same time who were certainly not taught by Pisanello. The other leading contributor to Borso's Bible was the Mantuan Franco dei Russi, and their perhaps slightly older contemporaries, Marco dell'Avogoro and the Modenese Giorgio d'Alemagna, took subsidiary rôles.[77] All of them re-employed models by Pisanello and his shop (fig. 5.40),[78] and all probably had access to drawings from it. But how did they get hold of them? By this time Pisanello was dead; he cannot have supplied them himself.

There are two possible solutions to this conundrum. It is possible that the Este patrons of this bevy of illuminators provided the drawings themselves. Studies such as the signed drawing in the British Museum (see fig. 2.33), other surviving drawings with a similar level of finish, and the partially gilded equestrian image of Borso d'Este (see fig. 2.34) may already have been collected. Some Este manuscript painters, Giorgio d'Alemagna – in 1446 – and Guglielmo Giraldi among them, can be proved to have had their working spaces and residences at the Castel Novo in Ferrara;[79] some received salaries. A degree of patronal control over their output is therefore to be expected. Alternatively, the highly collaborative nature of the illuminators' work occasioned the circulation of the drawings. In almost all of the manuscripts we have examined two or more artists have been at work: this speaks for a lively interchange of motifs. Given Pisanello's involvement with manuscript painting, one would expect his patterns to have circulated and been copied by his collaborators. If the drawings assembled in the Codex Vallardi – and even other earlier ones – belonged to the workshop, they must have travelled with the artist to Naples, and there is no evidence that Pisanello ever returned to Ferrara. It is most likely therefore that Crivelli and his contemporaries were all consulting a collection (an album?) of copies made by one or more of Pisanello's illuminator pupils.

Giorgio d'Alemagna, for example, may have gained second-hand knowledge of Pisanello's models in Ferrara in the 1440s as a consequence of his joint contribution to a manuscript with an illuminator trained by Pisanello. Giorgio had been active at the Ferrarese court from 1441 and his career in the city therefore overlapped with Pisanello's. The description in a payment of 50 *lire* in August 1453 accords precisely with the poorly preserved frontispiece of *La Spagna in rima* ([The book of] Spain in rhyme) in the Biblioteca Communale Ariostea in Ferrara.[80] This contains a beautifully observed, 'Pisanellesque' hare in the lower border, and one of the portrait roundels is yet again

ABOVE

5.42 (detail of 5.41)

LEFT

5.41 **Attributed to Matteo de' Pasti**
Fragment of Breviary of Leonello d'Este, 1441–8
Tempera and gold on parchment, 27.3 × 20 cm
Harvard University, Houghton Library,
inv. MS Type 301

based on the Palaeologus medal. This image and other works for which Giorgio received documented payment form the basis of a stylistically coherent group. He is first recorded as one of the contributors to a breviary made for Leonello d'Este between 1441 and 1448. It is now dismembered and most of the pages are lost, but one of the few surviving sheets is now in the Houghton Library in Cambridge, Massachusetts (fig. 5.41).[81] Clearly this is not one of the pages decorated by Giorgio. The inclusion of both putti and coin portraits in the border link it with the Turin *Writers of Imperial History* (see fig. 3.27), enough in itself to place the manuscript in the ambit of Pisanello. Tying the page still more closely to Pisanello's workshop is the fact that one of the putti relates to the same drawing copying Donatello's Prato pulpit that was used by the illuminator of the Cesena Alexander miniature (fig. 5.42; see fig. 5.9).[82]

Payments were made for the breviary to three other illuminators: Guglielmo Giraldi (whose known style is also different from the Houghton page), Bartolommeo di Benincà and Matteo de' Pasti. Matteo, a Veronese, is first documented as a miniaturist in Venice in 1441, learning how to use powdered gold as a pigment while executing illuminations for a manuscript of Petrarch's *Triumphs* destined for Piero de' Medici in Florence.[83] He later worked for Leonello without leaving Verona. His birthplace and the fact that he, like Pisanello, seems to have been unable to leave Venice in the early 1440s suggest that he may well have been Pisanello's pupil. Given the coincidence of documented payment, the use of powdered gold, and stylistic references to Pisanello's workshop patterns (also evident, for example in the little lion and other animals at the bottom of the page), the attribution to him of the page from Leonello's breviary is logical. This single surviving example of Matteo's illuminating style has encouraged one art historian to attribute to Matteo, rather optimistically, the decoration of another manuscript, also replete with references to Pisanello (the Palaeologus profile for example), a Livy's *History* (Bibliothèque nationale, Ms Lat. 14360) thought to have been executed in Rimini in the second half of the 1440s.[84]

If Matteo had worked solely as an illuminator there might be grounds, on this paltry evidence, for calling him a follower rather than a pupil of Pisanello. However, he was also by far the most skilled of the generation of medallists who operated in the two decades following Pisanello's death.[85] The date, 1446, on his earliest medals, those of Sigismondo Malatesta and his mistress Isotta degli Atti (figs. 5.43, 5.44), could be thought to mark the moment when he embarked on his career as a medallist. However, the date may alternatively commemorate some important event in the lives of the couple.[86] The same date appears, surprisingly, since she died in 1474, on Isotta's tomb in the church of San Francesco in Rimini.[87] The legend around Matteo de' Pasti's veiled portrait of Isotta degli Atti translates as: 'To Isotta of Rimini, the ornament of Italy for beauty and virtue'.[88] Her posthumous reputation evidently concerned Sigismondo, who must have commissioned the medals. Matteo arrived in Rimini in about 1449 to act as Leon Battista Alberti's executive assistant in the rebuilding of the Malatesta church of San Francesco – often misleadingly called the Tempio Malatestiano. His series of medals of Sigismondo (including one with the projected façade of San Francesco) and of Isotta must date from then. Isotta's celebrated elephant reverse is perhaps related to the coin of Seleucus I (see

5.43a, b **Matteo de' Pasti**
Portrait medal of Isotta degli Atti, c.1449–52
Cast bronze, diam. 8.4 cm
London, The British Museum, inv. GIII, Var. Pr. 8

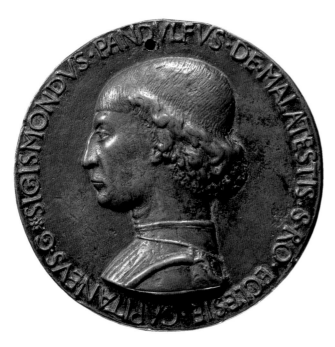

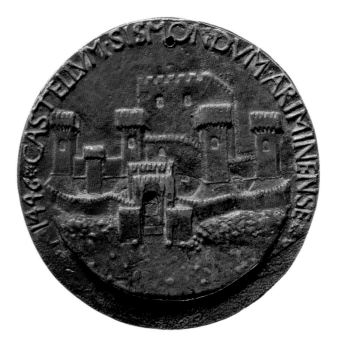

5.44a, b **Matteo de' Pasti**
Portrait medal of Sigismondo Malatesta, lord of
Rimini, c.1449–52
Cast bronze, diam. 8.4 cm
London, The British Museum, inv. 1933-11-12-2

fig. 3.39b) used by Pisanello for his medal of Francesco Sforza. Matteo followed these up with medals of his brother Benedetto, Guarino (see fig. 3.13), Alberti, Timoteo Maffei and Jesus Christ (a medal which is surely related to a design made in Naples by one of Pisanello's assistants there).[89] All of these were probably modelled in the mid to late 1450s or early in the next decade.

A comparison of one of Matteo's medals of Sigismondo with one by Pisanello immediately demonstrates the nature of his debt to the older artist. Quite apart from the common epigraphy, Matteo's developed naturalism expressed through refined and subtle relief is surely derived from a profound understanding of Pisanello's method. The prominent vein in Guarino's forehead (see fig. 4.82) is a lovely example of his approach. So, too, is the way he has applied principles of geometrical abstraction to the features of his subjects. Given that nothing is known of Pisanello's own training as a sculptor, one cannot be absolutely certain that he taught Matteo. Indeed in the chronicle written in Forlì by Giovanni di Mastro Pedrino, which recounts Matteo's failed journey to Constantinople in 1461, he is called 'Veronese goldsmith, member of the household of Lord Sigismondo'. However, no goldsmith of the period modelled in the way that Matteo did, and his tutelage by Pisanello remains the most sensible explanation of his artistic technique.[90]

MEDALS AND SIGNATURES

Given that Matteo almost certainly learned his skills as a medallist in Pisanello's shop, it is worth asking how the concept of artist-hero and the practice of his workshop marry in Pisanello's own medals: whether his medals, like his panel paintings, were indeed all his own work, as the signatures might be thought to imply, or whether there was, on occasion, workshop intervention.[91] If this was the case, it was of a different order to the activities of the workshop as manuscript illuminators, which are never explicitly proclaimed as Pisanello's. The stylistic and technical road for Pisanello's medals begins with his Filippo Maria Visconti (see fig. 2.24) and his small medals of Leonello d'Este (see figs. 3.5, 3.40, 3.41, 3.42) and leads to his Iñigo d'Avalos (see fig. 3.45), made in 1449–50.[92] The relief of the Leonello portraits moves with dramatic contrast from extremely shallow at the bridge of the nose to high and rather chunky modelling at the cheek-bone and hair. Pisanello has clearly wanted to express the bulk and the bone structure of the head; the approach is essentially naturalistic. This sculptural method is backed up by his attention to surface detail. All the early medals were modelled in much the same way. Although the relief is high, the surface is achieved, not just by building up the wax but also, to a much greater extent than is the case later, by its removal, so that, for example, the nudes seem to sink into the ground, the wax having been scraped away from around their contours. Much of the detail is rendered by the use of a point, by scoring and pricking.

The Iñigo d'Avalos (see fig. 3.45) was conceived and sculpted differently from the Leonello medals. The relief of the portrait is very shallow and the planar shifts are extremely subtle. The features have been smoothed and simplified so as to achieve a construction of the head both harmonious in itself and in satisfying accord with the

shape and legend of the medal. While the portrait is still convincing, it is less realistic, and the documentary element seen in the Leonello heads is entirely missing. So, too, is the method of modelling, which relies on scratching and scraping for its decorative effects. The reverse shows the same abstracting tendencies and the same desire to establish compositional interdependence between text and image. The sphere sits on a large field, balanced by and therefore not overbalancing the inscriptions and the heraldic elements. The detail in the modelling of the earth, sea and sky stands out against the flatness of the field, allowing the person handling the medal to appreciate Pisanello's rational organisation of the waves and stars. The inscription's placement has been perfectly judged, the letters elegant and even, the words and the stops between them evenly spaced. Its appropriately low relief, the abstracted quality of the emblem and, especially, of the portrait, and the total interdependence of text and images demonstrate that Pisanello has fully comprehended the intellectual function of the medal and the possibilities of the genre. It has become absolutely medallic, its ties to painting and to other kinds of sculpture much less explicit.

Both in style and technique most of Pisanello's medals are consistent, over time, with the stylistic trend identified above, and there is no good reason for thinking of them as modelled by anyone else (even if he may have had them cast by a founder). However, there are profound differences between the medal of Leonello with the three-faced putto reverse (fig. 5.46) and the others in this series.[93] Even in the best surviving casts (in Modena and, of lead, in a private collection in the USA), the modelling of this piece, on both obverse and reverse, has a softness and flaccidity foreign to Pisanello and contrasting emphatically with their fellows' high relief and bony structure. In the portrait, Leonello's lips and eyebrows seem rubbery and the hair is less hair than cauliflower. The lettering is unevenly sized and lacks the crispness of the legends on Pisanello's other Leonello medals. One must therefore deduce another hand at work. Support for this theory comes from a workshop drawing (fig. 5.45), another page from the *Taccuino di viaggio*, which may be a preliminary study for the medal in which the motif of the three-faced putto has been evolved.[94] The single-faced boy of the kind that may have been used as a basis for developing the *impresa* appears in the Alexander miniature in the Cesena Plutarch (see fig. 5.26) – an intriguing connection, which might be pursued.

The cases of the medal of Bellotto Cumano (see fig. 3.32)[95] and of the pieces with the portrait of Alfonso of Aragon (see figs. 3.44, 3.46, 3.47) are rather different, for here the division between Pisanello's own contribution and that of his assistants is more complicated. The lettering on both sides of the Bellotto medal is unevenly sized and spaced – compared especially to the Cecilia Gonzaga reverse, where a gap such as appears between the L and the V of the date would be unthinkable. The treatment of both the head and the ermine might be described as cursory rather than simplified, the shoulder particularly unconvincing. The reverse seems cramped and the elements seem to have been imitated from autograph medals, so that, for example, the tree stumps are taken from the Gianfrancesco Gonzaga reverse but are now to the wrong scale, the ermine moving through a Bonsai forest. It is true that Basinio da Parma included an

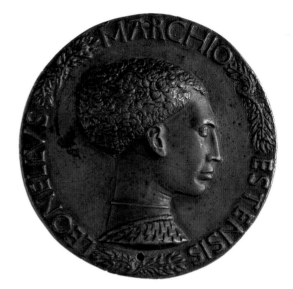

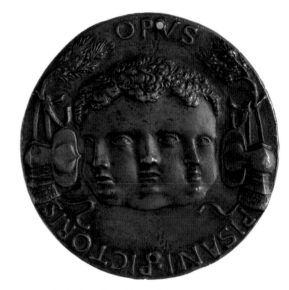

5.46a, b **Pisanello and/or workshop**
Portrait medal of Leonello d'Este, after 1441
Cast bronze, diam. 6.8 cm
Modena, Galleria Estense, inv. 8847

5.45 **Workshop of Pisanello**
Head of a child, three-faced putto,
two angels, c.1432–40
Pen and ink with brown wash over metalpoint
on parchment, 26.1 × 17.7 cm
Paris, Musée du Louvre, inv. RF 421 verso

RIGHT
5.47 (detail of 3.47a) **Pisanello and workshop**
Portrait medal of Alfonso V of Aragon,
king of Naples, obverse
London, The British Museum,
inv. GIII, Naples 3

FAR RIGHT
5.48 **Pisanello and workshop**
Portrait medal of Alfonso V of Aragon,
king of Naples, obverse, detail, 1449
Cast lead, diam. 10.8 cm
London, The British Museum, inv. 1875-10-4-1

image of Bellotto in his list of Pisanello's portraits, but this may have been a painting on which the medal was based, and, if it were the medal, the signature would justify its inclusion.

The absence of signature on the earliest casts of the Alfonso medal with the triumphal car reverse (see fig. 3.46) is interesting in view of the existence of a series of sketches for the medal.[96] These have been called timid, and they certainly seem less assured than the two profiles of the king on another page (see fig. 1.42).[97] The finished piece is close in design and handling to Pisanello's certain medals, especially in its flat relief, although some elements, primarily the quality of the lettering, provoke worry. The lack of signature has been explained by Pisanello's departure from Naples. It does seem possible that his workshop, by now smoothly imitating the style and ingredients of his medals, went on producing them, or at least this one, in his absence.

It is, of course, equally possible that Pisanello started a medal which was then finished by someone else or that he used assistants in the making of the wax model itself. A close examination of the two British Museum specimens, in bronze and in lead, of another of the Alfonso medals (see fig. 3.47), with a reverse showing a rejuvenated and near-naked king about to deal a death blow to a wild boar, raises just this possibility.[98] The variations in quality within the piece, moving from the assured modelling of the reverse, with the contrasts of texture so typical of Pisanello, to the lack of confidence in the lettering of the legend and the high relief of the portrait, might already suggest that this is a collaborative effort. There is additional evidence. The two British Museum examples have clearly been cast from the same wax model, but there exist small but important differences between them. Corrections have been made to the model after the casting of the bronze. On the reverse, the boar's tusks have been changed. In the portrait (figs. 5.47, 5.48), Alfonso's nose has been reduced and a dimple in the chin has been introduced. This latter alteration is particularly telling, since it ensured that the portrait conformed more closely with every other image of the king produced by Pisanello and his shop. It can only have been a deliberate intervention, and the obvious author of such

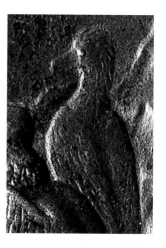

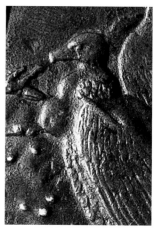

5.49 **Workshop of Pisanello**
Studies for the reverse of a portrait medal
of Alfonso V of Aragon, king of Naples
Black chalk reinforced with pen and ink, 28.2 × 21.2 cm
Paris, Musée du Louvre, inv. 2481 verso

5.50–52 (details of 3.44b)
Workshop of Pisanello
Portrait medal of Alfonso V of Aragon,
king of Naples, reverse: birds

interference is Pisanello himself, altering a workshop production. This fact, and the rather inconsistent elements within the medal itself, suggest that a Pisanello medal could be a team effort.

The three medals of Alfonso of Aragon suggest that methods of collaboration were not always straightforward. The relationship between Pisanello and his workshop after his arrival in Naples is not easy to reconstruct; the issue has been made particularly problematic by the re-attribution to his shop of a group of drawings connected with Neapolitan projects that was traditionally given to Pisanello. These include studies for the Alfonso medals, notably the one with the triumphal car reverse. Particularly problematic is a pen-and-ink profile of the king with sketches of birds of prey on the verso (fig. 5.49).[99] Executed somewhat mechanically, this is close in style to a drawing deemed to be a workshop copy after Pisanello's portrait of Filippo Maria Visconti.[100] Similarly difficult is the sheet showing Alfonso flanked by his crown and helmet and with the partially struck out date of 1448, which is almost certainly by the same hand (fig. 5.54).[101] The uncertain epigraphy has been condemned and it has been called a copy after a design by Pisanello. In fact, its composition is more worrying. As a drawing for a medal it is odd in giving no suggestion of a circular format, and having stubbornly horizontal inscriptions. It is not, moreover, a copy, for which the scribbled-out date would be most unexpected. These must, therefore, be preparatory sketches for the medal which relates most closely to them, the piece which calls Alfonso TRIVMPHATOR ET PACIFICVS and has an allegory of LIBERALITAS AVGVSTA (figs. 5.50–5.52).[102]

If, then, these drawings are not autograph, they seem to confirm that Pisanello, on occasion, employed members of his shop to design his medals. And the appearance of the finished piece suggests that the assistant's role was not restricted to its design. Compared to the considered and intelligent compositions of the Iñigo d'Avalos from the same period, the *Liberalitas Augusta* piece is chaotic. The obverse, significantly in high relief, is a somewhat random assemblage of elements rather than a unified composition. The perspectives on the crown and helmet are different, the helmet colliding with the back of the king's head. His shoulder-plate bangs clumsily against his chin. The date looks particularly odd, neither aligned with the crown nor successfully holding to the horizontal. The reverse shows a similar lack of judgement in the inscription's placing and in infelicities of composition. Especially noteworthy is the passage where the nose of the deer is crushed between the wing and head of the two birds of prey and where the branch pokes into the vulture's breast.

It has been objected that the still lower quality of medals by artists who may be associated with Pisanello rules out their – or any – collaboration.[103] However, this certainly does not apply to Matteo, and assessment of the quality of works by other medallists associated with Pisanello is hampered by the unusually low quality of surviving casts. Among the artists who reasonably have been supposed to have emerged from Pisanello's workshop, there are a number who practised partly or exclusively as medallists. Antonio Marescotti da Ferrara, for example, signed his first piece in 1444 and worked as a medallist in Ferrara until 1462.[104] Although he made larger sculptural works – the tomb-slab of bishop Giovanni Tavelli da Tossignano in the Oratorio di San Girolamo in

5.53a, b **Paolo da Ragusa**
Portrait medal of Alfonso V of Aragon, king of Naples, c.1450
Cast bronze, diam. 4.5 cm
London, The British Museum, inv. 1920-7-23-1

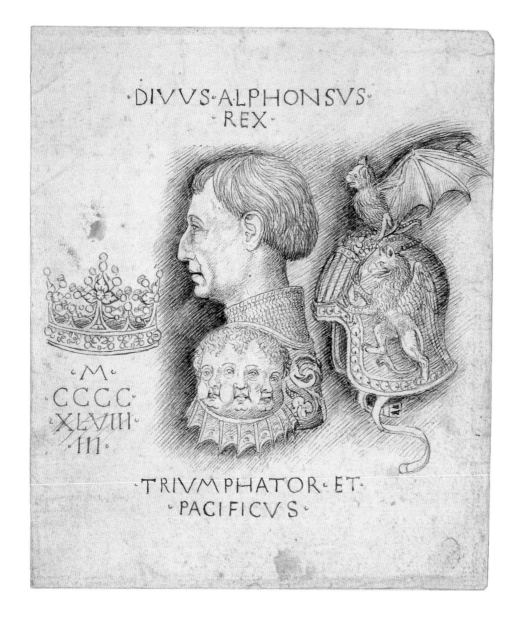

5.54 **Workshop of Pisanello**
Design for a portrait medal of Alfonso V of Aragon,
king of Naples
Pen and ink over black chalk, 16.9 × 14.5 cm
Paris, Musée du Louvre, inv. 2307

Ferrara and a terracotta sculpture of the same subject in the Ospedale di Sant'Anna[105] –
the modelling is rather clumsy, though the design, if schematic, is often ambitious
(fig. 5.55). Paolo da Ragusa on the other hand stuck to tried and tested formulae. He had
been an assistant to Donatello in Padua in 1447. His medals all date from 1450, and were
made therefore in Naples while Pisanello was resident there or just after his departure
(fig. 5.53). Given their closeness in style to Pisanello's own medals, it seems not unreason-
able to propose that he moved from Donatello's shop to Pisanello's, working again as
an assistant.[106]

Pietro di Martino da Milano, who lived in Ragusa (Dubrovnik) from 1432,[107] is
first recorded working on the Arch of the Castelnuovo in Naples in 1452–3. He was an

established master in Ragusa before his removal to Naples and is thus perhaps unlikely to have worked in Pisanello's shop as an assistant. However, the style of his medals (fig. 5.56) is utterly dependent on Pisanello's.[108] Another connection suggests itself. Pietro da Milano is often called the designer of the Arch. It may in fact be the case that he was working to a design that had come out of Pisanello's shop, given the survival of a drawing in Rotterdam for the Arch (fig. 5.57), which is closely related stylistically to shop drawings for medals of Alfonso of Aragon.[109] It seems likely, from later payments to the sculptors working on the Arch, that the artists had formed an *ad hoc* team.[110] Pisanello's whereabouts between 1450 and his death probably in Rome in 1455 are unknown. If he remained in Naples for any period of time the two artists would have coincided, and Pietro da Milano might even have been directed by Pisanello.

These examples indicate that medals emanating from Pisanello's workshop need not have been executed by its head. In this respect they do not differ substantially from the designs for cannon, textiles or goldsmiths' work which no-one would have expected Pisanello to have executed himself. It is possible indeed that his medals were always regarded as a secondary activity. It seems equally likely that in Pisanello we find a prototype for the category of artist who, later in the century, was to be termed *maestro di disegno* – 'master of design'.[111] Although he certainly sculpted most of his medals himself, it may have been the design element that was paramount (and certainly by the 1470s a medal might be signed by the artist who provided the drawing rather than by the modeller or

5.55a, b **Antonio Marescotti**
Portrait medal of Galeazzo Marescotti, c.1448
Cast bronze, diam. 9.1 cm
London, The British Museum, inv. 1925-8-13-5

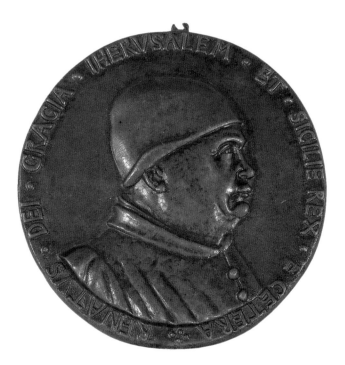

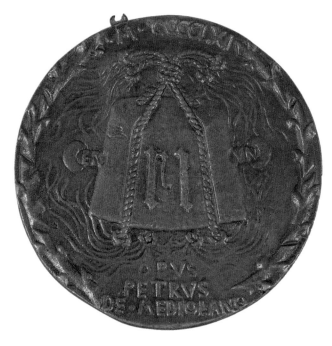

founder). The signature furnished proof that individual patrons could afford the individual *ingenium* of the famous painter Pisanello. His wall-paintings, which demanded extra labour by virtue of their scale, might be designed by him but painted, at least in part, by others. But in his panel paintings (in so far as their limited survival and often poor condition allow one to judge) he was expected to play a lone hand, to provide definitive evidence of his special talents.

It is ironic that final proof that design might sometimes matter more than execution is furnished by the larger of the two medallic portraits of Pisanello himself, the medal with which this book started (see fig. 1.2). For many years it was attributed to Marescotti, but has been recently re-proposed as a self-portrait.[112] The modelling, though of high quality, is too generalised to be the work of Pisanello himself, but its design is very likely to depend on an autograph drawing or painting. The style of modelling has been connected with that of the Bellotto Cumano.[113] Whether the work was handed by Pisanello to a member of his shop or a pre-existing portrait was adopted as a source without the collusion of its subject is unknowable. Either way, it is unlikely that Pisanello's responsibility for the image would have been questioned at the time of its manufacture. Thus the self-portrait, which is usually taken as one of the chief statements of artistic individuality in the Renaissance, actually demonstrates that individuality could – invisibly – incorporate the efforts of others. Pisanello, in this as in so many other respects, was able to integrate long-standing artistic tradition with his own brand of innovative modernity and lionised individualism.

5.56a, b **Pietro da Milano**
Portrait medal of René d'Anjou, 1461
Cast bronze, diam. 8.5 cm
Florence, Museo Nazionale del Bargello

OPPOSITE
5.57 **Pisanello or workshop**
Design for the entrance façade of
the Castelnuovo, Naples, c.1448–50
Pen and ink and brown wash over black chalk
on parchment, 31.1 × 16.2 cm
Rotterdam, Museum Boymans Van Beuningen,
inv. I.527

Giovanni da Ravena

235

REFERENCES

The following shorter forms are used for the main, mostly recent, literature relating to Pisanello:

Baxandall 1971
> M. Baxandall, *Giotto and the Orators: Humanist observers of painting in Italy and the discovery of pictorial composition 1350–1450*, Oxford 1971

Christiansen 1982
> K. Christiansen, *Gentile da Fabriano*, London 1982

Cordellier-Py 1998
> D. Cordellier and B. Py, ed., *Actes du colloque organisé au musée du Louvre: Pisanello,* 2 vols., Paris 1998

Cordellier 1995
> D. Cordellier, ed., 'Documenti e fonti su Pisanello (1395–1581 circa)', *Verona Illustrata*, VIII, 1995

Da Pisanello (Rome) 1988
> A. Cavallaro, E. Parlato, ed., *Da Pisanello alla nascita dei Musei Capitolini: L'Antico a Roma alla vigilia del Rinascimento*, exh. cat., Musei Capitolini, Rome 1988

Degenhart-Schmitt 1995
> B. Degenhart, A. Schmitt, ed., *Pisanello und Bono da Ferrara*, Munich 1995

De Marchi 1992
> A. De Marchi, *Gentile da Fabriano: un viaggio nella pittura italiana alle fine del gotico*, Milan 1992

Fossi Todorow 1966
> M. Fossi Todorow, *I disegni del Pisanello e della sua cerchia*, Florence 1966

Hill 1930
> G.F. Hill, *A Corpus of Italian Medals of the Renaissance before Cellini*, London 1930

Le muse (Milan) 1991, *Catalogo / Saggi*
> A. Mottola Molfino, M. Natale, ed., *Le muse e il principe: arte di corte nel rinascimento padano:* 2 vols., *Catalogo* and *Saggi*, exh. cat., Museo Poldi Pezzoli, Milan, 1991

Pisanello (Verona) 1996
> P. Marini, ed., *Pisanello*, exh. cat., Museo di Castelvecchio, Verona, 1996

Pisanello (Paris) 1996
> *Pisanello. Le Peintre aux sept vertus*, exh. cat., Louvre, Paris, 1996

Puppi 1996
> L. Puppi, ed., *Pisanello: una poetica dell'inatteso*, Milan 1996

Woods-Marsden 1988
> J. Woods-Marsden, *The Gonzaga of Mantua and Pisanello's Arthurian Frescoes*, Princeton NJ 1988

Other works are cited in short form only after citation in full in an earlier note within each chapter.

CHAPTER I · LIFE AND WORK

1. The name Vittore given to Pisanello by Vasari in his *Lives of the Most Excellent Painters, Sculptors and Architects* (*Le Vite...*, ed. G. Milanesi, Florence 1878, III, pp. 5–14) seems to have arisen from a misreading of the 'P' in Pisanello's signature on his medals. G. Perretti in Cordellier-Py 1998, I, p. 37, suggests that it comes from a misreading of Pisanello's way of signing himself as *(ser) vitor* in the only letter surviving from his hand.

2. S. de Turckheim-Pey in *Pisanello* (Paris) 1996, p. 34, cat. 1. See also the portrait medal of Pisanello by another Ferrarese medallist: ibid., p. 34, cat. 2.

3. D. Cordellier, 'Le Peintre aux sept vertus', in *Pisanello* (Paris) 1996, p. 15–18, esp. p. 16; J. Woods-Marsden, 'Pisanello et le moi', in Cordellier-Py 1998, I, pp. 265–95, esp. p. 266.

4. A. Ryder, *The Kingdom of Naples Under Alfonso the Magnanimous: The Making of a Modern State*, Oxford 1996, p. 26.

5. M. Mallett, *Mercenaries and their Masters*, London 1974, passim.

6. W. L. Gundersheimer, *Ferrara: The Style of A Renaissance Despotism*, Princeton NJ 1973. The Este also ruled the imperial fiefs of Modena and Reggio to the west.

7. J. Gill, *The Council of Florence*, Cambridge 1959; for background see pp. 16–84.

8. For the will see Cordellier 1995, pp. 15–16, doc. 1; also D. Battilotti, 'Regesto documentario', in Puppi 1996, p. 236. The original is lost, but survives in a copy made in Verona 8 July 1424. The year had always been thought to be 1395, until it was pointed out that the will was drawn up in Pisa, which began the calendar year a year ahead (see L. Puppi, 'Umanesimo e cortesia nell'arte del Pisanello', in Puppi 1996, pp. 10–11; D. Cordellier, 'Conclusion', in Cordellier-Py 1998, II, pp. 749–50). Pisanello's age is not given in the will, which merely serves as a *terminus ante quem* for his birth. Pisanello inherited 600 gold florins from his father, a substantial sum (see Cordellier 1995, pp. 15–16, doc. 1).

9. Cordellier 1995, pp. 19–30, docs. 4, 5, and 6. His stepfather is documented in Verona in 1404 (see D. Battilotti, 'Regesto documentario', in Puppi 1996, p. 236) lending credence to the supposition he grew up there (see also documents for 1409 and 1414, ibid.).

10. Cordellier 1995, pp. 33–34, doc. 8.

11. Cordellier 1995, pp. 17–18, doc. 2.

12. Cordellier 1995, p. 31, doc. 7.

13. Cordellier 1995, pp. 33–34, doc. 8.

14. For the San Fermo fresco see A. Schmitt, 'Pisanellos Wandbild zum Grabmonument des Nicolò Brenzoni in San Fermo Maggiore, Verona', in Degenhart-Schmitt 1995, pp. 55–79; M. Molteni, 'Dipinti autografi, in Puppi 1996, pp. 48–58, no. 2.

15. 'vir nobilis, civis optimus, et assiduus paterfamilias'. For the epitaph see *Pisanello* (Verona) 1996, pp. 94–5, cat. 8. The original, which survives only in part, and is now in the Museo di Castelvecchio, Verona (inv. B646) was replaced in 1592.

16. Niccolò Brenzoni made his will on 4 May 1422. See Cordellier 1995, pp. 18–9, doc. 3.

17. See the essay by T. Franco, 'Qui post mortem statuis honorati sunt. Monumenti familiari a destinazione funebre e celebrativa nella Verona del primo Quattrocento', in *Pisanello* (Verona) 1996, pp. 139–50, and ead., 'Pisanello et les expériences complémentaires de la peinture à Vérone entre 1420 et 1440', in Cordellier-Py 1998, I, pp. 121–60.

18. E. Moench, 'Verona: gli anni venti del Quattrocento', in *Pisanello* (Verona) 1996, p. 60, suggests that Pisanello could have met Nanni di Bartolo in Venice in 1423, but that a sojourn in Florence with Gentile when he was painting the Strozzi *Adoration of the Magi* is not impossible.

19. See also the frescoes of *The Annunciation* of *c.*1398–9 by Martino da Verona in San Zeno, Verona, often cited as a prototype, as well as of *c.*1400 in Santissima Trinita (illustrated in *Pisanello. I luoghi del gotico internazionale nel Veneto*, ed. F. M. Aliberti Gaudioso, Milan 1996, pp. 106 and 110). For the setting see D. M. Robb, 'The Iconography of the Annunciation in the Fourteenth and Fifteenth Centuries', *Art Bulletin*, XVII, 1936, pp. 480–526.

20. See also Molteni in Puppi 1996, p. 56, no. 2, who cites De Marchi 1992, p. 42 note 44 (a discussion of the overlap of the sacred and profane in Lombardy).

21. For Altichiero see J. Richards, *Altichiero. An Artist and his Patrons in the Italian Trecento*, Cambridge 2000.

22. De Marchi 1992, pp. 63, 82–5.

23. Although Christiansen (1982, pp. 60–1 and 71, note 18) denies Pisanello's early training with Gentile, the opposing case is convincingly argued by De Marchi 1992, pp. 63 and 93 note 102.

24. Cordellier 1995, pp. 162–7, doc. 75.

25. For the frescoes see De Marchi 1992, pp. 63–86; Cordellier 1995, pp. 34–5, 162–7, 226–8, docs. 9, 75 and 107; M. Molteni, 'Dipinti perduti', in Puppi 1996, pp. 106–7, no. 12; and S. Skerl del Conte, 'Pisanello et la culture du XIV siècle' in Cordellier-Py 1998, I, pp. 45–82. The most lucid account of the cycle is to be found in P. Fortini Brown, *Venetian Narrative Painting in the Age of Carpaccio*, New Haven and London 1988, pp. 261–5.

26. De Marchi 1992, p. 64.

27. See the documents published by Christiansen 1982, pp. 149–59 (docs. I and II for the presence in Venice, doc. III for his service in Brescia).

28. De Marchi 1992, p. 65. See also note 9 above.

29. See Molteni, 'Dipinti perduti', in Puppi 1996, p. 107, no. 12, for the differing dates which have been proposed for Pisanello's activity.

30. Cordellier 1995, pp. 34–5. A drawing that appears to correspond with that subject (D. Cordellier in *Pisanello* (Paris) 1996, pp. 36, 40, cat. 3) is problematic because it is evidently not by Pisanello and appears to be fourteenth-century. It has convincingly been related by Richards (2000, pp. 41–3) to Altichiero's fresco cycle in the Sala Grande in Verona.

31. Cordellier 1995, pp. 226–8, doc. 107.

32. Falling again into disrepair, much of the cycle was replaced by canvases, the first by Giovanni Bellini in 1474. The cycle was damaged in a fire in 1577.

33. Cordellier in *Pisanello* (Paris) 1996, pp. 298–9, cat. 190. The difficulty is that this sheet contains studies of dogs which were drawn *before* the architecture and which relate to the frescoes of Sant' Anastasia of *c.*1434–8 (for which see below). Cordellier makes the acute suggestion that Pisanello made a sketch after his own fresco when he subsequently revisited Venice, as a record for himself.

34. For the objection that Pisanello did not settle in Verona until 1425 see Moench in *Pisanello* (Paris) 1996, p. 78.

35. For Stefano's early career, probably training with his father, Jean d'Arbois, and Michelino in Pavia, see E. Moench, 'Stefano da Verona: la quête d'une double paternité', *Zeitschrift für Kunstgeschichte*, XL, 1986, pp. 220–8, who argues convincingly that Stefano da Verona cannot be the Stefano who is documented in Padua in the early part of the fifteenth century (who had a different wife and from whom no work survives); E. Moench, 'Stefano da Verona: La Mort critique d'un peintre', in *Hommage à Michel Laclotte*, Paris 1994, pp. 78–100; and also E. Karet, 'The Pavian Origins of Stefano da Verona', *Arte Lombarda*, C, 1992, pp. 8–19. Stefano was in the Trentino in 1434, back in Verona 1434–5 (E. Karet, 'The Castles of the Trentino and the Painter Stefano da Verona: an Active Presence', *Arte Lombarda*, CII, 1992, pp. 14–24).

36. The last digit of Stefano's *Adoration of the Magi* is a modern restoration and the authenticity of the signature has been doubted. See E. Moench in F. Zeri, ed., *Pinacoteca di Brera. Scuola Veneta*, Milan 1990, pp. 366–71, cat. 197.

37. For Michelino see M.G. Albertini Ottolenghi, 'Problemi della pittura a Pavia nella prima metà del Quattrocento', *Arte Cristiana*, DCCXVIII, 1987, pp. 4–16; and G. Algeri, 'L'attività di Michelino da Besozzo in Veneto', *Arte Cristiana*, no. 718, 1987, pp. 17–32.

38. Dated around 1420 by Pietro Torriti, *La Pinacoteca Nazionale di Siena. I dipinti dal XII al XV secolo*, Genoa 1980, p. 238.

39. In his treatise *De republica*, U. Decembrio, the father of Pier Candido and Angelo, praised Michelino for his depiction of birds and animals ('*aviculas et minutas animalium formas ita subtiliter et proprie designabat*'). See De Marchi 1992, p. 18.

40. For Pavia as the artistic capital of northern Italy until the death of Giangaleazzo Visconti see De Marchi 1992, pp. 11–45. For Giovannino de' Grassi see M. Rossi, *Giovannino de Grassi, la corte e la cattedrale*, Milan 1995, esp. pp. 45–61 for the animal and bird sketches in the Bergamo sketchbook.

41. For Pisanello and Michelino see A. Schmitt, 'Die Frühzeit Pisanellos: Verona, Venedig, Pavia', in Degenhart-Schmitt 1995, pp. 13–52. Cordellier is not in agreement (Cordellier in Cordellier-Py 1998, II, p. 772, note 37).

42. See most recently E. Moench in *Pisanello* (Paris) 1996, pp. 78–80, cat. 35; Molteni, 'Dipinti autografi', in Puppi 1996, pp. 45–48, no. 1; and Cordellier, 'Conclusion', in Cordellier-Py 1998, II, pp. 755–6.

43. Compare Degenhart-Schmitt 1995, pls. 5–6 and 68.

44. Most recently see E. Moench in *Pisanello* (Verona) 1996, pp. 76–9, cat. 2, where it is attributed to Michelino da Besozzo (?) or to Stefano da Verona; for its attribution to Stefano see also Moench, 'Stefano da Verona …', in *Hommage à Michel Laclotte* 1994, p. 81, and A. Schmitt, 'Die Frühzeit …', in Degenhart-Schmitt 1995, p. 277, note 2; there attributed to Michelino, p. 15. A drawing copying some of the angels in the painting (Vienna, Albertina, inv. 26) has been (probably wrongly) attributed to Pisanello. For the similarities between the two panel paintings see Schmitt, ibid., p. 15 (although she attributes them to different hands), and M. Molteni in Puppi 1996, pp. 46–7.

45. This way of painting rose-leaves may originate with Gentile (see his Perugia altarpiece, illustrated in De Marchi 1992, pl. 5) or with Michelino (illustrated in Degenhart-Schmitt 1995, pl. 7), and becomes standard in the work of Pisanello, used in the background of the San Fermo fresco and in the portrait of Leonello (see figs. 3.24, 3.25).

46. For example, the Aquila polyptych of *c.*1420–30 (ed. Gaudioso 1996, p. 116).

47. M. Boskovits, 'La jeunesse de Pisanello', in Cordellier-Py 1998, I, pp. 83–120.

48. See E. Moench in *Pisanello* (Paris) 1996, pp. 73, 78, cat. 34; E. Moench in *Pisanello* (Verona) 1996, pp. 80–2, cat. 3. Attributed to Stefano by M. Boskovits in Cordellier-Py 1998, I, pp. 91–2, although T. Franco, 'Dipinti espunti', in Puppi 1996, pp. 121–3, no. 18, has brought it within the circle of Giovanni Badile, probably Francesco Badile (active by end of fourteenth century; died before 1436), dating it around 1425.

49. Cordellier 1995, pp. 194–6, doc. 98.

50. For which see De Marchi 1992, p. 16. It is unlikely that the quality of reflection was due to the use of gold or silver leaf (suggested by Cordellier 1995, p. 199), since the latter would most likely have tarnished or at least dimmed by the sixteenth century, and it unlikely that the former would be compared to a mirror. See further E.S. Welch, 'Galeazzo Maria Sforza and the Castello di Pavia, 1469', in *Art Bulletin*, LXXI, no. 3, 1989, pp. 352–75.

51. M. E. Avagnina, 'La tecnica pittorica del Pisanello attraverso le fonti e analisi delle opere veronesi', in *Pisanello* (Verona) 1996, p. 466.

52. G. Vitalini Sacconi, *Pittura marchigiana. La scuola camerinese*, Trieste 1968, p. 80.

53. For Masaccio and Masolino in Rome see P. Joannides, *Masaccio and Masolino. A Complete Catalogue,* London 1993, pp. 72ff. (dating the Colonna altarpiece 1423), and P. L. Roberts, *Masolino da Panicale*, Oxford 1993, pp. 85–98. Masolino's frescoes of 1435 in Castiglione d'Olona almost certainly reflect Gentile's and Pisanello's work in Rome, although the precise relationship is impossible to define. See B. Blass-Simmen, 'Pisanellos Tätigkeit in Rom', in Degenhart-Schmitt 1995, pp. 81–117.

54. Christiansen 1982, p. 160, doc. IV, and discussion pp. 55ff..

55. See De Marchi 1992, pp. 135–92.

56. Christiansen 1982, pp. 55 and pp. 168–72, docs. XII–XVI; De Marchi 1992, pp. 193–216; M. Molteni, 'Dipinti perduti', in Puppi 1996, pp. 103–5, no. 11. See in particular A. De Marchi, 'Gentile da Fabriano et Pisanello à Saint-Jean de Latran', in Cordellier-Py 1998, I, pp. 161 – 213.

57. De Marchi 1992, p. 207, fig. 110, also fig. 111 for another possible fragment from the cycle.

58. Cordellier 1995, p. 167, doc. 75.

59. Cordellier in *Pisanello* (Paris) 1996, pp. 162–3, cat. 87.

60. Cordellier in *Pisanello* (Paris) 1996, pp. 163–4, cat. 88. See also Blass-Simmen in Degenhart-Schmitt 1995, pp. 81–116.

61. D. Stichel in her review of Degenhart-Schmitt 1995, in *Zeitschrift für Kunstgeschichte*, LIX, 1996, p. 421. The same objection is raised in the review of this book by A.J. Martin, *Burlington Magazine*, CXXXVIII, 1996, p. 332.

62. Cordellier 1995, p. 45. It is clear from the payments that Pisanello began work before Eugenius became pope.

63. Equivalent to 18 florins, 39 *soldi*: '*Recepimus pro suppellictilibus emptis tunc per capitulum Magistro Gentili que postea remanserunt Magistro pisano pictori …*'; Cordellier 1995, p. 55, doc. 18. See also Christiansen 1982, pp. 172–3, doc. XVII. Christiansen rightly stresses that this was not strictly 'an inheritance' (they were not bequeathed) and did not consist of drawings.

64. De Marchi, 'Gentile da Fabriano et Pisanello …', in Cordellier-Py 1998, I, p. 178, suggests that Martin V would not have wanted the frescoes to remain unfinished for so long and may have contacted Masolino, who was in Rome at the time (see above) – and that this explains the links between the frescoes of Masolino in Castiglione d'Olona and Gentile and Pisanello's works in Rome (see note 53 above).

65. Cordellier 1995, pp. 45–6, doc. 13.

66. See E. Moench in *Pisanello* (Paris) 1996, p. 95, cat. 47; E. Moench in *Pisanello* (Verona) 1996, pp. 122–3, cat. 19, and T. Franco, 'Dipinti autografi', in Puppi 1996, pp. 59–60, no. 3.

67. Cordellier 1995, pp. 48–9, doc. 15.

68. S. Tumidei, 'Un tableau perdu de Pisanello pour l'empereur Sigismond', in Cordellier-Py 1998, I, pp. 17–27.

69. Cordellier 1995, pp. 46–8, doc. 14. The year is not given in the letter. The letter, which has disappeared, has been suspected of being a forgery, but the facts would seem to indicate that it was genuine.

70. Cordellier 1995, pp. 48–50, doc. 15. The fact that Pisanello left behind both a painting and an assistant (see below) might suggest he intended to return.

71. Cordellier 1995, pp. 52–4, doc. 17.

72. Cordellier 1995, pp. 50–2, doc. 16.

73. Cordellier 1995, pp. 67–9, doc. 22.

74. Cordellier 1995, pp. 56–65, doc. 18bis, and p. 66, doc. 20.

75. P. Marini in *Pisanello* (Verona) 1996, pp. 232–7, cat. 26; D. Cordellier, 'Ventisei spunti per le gesta di San Giorgio', in *Pisanello* (Verona) 1996, pp. 223–4; M. Molteni, 'Dipinti autografi', in Puppi 1996, pp. 76–89, no. 6. A. Schmitt, 'Pisanellos Georgswandbild in Sant'Anastasia, Verona', in Degenhart-Schmitt 1995, pp. 119–79, proposes a starting date of 1435 (p. 179).

76. A. Schmitt, 'Bono da Ferrara', in Degenhart-Schmitt 1995, pp. 237ff., has discerned the extensive participation of Bono da Ferrara, largely on the basis of her attribution to Bono of drawings from the 'Red Album' (see further here below, chapter V).

77. G. M. Varanini, 'Verona nei primi decenni del Quattrocento: la famiglia Pellegrini e Pisanello', in *Pisanello* (Verona) 1996, pp. 23–44, esp. p. 37. See pp. 40–1 for Andrea's will.

78. Ed. Gaudioso 1996, pp. 82–4; *Pisanello* (Verona) 1996, p. 501.

79. Vasari, *Le Vite*, ed. Milanese, 1878, III, pp. 8–9.

80. Vasari's description of the frescoes used to be considered problematic, largely owing to the use of the word '*cappella*', which led scholars to attempt to locate the fresco of Saint Eustace within the chapel. However, B. Degenhart first suggested the fresco had been outside the chapel, and H. J. Eberhardt followed up the suggestion by reconstructing the figures of Saints Eustace and George on the exterior above the entrance arch to the chapel ('Zur Rekonstruktion von Pisanellos Wandgemälden in Sant'Anastasia', in Degenhart-Schmitt 1995, p. 185, pl. 200). During preparations for the Pisanello exhibition Varanini discovered a nineteenth-century transcription of a seventeenth-century description of the chapel, placing the fresco of Saint Eustace on the pilaster between the high altar and the chapel: G. M. Varanini, 'Gli affreschi della cappella Pellegrini nella descrizione di Giovanni Maria Pellegrini', in *Pisanello* (Verona) 1996, pp. 183–4; H.J. Eberhardt, 'Sulle tracce degli affreschi scomparsi di Sant'Anastasia', ibid., pp. 165–8.

81. For Louvre inv. 2290 see Cordellier in *Pisanello* (Paris) 1996, pp. 111–18, cat. 60; Cordellier in *Pisanello* (Verona) 1996, pp. 240–1, cat. 29.

82. For Louvre inv. 2281 see Cordellier in *Pisanello* (Paris) 1996, p. 51, cat. 15; Cordellier in *Pisanello* (Verona) 1996, pp. 244–5, cat. 31.

83. H.J. Eberhardt, 'Zur Rekonstruktion …', in Degenhart-Schmitt 1995, pp. 190–1.

84. Jacopo de Voragine, *The Golden Legend,* trans. William Granger Ryan, Princeton NJ, pp. 238–42.

85. U. Bauer-Eberhardt, 'Per l'iconografia del San Giorgio e la principessa di Pisanello', in *Pisanello* (Verona) 1996, pp. 151–64, and Cordellier, 'Ventisei spunti per le gesta di San Giorgio', ibid., pp. 201–2.

86. For the veracity of the sketches and the intended contrast between the fate of the corpses and that of the king see Cordellier, ibid., pp. 220–1.

87. See S. Rother, *Der Regenbogen: einer malereigeschichtliche Studie*, Cologne and Weimar 1992, pp. 15–29.

88. Bauer-Eberhardt, 'Per l'iconografia …', in *Pisanello* (Verona) 1996, p. 154; Cordellier, 'Ventisei spunti …', in *Pisanello* (Verona) 1996, pp. 202–3.

89. Varanini, 'Verona negli primi decenni …', in *Pisanello* (Verona) 1996, p. 36.

90. For example, the Cavalli family in their chapel in Sant'Anastasia, next door to the Pellegrini chapel, frescoed by Altichiero *c.*1369; a member of the Bevilaqua family above their family tomb in the Pellegrini chapel, frescoed by a follower of Altichiero *c.*1400; the Lupi family by Jacopo Avanzi in the Oratorio di San Giorgio, Padua (Richards 2000, pp. 275, pl. 16, p. 95, fig. 31, p. 311, pl. 96); etc.

91. Other local frescoes of Saint George killing the dragon are by Bartolomeo Badile (documented 1362–89) in San Pietro Martire (originally dedicated to Saint George), next door to Sant'Anastasia, and in San Valentino, Verona, attributed to Giovanni Badile (illustrated in colour in ed. Gaudioso 1996, pp. 67, 68, 126).

92. L. Puppi, 'La principessa di Trebisonda', in id., *Verso Gerusalemme: immagini e temi di urbanistica e di architettura simboliche*, Rome and Reggio Calabria 1982, pp. 44–61.

93. *The Golden Legend*, trans. Ryan, pp. 266–271.

94. The cult of Saint Eustace was most fervent in the Abruzzi, where, near Subiaco, the saint had his vision, and in Rome.

95. A. Schmitt, 'Bono da Ferrara', in Degenhart-Schmitt 1995, pp. 249, 252.

96. Cordellier in *Pisanello* (Paris) 1966, pp. 296–7, cat. 188.

97. Cordellier in *Pisanello* (Paris) 1996, pp. 244–6, cat. 151; Cordellier in *Pisanello* (Verona) 1996, pp. 270–1, cat. 43

98. Cordellier in *Pisanello* (Paris) 1996, p. 246, cat. 152.

99. Cordellier in *Pisanello* (Paris) 1996, pp. 356–7, cat. 238; Cordellier in *Pisanello* (Verona) 1996, pp. 315–7, cat. 69. Antonio Malaspina declared in his will that Jerome and Anthony were his patron saints. His chapel dedicated to Saint Jerome was in the cathedral of Verona, according to an inscription still *in situ*, and was founded in 1440. His will is partially published in Cordellier 1995, pp. 82–5, doc. 31.

100. Cordellier in *Pisanello* (Paris) 1996, pp. 356–7, cat. 238.

101. Cordellier in *Pisanello* (Paris) 1996, pp. 195–7, 206, cat. 112, 113.

102. Gill 1959, pp. 85–130, 293–4.

103. Ibid., p. 109.

104. V. Juren, 'A propos de la médaille de Jean VIII Paléologue par Pisanello', *Revue numismatique*, XV, 1973, pp. 219–25; M. Vickers, 'Some Preparatory Drawings for Pisanello's Medallion of John VIII Palaeologus', *Art Bulletin*, LX, 1978, pp. 417–24.

105. Fossi Todorow 1966, pp. 80–1, nos. 57–8.

106. Cordellier 1995, doc. 34, pp. 87–8. See also Varanini, 'Verona nei primi decenni …', in *Pisanello* (Verona) 1996, pp. 27–9.

107. Cordellier 1995, doc. 28, pp. 75–6.

108. G. Peretti, 'Pisanello a Marmirolo: un document inédit', in Cordellier-Py 1998, I, pp. 29–41.

109. Cordellier 1995, pp. 77–82, doc. 30.

110. Cordellier 1995, p. 86, doc. 32.

111. Cordellier 1995, pp. 87–93, doc. 34.

112. Cordellier 1995, pp. 93–4, docs. 35 and 36.

113. Cordellier 1995, p. 104, doc. 41.

114. Cordellier 1995, pp. 102–4, doc. 40.

115. Cordellier 1995, pp. 105–6, doc. 42. The offence committed '*pro verbis turpibus quibus usus fuit in Mantua cum domino Ludovico Gonzaga*' is ambiguous, but almost certainly relates to an offence committed *with* Lodovico (rather against), and against the Venetian state.

116. Cordellier 1995, p. 107, doc. 43. See also docs. 45 and 46, pp. 109–11.

117. Cordellier 1995, docs. 50, pp. 118–9.

118. Cordellier 1995, p. 111, doc. 47; pp. 118–9, doc. 50; p. 132, doc. 59.

119. Hill 1930, p. 10, no. 32; de Turckheim-Pey in *Pisanello* (Paris) 1996, pp. 397–8, nos. 272–3, illus. p. 390; D. Gasparotto in *Pisanello* (Verona) 1996, pp. 386–7, no. 87; R. Rugolo, 'Medaglie', in Puppi 1996, pp. 157–9, no. 9.

120. Cordellier 1995, pp. 122–4, docs. 53 and 54.

121. Cordellier 1995, p. 131, doc. 58.

122. Cordellier 1995, pp. 147–48, doc. 65.

123. Hill 1930, p. 11, no. 36; Turckheim-Pey in *Pisanello* (Paris) 1996, pp. 411–12, no. 286, illus. p. 407; Rugolo in Puppi 1996, p. 169, no. 15 (this lead piece is wrongly described as bronze).

124. Hill 1930, p. 34, no. 34; de Turckheim-Pey in *Pisanello* (Paris) 1996, pp. 401–404, illus., no. 277; Rugolo in Puppi 1996, p. 167, no. 13 (the example illustrated, from the British Museum, is misleadingly said to be cast in bronze rather than lead).

125. Cordellier 1995, p. 117, doc. 49, and pp. 119–20, doc. 51.

126. See Cordellier 1995, pp. 151–3, doc. 68. The document was cited by Caroline Elam in reference to Mantegna's work for the Gonzaga: C. Elam, 'Mantegna at Mantua' in D. Chambers and J. Martineau, ed., *Splendours of the Gonzaga*, exh. cat., Victoria and Albert Museum, London, 1981, pp. 15–25, esp. p. 15.

127. G. Urbani, 'Leonardo da Besozzo e Perinetto da Benevento', *Bollettino d'arte*, XXXVIII, 1953, pp. 297–306; F. Bologna, *Napoli e le rotte Mediterranee della pittura: da Alfonso il Magnanimo a Ferdinando il Cattolica*, Naples 1977, p. 74 note 49.

128. It has also been thought to be a design for contemporary architecture. For a typically useful summary of the arguments, see Cordellier in *Pisanello* (Paris) 1996, pp. 418–19, cat. 290.

129. Cordellier 1995, pp. 157–9, doc. 73.

130. Cordellier 1995, pp. 160–2, doc. 74.

131. Cordellier in *Pisanello* (Paris) 1996, pp. 453–6, cat. 320.

132. Cordellier in *Pisanello* (Paris) 1996, pp. 263–4, cat. 168.

133. Cordellier in *Pisanello* (Paris) 1996, p. 347, cat. 233.

134. See in particular W. Hood, *Fra Angelico at San Marco*, New Haven and London 1993.

CHAPTER II · THE CULTURE OF CHIVALRY
IN ITALY

1. Louvre inv. 2595 verso; Fossi Todorow 1966, pp. 83–84, no.65; D. Cordellier in *Pisanello* (Paris) 1998, pp. 141–7, cat.77.

2. Cordellier 1995, p. 74, doc.27.

3. The dating of this piece remains controversial – although the larger number of critics now agree that a date of *c*.1447 is correct. For different views see G.F. Hill, *Pisanello*, London, 1905, p. 169; Hill 1930, pp. 7–8, no. 20; J.G. Pollard, *Medaglie italiane del rinascimento nel Museo Nazionale del Bargello*, I, Florence 1984, p. 33, no.3; L. Syson in J. Rykwert, A. Engel, ed., *Leon Battista Alberti*, exh. cat., Palazzo Tè, Mantua, 1994, p. 53 note 37 and pp. 475–76, cat. 75; M. Rossi in S. Balbi de Caro, ed., *I Gonzaga: moneta, arte, storia*, exh. cat., Palazzo Tè, Mantua, 1995, pp. 394–5, cat.V.1,V.1a; S. de Turckheim-Pey in *Pisanello* (Paris) 1996, pp. 406–7, cat.284; D. Gasparotto in *Pisanello* (Verona) 1996, pp. 394–5, cat. 90; R. Rugolo, 'Medaglie', in Puppi 1996, pp. 163–5, no. 11; A. Schmitt, 'Pisanello et l'art du portrait', in Cordellier-Py 1998, I, pp. 337–75, esp. 346–7; L. Syson, '*Opus pisani pictoris*: les médailles de Pisanello et son atelier', in Cordellier-Py 1998, I, pp. 379–426, esp. pp. 390–1; D. Cordellier, 'Conclusion', in Cordellier-Py 1998, II, pp. 747–91, esp. p. 758.

4. Louvre inv. 2594 verso: above is a similarly sketchy rendition of St John the Baptist preaching to the animals; Fossi Todorow 1966, pp. 84–5, no. 66; Cordellier in *Pisanello* (Paris) 1996, pp. 147–8, cat. 78.

5. G. Peretti, 'Pisanello à Marmirolo: un document inédit', in Cordellier-Py 1998, I, pp. 29–41.

6. Even this wall is not fully worked up – areas, such as most of the armour worn by the knights, have been left at a second underdrawing stage in *terra verde*, which would surely have been elaborated with gilding and silvering applied *a secco*. See G. Paccagnini, *Il Pisanello e il ciclo pittorico cavalleresco di Mantova*, Milan 1972, p. 32; Woods-Marsden 1988, p. 125.

7. Woods-Marsden 1988, pp. 3–4, 10.

8. For documents revealing the extent of Pisanello's activities for the Gonzaga, see chapter 1. For supporters of a date in the mid to late 1420s, see S. Padovani, 'Pittori della corte estense nel primo Quattrocento', *Paragone*, no. 299, 1975, pp. 25–53; M. Boskovits, 'Arte lombarda del primo Quattrocento: un riesame', in *Arte in Lombardia tra Gotico e Rinascimento*, exh. cat., Palazzo Reale, Milan, 1988, pp. 9–49, esp. pp. 16–21; A. Conti, 'Frammenti di Mantova tardogotica', in M.T. Balboni Brizza, ed., *Quaderno di studi sull'arte lombarda dai Visconti agli Sforza: per gli 80 anni di Gian Alberto Dell'Acqua*, Milan 1990, pp. 41–7, esp. p. 46 note 7; L. Bellosi, 'The Chronology of Pisanello's Mantuan Frescoes Reconsidered', *Burlington Magazine*, CXXXIV, 1992, pp. 657–60; S. Skerl del Conte, 'Pisanello et la culture du XIVe siècle', in Cordellier-Py 1998, I, pp. 45–71, esp. pp. 59–60. Among most Italian scholars this date tends to be preferred to the dating in the late 1440s first promoted by Paccagnini 1972, pp. 235–46, and accepted by Woods-Marsden 1988, pp. 38–46. For dating around 1440 on grounds of armour see, for example, F. Rossi, 'Pisanello et la représentation des armes: réalité visuelle et valeur symbolique', in Cordellier-Py 1998, I, pp. 299–334, esp. p. 311; and, on grounds of restrictions on Pisanello's movements, Syson, '*Opus pisani pictoris*

...', in Cordellier-Py 1998, I, pp. 379–426, esp. p. 405 note 60. For useful summaries of the discussion see E. Moench in *Pisanello* (Paris) 1996, pp. 95–8, cat. 48; T. Franco in Puppi 1996, pp. 64–7; Cordellier, 'Conclusion', in Cordellier-Py 1998, II, pp. 747–91, esp. pp. 757–8.

9. A. Martindale, 'The *Sala di Pisanello* at Mantua – a New Reference', *Burlington Magazine*, CXVI, 1974, p. 101; Woods-Marsden 1988, pp. 8, 174–5 note 38; Cordellier 1995, pp. 176–7, doc.82 (see also pp. 182–4, docs. 87–9).

10. R. Varese, 'Il sistema delle "delizie" e lo "studiolo" di Belfiore', in *Le muse* (Milan) 1991, *Saggi*, pp. 187–201.

11. Louvre inv. 2324: Fossi Todorow 1966, p. 181, no. 379; Cordellier in *Pisanello* (Paris) 1996, pp. 94–95, cat. 46.

12. J. Woods-Marsden, 'The Sinopia as Preparatory Drawing: the Evolution of Pisanello's Tournament Scene', *Master Drawings*, nos. 23–24, 1986, pp. 175–92.

13. The only exception has been S. Osano, 'Giovanni Badile collaboratore del Pisanello? Contributo alla datazione del ciclo cavalleresco di Mantova', *Quaderni di Palazzo Tè*, VI.7, pp. 9–22. However, her proposal that this extra hand may have been Giovanni Badile is unacceptable on chronological grounds.

14. V. Pizzorusso Bertolucci, 'I cavalieri del Pisanello', *Studi mediolatini e volgari*, XX, 1972, pp. 37–48; Woods-Marsden 1988, pp. 13–21.

15. Woods-Marsden 1988, p. 63.

16. *Scriptores historiae Augustae vitae diversorum principum et tyrannorum a diversis compositae*, Turin, Biblioteca Nazionale Universitaria, Ms E.III.19; see especially folio 114 verso. See G. Toscano in *Pisanello* (Paris) 1996, pp. 138–40, cat. 75.

17. I. Toesca, 'Lancaster e Gonzaga: il fregio della sala del Pisanello nel Palazzo Ducale di Mantova', *Civiltà mantovana*, VII, 1973, pp. 361–77; ead., 'A Frieze by Pisanello', *Burlington Magazine*, CXVI, 1974, pp. 210–14; ead., 'More about the Pisanello Murals at Mantua', *Burlington Magazine*, CXVIII, 1976, pp. 622–9; ead., 'Altre osservazioni in margine alle pitture del Pisanello nel Palazzo Ducale di Mantova', *Civiltà mantovana*, XI, 1977, pp. 349–76; ead., 'Lancaster and Gonzaga: the Collar of SS at Mantua', in D. S. Chambers, J. Martineau, ed., *Splendours of the Gonzaga*, exh. cat., Victoria and Albert Museum, London, 1981, pp. 1–2. A dating in the late 1440s has justified the alternative suggestion that the commission might relate to Lodovico Gonzaga's membership of the Hohenzollern Order of Our Lady of the Swan founded by elector Frederick II of Brandenburg (Lodovico's uncle by marriage) shortly after 1440 (Woods-Marsden 1988, pp. 57–60). Lodovico and his consort, Barbara of Brandenburg, were certainly honorary members by 1464–5, although it is not known when they were invited to join (it is very unlikely to have been before 1448). The swan pendant has therefore been read as indicating Gonzaga membership of a different chivalric order. However, the frieze omits the image of the Virgin, which was part of the Order's insignia, and, more importantly, the paintings were almost certainly begun well before Lodovico received his membership.

18. J. Cherry, 'The Dunstable Swan Jewel', *Journal of the British Archaeological Association*, ser. III, XXXII, 1969, pp. 38–53, esp. pp. 48, 53; D.S. Chambers in *Splendours of the Gonzaga* 1981, p. 107, cat. 11.

19. R. Rayna, 'Ricordi di codici francesi posseduti dagli Estensi nel secolo XV', *Romania*, II, 1873, pp. 49–58; A. Cappelli, 'La biblioteca estense nella prima metà del secolo XV', *Giornale storico della letteratura italiana*, XIV, 1889, pp. 1–30; G. Bertoni, 'Un copista del Marchese Leonello d'Este (Biagio Bosoni da Cremona)', *Giornale storico della letteratura italiana*, LXXII, 1918, pp. 96–106, esp. 101–2; id., 'La biblioteca di Borso d'Este', *Atti della R. Accademia delle Scienze di Torino*, LXI, disp. 14a, 1925–6, pp. 379–402; E. Pellegrin, *La Bibliothèque des Visconti et des Sforza, ducs de Milan, au XVe siècle*, Paris 1955, p. 16; P. Kibre, 'The Intellectual Interests Reflected in the Libraries of the Fourteenth and Fifteenth Centuries', *Journal of the History of Ideas*, VII, 1946, pp. 257–97; D. De Robertis, 'Ferrara e la cultura cavalleresca', in E. Cecchi and N. Sapegno, ed., *Storia della letteratura italiana*, III, Milan 1966, pp. 57–74; C.W. Clough, 'The Library of the Gonzaga in Mantua', *Librarium: Revue de la Société Suisse de Bibliophiles*, XV, 1972, pp. 50–63; Woods-Marsden 1988, pp. 22–23.

20. A. Tissoni Benvenuti, 'Il mondo cavalleresco e la corte estense', in *I libri di Orlando Innamorato*, Modena 1987, pp. 13–33.

21. See, for example, Woods-Marsden 1988, p. 26

22. Bonamente Aliprandi, *Cronica di Mantua* (appendix to Antonio Nerli, *Breve Chronicon*), ed. O. Begani, *Rerum italicarum scriptores*, XXIV.13, Città di Castello 1908–10, p. 131 (chapter CXLVIII).

23. Galeazzo and Bartolomeo Gatari, *Cronaca Carrarese*, ed. A. Medin and G. Tolomei, *Rerum italicarum scriptores*, XVII.1, Part 1, Città di Castello 1909–20, p. 450; R. Barber and J. Barker, *Tournaments: Jousts, Chivalry and Pageants in the Middle Ages*, Woodbridge 1989, pp. 79–87. For a detailed, and different, account of the same event by B. Corio at the beginning of the sixteenth century – which describes three days of jousts, with prizes worth 1,000 ducats – see G. Franceschini, 'Aspetti della vita milanese nel Rinascimento', in *Storia di Milano*, VII, *L'età sforzesca*, Milan 1956, pp. 883–941, esp. p. 900. By then the jousts had clearly entered Milanese mythology.

24. Galeazzo and Bartolomeo Gatari, *Cronaca Carrarese*, ed. A. Medin and G. Tolomei, 1909–20, p. 439; Barber and Barker 1989, pp. 79–87.

25. R. Truffi, *Giostre e cantori di giostre*, Rocca San Casciano, 1911, pp. 153–54.

26. P. N. Signorelli, *Vicende della coltura nelle due Sicilie*, III, Naples 1810, pp. 530–59; J. Ametller y Vinyas, *Alfonso V de Aragon en Italia y la crisis religiosa del siglo XV*, 3 vols., 1903–28, II, 1903, p. 519.

27. H. Maxwell, '"Uno elefante grandissimo con lo castello di sopra": il trionfo aragonese del 1423', *Archivio storico italiano*, CL, 1992, pp. 847–75, esp. pp. 847–9.

28. L. Montalto, *La corte di Alfonso I de Aragona: vesti e gale*, Naples 1922, p. 16.

29. A. Ryder, *Alfonso the Magnanimous: King of Aragon, Naples and Sicily, 1396–1458*, Oxford 1990, p. 351.

30. Ryder 1976, p. 275.

31. M. Mallett, 'Venice and its Condottieri', in J. R. Hale, ed., *Renaissance Venice*, London 1973, pp. 121–45, esp. pp. 124, 128, 132, 136; C.M. Belfanti, 'I Gonzaga, signori della guerra (1410–1530)', in C. Mozzarelli, R. Oresko, L. Ventura, ed., *La corte di Mantova nell'età di Andrea Mantegna, 1450–1550*, Rome 1997, pp. 61–68.

32. L. Mazzoldi, *Mantova: la storia*, II, Mantua 1961, p. 5.

33. Woods-Marsden 1988, pp. 67, 213 note 136.

34. Varese in *Le muse* (Milan) 1991, *Saggi*, pp. 187–201, esp. pp. 190–91.

35. C. Fumagalli and L. Beltrami, *La cappella detta della Regina Teodolinda nella Basilica di San Giovanni in Monza e le sue pitture murali*, Milan 1891; G. Consoli, *I 'Giochi' Borromeo ed il Pisanello*, Milan 1966; M. L. Gengaro, 'Gli affreschi di Palazzo Borromeo', *Arte Lombarda*, nos. 80–2, 1987, pp. 196–205; L. Castelfranchi, 'Intorno agli affreschi zavattariani di Monza', *Arte Lombarda*, nos. 80–82, 1987, pp. 95–104; C. B. Strehlke, '"Li magistri con li discepoli": Thinking about Art in Lombardy', in B. Agosti et al., *Quattro pezzi lombardi (per Maria Teresa Binaghi)*, Brescia 1998, pp. 11–38, esp. pp. 24–26, 33–38.

36. P. Binski, 'International Gothic Style, c.1380–c.1440', in J. Turner, ed., *The Dictionary of Art*, XIII, London 1996, pp. 155–56.

37. De Marchi 1992, p. 15; M. Rossi, *Giovannino de Grassi: la corte e la cattedrale*, Milan 1995, pp. 141–7.

38. F. Cognasso, *I Visconti*, Varese 1966, pp. 241, 306–12.

39. Bertoni 1925–6, pp. 379–402, esp. p. 397.

40. R.J. Walsh, *Charles the Bold, Last Valois Duke of Burgundy, 1467–1477, and Italy*, unpublished Ph.D. thesis, University of Hull, 1977, pp. 608–34.

41. M. Meiss, *French Painting in the Time of Jean de Berry*, III, *The Limbourgs and their Contemporaries*, London 1974, pp. 246–7.

42. Paris, Bibliothèque nationale de France, Ms. fr. 166, fol. 1. This page seems to be a slightly later addition to the Limbourg brothers' manuscript, which belongs to the beginning of the first decade of the fifteenth century, and there is no scholarly accord as to whether this is the work of the Limbourgs themselves of c.1410 or a copy after a prototype by them of c.1420. Its disputed status does not affect its significance as a source for Pisanello, though it may begin to suggest ways in which Pisanello may have known it – either as a detached sheet or, more likely, as (another) copy. For a good summary of scholarly arguments related to the page see J. Lowden, *The Making of the Bibles Moralisées*, I, *The Manuscripts*, pp. 277–79, pl. XXVI. For Pisanello's drawings (Louvre inv. RF 423, Boymans inv. I.526 recto, with a workshop verso) see Fossi Todorow 1966, pp. 133, 199–200, no. 194, 461; A. Schmitt, 'Die Frühzeit Pisanellos: Verona, Venedig, Pavia', in Degenhart-Schmitt 1996, pp. 40–1; Cordellier in Pisanello (Paris) 1996, pp. 154–5, cat. 85.

43. E. H. Gombrich, 'Supply and Demand in the Evolution of Styles: the Example of International Gothic', in M. Bal et al., *Three Cultures: Fifteen Lectures on the Confrontation of Academic Cultures*, The Hague 1989, pp. 127–60, esp. pp. 147–51; R.W. Scheller, trans. M. Hoyle, *Exemplum: Model-Book Drawings and the Practice of Artistic Transmission in the Middle Ages (ca. 900–ca. 1470)*, Amsterdam 1995, pp. 19–20, 62–9.

44. M. Conway, 'Giovannino de' Grassi and the Brothers von Limbourg', *Burlington Magazine*, XVIII, 1910–11, pp. 144–9; O. Pächt, 'Early Italian Nature Studies and the Early Calendar Landscape', *Journal of the Warburg and Courtauld Institutes*, XIII, 1950, pp. 13–47, esp. p. 42; Meiss 1974, pp. 197, 214–15.

45. Turin, Biblioteca Reale, Ms. Var. 77; M. Meiss, *French Painting in the Time of Jean de Berry*, II, *The Boucicaut Master*, London 1968, pp. 32, 68.

46. M.G. Muzzarelli, *Guardaroba medioevale: vesti e società dal XIII al XVI secolo*, Bologna 1999, pp. 251–2.

47. A.R. Calderoni Masetti, 'Smalti *en ronde-basse* alla corte di Ferrara' in A.R. Calderoni Masetti, ed., *Oreficerie e smalti in Europa fra XIII e XV secolo: Atti del convegno di studi, Scuola Normale Superiore di Pisa, 7–8 novembre 1996*, Annali della Scuola Normale Superiore di Pisa: Quaderni, II, 1997, pp. 97–109; ead., 'Leonello d'Este e l'oreficeria parigina fra Tre e Quattrocento', in K. Bergdolt and G. Bonsanti, ed., *Opere e giorni: studi su mille anni di arte europea*, Venice 2001, pp. 291–8.

48. See R.W. Lightbown, *Secular Goldsmiths' Work in Medieval France: a History*, London 1978, p. 104, pl. LXXV.

49. Montalto 1922, pp. 4, 6–7.

50. Ibid., p. 7.

51. A. Bertolotti, 'Le arti minori alla corte di Mantova nei secoli XV, XVI, XVII', *Archivio storico lombardo*, ser. II, xv, 1888, pp. 259–318, 419–590, 980–1075, esp. pp. 1033–7.

52. G. Campori, 'L'arazzeria estense', *Atti e memorie delle RR. Deputazioni di storia patria per le provincie modenesi e parmensi*, VIII, 1876, pp. 415–80, esp. p. 419.

53. G. Bertoni and E.P. Vicini, *Il Castello di Ferrara ai tempi di Nicolò: inventario della suppellettile del Castello, 1436*, Bologna 1907, pp. 9–16 and elsewhere; G. Pardi, 'La suppellettile dei palazzi estensi in Ferrara nel 1436', *Atti e memorie della deputazione ferrarese di storia patria*, xv, 1908, pp. 5–181, esp. pp. 109–13.

54. N. Forti Grazzini, *Arazzi a Ferrara*, Ferrara 1982, p. 24.

55. Gombrich in Bal et al. 1989, pp. 127–60.

56. J. Gelli and G. Moretti, *Gli armaroli milanesi: i Missaglia e la loro casa, notizie, documenti, ricordi*, Milan 1903, pp. 31–37, 95–117 (particular interesting is a poem of 1424 recounting the visit of Florentine prisoners in Milan to armourers' workshops: '*Questo è maggior fato / che se trovase in la Cristianitade*'); E. Motta, 'Armaiuoli milanesi nel periodo Visconteo-Sforzesco', *Archivio storico lombardo*, ser. V, XLI, 1914, pp. 197–232, esp. 208.

57. A. Venturi, 'Relazioni artistiche tra le corti di Milano e Ferrara', *Archivio storico lombardo*, ser. II, II, 1885, pp. 225–80, esp. p. 230.

58. Ryder 1976, p. 76.

59. M. Scalini, *L'armeria Trapp di Castel Coira*, Udine 1996, pp. 226–7.

60. Hill 1930, pp. 8–9, no.24; E. Corradini in *Le muse* (Milan) 1991, *Catalogo*, p. 64–5, cat. 5; de Turckheim-Pey in *Pisanello* (Paris) 1996, pp. 383, 392, cat. 261–2; Rugolo in Puppi 1996, pp. 151–3, no. 6.

61. L. Boccia, 'L'armatura lombarda tra il XIV e il XVII secolo', in L.G. Boccia, R. Rossi, M. Morin, ed., *Armi e armature lombarde*, Milan 1980, pp. 13–177, esp. pp. 56–65, 68, 76; F. Rossi, 'Pisanello et la représentation des armes: réalité visuelle et valeur symbolique', in Cordellier-Py 1998, I, pp. 299–334 (on which we have based the interpretations of armour set out below).

62. G.F. Hill and S.J. Camp, 'Letters: Milanese Armourers' Marks', *Burlington Magazine*, XXXVI, 1920, pp. 49–50.

63. G. Peretti, 'Pisanello à Marmirolo: un document inédit', in Cordellier-Py 1998, I, pp. 29–41, esp. p. 40.

64. L. Boccia, *Il Museo Statale d'Arte Medievale e Moderna in Arezzo*, Florence 1987, p. 199; M. Scalini, *Il Saracino e gli spettacoli cavallereschi nella Toscana granducale*, Florence 1987, p. 41 (with bibliography); M. Scalini in P. Dal Poggetto, ed., *Piero e Urbino, Piero e le Corti rinascimentali*, exh. cat., Palazzo Ducale and Oratorio di San Giovanni Battista, Urbino, 1992, p. 186, cat. 35.

65. A. Lensi, 'Il Museo Bardini: II, le armi', *Dedalo*, VI, 1925–6, pp. 164–83, esp. p. 181; M. Bergstein, *The Sculpture of Nanni di Banco*, Princeton NJ 2000, p. 52, fig. 55.

66. *Diario Ferrarese dall'anno 1409 sino al 1502 di autori incerti*, ed. G. Pardi, *Rerum italicarum scriptores*, XXIV.7, Bologna 1928–33, p. 27.

67. Hill 1930, p. 8, no. 21; de Turckheim-Pey in *Pisanello* (Paris) 1996, p. 215, cat. 127; Gasparotto in *Pisanello* (Verona) 1996, pp. 378–79, cat. 82; Rugolo in Puppi 1996, pp. 138–43, no. 1.

68. For the medal of Sigismondo see Hill 1930, p. 34, no. 34; de Turckheim-Pey in *Pisanello* (Paris) 1996, p. 404, cat. 277; Rugolo in Puppi 1996, p. 167, no. 13. For the medal of Gianfrancesco see note 3 above.

69. Hill 1930, pp. 10–11, no. 35; de Turckheim-Pey in *Pisanello* (Paris) 1996, pp. 399–400, cat. 275; Gasparotto in *Pisanello* (Verona) 1996, pp. 292–3, cat. 89; Rugolo in Puppi 1996, p. 168, no. 14; Syson, '*Opus pisani pictoris…*', in Cordellier-Py 1998, I, pp. 379–426, esp. pp. 391–2.

70. Hill 1930, p. 10, no.33; de Turckheim-Pey in *Pisanello* (Paris) 1996, p. 404, cat. 278; Rugolo in Puppi 1996, pp. 165–66, no.12; F. Rossi, 'Pisanello et la représentation des armes…', in Cordellier-Py 1998, I, pp. 299–334, esp. p. 309; Syson, '*Opus pisani pictoris …*', in Cordellier-Py 1998, I, pp. 379–426, esp. p. 391; A. Schmitt, 'Pisanello et l'art du portrait', in Cordellier-Py 1998, I, pp. 337–75, esp. pp. 341–3.

71. Hill 1930, p. 11, no.36; de Turckheim-Pey in *Pisanello* (Paris) 1996, pp. 407,412, cat.286; Rugolo in Puppi 1996, p. 169, no.15; Rossi in Cordellier-Py 1998, I, pp. 299–334, esp. p. 311.

72. G. Peretti, 'Pisanello à Marmirolo: un document inédit', in Cordellier-Py 1998, I, pp. 29–41, esp. p. 40.

73. Louvre inv. 2295 recto: Fossi Todorow 1966, pp. 90–91, no.80; Cordellier in *Pisanello* (Paris) 1996, pp. 420–22, cat. 293.

74. Montalto 1922, p. 16. The 'siege perilous' had particular significance for Alfonso since he believed himself to be the owner of the Holy Grail – albeit he had left '*lo calser hon Jesu Crist consagra lo sanguis lo diijous dela cena*' behind in Valencia – in the sacristy of the cathedral – held in return for extensive funding for his Neapolitan campaign. See M. Navarro,

'Pignora sanctorum. Sulle reliquie, il loro culto e le loro funzioni', in J.J. Gavara, ed., *Reliquie e reliquari nell'espansione mediterranea della Corona d'Aragona: il Tesoro della Cattedrale di Valenza*, Valencia 1998, pp. 93–133, esp. pp. 126, 137.

75. Louvre inv. 2281 recto; Fossi Todorow 1966, pp. 61–2, no. 8; H.-J. Eberhardt, 'Zur Rekonstruktion von Pisanellos Wandgemälden in Sant'Anastasia', in Degenhart-Schmitt 1995, pp. 181–91, esp. pp. 190–1; Cordellier in *Pisanello* (Paris) 1996, p. 51, cat. 15 .

76. Ashmolean inv. P II 41 recto; Fossi Todorow 1966, p. 131, no. 190; Cordellier in *Pisanello* (Paris) 1996, pp. 182–4, cat. 102. Cf. Bonnat inv. 141 recto, Condé inv. FR I-3 recto: Fossi Todorow 1966, pp. 59–60, 122–3, nos. 5, 170; A. Schmitt, 'Die Frühzeit Pisanellos …', in Degenhart-Schmitt 1995, pp. 41, 48–9, 134.

77. Louvre inv. 2342 recto and verso; Fossi Todorow 1966, pp. 60–1, no. 7; Cordellier in *Pisanello* (Paris) 1996, pp. 296–7, cat. 188.

78. A. Franceschini, *Artisti a Ferrara in età umanistica e rinascimentale: testimonianze archivistiche*, I, Ferrara and Rome 1993, pp. 179–80, doc. 414.

79. D. Cordellier, *La princesse au brin de genévrier*, Paris 1996, p. 25.

80. W. Terni de Gregory, *Bianca Maria Visconti, duchessa di Milano*, Bergamo 1940, p. 47.

81. R. Levi Pisetzky, *Storia del costume in Italia*, II, Milan 1967, p. 187.

82. R. Levi Pisetzky, *Il Costume e la moda nella società italiana*, Turin 1978, pp. 6–7; J. Herald, *Renaissance Dress in Italy, 1400–1500*, London 1981, p. 45 .

83. Louvre inv. 232 verso: Herald 1981, p. 100.

84. M. Beaulieu, J. Baylé, *La Costume de Bourgogne de Philipe le Hardi à la mort de Charles le Téméraire (1364–1477)*, Paris 1956, pp. 48–9, 77–9; M. Scott, *The History of Dress Series: Late Gothic Europe, 1400–1500*, London 1980, pp. 78, 83.

85. M. Giuseppina Muzzarelli, *Guardaroba medioevale: vesti e società dal XIII al XVI secolo*, Bologna 1999, p. 85.

86. L. A. Gandini, 'Saggio degli usi e delle costumanze della corte di Ferrara al tempo di Niccolò III', *Atti e memorie della Reale Deputazione per la storia patria per le provincie di Romagna*, ser. II, VI, 1881, pp. 148–69, esp. p. 163; Levi Pisetzky, II, 1967, p. 342; G. Butazzi, 'La "magnificentia" della corte: per una storia della moda nella Ferrara estense prima del governo di Ercole I', in *Le muse* (Milan) 1991, *Saggi*, pp. 119–32, esp. p. 126.

87. R. Levi Pisetzky, 'L'apogeo dell'eleganza milanese durante il Ducato', *Storia di Milano*, VIII, *Tra Francia e Spagna*, Milan 1957, pp. 721–76; M. Cataldi Galli, 'Abbigliamento e potere: la corte come centro di diffusione della moda', in R. Varese, G. Butazzi, ed., *Storia della moda*, Bologna 1995, pp. 55–92.

88. M.G. Muzzarelli, *Gli inganni delle apparenze: disciplina di vesti e ornamenti alla fine del Medioevo*, Turin 1996, p. 175.

89. F. Malaguzzi Valeri, *La Corte di Lodovico il Moro*, I, *La vita privata*, Milan 1913, p. 215; Muzzarelli 1999, p. 84.

90. P. Mainoni, 'La seta a Milano nel XV secolo: aspetti economici e istituzionali', *Studi storici*, XXXV, 1994, pp. 871–96.

91. Muzzarelli 1996, p. 59.

92. Levi Pisetzky, II, 1967, p. 292.

93. R. Levi Pisetzky, 'Nuove mode della Milano viscontea nello scorcio del '300', in *Storia di Milano*, V, *La signoria dei Visconti (1310–1392)*, Milan 1955, pp. 875–908, esp. pp. 899–902.

94. The cloak was of gold cloth lined with ermine. See *Diario Ferrarese* 1928–33, p. 25.

95. E. Sáez, 'Semblanza de Alfonso el Magnánimo', in *Estudios sobre Alfonso el Magnánimo*, Barcelona 1960, p. 32.

96. Levi Pisetzky, II, 1967, p. 218.

97. P. Venturelli, 'Copricapi e acconciature femminili nella Lombardia feminile', in *La Lombardia delle Signorie*, Milan 1986, pp. 122–9 .

98. Levi Pisetzky, II, 1967, p. 290.

99. F. M. Graves, *Deux inventaires de la maison d'Orléans (1398 et 1408)*, Paris 1926, pp. 45, 61, 62, nos. 10, 24.

100. G. Bertoni, 'Motti francesi su maniche e vestiti di principesse estensi nel quattrocento', in *Poesie, leggende e costumanze del Medio Evo*, Modena 1927, pp. 197–202. Isotta d'Este's motto was *Loiaument. voil. finir.ma.vie.*

101. British Museum inv. 1846-5-9-143: Fossi Todorow 1966, pp. 92–3, no. 84; Cordellier in *Pisanello* (Paris) 1996, pp. 110–11, cat. 59.

102. Herald 1981, pp. 130–1.

103. Louvre inv. 2275 recto: Fossi Todorow 1966, p. 87, no. 71; Cordellier in *Pisanello* (Paris) 1996, pp. 120–1, cat. 63. Cf. Louvre inv. 2603 verso: Fossi Todorow 1966, p. 147, no. 234; Cordellier in *Pisanello* (Paris) 1996, p. 120, cat. 62. For the manuscript (Rome, Biblioteca Apostolica Vaticana, Cod. Rossiano 555) see M. Boskovits, 'Arte lombarda …', in *Arte in Lombardia tra Gotico e Rinascimento* 1988, pp. 9–49, esp. pp. 18–20.

104. Lugt inv. 6164: Fossi Todorow 1966, pp. 177–8, no. 363; J. Byam Shaw, *The Italian Drawings of the Frits Lugt Collection*, Paris and Basle, I, 1983, pp. 204–5, no. 203; Cordellier in *Pisanello* (Paris) 1996, pp. 108–10, cat. 58.

105. Hill 1930, p. 26–7, no. 96.

106. J. Woods-Marden '"Draw the irrational animals as often as you can from life": Cennino Cennini, Giovannino de' Grassi and Antonio Pisanello', *Studi di storia dell'arte*, III, 1992, pp. 67–78.

107. Bristish Library Add. Mss. 27695, 28841. The hunting scene is contained in Egerton Ms 3127, fol. 1v; O. Pächt, 'Early Italian Nature Studies and the Early Calendar Landscape', *Journal of the Warburg and Courtauld Institutes*, XIII, 1950, pp. 13–47, esp. pp. 21–2.

108. Fossi Todorow 1966, p. 103, no. 102; Cordellier in *Pisanello* (Paris) 1996, p. 262, under cat. 166.

109. Castello Ducale inv. 15.885; I. Toesca, 'Un cappuccio di falco nel Palazzo Ducale di Mantova', in G. Capecchi et al., ed., *In memoria di Enrico Paribeni*, Rome 1998, pp. 461–4, pls. CXXVIII–CCXXIX.

110. For the Pisanello workshop drawing (Albertina inv. 16) see Fossi Todorow 1966, p. 139, no. 206; Cordellier in *Pisanello* (Paris) 1996, p. 176, cat. 93. For the Michelino drawing (Louvre inv. 20692) see M. Boskovits, 'Arte lombarda …', in *Arte in Lombardia tra Gotico e Rinascimento* 1988, pp. 9–49, esp. pp. 11, 45 note 13; De Marchi 1992, p. 19, 42 note 54; Cordellier in *Pisanello* (Paris) 1996, pp. 169–76, cat. 93.

111. N. Forti Grazzini, *Arazzi a Ferrara*, Ferrara 1982, pp. 16–23.

112. G.W. Digby (with W. Hefford), *The Devonshire Hunting Tapestries*, London 1971.

113. Forti Grazzini 1982, p. 19.

114. Forti Grazzini 1982, p. 21.

115. A.S. Cavallo, *Medieval Tapestries in the Metropolitan Museum*, New York 1993, pp. 125–33.

116. W.L. Gundersheimer, ed., *Art and Life at the Court of Ercole I d'Este: the De triumphis religionis of Giovanni Sabadino degli Arienti*, Geneva 1972, pp. 23, 68. The cycle had four scenes: the hunt, the collection of the game, the open-air supper and the dance by a fountain. For other frescoed hunting scenes of uncertain period see pp. 24, 68–9.

117. F. Mazzini, with intro. by G. A. Dell'Acqua, *Affreschi lombardi del Quattrocento*, Milan 1965, p. 435, pls. 60–2. For scenes of a similar genre and date see D. Benati, 'Pittura tardogotica nei domini estensi', in D. Benati, ed., *Il tempo di Nicolò III: gli affreschi del Castello di Vignola e la pittura tardogotica nei domini estensi*, exh. cat., Rocca di Vignola, 1988, pp. 43–77, esp. p. 56, pl. XXIX – scenes of courtly life in the Torre di Passerino Bonacolsi, Castello di Pio, Carpi.

118. M. Montanari, 'Il ruolo della caccia nell'economia e nell'alimentazione dei ceti rurali dell'Italia del Nord: evoluzione dall'alto al basso Medioevo', in *La Chasse au Moyen Age: Actes du Colloque de Nice, 22–24 juin 1979*, Nice 1980 (Publications de la Faculté des lettres et des sciences humaines de Nice, XX), pp. 331–45; H. Zug Tucci, 'La caccia: da bene commune a privilegio', in R. Romano and U. Tucci, ed., *Economia naturale, economia monetaria, Storia d'Italia: Annali*, IV, Turin 1983, pp. 397–445; P. Galloni, *Il cervo e il lupo: caccia e cultura nobiliare nel Medioevo*, Bari 1993.

119. G. Biadego, 'Curiosità e divagazioni venatorie (documenti dei secoli XV e XVI)', *Atti e memorie dell'Accademia di agricoltura, scienze e lettere di Verona*, ser. IV, XIII, 1912, pp. 19–49.

120. A. Magnaguti, *Cacce gonzaghesche: studio condotto su documenti in gran parte inediti*, Mantua 1933; F. Cognasso, 'Istituzioni e signorili di Milano sotto i Visconti', in *Storia di Milano*, VI, *Il ducato Visconteo e la Repubblica Ambrosiana, 1392–1450*, Milan 1955, pp. 451–544, esp. pp. 535–7; R. Salvaroni, *La caccia e il potere: ritratti di duchi e marchesi alle corti dei Gonzaga e degli Estensi*, Bologna 1995.

121. C. Magenta, *I Visconti e gli Sforza nel Castello di Pavia e loro attinenze*, I, Milan 1883, p. 341; G. Franceschini, 'Aspetti della vita milanese nel Rinascimento', in *Storia di Milano*, VII, *L'età sforzesca*, Milan 1956, pp. 883–941, esp. pp. 910–12.

122. C. Magenta, *I Visconti e gli Sforza nel Castello di Pavia e loro attinenze*, I, Milan 1883, p. 341.

123. G. Malacarne, *Le cacce del principe: l'ars venandi nella terra dei Gonzaga*, Modena, 1998, p. 137

124. G. Pazzi, *Le "delizie Estensi" e l'Ariosto: fasti e piaceri di Ferrara nella Rinascenza*, Pescara 1933, passim, but esp. pp. 143–86. F. Cazzola, 'L'orto di Belfiore, la villa, il barco: una campagna per dilitto', in *Le muse* (Milan) 1991, *Saggi*, pp. 203–22.

125. Magenta 1883, p. 342.

126. T. Dean, *Land and Power in Late Medieval Ferrara: the Rule of the Este, 1350–1450*, Cambridge 1988, pp. 101, 126.

127. F. Cazzola, 'L'orto di Belfiore, la villa, il barco: una campagna per dilitto', in *Le muse* (Milan) 1991, *Saggi*, pp. 203–22, esp. pp. 205–6.

128. In drawings such as, for example, Louvre inv. 2459 (partridge), 2461 (teal), 2462 (smew), 2417 (boar), of which the autograph status cannot be doubted; see Cordellier in *Pisanello* (Paris) 1996, pp. 259–60, 261–2, 345, cat. 160, 161, 165, 228.

129. Montalto 1922, p. 15.

130. B. Thomas and O. Gamber, *Kunsthistorisches Museum, Wien, Waffensammlung: Katalog der Leibrüstkammer*, I (*Der Zeitraum von 500 bis 1530*), Vienna 1976, p. 73, no. D261, pl. 16.

131. Magenta 1883, pp. 341–42, 344.

132. Ryder 1976, pp. 72–3.

133. G. Malacarne, *Le cacce del principe: l'ars venandi nella terra dei Gonzaga*, Modena 1998, p. 66

134. Magenta 1883, p. 341.

135. Ryder 1976, pp. 72–3.

136. A. Franceschini, *Artisti a Ferrara in età umanistica e rinascimentale: testimonianze archivistiche*, I, Ferrara and Rome 1993, p. 233, doc. 493.

137. *Diario Ferrarese* 1928–33, p. 27.

138. A. Ryder, *Alfonso the Magnanimous*, Oxford 1990, pp. 353–7.

139. The pleasure of the hunt is stressed in a 1461 letter to Lodovico Gonzaga published by R. Signorini, *Opus Hoc Tenue*, Mantua 1985, p. 80 note 145. For the theory of falconry see G. Innamorati, ed., *Arte della caccia: testi di falconeria, uccellagione e altre cacce*, I, *Dal secolo XIII agli inizi del Seicento*, Milan 1965, pp. xviii, 3–75; G. Tilander, 'Etude sur les traductions en vieux français du traité *De arte venandi cum avibus*', *Zeitschrift für romanische Philologie*, XLVI, 1926, pp. 211, 591. For falconry as a metaphor of the skill required by a courtier to 'tame' his patron see A. Grafton, *Leon Battista Alberti: Master Builder of the Italian Renaissance*, London 2000, pp. 197–9.

140. M.J.B. Allen, 'The Chase: the Development of a Renaissance Theme', *Comparative Literature*, xx, 1968, pp. 301–12; M. Thiébaux, *The Stag of Love: The Chase in Medieval Literature*, Ithaca and London 1974, passim, esp. pp. 27, 77.

141. M. Thomas and F. Avril, ed., intro., *The Hunting Book of Gaston Phébus*, London 1998, p. 19; J. Cummins, *The Hound and the Hawk: the Art of Medieval Hunting*, New York 1988, pp. 2–3.

142. *The Hunting Book of Gaston Phébus*, ed. Thomas and Avril, pp. 76–8.

143. D. Fava, *La Biblioteca Estense nel suo sviluppo storico*, Modena 1925, p. 17; G. Tilander, ed., *Les livres du Roy Modus et de la Royne Ratio*, I, Paris 1932, pp. vii, ix (there are thirty-two surviving manuscripts in total).

144. De Marchi 1992, p. 11.

145. Cummins 1988, pp. 4, 272

146. Leon Battista Alberti, *The Family in Renaissance Florence: a Translation by Renée Neu Watkins of* I libri della famiglia, Columbia, S.C., 1969, p. 259.

CHAPTER III · CLASSICAL LEARNING AND
COURT ART

1. For standardised praise of Leonello's appearance as calm and amiable see E. Corradini, 'Medallic Portraits of the Este: *effigies ad vivum expressae*', in N. Mann and L. Syson, ed., *The Image of the Individual: Portraits in the Renaissance*, London 1998, pp. 22–39, esp. p. 27.

2. G. Ballardini, *Giovanni da Oriolo*, Florence 1911, p. 22; C. Grigioni, *La Pittura faentina*, Florence 1935, p. 63; M. Davies, *National Gallery Catalogues: The Earlier Italian Schools*, rev. edn, London 1961, pp. 241–2, no. 770.

3. Hill 1930, p. 21, no. 75.

4. Conversely, on the similarities between the medals, see G.F. Hill, *Pisanello*, London 1905, p. 144. For the family likeness see Corradini in Mann and Syson 1998, pp. 22–39, esp. pp. 32–6. See, for example, posthumous medals of Nicolò d'Este erroneously attributed to Amadio da Milano (Hill 1930, pp. 20–1, nos. 70–4), which are close to the drawing by Pisanello of Nicolò apparently wearing a straw hat (included in sheet of studies above the Diva Faustina, Louvre, inv. RF 519 recto, Fossi Todorow 1966, p. 85, no. 67; Cordellier in *Pisanello* (Paris) 1996, pp. 126–7). The Oriolo painting and Nicholaus medal bear a family resemblance to both these images and the early medal (*c.*1440–1) of Leonello's brother Borso by Amadio da Milano, apparently based on drawings by Pisanello (Hill 1930, p. 20, no. 69; Fossi Todorow 1966, pp. 81–2, 94, nos. 59, 89; Cordellier in *Pisanello* (Paris) 1996, pp. 377, 380, cat. 255–6), and even his later medallic portraits (1460) by Petrecino da Firenze and Jacopo Lixignolo (Hill 1930, pp. 26–7, nos. 94, 96).

5. J. Woods-Marsden, '*Ritratto al naturale*: Questions of Realism and Idealism in Early Renaissance Portraits', *Art Journal*, XLVI, 1987, pp. 209–16.

6. Louvre inv. 2315. For the coins from which this drawing is taken see M.J. Price, *The Coinage in the Name of Alexander the Great and Philip Arrhidaeus*, Zurich and London 1991 (2 vols.), esp. pls. xviii–xxviii.

7. L. Syson, 'Alberti e la ritrattistica', in J. Rykwert, A. Engel, ed., *Leon Battista Alberti*, exh. cat., Palazzo Tè, Mantua, 1994, pp. 46–53, esp. p. 51..

8. Pliny, *Natural History*, VII, 125, XXXV, 85.

9. Valerius Maximus, VIII, 11, 2.

10. Plutarch, *Moralia*, 335B (*Parallel Stories, On the Fortune of Alexander*).

11. G. Pardi, *Leonello d'Este: marchese di Ferrara*, Bologna 1904, p. 49.

12. D. Cordellier, *La Princesse au brin de genevrier*, Paris 1996, p. 20.

13. Pliny, *Natural History*, XVI, 96.

14. For its use see A. Venturi, 'Relazioni artistiche tra le corti di Milano e Ferrara nel secolo XV', *Archivio Storico Lombardo*, ser. II, 11, 1885, pp. 225–80, esp. pp. 239, 275; A. Venturi, 'La scoperta di un ritratto estense del Pisanello', *Archivio storico dell'arte*, II, 1889, p. 165; A. Franceschini, *Artisti a Ferrara in età umanistica e rinascimentale: testimonianze archivistiche*, I, Ferrara and Rome 1993, p. 223, doc. 481u; Cordellier, *La princesse au brin de genevrier*, 1996, p. 12.

15. U. Davitt-Asmus, *Corpus quasi vas*, Berlin 1977, pp. 17–40.

16. G.F. Hill, *Pisanello*, London 1905, p. 147.

17. N. Himmelmann, 'Nudità ideale', in Salvatore Settis, ed., *La memoria dell'antico nell'arte italiana*, Turin 1985, II, pp. 201–78, esp. pp. 263–4.

18. R. L. Rubinstein, 'The Renaissance Discovery of Antique River God Personifications', in R. Salvini, ed., *Scritti di storia dell'arte in onore di Roberto Salvini*, Florence 1984, pp. 254–63.

19. A. Nesselrath, 'Simboli di Roma', in *Da Pisanello* (Rome) 1988, pp. 195–205, esp. pp. 198–9 and 215, cat. 63.

20. Moreover, Pliny tells us that Alexander and his army wore ivy wreaths to mark the conquest of India: *Natural History*, XVI, 144.

21. Arrian, *Indica*, V, 9–13; A. Stewart, *Faces of Power: Alexander's Image and Hellenistic Politics*, Berkeley, Los Angeles and Oxford 1993, pp. 79–80. Alexander's identification with Bacchus is confirmed by the account in Quintus Curtius Rufus, *Life of Alexander the Great*, IX, x, 24–27: Alexander leads army in triumph from India towards Babylon, consciously imitating the mythical Indian progress of Bacchus.

22. G. Brunelli, 'Este, Leonello d'', in F. Bartoccini et al., ed., *Dizionario biografico degli italiani*, XLIII, Rome 1993, pp. 374–83, esp. pp. 374–5.

23. C.M. Rosenberg, *The Este Monuments and Urban Development in Este Ferrara*, Cambridge 1997, pp. 52, 206 note 14.

24. G. Pardi, *Leonello d'Este: marchese di Ferrara*, Bologna 1904, pp. 44–5.

25. A. Cappelli, 'La biblioteca Estense nella prima metà del secolo XV', *Giornale storico della letteratura italiana*, XIV, 1886, pp. 1–30; G. Bertoni, *La biblioteca Estense*, Turin 1903; W.L. Gundersheimer, *Ferrara: the Style of a Renaissance Despotism*, Princeton NJ 1973, pp. 85–6; A. Quondam, *Il libro a corte*, Rome 1994, pp. 10–16.

26. A. Tissoni Benvenuti, 'Guarino, i suoi libri e le lettere della corte estense' in *Le muse* (Milan) 1991, *Saggi*, pp. 63–79, esp. p. 66.

27. R. Sabbadini, ed., *Epistolario di Guarino Veronese*, 3 vols., Venice 1915–19, I, 1915, pp. 243–4, ep. 148; E. Grassi, *Renaissance Humanism: Studies in Philosophy and Poetics*, Binghamton NY 1988, pp. 52–5. For Guarino as a teacher and his career at court see G. Bertoni, *Guarino da Verona, fra letterati e cortigiani a Ferrara (1429–1460)*, Geneva 1921; R. Sabbadini, *Vita di Guarino Veronese* and *La scuola e gli studi di Guarino Veronese*, in *Guariniana*, ed. M. Sancipriano, Turin 1964; E. Garin, ed., *Il pensiero pedagogico dello umanesimo*, Florence 1958, pp. 306–504; id., *Guarino Veronese e la cultura a Ferrara: ritratti di umanisti*, Florence 1967, pp. 69–106; R. Schweyen, *Guarino Veronese: Philosophie und humanistische Pädagogik*, Munich 1973.

28. W.H. Woodward, *Vittorino da Feltre and Other Humanist Educators* (1897), ed. E.F. Rice Jr., New York 1963, p. x.

29. R. Sabbadini, ed., *Epistolario di Guarino Veronese* (3 vols), Venice, 1915–19, II, pp. 216–20, esp. p. 217, ep. 668.

30. C. Brink, *Arte et Marte: Kriegskunst und Kunstliebe im Herrscherbild des 15. und 16. Jahrhunderts in Italien*, Munich and Berlin 2000, pp. 48–62.

31. E. Paglia, 'La Casa Giocosa di Vittorino da Feltre in Mantova', *Archivio Storico Lombardo*, ser. II, i, 1884, pp. 150–8, esp. p. 150; A. Luzio, 'Cinque lettere di Vittorino da Feltre', *Archivio veneto*, N.S XVIII, 1888, pp. 329–41, esp. p. 330.

32. G. Flores d'Arcais, 'Vittorino da Feltre: la pedagogia come autobiografia', in N. Giannetto, ed., *Vittorino da Feltre e la sua scuola: Umanesimo, pedagogia, arti*, Florence 1981, pp. 35–53, esp. p. 46.

33. Woodward 1963; A. Gambara, *Vittorino da Feltre*, Turin 1946; C. Vasoli, 'Vittorino da Feltre e la formazione umanistica dell'uomo', in Giannetto 1981, pp. 13–33; G. Müller, *Mensch und Bildung in italienischen Renaissance-Humanismus: Vittorino da Feltre und die humanistischen Erziehungdenker*, Baden-Baden 1984.

34. G. Cimarosti, 'Le lettere di Vittorino da Feltre: le testimonianze dei contemporanei', in *Vittorino da Feltre: Quaderni di 'Paedagogium'*, Brescia 1947, pp. 45–85, esp. pp. 63–64.

35. Woodward 1963, p. 24.

36. Garin 1958, p. 641.

37. W.H. Woodward, *Studies in Education during the Age of the Renaissance, 1400–1600*, New York 1906, pp. 38–40; Sabbadini in Sancipriano 1964, pp. 44–7; W. Keith Percival, 'The Historical Sources of Guarino's *Regulae grammaticales*: a reconstruction of Sabbadini's evidence', in *Civiltà dell'Umanesimo: Atti del VI, VII, VIII convegno del Centro di Studi Umanistici 'Angelo Poliziano'*, Florence 1972, pp. 263–84; A. Grafton and L. Jardine, *From Humanism to the Humanities: Education and the Liberal Arts in Fifteenth- and Sixteenth-Century Europe*, Cambridge MA 1986, p. 10.

38. A. Luzio, 'Cinque lettere di Vittorino da Feltre', *Archivio Veneto*, N.S., XVIII, 1888, pp. 329–41, esp. p. 339.

39. G. Voigt, *Die Wiederbelebung des classischen Alterthums oder das erste Jahrhundert des Humanismus*, 2 vols., 1880–1, I, Berlin 1881, p. 553.

40. A manuscript now in the Biblioteca Laurenziana, Florence, Cod. Laur. LXIX, i. See A.M. Bandini, *Catalogus codicum graecorum Bibliothecae Mediceae Laurentianae*, Florence 1768–70, II, 1770, p. 622; R.R. Bolgar, *Classical Influences on European Culture, A.D. 500–1500*, Cambridge 1971, p. 485.

41. Tissoni Benvenuti in *Le muse* (Milan) 1991, *Saggi*, pp. 63–79, esp. p. 71. For the Este manuscript of Pliny of 1433 (Milan, Biblioteca Ambrosiana, D 531 inf.), for which the scribe was Biagio Busoni and one of the two illuminators Giovanni Falconi da Firenze, see F. Toniolo, 'Marco dell'Avogaro e la decorazione all'antica', in *Le muse* (Milan) 1991, *Catalogo*, pp. 132–40, esp. pp. 132–4. For Leonello's patronage of literature see Pardi 1904, pp. 141–76.

42. Tissoni Benvenuti in *Le muse* (Milan) 1991, *Saggi*, pp. 63–79, esp. p. 71.

43. A. Grafton, 'Comment créer une bibliothèque humaniste: le cas de Ferrare', in M. Baratin, C. Jacob, ed., *Le pouvoir des bibliothèques: le memoir des livres en Occident*, Paris 1996, pp. 189–203, esp p. 194.

44. M. Pade, 'Guarino and Caesar at the Court of the Este', in M. Pade, L. Waage Patersen, D. Quarta, ed., *La corte di Ferrara e il suo mecenatismo, 1441–1598*, Copenhagen and Modena 1990, pp. 71–91; L. Puppi, 'Umanesimo e cortesia nell'arte di Pisanello', in Puppi 1996, pp. 9–41, esp. p. 9.

45. M. Ricci, 'Il libro e il monumento; miniature ed iscrizioni per la gloria degli estensi', in R. Iotti, ed., *Gli Estensi*, I, *La corte di Ferrara*, Modena 1997, pp. 232–77, esp. p. 234.

46. For Suetonius see E. Pellegrin, *La Bibliothèque des Visconti et des Sforza, ducs de Milan, au XVe siècle*, Paris 1955, p. 389. For Caesar see C. Frati, 'Il volgarizzamento dei *Commentarii* di G. Cesare fatto da P.C. Decembro, *Archivium Romanicum*, V, 1921, pp. 74–8; E. Ditt, 'Pier Candido Decembro: contributo alla storia dell'Umanesimo italiano', *Memorie del Reale Istituto Lombardo di Scienze e Lettere*, IX, 1931, pp. 21–106, esp. pp. 73–4, 84.

47. A. Cappelli, 'La biblioteca Estense nella prima metà del secolo XV', *Giornale storico della letteratura italiana*, XIV, 1886, pp. 1–30 ,esp. pp. 12–30; Bolgar 1971, p. 529.

48. V. Zaccaria, 'Pier Candido Decembro, traduttore della Repubblica di Platone (Notizie dall'epistolario del Decembrio)', *Italia medioevale e umanistica*, II, 1959, pp. 179–206, esp. p. 195.

49. N. Caccia, *Luciano nel Quattrocento in Italia: le rappresentazioni e le figurazioni*, Florence 1907, p. 77; D. Cast, 'Aurispa, Petrarch, and Lucian: An Aspect of Renaissance Translation', *Renaissance Quarterly*, XXVII, 1974, pp. 157–73; E. Mattioli, *Luciano e l'Umanesimo*, Naples 1980, p. 58; A. Battini, 'La cultura a corte nei secoli XV e XVI attraverso i libri dedicati', in Iotti 1997, pp. 279–345, esp. p. 285.

50. V. R. Giustiniani, 'Sulle traduzioni latine delle *Vite* di Plutarcho nel Quattrocento', *Rinascimento*, ser. II, I, 1961, pp. 3–62; M. Pade, 'The Dedicatory Letter as Genre: the Prefaces of Guarino Veronese's Translations of Plutarch', in A. Dalzell et al., ed., *Acta Conventus Neo-Latini Torontonensis: Proceedings of the Seventh International Congress of Neo-Latin Studies*, Binghamton NY, 1991, pp. 559–68; ead., 'The Latin Translations of Plutarch's Lives in Fifteenth-Century Italy and their Diffusion', in C. Leonardi, B. Munk Olsen, ed., *The Classical Tradition in the Middle Ages and the Renaissance. Proceedings of the First European Science Foundation Workshop on 'The Reception of Classical Texts', Florence, Certosa del Galluzzo … 1992*, Florence 1995, pp. 169–83.

51. Pardi 1904, pp. 173–7; Battini in Iotti 1997, pp. 279–345, esp. pp. 286, 288.

52. Ambrogio Traversari, *Latinae Epistolae*, II, 1759, col. 418–19, lib. VIII, ep. 50; Bolgar 1971, p. 468.

53. Arrian, *Anabasis*, I, XVI, 14; C. Marchiori, *Bartolomeo Facio tra letteratura e vita*, Milan 1971, p. 105.

54. Cordellier 1995, pp. 36–42, doc. 10.

55. Suetonius, I,VII (the deified Julius); II, XVIII (the deified Augustus).

56. Ambrogio Traversari, *Latinae Epistolae*, II, 1759, col. 422–3, lib. XXIV, ep. 53; Bolgar 1971, p. 471.

57. Diodorus Siculus, *Historia*, XXXVII, XXI, 3; XL.4.

58. A. Tissoni Benvenuti, 'L'antico a corte: da Guarino a Boiardo', in M. Bertozzi, ed., *Alla corte degli Estensi: filosofia, arte e cultura a Ferrara nei secoli XV e XVI*, Ferrara 1994, pp. 389–404, esp. p. 402 note 15.

59. Baxandall 1971, pp. 128–9; G. Mariani Canova, 'La personalità di Vittorino da Feltre nel rapporto con le arti visive e il tema dell'educazione nel linguaggio figurativo del Quattrocento', in Giannetto 1981, pp. 199–212, esp. pp. 206–7; Müller 1984, p. 203.

60. Baxandall 1971, pp. 128–9.

61. Baxandall 1971, pp. 124–5.

62. P. D'Ancona, 'Gli affreschi del Castello di Manta nel Saluzzese', *L'Arte*, VIII, 1905, pp. 94–106; A. Griseri, *Jacquerio e il realismo gotico in Piemonte*, Turin 1966, pp. 61–70; M.M. Donato, 'Gli eroi romani fra storia ed 'exemplum': i primi cicli umanistici di Uomini famosi', in Settis 1985, pp. 97–152, esp. pp. 98, 111; C. Robotti, '"Moda e costume" al castello della Manta', *Bollettino della Società Piemontese di archeologia e belle arti*, N.S., XLII, 1988, pp. 39–56.

63. R. Varese, *Trecento ferrarese*, Milan 1976, pp. 49–51; D. Benati, 'Pittura tardogotica nei domini estensi', in D. Benati, ed., *Il tempo di Nicolò III: Gli affreschi del Castello di Vignola e la pittura tardogotica nei domini estensi*, exh. cat., Vignola 1988, pp. 43–59, esp. pp. 44–7, 58 notes 2, 4.

64. G. Orlandi, 'Intorno alla vita e alle opere di Pietro Andrea de' Bassi', *Giornale storico della letteratura iltaliana*, LXXXIII, 1926, pp. 285–320; A. Tissoni Benvenuti, 'Il mito di Ercole: aspetti della ricezione dell'antico alla corte estense nel primo Quattrocento', in *Omaggio a Gianfranco Folena*, Padua 1993, pp. 773–92; ead., 'L'antico a corte: da Guarino a Boiardo', in Bertozzi 1994, pp. 389–404.

65. A.S. Cavallo, 'Seeking a Context for the Amazons Tapestry in the Isabella Stewart Gardner Museum, Boston', *Bulletin de Liaison du Centre Internationale d'Etude des Textiles Anciens*, nos. 59–60, I–II, 1984, pp. 27–35, esp. pp. 27–32; id., *Textiles. Isabella Stewart Gardner Museum*, Boston 1986, pp. 20–5; N. Forti Grazzini, 'Leonello d'Este nell'autunno del Medioevo: gli arazzi delle "storie di Ercole"', in *Le muse* (Milan) 1991, *Saggi*, pp. 53–62. A second tapestry, now in the Gardner Museum, Boston, has also been shown to be identical with one purchased by Leonello.

66. Sabbadini 1915–19, III, 1919, p. 294–5, doc. 611.

67. Tissoni Benvenuti in Bertozzi 1994, pp. 389–404, esp. p. 395.

68. J. Pope-Hennessy, *The Portrait in The Renaissance*, Washington, D.C., 1966, pp. 35–7.

69. C. Sterling, 'La peinture de portrait à la cour de Bourgogne au début du XVe siècle', *Critica d'arte*, VI, 1959, pp. 289–312; L. Campbell, *Renaissance Portraits: European Portrait-Painting in the 14th, 15th and 16th Centuries*, New Haven and London 1990, pp. 81, 254–5 note 11.

70. M. Meiss, *French Painting in the Time of Jean de Berry*, I, *The Late Fourteenth Century and the Patronage of the Duke*, London 1967, 2 vols, I, pp. 73–4, II (Plates), fig. 512. Other such rings are recorded in inventories.

71. E. Panofsky, *Early Netherlandish Painting: its Origin and Character*, Cambridge MA 1953, pp. 82, 171; J.O. Hand and M. Wolff, *Early Netherlandish Painting: the Collections of the National Gallery of Art*, Washington, D.C., 1986, pp. 90–7. The picture has recently been reattributed to Niccolò di Pietro, a suggestion that is unlikely to gain much acceptance; see M. Boskovits, 'Le milieu du jeune Pisanello: quelques problèmes d'attribution', in Cordellier-Py 1998, I, pp. 85–120, esp. p. 87.

72. Fossi Todorow 1966, pp. 58–9, 154, nos. 4, 265; Cordellier in *Pisanello* (Paris) 1996, pp. 98–9, 104, cat. 49–50; A. Schmitt, 'Pisanello et l'art du portrait', in Cordellier-Py 1998, I, pp. 337–75, esp. pp. 338–43.

73. For the lost portrait of Francesco Sforza see G. Peretti, 'Pisanello à Marmirolo: un document inédit', in Cordellier-Py 1998, I, pp. 29–41, esp. pp. 35, 40. See Cordellier 1995, pp. 134–40, doc. 61 for Basinio da Parma's list of portraits executed by Pisanello. Some of those mentioned may be medals (although it is to Pisanello as a painter that Basinio appears to direct his praise). Others which do not survive as medals must surely have been painted – these include the humanists Guarino, Giovanni Aurispa, Porcellio (who himself states that Pisanello made a medal of him: see Cordellier 1995, p. 145–7, doc. 64), a 'Girolamo' (Girolamo Guarini or Girolamo Castelli?) and a 'Toscanella' (perhaps Giovanni Toscanella of Milan). Carlo Gonzaga is the only one of a list of rulers and *condottieri*, including Sigismondo Pandolfo Malatesta (if Basinio's 'Sismunde' is not the emperor Sigismund, which seems unlikely), Filippo Maria Visconti, Francesco Sforza and Niccolò Piccinino, whose image by Pisanello does not survive in any form. Given that a painted portrait of Francesco Sforza is now documented and that Pisanello portrayed Leonello d'Este (also mentioned by Basinio) in both painted and medallic portraits, it is possible that Basinio knew painted portraits of all the men – there are no women – he listed.

74. See, for example, L. Cheles, 'Il ritratto di corte a Ferrara e nelle altre corti centro-settentrionali', in *Le muse* (Milan) 1991, *Saggi*, pp. 13–24, esp. p. 16; T. Franco, 'Dipinti autografi', in Puppi 1996, pp. 90–2, no. 7.

75. For identification as Ginevra see, for example, G. F. Hill, 'Pisanello's Portrait of A Princess', *Burlington Magazine*, v, 1904, pp. 408–13.

76. Cordellier, *La princesse au brin de genevrier*, Paris 1996, p. 34.

77. F. Toniolo in *Le muse* (Milan) 1991, *Catalogo*, pp. 49–58, cat. 1.

78. K. Lippincott, '"Un Gran Pelago": the Impresa and the Medal Reverse in Fifteenth-Century Italy', in S.K. Scher, ed., *Perspectives on the Renaissance Medal*, New York and London 2000, pp. 75–96, esp. p. 78.

79. A. De Marchi, 'Meteore in Lombardia: Gentile da Fabriano a Pavia, Pisanello a Mantova, Masolino e Vecchietta a Castiglione d'Olona', in *La pittura in Lombardia. Il Quattrocento*, Milan 1993, pp. 289–314, esp. p. 297.

80. M. Levi D'Ancona, *The Garden of the Renaissance: Botanical Symbolism in Italian Painting*, Florence 1977, pp. 23–5; A. Schmitt, 'Höfische Werke Pisanellos', in Degenhart-Schmitt 1996, pp. 195–228, esp. p. 226.

81. Cordellier, *La princesse au brin de genevrier*, 1996, p. 13.

82. G. Cimarosti, 'Le lettere di Vittorino da Feltre: le testimonianze dei contemporanei', in *Vittorino da Feltre: Quaderni di 'Paedagogium'*, Brescia 1947, pp. 45–85, esp. p. 79 note 94.

83. F. Rossi in *Pisanello* (Paris) 1996, pp. 393–5, cat. 265; T. Franco, 'Dipinti autografi', in Puppi 1996, pp. 92–4, no. 8.

84. Cordellier 1995, pp. 96–100, doc. 38.

85. N. Grammacini, 'Wie Jacopo Bellini Pisanello Besiegte: Der Ferrareser Wettwerb von 1441', *Idea: Jahrbuch der Hamburger Kunsthalle*, I, 1982, pp. 27–53; M. Warnke, *The Court Artist: On the Ancestry of the Modern Artist*, Cambridge 1993, p. 94 and note 60.

86. Pliny, *Natural History*, XXXV, 72 (for competition between Zeuxis and Parrhasius), 86 (for competition between Parrhasius and Timanthes).

87. C. Eisler, *The Genius of Jacopo Bellini: Complete Paintings and Drawings*, New York, 1989, pp. 31, 531.

88. J. Manfasani, *George of Trebizond: a Biography and a Study of Rhetoric and Logic*, Leyden 1976, p. 31.

89. Baxandall 1971, p. 17; Cordellier 1995, pp. 120–2, doc. 52.

90. Louvre inv. 2322, 2309; Cordellier in *Pisanello* (Paris) 1996, pp. 380–1, cat. 256, 258.

91. Pliny, *Natural History*, XXXV, 151.

92. Leon Battista Alberti, ed. and trans. C. Grayson, *On Painting and On Sculpture: the Latin texts of* De Pictura *and* De Statua, London 1972, pp. 60–1. See also id., ed. L. Malle, *Della Pittura*, Florence 1950, p. 76; id., trans. with intro. and notes J.R. Spencer, *On Painting*, rev. edn, New Haven and London 1966, p. 118 note 1, where Spencer shows Alberti's statement on friendship to derive from Cicero, *De amicitia*, VII, 23.

93. Cordellier 1995, pp. 112–16, doc. 48.

94. Cordellier 1995, pp. 145–7, doc. 64.

95. Alberti, ed. Grayson, pp. 60–1; see also id., ed. Malle, p. 76.

96. Cordellier 1995, pp. 170–71, doc. 78.

97. Alberti, ed. Grayson, pp. 78–80. See also id., ed. Malle, p. 93.

98. Corradini, 'Medallic Portraits …', in Mann and Syson 1998, p. 25.

99. Baxandall 1971, pp. 102–4.

100. Ambrogio Traversari, *Latinae Epistolae*, 1759, II, lib. VIII, col. 417, ep. 48.

101. G.P. Marchi, 'Martino Rizzoni allievo di Guarino Veronese', *Atti e memorie dell'Accademia di Agricoltura, Scienze e Lettere di Verona*, ser. VI, XVII, 1965–6, pp. 324–5, esp. p. 319; id. 'Due corrispondenti Veronesi di Ciriaco d'Ancona', *Italia medioevale ed umanistica*, XI, 1968, pp. 317–23.

102. G. Voigt, *Die Wiederbelebung des classischen Alterthums oder das erste Jahrhundert des Humanismus*, 2 vols., I, Berlin 1881, p. 275; G.F. Hill, 'Classical Influence on the Renaissance Medal', *The Burlington Magazine*, XVIII, 1910–11, pp. 259–68, esp. p. 260.

103. B. Nogara, ed., *Scritti inediti e rari di Biondo Flavio*, Rome, 1927, p. 160; R. Weiss, *The Renaissance Discovery of Classical Antiquity*, Oxford 1969, p. 167 note 3.

104. E. Corradini in *Le muse* (Milan) 1991, *Catalogo*, pp. 86–90, cat. 15.

105. It is tempting to wonder if the author of this last (Ambrosiana inv. F.214 inf. 5) might not be one of the illuminators: see Fossi Todorow 1966, p. 127, no. 180; Cordellier in *Pisanello* (Paris) 1996, pp. 118–19, cat. 61.

106. Louvre 2315 recto: Fossi Todorow 1966, p. 157, no. 279: Cordellier in *Pisanello* (Paris) 1996, pp. 287–9, cat. 186.

107. See G. Fogolari, 'Un manoscritto perduto della Biblioteca di Torino', *L'arte*, VII, 1904, pp. 159–61; followed by B. Degenhart, 'Ludovico II. Gonzaga in einer Miniatur Pisanellos', *Pantheon*, XXX, 1972, pp. 193–210; G. Paccagnini, *Pisanello alla corte dei Gonzaga*, exh. cat., Palazzo Ducale, Mantua, 1972, . 107, cat. 61 and others.

108. See D. Ekserdjian, 'Parmigianino and the Antique', *Apollo*, CLIV, no. 473, July 2001, pp. 42–50, esp. pp. 46, 48, figs. 14, 15 for the identification of the source of the Hercules image.

109. Cordellier 1995, pp. 160–2, doc. 74.

110. M. Salmi, 'La "Divi Julii Caesaris Effigies" del Pisanello', *Commentari*, VIII, 1957, pp. 91–5. Salmi relates this lost work to the Caesar miniature in the first volume of the manuscript of Plutarch's *Vitae virorum illustrium* in the Biblioteca Malatestiana (see p. 211 and fig. 5.24 in this volume).

111. B. Nogara, ed., *Scritti inediti e rari di Biondo Flavio*, Rome 1927, pp. 159–60.

112. J. Raby, 'Pride and Prejudice: Mehmed the Conqueror and the Italian Portrait Medal', in J. G. Pollard, ed., *Italian Medals* (Studies in the History of Art 21), Washington, D.C., 1987, pp. 171–94, esp. pp. 187–8.

113. Pliny, *Natural History*, XXXV, 6. For bronze portraits in libraries see XXXV, 9.

114. Ibid., XXIV, 1, 6, 63.

115. Hill 1930, p. 3, nos. 1–4.

116. This piece was erroneously attributed to Pisanello by A. Venturi, ed., *Le Vite de' più eccellenti pittori, scultori e architetti, scritte da Giorgio Vasari*, I, *Gentile da Fabriano e il Pisanello*, Florence 1896, p. 73. It was first attributed to Alberti by A. Heiss, *Les Medailleurs de la Renaissance: Leon-Baptiste Alberti, Matteo de' Pasti*, Paris 1883, p. 14, no. 1. See later G.F. Hill, *Pisanello*, London 1905, pp. 192–3; K. Badt, 'Drei plastische Arbeiten von Leone Battista Alberti', *Mitteilungen des Kunsthistorischen Institutes in Florenz*, VIII, October 1957– May 1959, pp. 78–87; Pope-Hennessy 1966, pp. 66–9; U. Middeldorf, 'On the Dilettante Sculptor', *Apollo*, CVII, 1978, pp. 310–22, esp. p. 314; S. Danesi Squarzina, 'Eclisse del gusto cortese e nascita della cultura antiquaria: Ciriaco, Feliciano, Marcanova, Alberti', in *Da Pisanello* (Rome) 1988, pp. 27–35, esp. pp. 32–4. Most recent bibliography includes D. Lewis, 'Leon Battista Alberti: Self-Portrait in the Roman Style', in S.K. Scher, ed., *The Currency of Fame: Portrait Medals of the Renaissance*, exh. cat., National Gallery of Art, Washington, D.C., Frick Collection, New York, 1994, pp. 41–3, 375–6, cat. 3; L. Syson, 'Alberti e la ritrattistica', in J. Rykwert, A. Engel, ed., *Leon Battista Alberti*, exh. cat., Palazzo Tè, Mantua, 1994, pp. 46–53, esp. p. 49; J. Woods-Marsden, *Renaissance Self-Portraiture: The Visual Construction of Identity and the Social Status of the Artist*, New Haven and London 1998, pp. 71–7.

117. M.G. Trenti Antonelli, 'Il ruolo della medaglia nella cultura umanistica', in *Le muse* (Milan) 1991, *Saggi*, pp. 25–35, esp. pp. 25–8; S.K. Scher in *The Currency of Fame* 1994, p. 46, under cat. 4, 4a.

118. M. Righetti Tosti-Croce, 'Pisanello a S. Giovanni in Laterano', in *Da Pisanello* (Rome) 1988, pp. 107–8.

119. Hill 1930, p. 8, no. 23; de Turckheim-Pey in *Pisanello* (Paris) 1996, p. 215, cat. 128; Rugolo in Puppi 1996, p. 147, no. 3.

120. J. Gelli, *Motti, devise, imprese di famiglie e personaggi italiane*, Milan 1916; G. Gerola, 'Vecchie insegne di Casa Gonzaga', *Archivio Storico Lombardo*, ser. V, 1918, pp. 98–110; M. Pastoureau, *Couleurs, images, symboles: études d'histoire et d'anthropologie*, Paris 1990, pp. 141–46; K. Lippincott, 'The Genesis and Significance of the Fifteenth-Century Italian *Impresa*', in Sidney Anglo, ed., *Chivalry in the Renaissance*, San Francisco 1990, pp. 49–76; ead. in Scher 2000, pp. 75–96.

121. Leon Battista Alberti, ed. C. Grayson, J.-Y. Boriaud, F. Furlan, *De equo animante*, in *Albertiana*, II, 1999, pp. 191–235; A. Grafton, *Leon Battista Alberti: Master Builder of the Italian Renaissance*, London 2000, pp. 189–91.

122. C.M. Rosenberg, *The Este Monuments and Urban Development in Renaissance Ferrara*, Cambridge 1997, pp. 68–74.

123. Hill 1930, pp. 10–11, no. 36; S de Turckheim-Pey in *Pisanello* (Paris) 1996, p. 399, cat. 275; D. Gasparotto in *Pisanello* (Verona) 1996, p. 393, cat. 89; R. Rugolo, 'Medaglie', in Puppi 1996, pp. 168–9, no. 14; L. Syson, '*Opus pisani pictoris*: les médailles de Pisanello et son atelier', in Cordellier-Py 1998, I, pp. 391–2.

124. Hill 1930, p. 7, no. 19; de Turckheim-Pey in *Pisanello* (Paris) 1996, pp. 209–10, cat. 119; Gasparotto in *Pisanello* (Verona) 1996, pp. 366–7, cat. 77; Rugolo in Puppi 1996, pp. 144–6; Syson in Cordellier-Py 1998, I, pp. 379–426, esp. pp. 389–90.

125. J. von Schlosser, 'Die ältesten Medaillen und die Antike', *Jahrbuch der Kunsthistorischen Sammlungen des allerhöchsten Kaiserhauses*, XVIII, 1897, pp. 64–108; M. Jones, 'The First Cast Medals and the Limbourgs: the Iconography and Attribution of the Constantine and Heraclius Medals', *Art History*, II, 1979, pp. 35–44; S.K. Scher in *The Currency of Fame* 1994, pp. 41–3, 375–6, cat. 3; L. Jardine and J. Brotton, *Global Interests: Renaissance Art between East and West*, Ithaca NY 2000, pp. 23–4 .

126. G. Bertoni and E.P. Vicini, *Il castello di Ferrara ai tempi di Niccolò III: documenti e studi pubblicati per cura della Deputazione di Storia patria per le Provincie di Romagna*, III, Bologna 1909, p. 92, nos. 1650–1.

127. Jones 1979, pp. 35–44.

128. Hill 1930, p. 8, no. 21; de Turckheim-Pey in *Pisanello* (Paris) 1996, p. 215, cat. 127; Gasparotto in *Pisanello* (Verona) 1996, pp. 378–9, cat. 82; Rugolo in Puppi 1996, pp. 138–43, no.1.

129. M. Borsa, 'Pier Candido Decembrio e l'Umanesimo in Lombardia', *Archivio Storico Lombardo*, XX, 1893, pp. 5–75, 358–441. For the biography see Pier Candido Decembrio, *Opuscula historica*, ed. A. Butti, F. Fossati, G. Petraglione, *Rerum italicarum scriptores*, Bologna 1925–35, XX.1.

130. Hill 1930, p. 11, no. 37; Scher in *The Currency of Fame* 1994, pp. 52–3, cat. 7; de Turckheim-Pey in *Pisanello* (Paris) 1996, p. 407, cat. 285; Gasparotto in *Pisanello* (Verona) 1996, pp. 396–7, cat. 91; Rugolo in Puppi 1996, pp. 170–3, no. 16.

131. R. Signorini, ed., *In traccia del 'Magister Pelicanus'*, exh. cat., Commune di Mantova, Mantua, 1979, pp. 15–18. Interestingly, in the light of the discussion of meaning of juniper above, she entered the convent crowned by the plant.

132. See, for example, Giorgio Correr, 'Letter to the Virgin Cecilia Gonzaga, on fleeing this worldly life', in M. L King, A. Rabil, ed. and trans., *In Her Immaculate Hand: Selected works by and about Woman Humanists of Quattrocento Italy*, Binghamton NY 1983, pp. 91–105.

133. Louvre inv. RF 519 recto: Fossi Todorow 1966, pp. 85, no. 67; Cordellier in *Pisanello* (Paris) 1995, pp. 126–7, cat. 70.

134. The literature on the unicorn is somewhat eccentric, but see O. Shepard, *The Lore of the Unicorn*, London and New York 1930, pp. 46, 48, 70, 283 note 1; J.W. Einhorn, *Spiritalis Unicornis. Das Einhorn als Bedeutungsträger in Literatur und Kunst des Mittelalters*, Munich 1976, pp. 29, 182; L. Gotfredsen, *The Unicorn*, New York 1999, pp. 32–7, 129. The association between the Virgin Mary and the Unicorn is still more explicit in a piece of *verre eglomisé* (Paris, Musée Cluny inv. 130393) showing a Virgin and Child with a virgin with a unicorn in the gable above, probably Paduan, late 14th century.

135. N. Himmelmann, 'Nudità ideale', in Settis 1985, pp. 201–78, esp. p. 262. That the moon may itself be a Marian symbol is suggested by the link between the moon (though usually the full moon) and the Virgin iterated by Saint Bonaventure (1221–1274). See, for example, *Mirror of the Blessed Virgin Mary*, chapter 7: '… that moon, I say, of which it is said in the Canticle of Canticles: "Fair as the moon". This moon, therefore, is Mary. The full moon is Mary full of grace ….' See also fig. 4.30.

136. Hill 1930, p. 11, no. 39; de Turckheim-Pey in *Pisanello* (Paris) 1996, pp. 406, cat. 283; Rugolo in Puppi 1996, pp. 174–5, no. 18.

137. Hill 1905, p. 178.

138. Rugolo in Puppi 1996, pp. 174–5, no. 18.

139. Cordellier 1995, pp. 147–48, doc. 65. See Hill 1930, pp. 11–12, no. 40; de Turckheim-Pey in *Pisanello* (Paris) 1996, p. 406, cat. 282; Rugolo in Puppi 1996, pp. 176–7, no. 19.

140. Hill 1930, p. 11, no. 38; de Turckheim-Pey in *Pisanello* (Paris) 1996, pp. 404–5, cat. 279–80; Rugolo in Puppi 1996, pp. 173–4, no. 17.

141. Cordellier 1995, pp. 134–40, doc. 61.

142. Cordellier 1995, pp. 174–6, doc. 81.

143. For the appearance of the symbol in a fresco of the Crucifixion in the chapel in the Palazzo Ducale at Mantua, for example, see G. Paccagnini, *Pisanello alla corte dei Gonzaga*, exh. cat., Palazzo Ducale, Mantua, 1972, pp. 38–40. For the pelican pendant see G. H. Tait, *Seven Thousand Years of Jewellery*, London 1986, p. 140, no. 325.

144. Louvre 2398: Fossi Todorow 1966, p. 134, no. 196; Cordellier in *Pisanello* (Paris) 1996, p. 177, cat. 95.

145. Florence, Biblioteca Laurenziana, Plut. 55, 21; see R. Signorini, *In traccia del 'Magister Pelicanus'* 1979, p. 74.

146. For the medal see Hill 1930, p. 8, no. 23; de Turckheim-Pey in *Pisanello* (Paris) 1996, p. 215, cat. 128; Gasparotto in *Pisanello* (Verona) 1996, pp. 380–1, cat. 83; Rugolo in Puppi 1996, p. 147, no. 3. For the link with the coin see C.C. Vermeule III, 'Graeco-Roman Asia Minor to Renaissance Italy: Medallic and Related Arts', in Pollard 1987, pp. 263–81, esp. pp. 271–2.

147. M.H. Crawford, *Roman Republican Coinage*, II, Cambridge 1974, no. 25/1–3, pl. I, figs. 12–14.

148. For the medal see Hill 1930, p. 8, no. 22; de Turckheim-Pey in *Pisanello* (Paris) 1996, pp. 212–13, cat. 123; Rugolo in Puppi 1996, pp. 160–2, no. 10. For the coin see Crawford 1974, no. 20/1, pl. I, fig. 8. For Braccio da Montone see D. Waley, 'I mercenari e la guerra nell'età di Braccio da Montone', in M.V. Baruti Ceccopieri, ed., *Braccio da Montone e i Fortebracci: Atti del convegno internazionale di studi, Montone 23–25 1990*, Narni 1993, pp. 111–28; C. Regni, 'Il conte di Montone e Perugia: una Signoria annunciata', ibid., pp. 129–46.

149. For the column/sail reverse, see Hill 1930, p. 9, nos. 25–6; de Turckheim-Pey in *Pisanello* (Paris) 1996, p. 392, cat. 263; Gasparotto in *Pisanello* (Verona) 1996, p. 383, cat. 84; Rugolo in Puppi 1996, pp. 150–1, no. 5. For the two men with baskets reverse, see Hill 1930, p. 9, no. 27; de Turckheim-Pey in *Pisanello* (Paris) 1996, pp. 392–3, cat. 264; Gasparotto in *Pisanello* (Verona) 1996, p. 384, cat. 85; Rugolo in Puppi 1996, pp. 148–9, no. 4 (although only the obverse is illustrated, and even this is not the right medal).

150. Hill 1930, p. 8, no. 23; de Turckheim-Pey in *Pisanello* (Paris) 1996, pp. 383, 392, cat. 261–2; Rugolo in Puppi 1996, pp. 151–3, no. 60.

151. A. Franceschini, *Artisti a Ferrara in età umanistica e rinascimentale: testimonianze archivistiche*, I, Ferrara and Rome 1993, p. 172, doc. 404d (22 April 1435). This early use and its appearance in the border of a wall-painting at Schifanoia (see R. Varese, ed., *Atlante di Schifanoia*, Modena 1989, p. 167) suggest that this image may not have been invented by Pisanello.

152. See J. Gill, *The Council of Florence*, Cambridge 1959, pp. 227–69: a connection made by Rugolo in Puppi 1996, p. 153, no. 6. For the use of the three-faced putto image to stand for the Trinity, see *The Vision of Saint Augustine* in the Hermitage, St. Petersberg, by Fra Filippo Lippi (who also used it elsewhere) and his shop, for which see D. Gordon, 'The "Missing" Predella Panel from Pesellino's Trinity Altarpiece', *Burlington Magazine*, LXXXVIII, 1996, pp. 87–8, fig. 24.

153. C. Cieri Via, 'Cultura antiquariale e linguaggio simbolico in alcune medaglie del Pisanello', in *Da Pisanello* (Rome) 1988, pp. 109–13, esp. p. 111.

154. Lippincott in Scher 2000, pp. 75–96, esp p. 79.

155. See also medal by Amadio da Milano: Hill 1930, p. 20, no. 68. It remained in use throughout Leonello's marquisate. See for example its use in a window in 1448: Franceschini 1993, p. 308, doc. 60600.

156. C. Nordenfalk, 'Les cinq sens dans l'art du Moyen-âge', *Revue de l'art*, XXXIV, 1976, pp. 17–28; Lippincott in Scher 2000, pp. 75–96, esp. p. 80.

157. Hill 1930, p. 10, no. 32; de Turckheim-Pey in *Pisanello* (Paris) 1996, pp. 397–8, cat. 272–3; Gasparotto in *Pisanello* (Verona) 1996, pp. 386–7, cat. 87; Rugolo in Puppi 1996, pp. 157–9, no. 9.

158. Leonello's two surviving works were copied from a now lost manuscript containing many more. See E. Gardner, *Dukes and Poets in Ferrara*, London 1904, p. 53; L. Lockwood, *Music at Renaissance Ferrara: the Creation of a Musical Centre in the Fifteenth Century*, Oxford 1984, pp. 47 note 1, 74 note 1; S. Campbell, *Cosmè Tura of Ferrara: Style, Politics and the*

Renaissance City, 1450–1495, New Haven and London 1997, pp. 46–7.

159. Lockwood 1984, pp. 41–85, esp. pp. 46–7, 65, 71.

160. Hill 1930, p. 38, no. 158; A. Luchs in *The Currency of Fame* 1994, pp. 59–62, cat. 11, 11a.

161. E. Pontieri, *Alfonso il Magnanimo, re di Napoli (1435–1458)*, Naples 1975; A. Ryder, *The Kingdom of Naples under Alfonso the Magnanimous*, Oxford 1976; id., *Alfonso the Magnanimous: King of Aragon, Naples and Sicily, 1396–1458*, Oxford 1990.

162. E. R. Driscoll, 'Alfonso of Aragon as a Patron of Art: Some Reflections on the Decoration and Design of the Triumphal Arch of the Castel Nuovo in Naples', in L. F. Sandler, ed., *Essays in Memory of Karl Lehmann*, New York 1964, pp. 87–96; J. Woods-Marsden, 'Art and Political Identity in Fifteenth-Century Naples: Pisanello, Cristoforo di Geremia and King Alfonso's Imperial Fantasies', in C. M. Rosenberg, ed., *Art and Politics in Late Medieval and Early Renaissance Italy, 1250–1500*, Notre Dame and London 1990, pp. 11–37.

163. Marqués de Santillana, *Comedieta de Ponza, sonetos, serranillas y otras obras*, ed. R. Rohland de Langbehn, V. Beltràn, Barcelona 1997, pp. 137–84, esp. p. 143 (XXV); E. Sáez, 'Semblanza de Alfonso el Magnánimo', in *Estudios sobre Alfonso el Magnánimo*, Barcelona 1960, pp. 27–41, esp. p. 34. For the poem see P. M. Barreda-Thomas, 'Un análisis de la *Comedieta de Ponza*', *Boletín de Filología*, XXI, 1970, pp. 175–91.

164. B. Nogara, ed., *Scritti inediti e rari di Biondo Flavio*, Rome 1927, pp. 147–53, esp. pp. 150–3; J. Bentley, *Politics and Culture in Renaissance Naples*, Princeton NJ 1987, p. 47.

165. M. Ballesteros-Gaibrios, 'Alfonso V, amante de los libros', *Annales del Centro de Cultura Valenciana*, VI, 1945, pp. 61–73; T. de Marinis, *La biblioteca napoletana dei Re d'Aragona*, 4 vols., Milan 1947–52.

166. Bentley 1987, p. 94.

167. For humanism at Alfonso's court see J. Ametller y Vinyas, *Alfonso V de Aragón en Italia y la crisis religiosa del siglo XV*, 3 vols., Gerona 1903–28, II, 1903, pp. 105–30; A. Soria, *Los humanistas de la corte de Alfonso el Magnánimo*, Granada 1956; E. I. Rao, 'Alfonso of Aragon and the Italian Humanists', *Esperienze letterarie*, IV, 1979, pp. 43–57; Bentley 1987, passim. For the triumph see Hersey 1973, pp. 14–15.

168. A point made by A. Cole, *Art of the Italian Renaissance Courts: Virtue and Magnificence*, London 1995, p. 55.

169. G. L. Hersey, *The Aragonese Arch at Naples, 1443–1475*, New Haven and London 1973, p. 13; N. Patrone, *Príncipe y Mecenas: Alfonso V en los Dicos y hechos de A. Beccadelli*, New York 1995, pp. 49–80.

170. Bentley 1987, p. 229.

171. C. Minieri Riccio, 'Alcuni fatti di Alfonso I. di Aragona', *Archivio storico per le provincie napoletane*, VI, 1881, pp. 1–36, 231–58, 411–61, esp. p. 251; M. Catalano Tirrito, ed., *Nuovi documenti sul Panormita*, Catania 1910, pp. 182–9, 194–6, docs. VI, IX, XIII, XVI; Bentley 1987, pp. 87–8, 105, 115.

172. G. F. Hill, 'Classical Influence on the Renaissance Medal', *Burlington Magazine*, XVIII, 1910–11, pp. 259–68, esp. p. 260. According to Panormita, Alfonso carried around with him coins of 'illustrious emperors/ commanders'. He particularly prized coins of Julius

Caesar, rather than of Augustus as it is usually stated, an error for which Hill was responsible. The text runs as follows: '*Numismata illustrium imperatorum, sed Caesaris ante alios, per universam Italiam summo studio conquisita, in eburnea arcula, a rege, pene dixerim religionissime asservabantur. Quibus, quoniam alia eorum simulachra iam vetustate collapsa non extarent, mirum in modum sese delectari et quodammodo inflammari ad virtutem et gloriam inquiebat*'. See Panormita, *De dictis et factis*, II, 12.

173. Ryder 1976, p. 88.

174. C. Acidini Luchinat, 'La "santa antichità", la scuola, il giardino', in F. Borsi, ed., *'Per bellezza, per studio, per piacere': Lorenzo il Magnifico e gli spazi dell'arte*, Florence 1991, pp. 143–60, esp. p. 146 and note 21.

175. Ametller y Vinyas 1903–28, III, 1928, p. 2.

176. Hill 1930, p. 12, no. 41; de Turckheim-Pey in *Pisanello* (Paris) 1996, pp. 428–9, 435, cat. 300; Gasparotto in *Pisanello* (Verona) 1996, pp. 400–1, cat. 93; Rugolo in Puppi 1996, pp. 177–83, no. 20. Pisanello seems to have been made responsible for creating an easily repeatable portrait image of the king. His success can be measured by the various surviving images based on his medals: see, for example, E. Fahy in M. Natale, ed., *El Renacimiento Mediterraneo: viajes de artista e itinerarios de obras entre Italia, Francia y España en el siglo XV*, exh. cat., Museo Thyssen-Bornemisza, Madrid, Museu de Belles Arts de Valéncia, Valencia, 2001, pp. 527–9, cat. 90.

177. C. Brink, *Arte et Marte: Kriegskunst und Kunstliebe im Herrscherbild des 15. und 16. Jahrhunderts in Italien*, Munich and Berlin 2000, pp. 54–6, esp. note 164.

178. Patrone 1995, p. 64.

179. Suetonius, II.VII (the deified Augustus).

180. Hersey 1973, p. 28; S. Bertelli et al., *Italian Renaissance Courts*, London 1986, p. 47; J. Woods-Marsden, 'Visual Constructions of the Art of War: Images for Machiavelli's *Prince*', in Scher 2000, pp. 47–73, esp. p. 48.

181. L. Montalto, *La corte di Alfonso I di Aragona*, Naples 1922, p. 10.

182. Hill 1930, p. 12, no. 43; de Turckheim-Pey in *Pisanello* (Paris) 1996, p. 438, cat.303; Rugolo in Puppi 1996, pp. 187–8, no. 22.

183. Exodus 15:2; see also Psalm 118:14.

184. See Hill 1930, p. 13, no. 44; de Turckheim-Pey in *Pisanello* (Paris) 1996, p. 453, cat. 319; Gasparotto in *Pisanello* (Verona) 1996, pp. 410–11, cat. 98; Rugolo in Puppi 1996, pp. 188–90, no. 23.

185. Ryder 1976, pp. 169–70.

186. Homer, *Iliad*, XVIII, 478–613.

187. Virgil, *Aeneid*, VI, 797 ('the blazing star-studded sphere'); B. Bosworth, 'Augustus, The *Res gestae* and Hellenistic Theories of Apotheosis', *The Journal of Roman Studies*, LXXXIX, 1999, pp. 1–18, esp. pp. 2–4.

188. Scher in *The Currency of Fame* 1994, pp. 55–8, cat. 9, 9a.

189. de Turckheim-Pey in *Pisanello* (Paris) 1996, p. 453, cat. 319.

190. K. Barstow, *The Gualenghi-d'Este Hours: Art and Devotion in Renaissance Ferrara*, Los Angeles 2000, pp. 62–3.

191. P.P. Bober and R.L. Rubinstein, *Renaissance Artists and Antique Sculpture: A Handbook of Sources*, Oxford 1986, pp. 65–6, no. 21.

192. Staatliche Museen zu Berlin, Kupferstichkabinett, inv. KdZ 1358 recto: Fossi Todorow 1966, p. 122, no. 168; Anna Cavallaro in *Da Pisanello* (Rome) 1988, pp. 98–100, cat. 27; B. Blass-Simmen, 'Pisanellos Tätigkeit in Rome', in Degenhart-Schmitt 1995, pp. 92, 114.

193. Himmelmann in Settis 1985, pp. 201–78, esp. p. 262.

194. Staatliche Museen zu Berlin, Kupferstichkabinett, inv. 487 recto: Fossi Todorow 1966, p. 91, no. 81; Blass-Simmen in Degenhart-Schmitt 1995, pp. 94, 113–14.

195. Fitzwilliam inv. PD.124–1961: Fossi Todorow 1966, p. 79, no. 55.

196. Baxandall 1971, p. 127.

197. Alberti, ed. and trans. Grayson, pp. 100–1.

198. M. Fossi Todorow, 'Un taccuino di viaggi del Pisanello e della sua bottega', in F. M. Aliberti, *Scritti di storia dell'arte in onore di Mario Salmi*, 3 vols., 1959–63, II, Rome 1962, pp. 133–61; B. Degenhart, A. Schmitt, 'Gentile da Fabriano in Rom und die Anfänge des Antikestudiums', *Münchner Jahrbuch der Bildenden Kunst*, IX, 1960, pp. 59–151; A. Nesselrath, 'I libri di disegni di antichità: tentativo di una tipologia', in Settis 1985, pp. 89–147, esp. pp. 90–113; R.W. Scheller, trans. M. Hoyle, *Exemplum: Model-Book Drawings and the Practice of Artistic Transmission in the Middle Ages (ca. 900– ca. 1470)*, Amsterdam 1995, p. 345; Cordellier in *Pisanello* (Paris) 1996, pp. 465–7.

199. Ashmolean inv. P II 41 verso: Fossi Todorow 1966, p. 131, no. 190; Cordellier in *Pisanello* (Paris) 1996, pp. 182–4, cat. 102.

200. E. M. Moormann, *Ancient Sculpture in the Allard Pierson Museum, Amsterdam*, Amsterdam 2000, pp. 161–4, no. 221.

201. Ambrosiana inv. F.214 inf. 14 recto; Fossi Todorow 1966, pp. 129, no. 186; L. Scalabroni in *Da Pisanello* (Rome) 1988, p. 172, cat. 56.

202. Bober and Rubinstein 1986, p. 90, no. 52A.

203. Ambrosiana F.214 inf. 15; Fossi Todorow 1966, p. 130, no. 187; L. Scalabroni in *Da Pisanello* (Rome) 1988, p. 97, cat. 24; B. Blass-Simmen, 'Pisanellos Tätigkeit in Rome', in Degenhart-Schmitt 1995, pp. 88, 92.

204. Ambrosiana inv. F.214 inf. 10 verso: Fossi Todorow 1966, pp. 127–8, no. 182; A. Nesselrath, 'Simboli di Roma', in *Da Pisanello* (Rome) 1988, pp. 196–7, 211–12, cat. 61; Blass-Simmen in Degenhart-Schmitt 1995, p. 92; Cordellier in *Pisanello* (Paris) 1996, pp. 153–4, cat. 84.

205. Boymans Van Beuningen inv. I.523: Fossi Todorow 1966, p. 138, no. 204; A. Cavallaro in *Da Pisanello* (Rome) 1988, pp. 150, 152–3, cat. 44, 46; Blass-Simmen in Degenhart-Schmitt 1995, pp. 92, 108.

206. D. Lipton, *Francesco Squarcione*, Ann Arbor MI 1974, pp. 197–208; A. Schmitt, 'Francesco Squarcione als Zeichner und Stecher', *Münchner Jahrbuch der bildenden Kunst*, XXV, 1974, pp. 205–13; R. Lightbown, *Mantegna*, Oxford 1986, pp. 15–29; I. Favaretto, 'La raccolta di sculture antiche di Francesco Squarcione tra leggenda e realtà', in A. de Nicolò Salmazo, ed., *Francesco Squarcione: 'Pictorum gymnasiacha singularis'*, Padua 1999, pp. 233–44.

207. Louvre inv. 2315 verso; B. Degenhart, *Pisanello*, Vienna 1942, pp. 16, 34, 37, 68; Fossi Todorow 1966,

p. 157, no. 279; Cordellier in *Pisanello* (Paris) 1996, pp. 287–9, cat. 186.

208. A. Venturi, *La R. Galleria Estense in Modena*, Modena 1882, p. 81, fig. 29.

209. Pliny, *Natural History*, XXX, 58; proposed by Cordellier in *Pisanello* (Paris) 1996, p. 289, under cat. 186.

CHAPTER IV · DEVOTION, POETRY
AND PLEASURE: THE LONDON PANEL
PAINTINGS

1. For paintings by Pisanello which are now lost see M. Molteni, 'Dipinti perduti', in Puppi 1996, pp. 98–107.

2. D. Cordellier, in *Pisanello* (Paris) 1996, pp. 135–6, cat. 72, discusses what is almost certainly a design for an altarpiece by Pisanello on a sheet with studies of heads added by a member of his workshop.

3. S. Tumidei, 'Un tableau perdu de Pisanello pour l'empereur Sigismond', in Cordellier-Py 1998, I, pp. 17–27.

4. Cordellier 1995, pp. 50–2, doc. 16.

5. Although Pisanello is not named as the artist, there is no doubt that it is he who is being referred to. See Cordellier 1995, pp. 172–3, doc. 79.

6. There is no justification for attributing any part of this painting to Bono da Ferrara, as does F. d'Arcais, 'A proposito di Pisanello', *Arte Veneta*, XXXII, no. 1, 1998, p. 161.

7. See H. Trebbin, *Sankt Antonius: Geschichte, Kult und Kunst*, Frankfurt am Main 1994, p. 35; and W. Schouwink, *Der wilde Eber in Gottes Weinberg. Zur Darstellung des Schweins in Literatur und Kunst des Mittelalters*, Thorbecke 1985, p. 107–9.

8. See Cordellier in *Pisanello* (Paris) 1996, p. 225, cat. 133.

9. For a similar iconography – with the dragon below the saint's feet – see the fresco of around 1410 attributed to Michelino above the tomb of Giovanni Thiene in Santa Corona, Vicenza (G. Algeri, 'Per l'attività di Michelino da Besozzo in Veneto', *Arte Cristiana*, no. 718, 1987, pp. 17–82; illustrated in colour in F.A. Gaudioso, ed., *Pisanello. I luoghi del Gotico Internazionale nel Veneto*, Milan 1996, p. 152). For Saint George see G. Didi-Huberman, R. Garbetta, M. Morgaine, *Saint George et le dragon*, Paris 1994.

10. A. Gandini, 'Viaggi, cavalli, bardature e stalle degli estensi nel Quattrocento', *Atti e memorie della Reale Deputazione di Storia Patria per la Provincia di Romagna*, Bologna 1892, ser. III, x, p. 59. Hats made of straw lined with silk ('capelli di Fiandra') were particularly prized at beginning of century; see R. Levi Pisetzky, *Storia del costume in Italia*, II, Milan 1967, p. 359.

11. In 1451, Francesco Sforza, by then duke of Milan, ordered several hats both for himself and as gifts for Borso d'Este, for the bishop of Modena and for Sigismondo Pandolfo Malatesta of Rimini. Their descriptions are to be found in Cremonese account books: 'capello uno de paglia cum pene de paone chuperto de cendale crimisino adornato di frange et cordoni de oro et seda alla fuoza de quelli che porta il prefacto nostro S. che costarà circa lire 16', and 'fornimento de uno capello de paia finissimo fornito de cordele doro et de seta facte a stelle cum zendale sotto et in la testera fodrada de zendale' (Levi Pisetzky 1967, pp. 359–60). Antonio da Trezzo in the same year suggested that one of these lavish straw hats should be given by the duke to Pellegrino Pasini, the object of Borso's affection. See T. Tuohy, *Herculean Ferrara: Ercole d'Este, 1471–1505, and the Invention of a Ducal Capital*, Cambridge 1996, pp. 36–7.

12. The painting is on a single poplar plank with a vertical grain. The lip of raised gesso which survives on all four edges of the borders, and traces of gold on the left-hand barbe at the lower edge, indicate that the panel originally had a gilded frame. After this was removed, the borders were made up with modern gesso. The panel has been thinned to approximately 1.8 cm on the back, with a small rectangle left standing proud bearing the letters *CGB.C*, branded into the wood. This was the brand of the Costabili collection, a collection in Ferrara devoted largely to Ferrarese painting. It had been acquired from Pasetti collection (presumably in Ferrara) at an unknown date, but certainly before 1835, by Giovanni Battista Costabili Containi (1756–1841), whose collection passed to his nephew, G. Costabili (1815–1882). Sir Charles Eastlake, who saw it in that collection in 1858, bought it, had it restored and then sent it to England in 1862. It was presented to the National Gallery by Lady Eastlake in his memory after Eastlake's death in 1867. See also note 14 below.

13. Molteni described it as *'rovinato assai ma stupendo'* (very ruined but stupendous). He was so pleased with his work he considered changing his name to Vittore (then thought to be Pisanello's name; see note 1 on p. 237).

14. For a more detailed discussion of the condition see J. Dunkerton, 'L'état de restauration des deux Pisanello de la National Gallery de Londres', in Cordellier-Py 1998, II, pp. 659–81.

15. Fossi Todorow 1966, p. 138, no. 204; Degenhart-Schmitt 1995, pp. 97, 99, figs. 103, 105.

16. Cordellier in *Pisanello* (Paris) 1996, pp. 122–3, cat. 66.

17. Cordellier in *Pisanello* (Paris) 1996, p. 345, cat. 228; and the exhibition catalogue *Da Pisanello a Tiepolo. Disegni veneti dal Fitzwilliam Museum di Cambridge*, exh. cat., Fondazione Giorgio Cini, Venice, 1992, pp. 20–1, cat. 1.

18. Cordellier in *Pisanello* (Paris) 1996, p. 447, cat. 316.

19. Cordellier in *Pisanello* (Paris) 1996, pp. 216–7, 224, cat. 129–32.

20. S. de Turckheim-Pey in *Pisanello* (Paris) 1996, p. 215, cat. 128. The dating of 1441 is based on the title *Vicecomes* given on the medal to Francesco Sforza, and which he acquired on marrying Bianca Maria.

21. It has been considered to be a late work, in the 1440s, by G. M. Richter, 'Pisanello Studies – II', *Burlington Magazine*, LV, no. 318, 1929, p. 134; A. Venturi, *Pisanello*, Rome 1939, p. 289; B. Degenhart, *Pisanello*, Turin 1945, p. 53; A. Hentzen, *Die Vision des heiligen Eustachius*, Berlin 1948, p. 15; R. Brenzoni, *Pisanello*, Florence 1952, pp. 157–9; C. Tellini Perina, 'Considerazioni sul Pisanello. La monografia di Giovanni Paccagnini', *Civiltà Mantovana*, VI, 1972, p. 316; B. Degenhart, 'Pisanello in Mantua', *Pantheon*, XXXI, 1973, p. 410; id., 'Pisanello's Mantuaner Wandbilder', *Kunstchronik*, XXVI, 1973, p. 69; F. Bologna, *Napoli e le rotte mediterranee della pittura*, 1978, pp. 42, 44; L. Bellosi, 'The chronology of Pisanello's Mantuan frescoes reconsidered', *Burlington Magazine*, CXXXIV, no. 1075, 1992, p. 659 note 11; A. De Marchi, 'Meteore in Lombardia: Gentile da Fabriano a Pavia e a Brescia, Pisanello a Mantova, Masolino a Castiglione d'Olona', in *La Pittura in Lombardia. Il Quattrocento*, Milan 1993, p. 300. An early date for the painting has been argued by R. Van Marle, *The Development of the Italian Schools of Painting*, VIII, The Hague, 1927, p. 112; A. Schmitt, 'Die Frühzeit Pisanellos: Verona, Venedig, Pavia', in Degenhart-Schmitt 1995, p. 41.

22. M. Meiss, 'French and Italian Variations on an Early Fifteenth-Century Theme: St. Jerome and his Study', *Gazette des Beaux Arts*, LXII, 1963, pp. 164–5, 169 note 54. Meiss later suggested that Pisanello might himself have travelled to France (M. Meiss, *French Painting in the Time of Jean de Berry. The Limbourgs and their Contemporaries*, New York 1974, p. 247).

23. It was first noted by C. Glaser that the iconography of the drawing of the Virgin and Child (fig. 4.29) was related to the Virgin and Child in a Westphalian *Nativity* (C. Glaser, 'Italienische Bildmotive in der altdeutschen Malerei', *Zeitschrift für bildende Kunst*, 1914, p. 157). The French influence was more deeply explored by O. Pächt, 'The Limbourgs and Pisanello', *Gazette des Beaux Arts*, LXII, 1963, pp. 109–21.

24. R. Wieck et al., *Leaves of Gold: Manuscript Illumination from Philadelphia Collections*, exh. cat., ed. J.R. Tanis with J.A. Thompson, Philadelphia Museum of Art, Philadelphia, 2001, pp. 103–5, cat. 32, figs. 31, 32.

25. *Pisanello* (Paris) 1996, pp. 226–7, cat. 134; attributed by A. Schmitt, 'Bono da Ferrara', in Degenhart-Schmitt 1995, p. 237, fig. 257, to Bono da Ferrara (but see here chapter 5, pp. 202ff.).

26. Degenhart-Schmitt 1995, p. 228. This had first been suggested by J.A. Crowe and G.-B. Cavalcaselle, *A History of Painting in North Italy*, London 1871, I, p. 455. See also Cordellier in *Pisanello* (Paris) 1996, p. 226, cat. 133. For those who have accepted the identification and for the arguments against see Cordellier 1995, p. 51.

27. See Cordellier in *Pisanello* (Paris) 1996, p. 226, who pointed out that the profile was more aquiline.

28. For example, by R. Chiarelli, *L'opera completa del Pisanello*, Milan 1972, pp. 84, 99. For the payments see Cordellier 1995, pp. 122–4, docs. 53, 54, and commentary on p. 123. Leonello made him another payment on 8 January 1447 (p. 131, doc. 58) but it is not certainly connected with the commission. M. Natale in *Le muse* (Milan) 1991, *Catalogo*, p. 21 note 17, says that the identification is unlikely because of the small dimensions of the painting. See also Cordellier in *Pisanello* (Paris) 1996, p. 226.

29. D. Webb, *Patrons and Defenders: the Saints in the Italian City-States*, New York 1996, pp. 120, 139. Full attendance was required for Saint George – rural communities, doctors of studio and college of notaries were excused participation for Saints Dominic and Anthony.

30. Cordellier in *Pisanello* (Paris) 1996, p. 226.

31. D. Stichel in her review of Degenhart-Schmitt 1995, in *Zeitschrift für Kunstgeschichte*, LIX, 1996, p. 427.

32. B. Degenhart, 'Ludovico II. Gonzaga in einer Miniatur Pisanellos', *Pantheon*, XXX, Heft 3, 1972, pp. 200, 206.

33. G. Paccagnini, *Pisanello e il ciclo cavalleresco di Mantova*, Milan 1972, pp. 219–21, 247 note 22. See also Paccagnini in *Pisanello alla corte dei Gonzaga*, exh. cat., Palazzo Ducale, Mantua, 1972, p. 108.

34. Cordellier in *Pisanello* (Paris) 1996, pp. 124–5, cat. 68. De Marchi, 'Meteore …, in *La Pittura in Lombardia. Il Quattrocento* 1993, p. 296, fig. 318, titled the study a Madonna of Humility. See also T. Franco, 'Dipinti autografi', in Puppi 1996, p. 97.

35. See M. Meiss and E.W. Kirsch, *The Visconti Hours*, London 1972, p. 11; E.W. Kirsch, *Five Illuminated Manuscripts of Giangaleazzo Visconti*, University Park Pennsylvania and London 1991, p. 29.

36. See Kirsch 1991, p. 10 and note 52: '*juxta arcam beatissimi Antonii patroni sui*'.

37. For the radiant sun device (the '*raza*') see E.S. Welch, *Art and Authority in Renaissance Milan*, New Haven and London, 1995, pp. 7, 110, 112, 213, 226 (the last two pages show the *impresa* still being used by the Sforza).

38. Petri Candidi Decembrii, *Vita Philippi Mariae Tertij Ligurum Ducis*, ed. A. Butti, F. Fossati, G. Petraglioni, *Rerum italicarum scriptores*, XXI, Bologna 1925–35, pp. 406–7.

39. One of the key processions for the Sforza under duke Galeazzo Maria was the blessing of militia standards at the cathedral on the feast-day of Saint George in the 1470s: see Welch 1995, p. 197.

40. For example, Saints Anthony and George appear side by side to the left of the Virgin and Child in a polyptych, which also includes Saints Blaise and Martin, attributed to Battista da Vicenza, dated 1408, originally in the Velo family chapel dedicated to Saint Anthony in the church of San Giorgio in Velo d'Astico near Vicenza, decorated with a fresco of Saint George spearing the dragon (ed. Gaudioso 1996, pp. 176–8); and in a polyptych signed by Giovanni Badile of *c.* 1420–30 in the Museo di Castelvecchio, Verona – again together with other saints – painted possibly for the Boldieri chapel in Sant'Anastasia (ed. Gaudioso 1996, p. 116). Saint Anthony Abbot is shown on the right opposite Saint George, but with a number of other saints, in the Pellegrini/Bevilaqua tomb in the Pellegrini chapel in the fourteenth-century frescoes attributed to Martino da Verona (ed. Gaudioso 1996, p. 86).

41. N. Gramaccini, 'Wie Jacopo Bellini Pisanello besiegte: der Ferrareser Wettbewerb von 1441', *Idea. Jahrbuch der Hamburger Kunsthalle*, I, 1982, pp. 42–4. Cordellier, in *Pisanello* (Paris) 1996, p. 225, suggests that the three Ages of Man are alluded to by the Child, Saint George and Saint Anthony. Stichel sees Saint Anthony's expression as a reference to death and the transience of earthly life (D. Stichel in *Zeitschrift für Kunstgeschichte*, 1996, p. 428). A somewhat bizarre suggestion is that the signature as small snakes was intended to show that Pisanello himself belonged to mankind under the curse of Original Sin, as did the saints who triumphed over Sin, redeemed by Christ and the Virgin *immacolata* (M. Levi d'Ancona, *The Iconography of the Immaculate Conception in the Middle Ages and Early Renaissance*, College Art Association in conjunction with the *Art Bulletin*, 1957, p. 28). Tiziana Franco's suggestion (T. Franco, 'Dipinti autografi', in Puppi 1996, p. 95) that the painting represents the Temptation of Saint Anthony is certainly wrong.

42. Van Marle 1927, VIII, p. 76; Bologna 1977, pp. 41–2 (still influenced by Gentile da Fabriano); Venturi 1939, pp. 20–2 (between 1426 and 1431); Hill 1905, p. 62 (between 1426 and the Sant'Anastasia frescoes). It was dated to the 1440s by A. Hentzen, *Die Vision des heiligen Eustachius*, Berlin 1948, p. 12; E. Sindona, *Pisanello*, Milan 1961, pp. 32–3, 120; id., *Pisanello*, trans. J. Ross, New York 1968, pp. 32–3 and 126; Paccagnini 1972, pp. 222ff.; C. Tellini Perina, 'Considerazioni sul Pisanello. La monografia di Giovanni Paccagnini', *Civiltà Mantovana*, VI, 1972, p. 316. See also V. Juren, 'Pisanello', *Revue de l'Art*, 1975, p. 59; S. Zuffi, *Pisanello*, Milan 1996, p. 52; B. Degenhart, 'Pisanello in Mantua', *Pantheon*, XXXI, Heft 5, 1973, p. 410; id., 'Pisanello's Mantuaner Wandbilder', *Kunstchronik*, XXVI, 1973, pp. 69–74 (after 1447).

43. See also Cordellier in *Pisanello* (Paris) 1996, pp. 248–9, cat. 156.

44. For a more detailed discussion of the condition see J. Dunkerton, 'L'Etat de restauration des deux Pisanello de la National Gallery de Londres', in Cordellier-Py 1998, II, pp. 665–81.

45. Jacopo de Voragine, *The Golden Legend*, trans. W.G. Ryan, 2 vols., Princeton NJ, pp. 226–71.

46. M. Davies, *National Gallery Catalogues: The Early Italian Schools*, London 1961, p. 441, note 1.

47. J. Cummins, *The Hound and the Hawk: the Art of Medieval Hunting*, New York 1988, pp. 27, 77.

48. For a facsimile of Paris, Bibliothèque nationale, Ms fr. 616 see *The Hunting Book of Gaston Phèbus*, ed. M. Thomas and F. Avril, intro., London 1998.

49. Ibid., fol. 93 verso.

50. Ibid., chapters 34, 35, 36.

51. The information on the dogs cited here is taken from the notes of W. Schlag, ibid., pp. 33–36.

52. Ibid., chapter 18, fol. 46 verso.

53. Ibid., chapter 19, fol. 47 verso.

54. Ibid., chapter 17, fol. 45 verso.

55. Ibid., chapter 20, fol. 5.

56. It has even been suggested by B. Degenhart that Saint Eustace is a portrait of Lodovico Gonzaga (B. Degenhart and A. Schmitt, *Zeichnungen*, I, Berlin 1968; B. Degenhart, 'Ludovico II. Gonzaga in einer Miniatur Pisanellos', *Pantheon*, XXX, Heft 3, 1972, p. 200; B. Degenhart, 'Pisanello in Mantua', *Pantheon* 1973, XXXII, Heft 5, p. 410 note 95).

57. Petri Candidi Decembrii, *Vita Philippi Mariae Tertij Ligurum Ducis*, ed. A. Butti, F. Fossati, G. Petraglioni, *Rerum italicarum scriptores*, XXI, Bologna 1925–35, ch. LX, pp. 322–3.

58. See Cordellier in *Pisanello* (Paris) 1996, p. 109.

59. L. Olivata, 'La principessa Trebisonda; per un ritratto di Pisanello' in P. Castelli, ed., *Ferrara e il Concilio, 1438–1439: Atti del convegno di studi nel 550° anniversario del Concilio dell'unione delle due Chiese d'oriente e d'occidente*, Ferrara 1992, pp. 193–211. Her argument is adapted in L. Jardine and J. Brotton, *Global Interests: Renaissance Art between East and West*, London 2000, pp. 28–9.

60. R. Chiarelli, 'Due questioni Pisanelliane. Il Pisanello a Firenze e gli affreschi "perduti" della Cappella Pellegrini', *Atti e memorie della Accademia di Agricoltura Scienze e Lettere di Verona 1965–66*, serie VI, XVII, 1967, p. 381. Chiarelli's argument is based on the supposition that Vasari was confused into thinking that the depiction of Saint Eustace was a fresco when in fact it was a panel painting, and that the painting was in fact the National Gallery painting because it contains a similar dog, and a hound turning back as if it had heard a sound. However, it has since been shown that Saint Eustace was painted on a pilaster (see chapter 1, p. 22 and note 80).

61. Cordellier in *Pisanello* (Paris) 1996, pp. 301–2, cat. 194; D. Cordellier in *Pisanello* (Verona) 1996, pp. 264–5, cat. 40.

62. Cordellier in *Pisanello* (Paris) 1996, pp. 246–7, cat. 153; Cordellier in *Pisanello* (Verona) 1996, p. 262, cat. 39.

63. Cordellier in *Pisanello* (Paris) 1996, pp. 279–81, cat. 181–2.

64. A facsimile was published by Monumenta Bergomensia, 1961.

65. Cordellier in *Pisanello* (Paris) 1996, p. 281, cat. 183.

66. Ibid., pp. 286–7, cat. 185.

67. Ibid., p. 273, cat. 176.

68. Ibid., pp. 278–9, cat. 179.

69. Ibid., p. 278, cat. 178.

70. Ibid., pp. 273, 278, cat. 177.

71. Ibid., pp. 121–2, cat. 64, 65.

72. Ibid., pp. 264–5, cat.169.

73. Ibid., pp. 312–4, cat. 199v, 200.

74. Ibid., p. 270, cat. 171.

75. Ibid., pp. 265–70, cat. 170.

76. See C. Ricci, *Iacopo Bellini e i suoi Libri di Disegni*, Florence 1908, I, *Il Libro del Louvre*, pp. 42–3; II, *Il Libro del British Museum*, pp. 161–2, 246–7. In all three drawings (British Museum ff. 27 and 72; Louvre ff. 41 verso and 42) Saint Eustace is mounted and raises his right hand, as in the National Gallery painting. A gibbet is included in the scene of Saint Eustace in Jacopo Bellini's Sketchbook in the Louvre, Paris. See further C. Eisler, *The Genius of Jacopo Bellini, The Complete Paintings and Drawings*, New York 1989, pp. 77–104.

77. See Cordellier 1995, pp. 99–100, doc. 38.

78. K. Barstow, *The Gualenghi–d'Este Hours: Art and Devotion in Renaissance Ferrara*, Los Angeles 2000, p. 176.

79. See M. Baxandall, 'Guarino, Pisanello and Manuel Chrysoloras', *Journal of the Warburg and Courtauld Institutes*, XXVIII, 1965, pp. 185–6.

80. See Cordellier 1995, pp. 40–2, doc. 10; the quotation comes from lines 33–47. For an English translation of the passage, see Baxandall 1971, pp. 92–3.

81. See Cordellier 1995, p. 41, doc. 10, lines 60–1.

82. On ekphrasis, see Baxandall 1971, esp. pp. 85–8.

83. See Hermogenes, *Opera*, ed. H. Rabe, Leipzig 1913, pp. 22–3; cited in Baxandall 1971, p. 85.

84. See Cordellier 1995, p. 116, doc. 48, lines 5–18. For an English translation of this passage, see Baxandall 1971, p. 93. See also B. Mesdjian, 'Tito Vespasiano Strozzi et la peinture: un éloge humaniste de Pisanello, illustration de l'art du portrait', *Studi Umanistici Piceni*, xv, 1995, pp. 145–57.

85. For the additional two Latin couplets in 1513 Aldine edition of poem, see Cordellier 1995, p. 115.

86. The mention of hounds coursing hares also recalls certain of Pisanello's drawings, including figs. 4.54, 4.55, as well as his drawing of a running hare (fig. 4.58). The reference to bears brings to mind Pisanello's drawing, fig. 4.41.

87. See also Pisanello's drawings of birds, including *Flying egrets* (fig. 4.52) and *A teal* (fig. 2.41).

88. There are frequent representations of game among Pisanello's drawings, for instance boars (figs. 4.16, 4.17) and deer (figs. 4.75, 4.76).

89. See Cordellier 1995, pp. 139–40, doc. 61, esp. lines 51–69.

90. Ibid., pp. 146–7, doc. 64.

91. Ibid., pp. 149–50, doc. 66.

92. Ibid., p. 167, doc. 75; see also M. Baxandall, 'Bartholomaeus Facius on Painting: a fifteenth-century manuscript of the *De Viris Illustribus*', *Journal of the Warburg and Courtauld Institutes*, xxvii, 1964, pp. 90–107; for quotation concerning Gentile da Fabriano see p. 100.

93. Ibid., p. 104.

94. See Cordellier 1995: 1568 edition of Vasari, doc. 103, pp. 215–7; for Vasari's mention of famous writers praising Pisanello, p. 217.

95. See M. Baxandall, 'A Dialogue on Art from the Court of Leonello d'Este: Angelo Decembrio's *De Politia Litteraria Pars LXVIII*', *Journal of the Warburg and Courtauld Institutes*, xxvi, 1963, pp. 304–26; for Decembrio's claim regarding the superiority of poets, pp. 318–21.

96. See above note 5.

CHAPTER V · ARTISTIC INDIVIDUALITY AND THE WORKSHOP TRADITION

1. Cordellier 1995, pp. 96–100, 120–2, docs. 38, 52.

2. Ibid., pp. 151–3, doc. 68.

3. Ibid., pp. 48–50, doc. 15.

4. Ibid., pp. 67–9, doc. 22.

5. Ibid., pp. 160–2, doc. 160.

6. See, for example, J. R. Spencer, 'Filarete's Bronze Doors at St. Peter's', in W. Stedman Sheard, J.T. Paoletti, ed., *Collaboration in Italian Renaissance Art*, New Haven and London 1978, pp. 33–45; H.B.J. Maginnis, 'The Craftsman's Genius: Painters, Patrons and Drawings in Trecento Siena', in A. Ladis, C. Wood, ed., *The Craft of Art: Originality and Industry in the Italian Renaissance and Baroque Workshop*, Athens GA and London 1995, pp. 25–47, esp. pp. 26–7.

7. A. Bolland, 'Art and Humanism in Early Renaissance Padua: Cennini, Vergerio and Petrarch on Imitation', *Renaissance Quarterly*, xLIX, 1996, pp. 469–87, esp. p. 470.

8. Cordellier 1995, p. 147–8, doc. 65.

9. P. Joachimsohn, ed., *Herman Schedels Briefwechsel (1452–1478)*, Tübingen 1893, pp. 54, 58; J.G. Pollard, 'The Italian Renaissance Medal: Collecting and Connoisseurship', in J.G. Pollard, ed., *Italian Medals* (Studies in the History of Art 21), National Gallery of Art, Washington, D.C., 1987, pp. 161–9, esp. pp. 161–2.

10. Hill 1930, pp. 38, 235 no. 158, 906 (for medals of Guarino and Filelfo); G.F. Hill, 'A Lost Medal by Pisanello', *Pantheon*, VIII, 1931, pp. 487–8; U. Middeldorf, 'A New Medal by Pisanello', *Burlington Magazine*, cxxvIII, 1981, pp. 19–20; R. Rugolo, 'Medaglie', in Puppi 1996, p. 191, no.24 (where the medal of Giovanni Pietro d'Avenza, surely by a member of Pisanello's shop, rather than by Pisanello himself, is erroneously located in Cambridge).

11. H. Stevenson, 'Note sur les tuiles de plomb de la basilique de S. Marc ornées des armoires de Paul II e de médaillons de la Renaissance', *Mélanges d'archéologie et d'histoire*, VIII, 1888, pp. 439–77, pl. X.

12. See G. Donatone, *La maiolica napoletana del Rinascimento*, Naples 1994, pp. 37–8, pls. 5, 108, where it is attributed to Naples and dated to the second half of the fifteenth century. Tim Wilson advises us that its ornament is typical of Deruta *c*.1500. We are grateful to him for sharing his views of this piece with us.

13. R. Weiss, *Pisanello's Medallion of the Emperor John VIII Palaeologus*, London 1966, pp. 20–8, 31–2 (for bibliography).

14. S. Osano, 'Giovanni Badile collaboratore del Pisanello: riflessioni nel suo itinerario artistico', in M. Cova, ed., *La Cappella Guantieri in S. Maria della Scala a Verona. Il restauro degli affreschi di Giovanni Badile e dell'Arca*, Verona 1989, pp. 51–82; D. Cordellier in *Pisanello* (Paris) 1996, p. 98 under cat. 48, p. 109 under cat. 58.

15. C. Ginzburg, *The Enigma of Piero*, Thetford 1985, pp. 43–4; E. Battisti, *Piero della Francesca*, rev. edn, Milan 1992, p. 253.

16. Inv. M.N. 952; R.W. Scheller, trans. M. Hoyle, *Exemplum: Model-Book Drawings and the Practice of Artistic Transmission in the Middle Ages (ca.900–ca.1470)*, Amsterdam 1995, pp. 357–62.

17. For Domenico Veneziano, for example, see F. Ames-Lewis, 'Domenico Veneziano and the Medici', *Jahrbuch der Berliner Museen*, xxI, 1979, pp. 67–90; for eight panels executed in Perugia in the early 1470s on which are represented the miracles of San Bernardino of Siena see Weiss 1966, pp. 23–4; F. Santi, *Galleria nazionale dell'Umbria: dipinti, sculture e oggetti dei secoli XV–XVI*, Rome 1985, pp. 86–96, no. 75; V. Garibaldi in P. Dal Poggetto, ed., *Piero e Urbino, Piero e le corti rinascimentali*, exh. cat., Palazzo Ducale, Oratorio di San Giovanni Battista, Urbino, 1992, pp. 316–17, cat. 66. The anonymous artist of these panels used the medal of John VIII as the source for one of the onlookers witnessing the

moment when San Bernardino brought back to life a boy killed by a rampaging bull. However, in addition, other figures, in this and the other panels in the group, seem to demonstrate that the artist had sight of drawings by Pisanello (or copies after them) of the retinue of the emperor; the artist has painted figures as exotically bearded and costumed Byzantines in similar poses – seen from the back, in lost profile and in three-quarter view. An inscription on another of the panels, placed in the frieze of the classical building which dominates a scene of the healing of a little girl, shows that it was finished in 1473. Given that the pictures were executed so long after Pisanello's death, this belated reference to his work might seem rather strange. An explanation may be provided by the first part of the inscription, which, peculiarly, given the historical period in which the episode is ostensibly set, dedicates the building – or the picture – 'to Divus Titus Vespasian Augustus, son of Vespasian'. It may, however, be no coincidence that the humanist poet Tito Vespasiano Strozzi was in Perugia with Borso d'Este in 1471, and if, as it seems, he was in some way connected with the commission of the San Bernardino panels, it may also have been he who provided the enduring link with Pisanello.

18. Louvre inv. 2472, 2470: Fossi Todorow 1966, pp. 113, 190–1, no. 142, 420; Cordellier in *Pisanello* (Paris) 1996, pp. 248–9, 258, cat. 156, 158

19. Louvre inv. 2463: Fossi Todorow 1966, p. 96, no. 95; Cordellier in *Pisanello* (Paris) 1996, p. 260, cat. 162.

20. Albertina inv. 5 (from the *Taccuino di viaggio*): Fossi Todorow 1966, pp. 138–9, no. 205v; A. Schmitt, 'Die Frühzeit Pisanellos: Verona, Venedig, Pavia', in Degenhart-Schmitt 1995, pp. 13–53, esp. p. 50.

21. Louvre 2623 verso: Fossi Todorow 1966, p. 160, no. 285; Cordellier in *Pisanello* (Paris) 1996, pp. 226–7, cat. 134.

22. Louvre inv. 2271, 2279, 2287, 2288, 2291, 2292, 2293, 2294, 2305, 2307, 2317, 2534, 2535, 2537, 2539: Fossi Todorow 1966, pp. 90, 116–20, 153, nos. 78, 152–64, 263; Cordellier in *Pisanello* (Paris) 1996, pp. 413, 419–20, 422–3, 425–37, 440, 446–7, 452–3, cat. 288, 291–2, 294–5, 298–9, 301–2, 310, 313–15, 317–18.

23. M. Fossi Todorow, 'Un taccuino di viaggi del Pisanello e della sua bottega', in F. M. Aliberti, *Scritti di storia dell'arte in onore di Mario Salmi*, 3 vols., 1959–63, II, Rome 1962, pp. 133–61; B. Degenhart, A. Schmitt, 'Gentile da Fabriano in Rom und die Anfänge des Antikestudiums', *Münchner Jahrbuch der Bildenden Kunst*, IX, 1960, pp. 59–151; Fossi Todorow 1966, pp. 47–48, 121–40, nos. 166–208; Scheller 1995, p. 345; Cordellier in *Pisanello* (Paris) 1996, pp. 465–7.

24. Boymans Van Beuningen inv. I.520 recto: Fossi Todorow 1966, pp. 57–8, no. 2; Cordellier in *Pisanello* (Paris) 1996, pp. 84–5, cat. 41. The erroneous annotation and the verso drawing (see note 32) link the drawing to the rest of the parchment sheets in the *Taccuino*.

25. Boymans Van Beuningen inv. I.523: Fossi Todorow 1966, p. 138, no. 204; A. Cavallaro in *Da Pisanello* (Rome) 1988, p. 150, 152–3, cat. 44, 46; B. Blass-Simmen, 'Pisanellos Tätigkeit in Rome', in Degenhart-Schmitt 1995, pp. 92, 108.

26. Staatliche Museen zu Berlin, Kupferstichkabinett inv. 1359 verso: Fossi Todorow 1966, p. 122, no. 169; A. Nesselrath in *Da Pisanello* (Rome) 1988, pp. 149–50, 152–3, cat. 44, 46; B. Blass-Simmen, 'Pisanellos Tätigkeit in Rome', in Degenhart-Schmitt 1995, pp. 92, 114.

27. Louvre inv. 2485: Fossi Todorow 1966, pp. 134–5, no. 197; Cordellier in *Pisanello* (Paris) 1996, p. 62, cat. 23.

28. Louvre inv. RF 423: Fossi Todorow 1966, pp. 133, no. 194; Cordellier in *Pisanello* (Paris) 1996, p. 154–5, cat. 85.

29. Ambrosiana inv. F.214 inf. N10 verso: Fossi Todorow 1966, pp. 127–8, no. 182; Nesselrath in *Da Pisanello* (Rome) 1988, pp. 211–12, cat. 61; Cordellier in *Pisanello* (Paris) 1996, pp. 153–4, cat. 84.

30. Louvre inv. 2398: Fossi Todorow 1966, p. 134, no. 196; Cordellier in *Pisanello* (Paris) 1996, p. 177, cat. 95.

31. Staatliche Museen zu Berlin, Kupferstichkabinett inv. 1358 verso, Ambrosiana inv. F.214 inf. N13 verso: Fossi Todorow 1966, pp. 122, 129, nos. 168, 185; M. Bollati in *Le muse* (Milan) 1991, *Catalogo*, pp. 150–2, cat. 33.

32. This artist may also be responsible for drawings after the Antique – of motifs taken from a Venus sarcophagus in the Museo Profano Laterano at the Vatican (Milan, Ambrosiana, inv. F.214 inf. 14 verso) and a relief on the arch of Constantine (Chantilly, Musée Condé, inv. FR 1–4 recto). See Fossi Todorow 1966, pp. 123–4, 129–30, nos. 171, 186; A. Cavallaro, 'I rilievi storici: l'Arco di Costantino e la Colonna Traiana', in *Da Pisanello* (Rome) 1988, pp. 181, 183, fig. 53; Blass-Simmen in Degenhart-Schmitt 1995, pp. 92, 100, 108. It may be that this is the hand responsible for the Louvre drawing copying motifs from Stefano da Verona (see note 30) and for other drawings of religious motifs in the *Taccuino* (for example, Louvre inv. 2542: Fossi Todorow 1966, p. 139, no, 199; Cordellier in *Pisanello* (Paris) 1996, pp. 166–7, cat. 91).

33. Staatliche Museen zu Berlin, Kupferstichkabinett, inv. 1359 verso: Fossi Todorow 1966, p. 122, no. 169; Cavallaro in *Da Pisanello* (Rome) 1988, p. 155, cat. 48.

34. He may also be responsible for figures, for example, from the Mars and Rhea Silvia sarcophagus (Ambrosiana F.214 inf. 13 recto); figures from the Adonis and Marsyas sarcophagi (Louvre 2397 verso); bound figures *all'antica* (Uffizi n.3 Santarelli). See Fossi Todorow 1966, pp. 124, 129, 133–4, nos. 173, 185, 195; Cavallaro in *Da Pisanello* (Rome) 1988, pp. 93–6, 98, cat. 23, 24, 26; M. Bollati in *Le muse* (Milan) 1991, *Catalogo*, pp. 150–2, cat. 33; Blass-Simmen in Degenhart-Schmitt 1995, pp. 92, 104, 108; Cordellier in *Pisanello* (Paris) 1996, pp. 180–1, cat. 100.

35. Ambrosiana F.214 inf. 8; see also Ambrosiana F.214 inf. 7 (Virgin and Child with saint). See Fossi Todorow 1966, pp. 140–1, nos. 210, 211; Blass-Simmen in Degenhart-Schmitt 1995, pp. 112–13.

36. K. Z. von Manteuffel, *Die Gemälde und Zeichnungen des Antonio Pisano aus Verona*, Halle 1909, pp. 65, 138; Fossi Todorow 1966, pp. 48–50, 140–52, nos. 209–59; Cordellier in *Pisanello* (Paris) 1996, pp. 457–62

37. Drawings such as Louvre inv. 2629 recto, 2628: see Fossi Todorow 1966, pp. 160–1, nos. 287–8; Cordellier in *Pisanello* (Paris) 1996, pp. 53, 60, cat, 19, 20. For the drawing (Louvre inv. 2621) copying the type represented in the figure in ermine in the Sant' Anastasia fresco, see Fossi Todorow 1966, pp. 159–60, no. 284; Cordellier in *Pisanello* (Paris) 1996, pp. 51–2, cat. 16.

38. Louvre inv. 2631 recto: Fossi Todorow 1966, pp. 98, 161, nos. 100, 290; Cordellier in *Pisanello* (Paris) 1996, pp. 356–57, cat. 238.

39. A. Schmitt, 'Bono da Ferrara', in Degenhart-Schmitt 1995, pp. 229–64; M. Dachs, 'Pisanello in neue Glanz', *Pantheon*, LIV, 1996, pp. 174–6.

40. NG 771: M. Davies, *National Gallery Catalogues: The Early Italian Schools*, London 1961, pp. 93–4; T. Franco, 'Dipinti autografi', in Puppi 1996, pp. 117–19, no. 11.

41. For the suggestion that this is an Hieronimite habit, see D. Russo, *Saint Jérome en Italie: Etude d'icono-graphie et de spiritualité, XIII–XIVe siècles*, Paris and Rome 1987, pp. 231, 235; F. Lollini, 'Le Vite di Plutarco all Malatestiana (S. XV.1, S. XV.2, S. XVII.2): proposte ed osservazioni per il periodo di transizione tra tardogotico e rinascimento nella miniatura settentrionale', in F. Lollini, P. Lucchi, ed., *Libraria Domini: i manoscritti della Bibliotheca Malatestiana, testi e decorazioni*, Bologna 1995, pp. 189–224, esp. p. 214 note 13.

42. M. Baxandall, 'A Dialogue on Art from the Court of Leonello d'Este', *Journal of the Warburg and Courtauld Institutes*, XXVI, 1963, p. 326, note 74; id., 'Guarino, Pisanello and Manuel Chrysoloras', *Journal of the Warburg and Courtauld Institutes*, XXVIII, 1965, pp. 183–204; Baxandall 1971, pp. 228–33; Cordellier 1995, pp. 162–7, doc. 75.

43. Baxandall 1971, pp. 108.

44. W. L. Gundersheimer, *Ferrara: The Style of A Renaissance Despotism*, Princeton NJ 1973, pp. 108–9.

45. H.W. Janson, *The Sculpture of Donatello*, II, Princeton NJ 1957, p. 165.

46. Florence, Bibliotheca Laurenziana, Plut. 55, 21; R. Signorini, ed., *In traccia del 'Magister Pelicanus'*, exh. cat., Commune di Mantova, Mantua, 1979, p. 74.

47. E. Rigoni, 'Jacopo Bellini a Padova nel 1430', *Rivista d'Arte*, XI, 1929, pp. 261–4, esp. p. 263.

48. H.-J. Eberhardt, 'Lebensdaten des Bono da Ferrara', in Degenhart-Schmitt 1995, pp. 275–6.

49. L.N. Cittadella, *Notizie amministrative, storiche, artistiche relative a Ferrara ricavate da documenti*, Ferrara 1868, II, pp. 184, 303; F. Todini in *Le muse* (Milan) 1991, *Catalogo*, pp. 283–9, cat. 73, esp. p. 284.

50. E. Rigoni, 'Il pittore Nicolò Pizolo' (1948), in id., *L'arte rinascimentale in Padova: studi e documenti*, Padua 1970, pp. 33–4, 44–5.

51. Boymans Van Beuningen inv. I.521 recto: Fossi Todorow 1966, pp. 137–8, no. 203; Blass-Simmen in Degenhart-Schmitt 1995, p. 88.

52. A. Schmitt, 'Bono da Ferrara', in Degenhart-Schmitt 1995, pp. 229–64.

53. Lugt inv. 1344; L. Magagnato, ed., *Da Altichiero a Pisanello*, exh. cat., Museo di Castelvecchio, Verona, 1958, p. 102, pl. CXXb; J. Byam Shaw, *The Italian Drawings of the Frits Lugt Collection*, Paris and Basle, I, 1983, p. 212, no. 211; D. Cordellier, 'Conclusion', in Cordellier-Py 1998, II, pp. 749–91, esp. p. 762.

54. British Museum inv. 1946-7-13-206, Louvre inv. 2332 recto and verso: E.A. Popham and P. Pouncey, *Italian Drawings in the Department of Prints and Drawings in the British Museum: the Fourteenth and Fifteenth Centuries*, London 1950, p. 191, no. 303; Fossi Todorow 1966, pp. 104, 105–6, nos. 105, 111; Cordellier in *Pisanello* (Paris) 1996, pp. 271–2, cat. 174.

55. Louvre inv. 2439, 2299, 2450: Fossi Todorow 1966, pp. 105, 109–11, nos. 110, 127, 131; Cordellier in *Pisanello* (Paris) 1996, pp. 247–8, 270–1, cat. 154, 172, 173.

56. M. Boskovits, 'Le milieu du jeune Pisanello: quelques problèmes d'attribution', in Cordellier-Py 1998, I, pp. 85–120, esp. pp. 85–6.

57. A. Schmitt, 'Bono da Ferrara', in Degenhart-Schmitt 1995, pp. 229–64, esp. pp. 254–5, 257–9.

58. Cordellier 1995, pp. 162–67, doc. 75.

59. Cesena, Bibliotheca Malatestiana, S.XV.1: G. Mariani Canova in *Le muse* (Milan) 1991, *Catalogo*, pp. 121–9, cat. 29; ead., 'The Italian Renaissance Miniature', in J.J.G. Alexander, ed., *The Painted Page: Italian Renaissance Book Illumination*, exh. cat., Royal Academy of Arts, London, Pierpont Morgan Library, New York, 1994, pp. 21–34, esp. p. 22; Lollini in Lollini, Lucchi 1995, pp. 189–224; id., 'Production littéraire et circulation artistique dans les cours de Rimini et Cesena vers 1450: un essai de lecture parallèle', in Cordellier-Py, II, pp. 461–98.

60. In Bibliotheca Malatestiana, S.XV.2, fol. 189 verso: G. Mariani Canova in *Le muse* (Milan) 1991, *Catalogo*, pp. 121–9, cat. 29, esp. p. 125.

61. Louvre inv. 2265: Cordellier in *Pisanello* (Paris) 1996, p. 136, cat. 73.

62. Fossi Todorow 1966, p. 143, p. 218; E. Parlato, 'L'iconografia imperiale', in *Da Pisanello* (Rome) 1988, pp. 73–4, fig.21. The Augustus seems to have served as a model for the miniature of the medallion miniature of Octavian by Marco dell'Avogaro in a Suetonius manuscript in Blickling Hall, Norfolk (Ms. 6917, fol. 23v): see F. Toniolo, 'Marco dell'Avogaro e la decorazione all'antica', in *Le muse* (Milan) 1991, *Catalogo*, pp. 132–40, esp. p. 135.

63. Turin, Bibliotheca Nazionale Universitaria, Ms. E.III.19; S. Bandera Bistoletti in *Da Pisanello* (Rome) 1988, pp. 76–8, cat. 14; G. Toscano in *Pisanello* (Paris) 1996, pp. 138–40, cat. 75; T. Franco in Puppi 1996, pp. 123–5, no. 19.

64. See for example Musée Marmotton, Paris, Wildenstein coll., Ms. 91-III.5; British Library, Ms. 22569; Bibliotheca Apostolica Vaticana, Ms. Ross. 555. See A. Cadei, 'Gli Zavattari nella civiltà pittorica padana del primo Quattrocento', in A. Ghidoli, ed., *Il polittico degli Zavattari in Castel Sant'Angelo: contributi per la pittura tardogotica lombarda*, exh. cat., Castel Sant'Angelo, Rome, 1984, pp. 17–51, esp. pp. 42–3: M. Boskovits, 'Arte lombarda del primo Quattrocento: un riesame', in *Arte in Lombardia tra Gotico e Rinascimento*, exh. cat., Palazzo Reale, Milan, 1988, pp. 9–49, esp. pp. 18–20; A. Conti, 'Frammenti di Mantova tardogotica', in M.T. Balboni Brizza, ed., *Quaderno di studi sull'arte lombarda dai Visconti agli Sforza: per gli 80 anni di Gian Alberto Dell'Acqua*, Milan 1990, pp. 41–7, esp. pp. 41–4.

65. Beginning with B. Degenhart, 'Ludovico II . Gonzaga in einer Miniatur Pisanellos', *Pantheon*, xxx, Heft 3, 1972, pp. 193–210.

66. G. Toscano in *Pisanello* (Paris) 1996, p. 140, cat. 76.

67. G. Mariani Canova, 'Il recupero d'un complesso librario dimenticato: i corali quattrocenteschi di San Giorgio Maggiore a Venezia', *Arte Veneta*, xxvii, 1973, pp. 39–64; M. Bollati, *Una collezione di miniature italiane: dal Duecento al Cinquecento*, II, Milan, 1994, pp. 45–7; T. Franco in Puppi 1996, p. 119, no. 12.

68. London, Victoria and Albert Museum, Prints, Drawings and Paintings, inv. I.30.A [433]; K. Christiansen, opinion cited in Christie's sale catalogue, London, 11 December 1990, lot 22. See R. Cipriani in R. Longhi et al, *Arte lombarda dai Visconti agli Sforza*, exh. cat., Palazzo Reale, Milan, 1958, pp. 78–9, note 243; G. Castiglioni, 'Un secolo di miniatura veronese, 1450–1550', in G. Castiglioni, S. Marinelli, ed., *Miniatura veronese del Rinascimento*, exh. cat., Museo di Castelvecchio, Verona, 1986, pp. 47–99, esp. p. 48, fig. III.6. For its context see pp. 185–7, cat. 1. This illumination, like the Wildenstein page, has been attributed to the Master of the Antiphonal Q: see Mariani Canova 1973, pp. 39–64. The Victoria and Albert and Wildenstein illuminations share a figurative style and both have very much the same kind of acanthus framing around the miniature, but they do not, however, appear to be by the painter of Antiphonal Q, whose work is less refined. Moreover, the landscape element in the Victoria and Albert *Calling of Saint Andrew* in unique to this fragment.

69. A. Conti, 'Una miniatura ed altre considerazioni sul Pisanello', *Itinerari: Contributi alla storia dell'arte in memoria di Maria Luisa Ferrari*, I, 1979, pp. 67–76.

70. We are very grateful to Scot McKendrick and Nicolas Bell for their assistance with the musical notation.

71. B. Blass-Simmen, 'Pisanello et l'enluminure ferraraise', in Cordellier-Py 1998, II, pp. 577–61.

72. F. Toniolo, 'I miniatori estensi', in H.J. Hermann, ed. F. Toniolo, trans. G. Valenzano, *La miniatura estense*, Modena 1994, pp. 209–19.

73. K. Barstow, *The Gualenghi-d'Este Hours: Art and Devotion in Renaissance Ferrara*, Los Angeles 2000, pp. 60–2, for Taddeo's use in Borso's Bible of the birds-of-prey medal reverse of Alfonso of Aragon.

74. E.g. Louvre inv. 2389 verso, 2390 recto, 2513: Fossi Todorow 1966, pp. 69, 77, nos. 24, 25, 49; Cordellier in *Pisanello* (Paris) 1996, pp. 302–3, 312, 325, cat. 196, 197, 214 (who discusses connections with Borso's Bible); B. Blass-Simmen, 'Pisanello et l'enluminure ferraraise' in Cordellier-Py 1998, II, pp. 577–615. For Borso's Bible see F. Toniolo, 'La Bibbia di Borso d'Este: cortesia e magnificenza a Ferrara tra Tardogotico e Rinascimento', in *La Bibbia di Borso d'Este: commentaria al codice*, Modena 1997, pp. 295–573 (including description of volume II).

75. Oxford, Bodleian Library, Ms Holkham misc. 49: F. Toniolo in *The Painted Page* 1994, p. 214, cat. 110. The manuscript was made for Teofilo Calcagnini.

76. Blass-Simmen in Cordellier-Py 1998, II, pp. 577–615, esp. p. 587; Barstow 2000, p. 59–70.

77. Toniolo in Hermann 1994, pp. 231–40; F. Toniolo, 'L'enluminure à la cour des Este de Pisanello à Mantegna', in Cordellier-Py 1998, II, pp. 617–54, esp. pp. 629–31.

78. Toniolo in Cordellier-Py 1998, II, pp. 617–54, esp. pp. 630–1.

79. T. Tuohy, *Herculean Ferrara: Ercole d'Este, 1471–1505, and the Invention of a Ducal Capital*, Cambridge 1996, p. 313.

80. Biblioteca Communale Ariostea, Ferrara, Ms. II, 132; M. Medica, *Le muse* (Milan) 1991, *Catalogo*, pp. 190–3, cat. 49; F. Lollini in F. Toniolo, ed., *La miniatura a Ferrara dal tempo di Cosmè Tura all'eredità di Ercole de' Roberti*, exh. cat., Palazzo Schifanoia, Ferrara, 1998, pp. 89–91, cat. 7.

81. Houghton Library, Cambridge ma, Ms. Typ. 301: F. Lollini, 'Bologna, Ferrara, Cesena: i corali del Bessarione tra circuiti umanistici e percorsi di artisti', in P. Lucchi, ed., *Corali miniati del Quattrocento nella Biblioteca Malatestiana*, exh. cat., Biblioteca Malatstiana, Cesena, 1989, pp. 19–36, 99–103, esp. pp. 100–101; M. Medica in *Le muse* (Milan) 1991, *Catalogo*, pp. 190–3, cat. 49; id., 'Matteo de' Pasti et l'enluminure dans les cours d'Italie du Nord, entre le gothique finissant et la Renaissance', in Cordellier-Py 1998, II, pp. 499–532.

82. T. Franco in Puppi 1996, pp. 123–4, no. 19; Medica in Cordellier-Py 1998, II, pp. 499–532, esp. p. 508.

83. D.S. Chambers, *Patrons and Artists in the Italian Renaissance*, London 1970, pp. 94–5; F. Ames-Lewis, 'Matteo de' Pasti and the Use of Powdered Gold', *Mitteilungen des Kunsthistorischen Instituts in Florenz*, xxviii, 1984, pp. 351–61, esp. pp. 351–2. Ames-Lewis connected the work with a manuscript, from which the Triumph miniatures have been cut out, thought to have belonged to Piero de' Medici: Bibliothèque nationale de France, Paris, Ms Ital. 1471.

84. Medica in Cordellier-Py 1998, II, pp. 499–532.

85. Hill 1930, pp. 37–43, nos. 158–89; P.G. Pasini, 'Note su Matteo de' Pasti e la medaglistica malatestiana', in F. Panvini Rosati, ed., *La medaglia d'arte: Atti del primo convegno internazionale di studio, Udine, ottobre 1970*, Udine 1973, pp. 41–75; id., 'Matteo de' Pasti: Problems of Style and Chronology', in J.G. Pollard, ed., *Italian Medals* (Studies in the History of Art 21), Washington, D.C., 1987, pp. 143–59.

86. E. Luciano, '*Diva Isotta* and the Medals of Matteo de' Pasti: a Success Story', *The Medal*, no. 29, 1996, pp. 3–17.

87. C. Hope, 'The Early History of the Tempio Malatestiano', *Journal of the Warburg and Courtauld Institutes*, lv, 1992, pp. 51–154, especially p. 62. The original date and inscription was the same as that on the medal.

88. Hill 1930, p. 40, no. 170; A. Luchs in S.K. Scher, ed., *The Currency of Fame*: Portrait Medals of the Renaissance, exh. cat., National Gallery of Art, Washington, D.C., Frick Collection, New York, 1994, pp. 62–4, cat. 12, 12a; L. Syson, 'Consorts, Mistresses and Exemplary Women: the Female Medallic Portrait in Fifteenth-Century Italy', in S. Currie and P. Motture, ed., *The Sculpted Object, 1400–1700*, Aldershot 1997, pp. 43–64, esp. pp. 49–50.

89. For this last see G.F. Hill, *Medallic Portraits of Christ*, Oxford 1920, pp. 12–13; Hill 1930, p. 39, no. 162; for the related drawing (Louvre inv. 2305) see Fossi Todorow 1966, p. 153, no. 263; Cordellier in *Pisanello* (Paris) 1996, p. 413, cat. 288.

90. S. Tumidei, 'Un tableau perdu de Pisanello pour l'empereur Sigismond', in Cordellier-Py 1998, I, pp. 17–27, esp. p. 19.

91. The following section derives in part from L. Syson, 'The Circulation of Drawings for Medals in Fifteenth-Century Italy', in M. Jones, ed., *Designs on Posterity: Drawings for Medals*, London 1994, pp. 10–26, 41–2; id., '*Opus pisani pictoris*: les médailles de Pisanello et son atelier', in Cordellier-Py 1998, I, pp. 379–426.

92. Hill 1930, pp. 8, 9, 13, nos. 21, 26–8, 30, 44; E. Corradini in *Le muse* (Milan) 1991, *Catalogo*, pp. 60–4, 66–7, 90–2, cat. 3, 4, 6, 16; de Turckheim-Pey in *Pisanello* (Paris) 1996, pp. 215, 362, 395–6, 453, cat. 127, 263, 266, 270, 319; D. Gasparotto in *Pisanello* (Verona) 1996, pp. 378, 383–5, 410–11, cat. 82, 84–6, 98; R. Rugolo, 'Medaglie', in Puppi 1996, pp. 139–43, 148–50, 154–7, 188–90, nos.1, 4, 5, 7, 8, 23.

93. Hill 1930, pp. 8–9, no. 24; Corradini in *Le muse* (Milan) 1991, *Catalogo*, pp. 64–5, cat. 5; de Turckheim-Pey in *Pisanello* (Paris) 1996, pp. 383–4, 392, cat. 261–2; Rugolo in Puppi 1996, pp. 151–53, no. 6.

94. Fossi Todorow 1966, p. 132, no. 192; Cordellier in *Pisanello* (Paris) 1996, pp. 162–3, cat. 87

95. Hill 1930, p. 11, no. 39; de Turckheim-Pey in *Pisanello* (Paris) 1996, p. 406, cat. 283; Rugolo in Puppi 1996, pp. 174–5, no. 18. The view that this is a workshop piece is opposed by Cordellier, 'Conclusion', in Cordellier-Py 1998, II, pp. 747–91, esp. pp. 761, 774 note 72.

96. For the medal see Hill 1930, p. 12, no. 43; de Turckheim-Pey in *Pisanello* (Paris) 1996, p. 438, cat. 303 (the size and crispness of the British Museum specimen certainly indicates that it is the earliest surviving cast; the author notices the vestiges of a signature defaced on the model from which the medal was cast); Rugolo in Puppi 1996, pp. 187–8, no. 22. For the related drawing (Louvre inv. 2317), see Fossi Todorow 1966, p. 119, no. 61; Cordellier in *Pisanello* (Paris) 1996, p. 437, cat. 302.

97. Louvre inv. 2306: Fossi Todorow 1966, p. 89, no. 75; Cordellier in *Pisanello* (Paris) 1996, pp. 439–40, cat. 308.

98. Hill 1930, p. 12, no. 42; de Turckheim-Pey in *Pisanello* (Paris) 1996, pp. 432–3, 438–9, nos. 305–6; Gasparotto in *Pisanello* (Verona) 1996, pp. 406–7, no. 96; Rugolo in Puppi 1996, pp. 184–6, no. 21 (which illustrates the British Museum bronze cast, inv. George III, Naples 3). See Syson in Cordellier-Py 1998, I, pp. 379–426, esp. pp. 395–6.

99. Louvre inv. 2481: Fossi Todorow, 1966, p. 164, no. 302; Cordellier in Pisanello (Paris) 1996, p. 434, cat. 299.

100. Cordellier in *Pisanello* (Paris) 1996, pp. 204, 214–15, cat. 126.

101. Louvre inv. 2307: Fossi Todorow 1966, pp. 118–19, no. 160; Cordellier in *Pisanello* (Paris) 1996, pp. 428, 435–6, cat. 301.

102. Hill 1930, p. 12, no. 41; de Turckheim-Pey in *Pisanello* (Paris) 1996, pp. 428–9, 435, cat. 300; Gasparotto in *Pisanello* (Verona) 1996, pp. 400–1, cat. 93; Rugolo in Puppi 1996, pp. 177–83, no. 20.

103. Cordellier, 'Conclusion', in Cordellier-Py 1998, II, pp. 747–91, esp. p. 761.

104. Hill 1930, pp. 22–5, nos. 78–90.

105. E. Peverada, 'Attestati di santità nel Quattrocento per il vescovo di Ferrara, Giovanni Tavelli', *Analecta Pomposiana*, XIV, 1989, pp. 63–108; S. Campbell, *Cosmè Tura of Ferrara*, New Haven and London 1997, pp. 88–9.

106. Hill 1930, pp. 13–14.

107. C. von Fabriczy, 'Pietro di Martino da Milano in Ragusa', *Repertorium für Kunstwissenschaft*, XXVIII, 1905, pp. 192–3; V. Gvozdanovi , 'The Dalmatian Works of Pietro di Martino da Milano and the beginnings of Francesco Laurana', *Arte Lombarda*, nos. 80–2, 1975, pp. 113–23; S. Kokole, 'Cyriacus of Ancona and the Revival of Two Ancient Personifications in the Rector's Palace of Dubrovnik', *Renaissance Quarterly*, XLIX, 1996, pp. 225–67.

108. Hill 1930, pp. 15–16, nos. 51–6.

109. Cordellier in *Pisanello* (Paris) 1996, pp. 418–9, cat. 290.

110. G. L. Hersey, *The Aragonese Arch at Naples, 1443–1475*, New Haven and London 1973, pp. 22–3; H.-W. Kruft, *Francesco Laurana. Ein Bildhauer der Frührenaissance*, Munich 1994, pp. 35–66, p. 207 notes 14, 393.

111. See, for example, for Antonio del Pollaiuolo, A. Perosa, ed., *Giovanni Rucellai ed il suo Zibaldone*, London 1960, I, *Il Zibaldone Quaresimale*, pp. 23–4; A. Wright, 'Antonio Pollaiuolo: *maestro di disegno*', in E. Cropper, ed., *Florentine Drawing at the Time of Lorenzo the Magnificent*, *Papers of the Villa Spelman Colloquium*, 1992, VI, Bologna 1994, pp. 131–46. For Francesco del Cossa, called a '*mastro al disegno*' by the Bolognese scholar-poet, Sebastiano Aldrovandi, see A. Bacchi, *Francesco del Cossa*, Soncino 1991, p. 5.

112. Hill 1930, p. 24, no. 87 (as Marescotti); Y. Shchukina in Scher *The Currency of Fame* 1994, pp. 58–9, cat. 10

(as unknown Ferrarese master); A.N. Stone, 'Pisanus Pictor: a Self-Portrait Medal', *The Medal*, no. 25, 1994, pp. 3–5 (as Pisanello); L. Syson in J. Rykwert, A. Engel, ed., *Leon Battista Alberti*, exh. cat., Palazzo Tè, Mantua, 1994, pp. 53 note 43, 481–2, cat. 84 (as anonymous (Ferrarese?) after a design by Pisanello); de Turckheim-Pey in *Pisanello* (Paris) 1996, p. 34, cat. 1 (as Marescotti) (see also Cordellier, in *Pisanello* (Paris) 1996, p. 17, who argues that the piece is posthumous, which does not, of course, rule out the probability that it was based on a drawing or even a painting by Pisanello's own hand); Gasparotto in *Pisanello* (Verona) 1996, pp. 364–5, cat. 75 (as Pisanello and an anonymous (Ferrarese?) master).

113. Gasparotto in *Pisanello* (Verona) 1996, p. 364, cat. 75.

AUTHORS' NOTE

Everything in the book has been discussed and agreed by the authors. However, inevitably, chapters were drafted independently. Dillian Gordon wrote chapter I and, in collaboration with Susanna Avery-Quash, chapter IV. Luke Syson wrote chapters II, III and V. Susanna Avery-Quash drew up the chronology and the list of loans to the exhibition.

CHRONOLOGY

by 1394		Antonio Pisano, called Pisanello, born; son of Puccio di Giovanni de Cereto of Pisa (who designated his son universal heir to the family estate in his will drawn up 22 November 1394) and Isabetta of Verona (daughter of Nicolò Zuperio)
early 1400s	VERONA	Lived with mother, who married a second time (to a certain Bartolomeo of Pisa). Once more widowed, on 6 September 1414, Pisanello's mother took a new husband, Filippo del fu Galvano of Ostiglia, a draper
c. 1415–19	VENICE	Collaborated with Gentile da Fabriano, probably his former master, and completed decoration of Ducal Palace, Venice; Pisanello painted at least one of the frescoes in Hall of the Great Council, showing Otto, liberated by the Venetians, pleading with his father Frederick Barbarossa to make peace with pope Alexander III and the Lombards (replaced by a canvas by Alvise Vivarini in 1488, also now lost)
June 1416	PADUA	The humanist Guarino da Verona wrote from Padua to one of his pupils asking him to return a copy of Cicero which a certain '*Magister* Antonius Pisanus' (perhaps Pisanello) had taken on his way through Padua, perhaps to Venice
by 1422	MANTUA AND VERONA	First recorded as resident in Mantua (a document witnessed in Verona on 4 July 1422). This records Pisanello buying a house in Campo Marzio, Verona (agreement ratified 12 August 1422), which later passed to his daughter Camilla
1424–5	MANTUA	Worked for Gonzaga family: received two small payments for unspecified activity
c. 1424–26	VERONA	First extant signed work, dated 1426: fresco of the Annunciation and Archangels Raphael and Michael around funerary monument by Nanni di Bartolo, called Il Rosso, of Niccolò Brenzoni (died 6 January 1422) in Franciscan church of San Fermo, Verona
possibly after 1426 before 1431	PAVIA	Frescoes, probably showing scenes of court life, commissioned by Filippo Maria Visconti, 3rd duke of Milan, for the Castello Visconteo (destroyed 4 September 1527 during the siege of Pavia)
by March 1431– July 1432	ROME	Completed fresco cycle of the Life of John the Baptist for nave of papal basilica of San Giovanni in Laterano, left unfinished by Gentile da Fabriano (died 1427); received payments on 18 March and 27 November 1431 and 29 February 1432 (destroyed when church remodelled in 1646 by Francesco Borromini)
		After March 1431 Pisanello became member of household of pope Eugenius IV. On 26 July 1432 given leave to depart by pope and a safe-conduct for himself, assistants and household. Pope bought from him painting of the Virgin with Saint Jerome

as a gift for Emperor Sigismund, who visited Italy between autumn 1431 and September 1433

Took over some of Gentile's household effects, which were then sold by the Chapter of San Giovanni in Laterano in April 1433

1431/2		Letter from Pisanello to Filippo Maria Visconti, from Rome, dated 28 June 1431 or 1432 (now lost), asking his patron to wait until the end of October to receive a work he was executing in bronze and informing him that he would not be allowed to leave Rome until he had finished his work in San Giovanni in Laterano
1432	FERRARA	After Rome, Pisanello stopped in Ferrara on his way to Verona: his first documented contact with the Este family. Letter from Leonello d'Este to his brother Meliaduse in Rome (dated 20 January 1431 or 1432) recording Pisanello's visit and asking his brother to send Pisanello's painting of the Virgin which Pisanello had promised him but left behind in Rome
1432	FERRARA OR MANTUA	Pisanello drew rough sketch of the emperor Sigismund in his *chapka* and a more finished drawing of his profile, and sketches of his retinue, in Ferrara or Mantua
between 1433 and 1438–9	VERONA	Pisanello returned to Verona; documented in 1433 as living with seventy-year-old widowed mother, four-year-old daughter Camilla and two servants
c. 1434–8		Executed group of frescoes including images of Saint George and the Princess of Silena and Saints Eustace and George (lost) over and beside arch above entrance to Pellegrini chapel in Dominican church of Sant'Anastasia, Verona
February 1435		Sent image of Julius Caesar (untraced) to Leonello d'Este, marquis of Ferrara, to mark his marriage to Margherita Gonzaga (on 6 February 1435) and was rewarded with two ducats (on 1 February 1435)
c. 1435–41		Only surviving signed panel painting, *The Virgin and Child with Saints Anthony Abbot and George* (London, National Gallery) may belong to this time
*c.*1438		Possibly consulted by Veronese canon Antonio Malaspina regarding decoration of his funerary chapel (instructions left in his will of 27 May 1440): executed preliminary sketch
March 1438– July 1439	FERRARA	During the ecumenical Council of Greek and Latin Churches in Ferrara from 4 March 1438 (which moved to Florence from 16 January to 5 July 1439) drew a series of sketches of John VIII Palaeologus and members of his retinue
*c.*1438–40		To this period belongs the portrait of Margherita d'Este (died July 1439; Paris, Louvre)
*c.*1438–42		*The Vision of Saint Eustace* (London, National Gallery) probably dates from this period

May 1439		Worked for Gonzaga family, receiving a payment of 80 ducats from Gianfrancesco (on 12 May 1439) for an unspecified commission
November 1439	MANTUA?	Became embroiled in war between Venice and Milan, siding with Gianfrancesco Gonzaga, *condottiere* marquis of Mantua, who was fighting for the Milanese interest in the sack of Verona between 17 and 20 November 1439; consequently Pisanello was declared a rebel by Venetians on 1 December 1440 and his goods were confiscated
		Painted, with assistance, Arthurian fresco cycle of the Story of Bohort for the *sala* of the Ducal Palace, Mantua (later known as the Sala del Pisanello) for Gianfrancesco Gonzaga (unfinished; uncovered in 1969)
c.1439–42		In this period Pisanello executed the medal of Nicolò Piccinino
1439–40	MARMIROLO	Working in Gonzaga castle at Marmirolo in the chapel of Santa Croce (documented in letter from Pisanello to Francesco Sforza dated 6 March 1440)
March 1440		Pisanello planned portrait of Francesco Sforza (lost)
May 1440	MILAN	In 11 May 1440 recorded in Milan, though living in Mantua
Probably 1441	FERRARA	Painted portrait of Leonello d'Este (thought to be the painting in Bergamo, Accademia Carrara), placed in competition with Jacopo Bellini (whose painting was supposedly preferred by Leonello's father, Nicolò, who died 26 December 1441; Bellini's picture is lost); competition recorded by Ulisse degli Aleotti and (later) Angelo Decembrio
August 1441	MANTUA	Pisanello sent by Nicolò d'Este from Ferrara to Mantua by boat 15–16 August 1441
after October 1441		Pisanello cast medals of Francesco Sforza when he became lord of Cremona, a title which appears on one of the medals
late 1441– early 1442		At this time made five small uniform medals for Leonello d'Este with and without full title of marquis of Ferrara, Modena and Reggio
1442–4		Pisanello is recorded in the Gonzaga account books
October 1442	VENICE	On 17 October tried for speaking out against the Venetian state; threatened with having his tongue cut out, confined to Venice, and forbidden to sell anything without permission
November 1442 – end of decade	FERRARA	Pisanello made Ferrara his base, with special permission from the Venetian authorities, not being allowed to go to Mantua or Verona by Venetian edict of 17 October 1442
		Took to Ferrara a painting of God the Father or Christ belonging to Gianfrancesco Gonzaga, who wrote to him in 6 November 1443 asking for it back
		Other correspondence from Gianfrancesco (e.g. letters of 11 September 1443 and 11 March 1444) in which he apologises for not being able to meet Pisanello's financial requests

before September 1443		Portrait of humanist poet Tito Vespasiano Strozzi (lost)
1444		Various Este commissions, including a medal (dated) commemorating the second marriage of Leonello, to Maria of Aragon, on 24 April 1444
1445		Pisanello produced painting (lost) for the Este palace of Belriguardo, for which he was paid 50 ducats by Leonello on 15–17 August 1445
		Cast two portrait medals of Sigismondo Malatesta, one dated 1445; however, no documentary evidence of Pisanello's presence at any time in Rimini or Cesena
1447	FERRARA	Documented as residing in parish of Santa Maria in Vado in Ferrara
		Medals of Cecilia Gonzaga and Bellotto Cumano (dated)
c. 1447		Medals of Lodovico II Gonzaga, the reigning marquis of Mantua and captain general of the Florentine troops (a title he received 18 January 1447), and of his father Gianfrancesco Gonzaga (died 24 September 1444) and the humanist Vittorino da Feltre (died 2 February 1446)
1448		Cast two medals of Pier Candido Decembrio, commissioned by Leonello d'Este (mentioned in a letter from Leonello to the humanist, 18 August 1448)
		Paid 25 florins for unspecified commissions by Leonello on 8 January 1447; Pisanello is further mentioned in the Este account books on 28 March and 31 December 1448
1448–9	NAPLES	Settled at court of king Alfonso V of Aragon as court artist for unknown period (privilege granted 14 February 1449): primarily exploited as a designer. Made three medals of Alfonso (sketches dated 1448 and 1449 and medal dated 1449) and a medal of his chancellor, Iñigo d'Avalos; also made drawings for goldsmith's work, embroideries, cannon and architecture
later 1440s/early 1450s		Portrait medal of Pisanello dates to this time
July 1455		Named as debtor of his brother-in-law, Bartolomeo della Levata, in Verona, in document of 14 July 1455
by October 1455	ROME	Pisanello dead: Carlo de' Medici recounted in a letter from Rome to his brother Giovanni in Florence how he bought 30 silver coins from one of Pisanello's assistants, the artist himself being but recently dead
		During period immediately before death sketched design for a portrait of Pope Nicholas V (never cast because of pope's death in 24 March 1455)

LIST OF WORKS IN EXHIBITION

Works shown in the exhibition *Pisanello: Painter to the Renaissance Court* at the National Gallery, London, 24 October 2001 – 13 January 2002 are listed below by catalogue number, with cross reference to their figure number in this book.

1 Pisanello and/or workshop
 Self-portrait medal, obverse (fig. 1.2a), *c*.1445–52
 Cast bronze, diam. 5.8 cm
 New York, Alan Stone and Lesley Hill

2 Pisanello
 Portrait medal of Gianfrancesco Gonzaga, marquis of Mantua, obverse (fig. 2.3a), *c*.1447
 Cast lead, diam. 10 cm
 London, The British Museum, inv. 1912-3-6-1

3 Pisanello
 Portrait medal of Lodovico Gonzaga, marquis of Mantua, obverse (fig. 2.25a,), *c*.1447
 Cast lead, diam. 10.3 cm
 London, The British Museum, inv. GIII, Mant. M5

4 Pisanello
 Portrait medal of Lodovico Gonzaga, marquis of Mantua, reverse (see fig. 2.25b for another example), *c*.1447
 Cast lead, diam. 10.2 cm
 London, Victoria and Albert Museum, inv. 7137-1860

5 Pisanello
 Portrait medal of Cecilia Gonzaga, obverse (fig. 3.31a), 1447
 Cast bronze, diam. 8.8 cm
 Milan, Gabinetto Numismatico Museo Archeologico, inv. M.O.9.1417

6 Pisanello
 Portrait medal of Cecilia Gonzaga, reverse (see fig. 3.31b for another example), 1447
 Cast bronze, diam. 8.6 cm
 Berlin, Staatliche Museen zu Berlin, Münzkabinett, inv. 21.1

7 Pisanello
 Margherita Gonzaga (fig. 3.19), *c*.1438–40
 Egg tempera on panel, 42 × 29.6 cm
 Paris, Musée du Louvre, inv. RF 766

8 Pisanello
 Leonello d'Este, marquis of Ferrara (fig. 3.2), *c*.1441
 Tempera on panel, 28 × 19 cm
 Bergamo, Accademia Carrara di Belle Arti, inv. 919

9 Pisanello
 Portrait medal of Leonello d'Este, marquis of Ferrara, obverse (fig. 3.43a), 1444
 Cast bronze, diam. 10.1 cm
 London, Victoria and Albert Museum, inv. A.165-1910

10 Pisanello
 Portrait medal of Leonello d'Este, marquis of Ferrara, reverse (see fig. 3.43b for another example), 1444
 Cast bronze, diam. 10.2 cm
 Milan, Gabinetto Numismatico Museo Archeologico, inv. M.O.9.554

11 Pisanello
 Portrait medal of Leonello d'Este, marquis of Ferrara, reverse (showing two men with a basket of olives) (fig. 3.40ab), *c*.1441
 Cast bronze, diam. 6.9 cm
 London, Victoria and Albert Museum, inv. 678-1865

12 Pisanello
 Portrait medal of Leonello d'Este, marquis of Ferrara, reverse (showing two men in dialogue, with column and sail) (fig. 3.42), *c*.1441
 Cast bronze, diam. 6.8 cm
 London, The British Museum, inv. GIII, Ferrara M25

13 Pisanello
 Portrait medal of Leonello d'Este, marquis of Ferrara, reverse (with blindfold lynx) (fig. 3.41), *c*.1442
 Cast bronze, diam. 6.8 cm
 London, The British Museum, inv. GIII, Ferrara M27

14 Giovanni da Oriolo
 Leonello d'Este, marquis of Ferrara (fig. 3.4), probably 1447
 Egg tempera on wood, 57.6 × 39.5 cm
 London, National Gallery, inv. NG770

15 Pisanello
 Sketches for a portrait medal of Alfonso V of Aragon, king of Naples (fig. 1.42), 1449
 Pen and ink over black chalk, 20.6 × 14.8 cm
 Paris, Musée du Louvre, inv. 2306 recto

 Pisanello or workshop
 Design for an embroidery (fig. 1.43), *c*.1449
 Pen and ink and brown wash over black chalk, 20.6 × 14.8 cm
 Paris, Musée du Louvre, inv. 2306 verso

16 Pisanello and workshop
 Portrait medal of Alfonso V of Aragon, king of Naples, obverse and reverse (fig. 3.47a, b), *c*.1449
 Cast bronze, diam. 10.8 cm
 London, The British Museum, inv. GIII, Naples 3

17 Pisanello
 Portrait medal of Iñigo d'Avalos, obverse (fig. 3.45a), *c*.1448–50
 Cast bronze, diam. 7.7 cm
 Berlin, Staatliche Museen zu Berlin, Münzkabinett, inv. 25

18 Pisanello
 Portrait medal of Iñigo d'Avalos, reverse (see fig. 3.45b for another example), *c*.1448–50
 Cast bronze, diam. 7.7 cm
 London, The British Museum, inv. Bank Coll. It. Med. 9

19 Pisanello
 Portrait medal of Sigismondo Pandolfo Malatesta, lord of Rimini, reverse (fig. 2.19b), *c*.1445
 Cast lead, diam. 9.5 cm
 London, The British Museum, inv. 1875-10-4-4

20 Pisanello
 Portrait medal of Filippo Maria Visconti, duke of Milan, obverse (fig. 2.24a) , *c*.1435–40
 Cast bronze, diam. 10.2 cm
 Milan, Gabinetto Numismatico, inv. M.0.9.553

21 Pisanello
 Portrait medal of Filippo Maria Visconti, duke of Milan, reverse (see fig. 2.24b for another example), *c*.1435–40
 Cast bronze, diam. 10.1 cm
 Modena, Galleria Estense, inv. 9593

22 Pisanello
 Three helmets and their crests, six pieces of cannon (fig. 2.27), *c*.1448–9
 Pen and ink over black chalk, 28.7 × 20.6 cm
 Paris, Musée du Louvre, inv. 2295 recto

23 Milanese
 Armet (fig. 2.28), *c*.1450
 Steel, 25.5 × 18.5 × 28 cm; 3525 g
 Leeds, Royal Armouries Museum, inv. IV.498

24 Italian
 Gauntlet
 Steel, 30 × 13 × 30 cm; 435 g
 Leeds, Royal Armouries Museum, inv. III.1225

25 Italian
 Vambrace with reinforcing couter
 Steel, vambrace: 31 × 15 × 10; couter: 26 × 27 × 9 cm; combined weight 1510 g
 Leeds, Royal Armouries Museum, inv. III.4700

26 Italian
 Sword
 Steel, 107 cm long; 1530 g
 Leeds, Royal Armouries Museum, inv. IX.2149

27 Pisanello and/or workshop
 Portrait medal of Leonello d'Este, reverse (fig. 5.46b), after 1441
 Cast bronze, diam. 6.8 cm
 Modena, Galleria Estense, inv. 8847

28 Italian, probably Milanese
 Left poleyn (knee-defence) (fig. 2.21), c.1450
 Steel, 25.4 × 15 × 24; 620 g
 Leeds, Royal Armouries Museum, inv. III.1286

29 Italian
 Pair of sabatons (fig. 2.30), c.1450
 Steel, each 11 × 14 × 30 cm; 645 g
 Leeds, Royal Armouries Museum, inv. III.1348

30 Italian
 Rowel-spur (fig. 4.38), c.1460
 Tinned steel, 4 × 7.5 × 23 cm; 135g
 Leeds, Royal Armouries Museum, inv. VI.322a

31 Italian
 Rowel-spur, 15th century
 Metal, 4.7 × 8.8 × 27 cm
 Glasgow, Burrell Collection, inv. 2.24

32 Pisanello
 Costumes (three courtiers) (fig. 2.33), c.1433
 Pen and ink and grey wash over leadpoint on
 parchment, 24.8 × 33.8 cm
 London, The British Museum, inv. 1846-5-9-143

33 Follower of Pisanello
 Borso d'Este (?), hunting with a falcon (fig. 2.24), c.1450
 Pen and ink, brown wash and gold heightening
 over black chalk on brown prepared paper,
 22.5 × 17.2 cm
 Paris, Institut Néerlandais, Collection Frits Lugt,
 inv. 6164 (JBS 203)

34 Pisanello
 Studies of a female dwarf, hanged men, a child's
 head (fig. 1.26), c.1434-8
 Pen and ink over metalpoint, 28.3 × 19.3 cm
 London, The British Museum, inv. 1895-9-15-441

35 Workshop of Pisanello
 Study of costumes (fig. 2.32), c.1432-5
 Pen and ink with watercolour washes on
 parchment, 18.3 × 24 cm
 Oxford, Ashmolean Museum, inv. P.II.41 recto

 Workshop of Pisanello
 Studies of Maenads (fig. 3.52), c.1431-5
 Pen and ink on parchment, 18.3 × 24 cm
 Oxford, Ashmolean Museum, inv. P.II.41 verso

36 Franco-Burgundian
 Hercules on Mount Olympus (fig. 3.15), c.1425-50
 Tapestry, 398 × 462 cm
 Glasgow, Burrell Collection, inv. 48.60

37 Workshop of Pisanello
 Women with falcons, an armoured knight (fig. 2.39),
 c.1431-40
 Pen and ink on parchment, 18.4 × 25.7 cm
 Vienna, Albertina, inv. 16

38 Lombard or workshop of Pisanello
 Falcon (fig. 2.38), c.1434-5
 Pen and ink, 21.9 × 17.1 cm
 Trustees of the Chatsworth Settlement, inv. 63
 (Birds no. 30)

39 Pisanello
 Young falcon (fig. 2.36), c.1434-45
 Pen and ink, brown wash, watercolour and white
 heightening over black chalk, 23.7 × 15.1 cm
 Paris, Musée du Louvre, inv. 2453

40 Mantuan
 Falcon's hood (fig. 2.37), c.1450
 Tooled leather, with traces of gilding, 7 × 6.5 cm
 Mantua, Museo del Palazzo Ducale, inv. 15885

41 Genoese
 Fragment of a treatise on the Vices by a member
 of the Coccarelli family of Genoa, folio 1v: Hunting
 scene (fig. 2.35), c.1380-1400
 Tempera and gold on grey ground on parchment,
 16.5 × 10 cm
 London, The British Library, inv. Egerton 3127

42 French
 Henri de Ferrières, Le Livre du roy Modus et de la
 royne Ratio (The Book of King Practice and Queen
 Theory), folio 12: Stag hunt (fig. 2.44), c.1465
 Tempera on parchment, 29.5 × 22.3 cm
 New York, The Pierpont Morgan Library, inv. M.820

43 North Italian
 Hunting cutlery of emperor Frederick III (fig. 2.42)
 c.1430-40
 Steel, brass, horn and leather, from 18 to 36 cm long
 Vienna, Kunsthistorisches Museum, inv. D 261

44 Matteo de' Pasti
 Portrait medal of Guarino da Verona, obverse
 (fig. 3.13a), c.1450
 Cast bronze, diam. 9.5 cm
 London, The British Museum, inv. GIII, Ill. P., 419

45 Pisanello
 Portrait medal of Pier Candido Decembrio, obverse
 (see fig. 3.33a for another example), 1448
 Cast lead, diam. 8.1 cm
 Milan, Gabinetto Numismatico, inv. M.0.9.1403

46 Pisanello
 Portrait medal of Pier Candido Decembrio, reverse
 (fig. 3.33b), 1448
 Cast lead, diam. 8.1 cm
 London, The British Museum, inv. 1906-11-3-139

47 Pisanello
 Portrait medal of Vittorino da Feltre, obverse
 (fig. 3.34a), c.1446
 Cast bronze, diam. 6.7 cm
 Berlin, Staatliche Museen zu Berlin, Münzkabinett,
 inv. 22

48 Pisanello
 Portrait medal of Vittorino da Feltre, reverse
 (see fig. 3.34b for another example), c.1446
 Cast bronze, diam. 6.7 cm
 London, Victoria and Albert Museum, inv. 504-1864

49 Workshop of Pisanello
 Portrait medal of Bellotto Cumano, reverse (see
 fig. 3.32b for another example), 1447
 Cast bronze, diam. 5.8 cm
 Berlin, Staatliche Museen zu Berlin, Münzkabinett,
 inv. 23

50 Workshop of Pisanello
 Portrait medal of Bellotto Cumano, obverse
 (fig. 3.32a), 1447
 Cast bronze, diam. 5.8 cm
 Milan, Gabinetto Numismatico, inv. M.0.9.1402

51 Workshop of Pisanello
 Study of figures from The Indian Triumph of Bacchus
 from an ancient sarcophagus; a dragon (fig. 3.55),
 c.1431-40
 Pen and ink and brown wash over metalpoint on
 parchment, 16.3 × 22 cm
 Milan, Pinacoteca Ambrosiana, inv. F.214 inf. 14 recto

52 Roman
 Sarcophagus relief: The Indian Triumph of Bacchus
 (fig. 3.54), 2nd century
 Marble, 69 × 70 cm
 Grottaferrata, Museo del Monumento Nazionale
 della Badia Greca

53 Workshop of Pisanello
 Study of the 'Horse-Tamer' (Dioscurus); peacocks
 (detail, fig. 3.56), c.1431-40
 Pen and ink over metalpoint (for Dioscurus) on
 parchment, 23 × 36 cm
 Milan, Pinacoteca Ambrosiana, inv. F.214 inf. 10 verso

54 Workshop of Pisanello
 Study of figures from The Death of Adonis from
 an ancient sarcophagus (fig. 3.48), c.1431-40
 Pen and ink over metalpoint on parchment,
 18.8 × 11.9 cm
 Berlin, Staatliche Museen zu Berlin,
 Kupferstichkabinett, inv. 1358 recto

55 Pisanello and workshop
 Portrait medal of Alfonso V of Aragon, king of
 Naples, obverse (detail, fig. 5.47), 1449
 Cast lead, diam. 10.8 cm
 London, The British Museum, inv. 1875-10-4-1

56 Pisanello
 Two youths, a standing saint or Prophet (fig. 3.50),
 c.1430-5
 Pen and ink over metalpoint on parchment,
 28.3 × 19.1 cm
 Berlin, Staatliche Museen zu Berlin,
 Kupferstichkabinett, inv. 487 recto

57 Workshop of Pisanello
 Plutarch, Parallel Lives (Vitae virorum illustrium),
 folio 29: Julius Caesar (fig. 5.26), c.1446-8
 Tempera on parchment, 36.2 × 24.7 cm
 Cesena, Biblioteca Malatestiana, inv. Ms.S.XV.1

58 Pisanello
 Studies after three ancient coins and an ancient gem
 (fig. 3.6), c.1434-8
 Pen and ink and brown wash over black chalk on
 red prepared paper, 21.7 × 19.3 cm
 Paris, Musée du Louvre, inv. 2315 recto

 Pisanello
 Head of a bearded man (fig. 3.58), c.1434-8
 Pen and ink over black chalk on red prepared paper,
 21.7 × 19.3 cm
 Paris, Musée du Louvre, inv. 2315 verso

59 Roman
Republican coin of Octavian with posthumous
portrait of Julius Caesar, obverse (fig. 3.7), c.38 BC
Struck bronze, diam. 3.1 cm
London, The British Museum, inv. 1872-7-9-432

60 Roman
Imperial coin of Tiberius with posthumous portrait
of emperor Augustus, obverse (fig. 3.8), 14–37 AD
Struck bronze, diam. 2.9 cm
London, The British Museum, inv. BMC Tiberius 155

61 Macedonian
Tetradrachm of Alexander the Great of Macedonia,
obverse with image of Hercules (fig. 3.9), c.336–323 BC
Struck silver, diam. 2.4 cm
London, The British Museum, inv. 1929-8-11-42

62 Pisanello
Portrait medal of Leonello d'Este, marquis of
Ferrara, obverse (see fig. 3.5a for another example),
c.1442
Cast bronze, diam. 6.8 cm
Milan, Gabinetto Numismatico, inv. M.0.9.555

63 Pisanello
Portrait medal of Leonello d'Este, marquis of
Ferrara, reverse (fig. 3.5b), c.1442
Cast bronze, diam. 6.8 cm
London, The British Museum, inv. GIII,
Ferrara M26

64 Pisanello
Study of ancient sculpted *River Tigris* (fig. 3.10),
c.1431–2
Pen and ink and wash over metalpoint on parchment,
13.7 × 20.5 cm
Berlin, Staatliche Museen zu Berlin,
Kupferstichkabinett, inv. KdZ 1359

65 Seleucid
Tetradrachm of king Seleucus I of Syria
(Mint of Pergamum or Epheseus), obverse (with
Bucephalus) (fig. 3.39a), 281–280 BC
Struck silver, diam. 6.8 cm
London, The British Museum, inv. 1888-12-8-33
Oxus Treasure

66 Pisanello
Portrait medal of Francesco Sforza, reverse
(fig. 3.38b), c.1441
Cast bronze, diam. 8.7 cm
Berlin, Staatliche Museen zu Berlin, Münzkabinett,
inv. 9.1

67 Roman
Republican coin with image of the She-wolf (*Lupa*)
of Rome, reverse (fig. 3.36), early 3rd century BC
Struck silver, diam. 2 cm
London, The British Museum, inv. BMC Romano-
Camp. 28

68 Pisanello
Portrait medal of Niccolò Piccinino, obverse
(fig. 3.37a), c.1439–42
Cast bronze, diam. 8.9 cm
London, Victoria and Albert Museum,
inv. A.170-1910

69 Pisanello
Portrait medal of Niccolò Piccinino, reverse
(see fig. 3.37b for another example), c.1439–42
Cast bronze, diam. 8.9 cm
London, The British Museum, inv. GIII, Ill. P.748

70 Attributed to workshop of Pisanello
Scriptores historiae augustae (Writers of Imperial
History), folio 85 (fig. 3.26), c.1435–45
Tempera and gold on parchment, c.27 × c.19 cm
(maximum)
Turin, Biblioteca Nazionale, inv. Ms.E.III.19

71 Pisanello
Portrait medal of emperor John VIII Palaeologus,
obverse (fig. 1.35a), c.1438–43
Cast bronze, diam. 10.3 cm
London, The British Museum, inv. GIII, Naples 9

72 Pisanello
Portrait medal of emperor John VIII Palaeologus,
reverse (see fig. 1.35b for another example), c.1438–43
Cast bronze, diam. 10.3 cm
London, Victoria and Albert Museum, inv. A.169-1910

73 Pisanello
Portrait medal of Domenico Malatesta Novello,
lord of Cesena, obverse (see fig. 4.50a for another
example), c.1446–52
Cast bronze, diam. 8.5 cm
Berlin, Staatliche Museen zu Berlin, Münzkabinett,
inv. 19.1

74 Pisanello
Portrait medal of Domenico Malatesta Novello,
lord of Cesena, reverse (see fig. 4.50b for another
example), c.1446–52
Cast bronze, diam. 8.5 cm
London, Victoria and Albert Museum inv. A.168-1910

75 Pisanello
The Vision of Saint Eustace (fig. 4.35), c.1438–42
Egg tempera on poplar, 54.8 × 65.5 cm
London, National Gallery, inv. NG1436

76 Pisanello
Two studies of a bear (fig. 4.41), c.1434–42
Black chalk over stylus, traces of pen and ink,
24.3 × 17.2 cm
Paris, Musée du Louvre, inv. 2414 recto

77 Pisanello
Running hare (fig. 4.58), c.1430–42
Watercolour over black chalk, 13.7 × 22.3 cm
Paris, Musée du Louvre, inv. 2445

78 Pisanello
Two studies of a hoopoe (fig. 4.73), c. 1434–42
Pen and ink over leadpoint (for the right-hand
study), brown wash and watercolour with white
heightening (for the left-hand study), 16.1 × 21.7 cm
Paris, Musée du Louvre, inv. 2467

79 Pisanello
Teal (fig. 2.41), c.1434–45
Pen and ink, watercolour and white heightening
over black chalk, 14 × 21.4 cm
Paris, Musée du Louvre, inv. 2461

80 Workshop of Pisanello
Two teal (fig. 5.5), c.1434–45
Pen and ink, watercolour and brown wash over
black chalk, 20 × 16.1 cm
Paris, Musée du Louvre, inv. 2463

81 Pisanello
Dead lapwing (fig. 1.45), c.1434–45
Pen and ink, watercolour and white heightening
over leadpoint, 18.7 × 16.7 cm
Paris, Musée du Louvre, inv. 2464

82 Pisanello
Wryneck and two goldfinches (fig. 1.46), c.1434–45
Pen and ink, brown wash, watercolour and white
heightening over black chalk, 17.7 × 19.1 cm
Paris, Musée du Louvre, inv. 2466

83 Pisanello
Flying egrets (fig. 4.52), c.1434–8
Pen and ink, 16.5 × 24.7 cm
Paris, Musée du Louvre, inv. 2469 recto

84 Workshop of Pisanello
Herons (fig. 5.3), c.1434–45
Pen and ink with areas of green wash on
parchment, 18.1 × 27 cm
Paris, Musée du Louvre, inv. 2472

85 Workshop of Pisanello
Herons (fig. 5.4), c.1434–45
Pen and ink over leadpoint, watercolour (for the
coloured heron) and white heightening, 20 × 16.1 cm
Paris, Musée du Louvre, inv. 2471 recto

86 Attributed to Bono da Ferrara
Heron (fig. 5.22), c.1440–5
Pen and ink over leadpoint, 24.3 × 17.5 cm
Paris, Musée du Louvre, inv. 2450

87 Pisanello or workshop
Studies of a kingfisher (fig. 4.71), c.1434–42
Pen and ink over black chalk or lead point on red
prepared paper, 24.9 × 18 cm
Paris, Musée du Louvre, inv. 2509 recto

88 Pisanello
Study of plants (fig. 4.69), c.1438–42
Pen and ink, brown wash and white heightening
on red prepared paper, 23.3 × 17.6 cm
Montauban, Musée Ingres, inv. MIC69.2.D verso

89 Pisanello
Croup of a horse, a hoof (fig. 4.65), c.1434–42
Pen and ink over metalpoint (?) on red prepared
paper, 23.8 × 17.6 cm
Paris, Musée du Louvre, inv. 2365 recto

90 Pisanello
Croup of a horse (fig. 4.64), c.1434–42
Pen and ink, light-brown wash and watercolour
over stylus, 25.6 × 20.2 cm
Paris, Musée du Louvre, inv. 2366

91 Pisanello
Horse's head and hoof (fig. 4.62), c.1434–42
Pen and ink, brown wash and watercolour over
stylus, 25.8 × 19.7 cm
Paris, Musée du Louvre, inv. 2356

92 Pisanello
Head of a horse (fig. 4.68), *c.*1434–42
Pen and ink over black chalk, 26.6 × 17.1 cm
Paris, Musée du Louvre, inv. 2359

93 Pisanello
Three studies of deers' heads (fig. 4.76), *c.*1438–42
Pen and ink over black chalk, 15.8 × 20.8 cm
Paris, Musée du Louvre, inv. 2490

94 Pisanello
A deer seen from behind (fig. 4.75), *c.*1438–42
Pen and ink over stylus and metalpoint, 20.2 × 27.5 cm
Paris, Musée du Louvre, inv. 2489

95 Pisanello
Studies for a crucifix, a gibbet (fig. 4.48), *c.*1434–8
Pen and ink over black chalk on red prepared paper,
26 × 19.5 cm
Paris, Musée du Louvre, inv. 2368 verso

Pisanello
Horse and rider (fig. 4.51), *c.*1434–8
Pen and ink on red prepared paper, 19.5 × 26 cm
Paris, Musée du Louvre, inv. 2368 recto

96 Pisanello
Hound (fig. 4.59), *c.*1438–42
Black chalk, 18.2 × 21.9 cm
Paris, Musée du Louvre, inv. 2429 verso

Pisanello
Head of a hound (fig. 4.61), *c.*1438–42
Leadpoint, brown wash and watercolour,
18.2 × 21.9 cm
Paris, Musée du Louvre, inv. 2429 recto

97 Jacopo Bellini
The London Sketchbook, folio 71: *The Vision of Saint Eustace* (fig. 4.79), *c.*1445–60
Leadpoint on paper, 51.4 × 78 cm
London, The British Museum, inv. 1855-8-11

98 Limbourg brothers
Les Belles Heures, folio 26v: *The Tiburtine Sibyl showing the emperor Augustus the Virgin and Child* (fig. 4.30), *c.*1406–9
Tempera and gold leaf on parchment,
23.8 × 16.8 cm
New York, Metropolitan Museum, The Cloisters, inv. MS 54.11.1.

99 Pisanello
Wild boar (fig. 4.17), *c.*1434–45
Pen and ink, watercolour, and white heightening over black chalk or metalpoint, 14 × 20 cm
Paris, Musée du Louvre, inv. 2417

100 Pisanello
Wild boar (fig. 4.16), *c.*1430–5
Pen and ink and brown wash on parchment,
9.9 × 16.8 cm
Cambridge, Fitzwilliam Museum, inv. PD. 124-1961

101 Pisanello
Design for a dragon salt cellar (fig. 4.19), *c.*1448–9
Pen and ink and brown wash over black chalk,
19.4 × 28.3 cm
Paris, Musée du Louvre, inv. 2289

102 Workshop of Pisanello
Two studies of the Virgin and Child (fig. 5.10),
*c.*1431–40
Pen and ink over metalpoint on red prepared paper,
19.9 × 26 cm
Milan, Pinacoteca Ambrosiana, inv. F.214 inf. 8

103 Workshop of Pisanello
Two standing figures in monastic habits (fig. 5.7),
*c.*1431–40
Pen and ink and wash on parchment, 21.1 × 16 cm
Vienna, Albertina, inv. 5 verso

104 Pisanello
Studies of a squid, a human leg, flowers, the Virgin and Child (fig. 4.13), *c.*1435–41
Pen and ink over metalpoint or black chalk, with watercolour (for the squid); for the Virgin and Child metalpoint or black chalk only, 24.4 × 18.5 cm
Paris, Musée du Louvre, inv. 2262

105 Pisanello
Study of *Two Naiads riding sea-monsters* and a *Season* from an ancient sarcophagus (fig. 4 .8), *c.*1431–2
Pen and ink and brown wash over metalpoint on parchment, 21.2 × 15.6 cm
Rotterdam, Museum Boymans Van Beuningen,
inv. I.523 verso

106 Pisanello
The Virgin and Child with Saints Anthony Abbot and George (fig. 4.4), *c.*1435–41
Egg tempera on wood, 46.5 × 31 cm
London, National Gallery, inv. NG776

107 Pisanello
Studies of the mouth and nostrils of a horse
(fig. 4.20), *c.*1434–8
Pen and ink over black chalk, 17.2 × 23.8 cm
Paris, Musée du Louvre, inv. 2352

108 Pisanello
Head of a horse (fig. 4.22), *c.*1434–8
Pen and ink over metal- or leadpoint, 23.5 × 16 cm
Paris, Musée du Louvre, inv. 2355

109 Pisanello
Horse's heads (fig. 4.23), *c.*1434–8
Pen and ink over black chalk, 29.1 × 18.4 cm
Paris, Musée du Louvre, inv. 2354

110 Pisanello and workshop
Horse's head; study for the Malaspina chapel
(figs. 1.34, 5.11), *c.*1438
Pen and ink over black chalk on red prepared paper,
25.3 × 37.5 cm
Paris, Musée du Louvre, inv. 2631 recto

111 Pisanello
A young man with his hands behind his back
(fig. 1.25), *c.*1434–8
Pen and ink over metalpoint, 26.8 × 18.6 cm
Edinburgh, National Gallery of Scotland, inv. D722

112 Bono da Ferrara
Saint Jerome in a landscape (fig. 5.18), *c.*1440
Pen and ink, 20.3 × 29.5 cm
Paris, Institut Néerlandais, Collection Frits Lugt,
inv. 1344

113 Bono da Ferrara
Saint Jerome in a landscape (fig. 5.12), *c.*1440
Egg tempera on wood, 5.35 × 39.6 cm
London, National Gallery, inv. NG771

114 Attributed to Bono da Ferrara
Seated man in monastic habit (fig. 5.19), *c.*1440–5
Pen and ink over metalpoint, 27.2 × 19.5 cm
Paris, Musée du Louvre, inv. 2332 verso

115 Attributed to Bono da Ferrara
Seated man in monastic habit (fig. 5.21), *c.*1440
Pen and ink, 18.8 × 11.7 cm
London, The British Museum, inv. 1946-7-13-206

116 Workshop of Pisanello
Studies of ancient sculpture: *head of Jupiter, lion's head, feet* (fig. 5.14), *c.*1432–40
Pen and ink, brown wash and metalpoint on parchment, 17.9 × 12.8 cm
Rotterdam, Museum Boymans Van Beuningen,
inv. I.521 recto

117 Workshop of Pisanello
Julius Caesar, *Commentaries* (*De bello gallico*), folio 1r (fig. 5.32), *c.*1438–50
London, The British Library,
inv. Harley 2683

118 Workshop of Pisanello and unidentified Veronese illuminator
The Conversion of Saint Paul (fig. 5.29), *c.*1438–50
Gold leaf, gold paint, silver leaf, ink and tempera on parchment, 14.2 × 9 cm
Los Angeles, The J. Paul Getty Museum,
inv. 91.Ms.5 verso

119 Workshop of Pisanello
Study of *Bacchus with satyrs and Maenads* from an ancient sarcophagus (fig. 5.34), *c.*1431–40
Pen and ink over metalpoint on parchment,
19.5 × 27.4 cm
Milan, Pinacoteca Ambrosiana, inv. F.214 inf.
15 recto

120 Taddeo Crivelli
Boccaccio, *Decameron*, folio 5v: *The Meeting in Santa Maria Novella* (fig. 5.38), 1467
Tempera and gold on parchment, 36 × 26.4 cm
Oxford, Bodleian Library, inv. MS.Holkham
misc.49

121 Taddeo Crivelli
The Gualenghi-d'Este Hours, folio 174: *Saint Jerome kneeling before the Cross* (fig. 5.36), *c.*1469
Gold leaf, gold paint and tempera on parchment,
10.8 × 7.9 cm
Los Angeles, The J. Paul Getty Museum,
inv. 83.ML.109

122 Pisanello
Portrait medal of Sigismondo Pandolfo Malatesta, lord of Rimini, obverse (see fig. 1.40a for another example), 1445
Cast bronze, diam. 10.5 cm
London, The British Museum, inv. 1921-6-11-14

123 Pisanello
Portrait medal of Sigismondo Pandolfo Malatesta,
lord of Rimini, reverse (fig. 1.40b), 1445
Cast bronze, diam. 10.5 cm
London, Victoria and Albert Museum, inv. A.167-1910

124 Matteo de' Pasti
Portrait medal of Sigismondo Malatesta, lord of
Rimini, obverse (fig. 5.44a), c.1449–52
Cast bronze, diam. 8.4 cm
London, The British Museum, inv. 1933-11-12-2

125 Matteo de' Pasti
Portrait medal of Isotta degli Atti, reverse
(fig. 5.43a), c.1449–52
Cast bronze, diam. 8.4 cm
London, The British Museum, inv. GIII, Var. Pr. 8

126 Workshop of Pisanello
Design for a portrait medal of Alfonso V of Aragon,
king of Naples (fig. 5.54)
Pen and ink over black chalk, 16.9 × 14.5 cm
Paris, Musée du Louvre, inv. 2307

127 Workshop of Pisanello
Portrait medal of Alfonso V of Aragon, king of
Naples, obverse (fig. 3.44a), 1449
Cast lead, diam. 10.9 cm
Berlin, Staatliche Museen zu Berlin, Münzkabinett,
inv. 24

128 Workshop of Pisanello
Portrait medal of Alfonso V of Aragon, king of
Naples, reverse (see fig. 3.44b for another example),
1449
Cast lead, diam. 11 cm
London, The British Museum, inv. 1875-10-4-2

129 Pisanello and workshop
Portrait medal of Alfonso V of Aragon, king of
Naples, reverse (fig. 3.46b), c.1449–50
Cast bronze, diam. 11.2 cm
London, The British Museum, inv. GIII, Naples 2

130 Paolo da Ragusa
Portrait medal of Alfonso V of Aragon, king of
Naples, obverse (fig. 5.53a), c.1450
Cast bronze, diam. 4.5 cm
London, The British Museum, inv. 1920-7-23-1

131 Pisanello or workshop
Design for the entrance façade of the Castelnuovo,
Naples (fig. 5.57), c.1448–50
Pen and ink and brown wash over black
chalk on parchment, 31.1 × 16.2 cm
Rotterdam, Museum Boymans Van Beuningen,
inv. I.527

132 Pisanello and / or workshop
Self-portrait medal, obverse (see fig. 1.2a for
another example), c.1445–52
Cast bronze, diam. 5.8 cm
London, The British Museum, inv. GIII, Ill. P. 994

PICTURE CREDITS

AMSTERDAM
Allard Pierson Museum, Amsterdam © Allard Pierson Museum, Amsterdam. Archaeological Museum of the University of Amsterdam 3.53

AREZZO
Museo Medioevale e Moderno di Statale di Arte, Arezzo © Soprintendenza per i beni ambientali, archittetonici, artistici e storici, Arezzo 2.22

BERGAMO
Accademia Carrara di Belle Arti, Bergamo © Accademia Carrara di Belle Arti, Bergamo. Photo: Gamberoni 3.2 Civica Biblioteca Angelo Mai, Bergamo © Civica Biblioteca Angelo Mai, Bergamo. Photo: Studio Fotografico Dare 4.56

BERLIN
Kunstbibliothek, Staatliche Museen zu Berlin © Staatliche Museen zu Berlin 1.18 Kupferstichkabinett, Berlin © Staatliche Museen zu Berlin. Bildarchiv Preussischer Kulturbesitz, Joerg P. Anders 3.10, 3.48, 3.50 Münzkabinett, Staatliche Museen zu Berlin © Staatliche Museen zu Berlin 3.34, 3.38, 3.44, 3.45, 5.50, 5.51, 5.52

BOSTON
Courtesy Museum of Fine Arts, Boston. Theodora Wilbour Fund in memory of Zoe Wibour, 1997.91 © 2000 Museum of Fine Arts Boston. All Rights Reserved 3.39

CAMBRIDGE, UK
Lent by the Syndics of the Fitzwilliam Museum, University of Cambridge © Fitzwilliam Museum, University of Cambridge 4.16

CAMBRIDGE, USA
Houghton Library, Harvard University © President and Fellows of Harvard College, Harvard University 5.41, 5.42

CESENA
Istituzione Biblioteca Malatestiana, Cesena © Istituzione Biblioteca Malatestiana, Cesena. Laboratorio Fotografico: Ivano Giovannini 5.25, 5.26

CHANTILLY
Musée Condé Chantilly © Photo: RMN, Paris J.G. Berizzi 4.25 R.G. Ojeda 2.15, 4.27, 4.28

CHICAGO
The Art Institute of Chicago © Photo: The Art Insitute of Chicago 1.38, 1.39

DERBYSHIRE
Devonshire Collection, Chatsworth © Devonshire Collection, Chatsworth. Reproduced by permission of the Duke of Devonshire and the Chatsworth Settlement Trustees 2.38

EDINBURGH
The National Gallery of Scotland, Edinburgh © National Galleries of Scotland. Photo: Antonia Reeve 1.25

FLORENCE
Archivi Alinari, Florence © Fratelli Alinari, Florence. All rights reserved 2001 3.11, 3.57 Biblioteca Nazionale Centrale di Firenze © Biblioteca Nazionale Centrale di Firenze Photo: Nicolo Orsi Battaglini, Florence 4.33, 4.34 Galleria degli Uffizi, Florence © Photo: SCALA, Florence 1.17 Museo Nazionale del Bargello, Florence © Museo Nazionale del Bargello, Florence. Photo: Nicolo Orsi Battaglini, Florence 5.56

GLASGOW
The Burrell Collection, Glasgow © Glasgow Museums 2.40, 3.15

GROTTAFERRATA
Museo dell'Abbazia Greca, Grottaferrata. Soprintendenza Archeologica Lazio © Museo dell'Abbazia Greca, Grottaferrata. Soprintendenza Archeologica Lazio 3.54

LEEDS
Royal Armouries Museum Leeds © Royal Armouries Museum Leeds 2.21, 2.28, 2.30, 4.38

LONDON
National Gallery, London © National Gallery, London 3.4, 4.1, 4.2, 4.3, 4.4, 4.7, 4.11, 4.12, 4.15, 4.18, 4.21, 4.35, 4.36, 4.39, 4.43, 4.49, 4.53, 4.57, 4.60, 4.63, 4.66, 4.67, 4.70, 4.72, 4.74, 4.77, 4.81, 5.12, 5.15, 5.16, 5.17 The British Library, London © The British Library, London 2.35, 4.5, 5.32, 5.33 The British Museum, London © Copyright The British Museum 1.26, 1.35, 2.3, 2.19, 2.25, 2.33, 3.1, 3.3, 3.5, 3.7, 3.8, 3.9, 3.12, 3.13, 3.29, 3.30, 3.33, 3.35, 3.36, 3.41, 3.42, 3.46, 3.47, 3.51, 4.78, 4.79, 4.82, 5.21, 5.34, 5.43, 5.44, 5.46, 5.47, 5.53, 5.55 The Victoria and Albert Museum, London © V&A Picture Library 1.40, 3.37, 3.40, 3.43, 4.40, 4.50, 5.30, 5.37

LOS ANGELES
The J. Paul Getty Museum, Los Angeles © The J. Paul Getty Museum, Los Angeles 5.1, 5.29, 5.31, 5.36

MANTA (CUNEO)
Manta Castle, Manta, Cuneo. © Photo: SCALA, Florence 3.14

MANTUA
Palazzo Ducale, Mantova © Photo: SCALA, Florence 2.1, 2.4, 2.6, 2.7, 2.8, 2.10, 2.11, 2.12, 2.13, 2.26, 5.23 © Soprintendenza per il patrimonio storico, artistico e antropologico di Brescia, Cremona e Mantova. Photo: Gabriele Finazzer 2.37, 3.49

MILAN
Biblioteca-Pinacoteca Ambrosiana, Milan © Property of the Ambrosian Library. All rights reserved. Reproduction is forbidden 3.55, 3.56, 5.9, 5.10, 5.27, 5.34 Gabinetto Numismatico Museo Archeologico, Milan © Gabinetto Numismatico Milan. Photo: Giancarlo Mascher 2.24, 2.31, 3.31, 3.32 Pinacoteca di Brera, Milan © Photo: SCALA, Florence 1.10, 1.11, 1.16

MODENA
Biblioteca Estense Universitaria, Modena © Biblioteca Estense Universitaria, Modena. Su Concessione del Ministero per I Beni e le Attivita 5.40 Archivico Fotografico della Soprintendenza per I Beni Artistici e Storici di Modena e Reggio Emilia. Photo: Pugnaghi 2.20, 5.39, 5.46

MONTAUBAN
Musée Ingres, Montauban © Musée Ingres, Montauban. Cliché Roumagnac 4.69

MONZA
Duomo, Chapel of Teodolinda © Photo: SCALA, Florence 2.14

NAPLES
Property of H.S.H The Prince Francesco d'Avalos, Naples © Property of H.S.H The Prince Francesco d'Avalos, Naples 5.2

NEW YORK
Alan Stone and Lesley Hill, New York © Alan Stone and Lesley Hill. Photo: Maggie Nimkin, New York 1.2 The Metropolitan Museum of Art, The Cloisters Collection 1954.1 (54.1.1.) © The Metropolitan Museum of Art, New York 4.30, 4.31 The Pierpont Morgan Library, New York © The Pierpont Morgan Library. Photo: Lee Schecter 2.44

OXFORD
Ashmolean Museum, Oxford © Copyright in this Photograph is Reserved to the Ashmolean Museum, Oxford 2.32, 3.52 Bodleian Library, Oxford © Bodleian Library, University of Oxford 5.38

PADUA
Chiesa degli Eremitani, Padua © Chiesa degli Eremitani, Padua 5.13

PARIS
Bibliothèque nationale, Paris © Bibliothèque nationale de France 2.16, 4.42, 4.44, 4.45, 4.46, 4.47 Collection Frits Lugt, Institut Néerlandais, Paris © Collection Frits Lugt, Institut Néerlandais, Paris 2.34, 5.18 Musée du Louvre, Paris © Photo: RMN, Paris. Michele Bellot 1.42, 2.9, 2.29, 3.6, 4.13, 4.14, 4.19, 4.32, 4.37, 4.41, 4.52, 4.65, 4.71, 5.4, 5.24, 5.28 J.G. Berizzi 1.19, 1.23, 1.24, 1.29, 1.30, 1.31, 1.32, 1.33, 1.34, 1.41, 1.43, 1.44, 1.45, 1.46, 2.2, 2.5, 2.27, 2.41, 3.17, 3.18, 3.20, 3.21, 3.22, 3.23, 3.58, 4.17, 4.22, 4.23, 4.29, 4.48, 4.51, 4.54, 4.55, 4.59, 4.61, 4.62, 4.64, 4.68, 4.73, 4.75, 5.5, 5.11, 5.19, 5.20, 5.45, 5.49, 5.54 Gerard Blot 1.36, 1.37, 4.20, 4.80, 5.3, 5.22 C. Jean 2.36, 3.19, 3.25, 4.58, 4.76

PHILADELPHIA
The Free Library of Philadelphia © The Free Library of Philadelphia 4.26

ROME
Palazzo Venezia, Roma © Photo: SCALA, Florence 1.12, 1.20 San Clemente, Rome © Engelbert Seehuber. Courtesy of Schmitt-Degenhart Stiftung. Corpus der Italienischen Zeichnungen, Graphische Sammlung Munich 1.22

ROTTERDAM
Museum Boijmans Van Beuningen, Rotterdam © Museum Boijmans Van Beuningen, Rotterdam 2.17, 4.8, 4.9, 4.10, 5.6, 5.8, 5.14, 5.57

SIENA
Pinacoteca Nazionale, Siena © Photo: SCALA, Florence 1.13

SLUDERN
Schloss de Churburg, Sludern © Photo: Magnus Edizione, Fagagna (UD) 2.18, 2.23

TURIN
Biblioteca Nazionale Universitaria di Torino © Ministerio per i Beni e le Attività Culturali. Laboratorio fotografico M.G. di Luca Castagno, Torino 3.26, 3.27

VERONA
Basilica di Sant'Anastasia, Verona © Engelbert Seehuber. Courtesy of Schmitt-Degenhart Stiftung. Corpus der Italienischen Zeichnungen, Graphische Sammlung, Munich 1.21, 1.27, 3.24, 4.24 © Photo: SCALA, Florence 1.1, 1.28 Basilica di San Fermo Maggiore, Verona © Engelbert Seehuber. Courtesy of Schmitt-Degenhart Stiftung. Corpus der Italienischen Zeichnungen, Graphische Sammlung, Munich 1.5, 1.6, 1.9, 4.6 © Photo: SCALA, Florence 1.7, 1.8 © Soprintendenza per i beni artistici e storici del Veneto. Photo: Giorgio Bianconi 1.4 Museo di Castelvecchio, Verona © Photo: SCALA, Florence 1.14, 1.15

VIENNA
Albertina, Vienna © Albertina, Vienna 2.39, 5.7 Kunsthistorisches Museum, Vienna © KHM, Vienna 2.42, 2.43

WASHINGTON D.C.
National Gallery of Art, Washington, D.C., Andrew W. Mellon Collection 1937 © 2000 Board of Trustees, National Gallery of Art, Washington, Photo: Richard Carafelli 3.16 Samuel H. Kress Collection 1957 3.28

Map by Olive Pearson 1.3

INDEX